The political aesthetics of the Armenian avant-garde

Manchester University Press

rethinking
art's histories

SERIES EDITORS
Amelia G. Jones, Marsha Meskimmon

Rethinking Art's Histories aims to open out art history from its most basic structures by fore-grounding work that challenges the conventional periodisation and geographical subfields of traditional art history, and addressing a wide range of visual cultural forms from the early modern period to the present.

These books will acknowledge the impact of recent scholarship on our understanding of the complex temporalities and cartographies that have emerged through centuries of world-wide trade, political colonisation and the diasporic movement of people and ideas across national and continental borders.

The political aesthetics of the Armenian avant-garde

The journey of the 'painterly real', 1987–2004

Angela Harutyunyan

Manchester University Press

Published by Manchester University Press
Altrincham Street, Manchester M1 7JA

www.manchesteruniversitypress.co.uk

British Library Cataloguing-in-Publication Data
A catalogue record for this book is available from the British Library

Library of Congress Cataloging-in-Publication Data applied for

ISBN 978 0 7190 8953 4 hardback

First published 2017

Typeset by
Servis Filmsetting Ltd, Stockport, Cheshire
Printed in Great Britain by
TJ International Ltd, Padstow, Cornwall

Dedicated to the memory of David Kareyan

Contents

Plates

Figures

Every effort has been made to obtain permission to reproduce copyright material, and the publisher will be pleased to be informed of any errors and omissions for correction in future editions.

Preface

It has been almost a decade since I took up the arduous task of piecing together the fragments of documentation and scattered sources to write a cohesive narrative dealing with what has come to be known as 'contemporary art' in Armenia. I call this task an arduous one since most of the primary sources for my research had to be literally recovered and dusted off from beneath thick layers of oblivion. This is partly a result of the methodical rejection of historical memory that characterizes all avant-garde art, and partly a result of the commonplace prejudice that the recent past is too recent for historical work. Historical documents and materials, depending on what they reveal and conceal, have guided my theoretical approach and the structure of my narrative: any biases in the book are both subjective – a matter of a particular perspective and political partisanship – and objective – called forth by the nature and availability of documents.

While recognizing the factographic importance of primary sources, this book is also a product of long and deeply engaging conversations, conversations that have stemmed from friendship, common scholarly and political concerns, the need to make sense of one's historical present, but also of disagreements, conflicts and contradictions. Every historical narrative engaging the pasts of those who are still active participants on the contemporary art scene is inevitably a contested endeavour. I have learned much from these conflicts, and most importantly, I have learned the need to listen to the participants and actors of the contexts I have attempted to narrate, even if their stories and recollections have at times been biased or subject to the dictates of their present convictions. Rather than asking whether the narratives of my witness-interlocutors were true or false, I have tried to understand the motivations informing the ways the past was being retold.

I would like to see this book as a fruit of the combined efforts of many individuals. The research for this book and the art-historical perspective that is developed in it would not have been possible without the sustained and deeply engaged conversations with my main interlocutor, art historian and friend Vardan Azatyan, whose writing on contemporary art in Armenia in

the early 2000s has been formative for my own work. It was to his call for self-historicization that I responded, and that I echoed in my own work. His honest feedback, his thorough and critical questions regarding methods of art-historical writing and his generosity in sharing with me archival materials he has collected over the years represent irreplaceable and peerless contributions. The years I spent writing my PhD under the supervision of Professor Amelia Jones were equally crucial for the fruition of this work. It was her constant encouragement and critical advice that motivated me to subject the PhD dissertation to a thorough revision. In terms of its historical framework, the book stems from the dissertation, but both in its theoretical approach to the historical material as well as the perspective of the historian vis-à-vis the object of her study, not much remains of the PhD dissertation in its current, published form. If the dissertation impatiently applied a catalogue of postmodern theories to the Armenian material, the book has taken the historical context itself as a source for theorization. In addition to these influences, Eric Goodfield's intellectual camaraderie, linguistic spirit and breadth of experience has provided a constant sounding board for my writing, thoughts and the questions they have spawned.

My special gratitude goes to the artists, curators and critics who appear as historical actors in this book and who responded to my call to dig deep into their closets, desks and memories to salvage the material fragments of their pasts as well as snippets of memories: Nazareth Karoyan, Hrach Armenakyan, Diana Hakobyan, Vahram Aghasyan, Arman Grigoryan, Kiki (Grigor Mikaelyan), Narek Avetisyan, Mher Azatyan, Karine Matsakyan and many others.

Lusine Chergeshtyan's and Ruzanna Grigoryan's help was indispensable in compiling and formatting the images and the bibliography of the work, and so was Catherine Hansen's thorough reading of my work and her editorial interventions. I am infinitely grateful to Octavian Esanu, Nadia Bou Ali, Sven Spieker, Karen Benezra and Rico Franses for reading and commenting on various chapters, as well as the anonymous reviewers of Manchester University Press for their constructive feedback.

My gratitude goes to Nare Sahakyan, Gagik Ghazareh, Armine Gharibyan, Angela Mikaelyan and Haykush Sahakyan for their technical support with securing permissions for reproductions, and to Adiba Jebara and Thomas Kim of the American University of Beirut's Department of Fine Arts and Art History for facilitating administrative work related to the production of the book. The AUB's former Dean of the Faculty of Arts and Sciences, Patrick McGreevy, deserves a special place in these acknowledgments for his intellectual and moral support of the faculty, and for the financial support he allocated for the editing and printing of reproductions in this book.

My gratitude goes to all my friends, colleagues and students with whom I have been conversing in the past decade on life, art and politics: Kasper Kovitz, Sami Khatib, Hala Auji, Clare Davies, Shady El Noshokaty, Aras Ozgun, Ghalya Saadawi, David Isajanyan, Hovhannes Davtyan, Tevz Logar, Combiz Moussavi-Aghdam and many others who I cannot name here. Last but not least, I am thankful to my family – my grandparents, parents and twin brothers for their unconditional love and support, and for forgiving my workaholism during the all-too-short summer holidays I spend with them.

It is my hope that this book may start a conversation not only on art historiography beyond Armenia's borders but also on the art historian's position vis-à-vis her object of study. But it is with the deepest regret that one of my main interlocutors in the book – David Kareyan cannot rejoin the debate we started more than a decade ago. His tragic death in 2011 put an end to his productive but also contradictory artistic career and his life. It is to the memory of this absent but always present interlocutor that the book is dedicated.

Introduction

Art's contiguous ideal of autonomy

This book addresses the discursive and representational field of contemporary art in Armenia in the context of the post-Soviet condition, from the late 1980s through the 1990s up until the early 2000s. Contemporary art, I argue, is what best captures the historical and social contradictions of the period of the so-called 'transition', especially if one considers 'transition' from the perspective of the former Soviet republics that have been consistently marginalized in Russian- and East European-dominated post-socialist studies. Occupying a sphere distinct from other social and cultural spheres of productive activity and yet inextricably connected to social institutions, contemporary art in Armenia has become a negative mirror for the social: art has been viewed as that which reflects those wishes and desires for emancipation that the social world has been incapable of accommodating in both late Soviet and post-Soviet contexts. Contemporary art's status as a negative mirror is due to its particular historical emergence in transnational (Soviet) and national (post-Soviet) contexts, its peculiar institutionalization in relation to official cultural discourse, and to a prevailing belief in art's autonomy. Throughout the two decades that encompass the chronological scope of this work, contemporary art has encapsulated the difficult dilemmas of autonomy and social participation, innovation and tradition, progressive political ethos and national identification, the problematic of communication with the world beyond Armenia's borders, dreams of subjective freedom and the imperative to find an identity in the new circumstances after the collapse of the Soviet Union. These are questions that have occupied culture and society at large, in the post-Soviet context and beyond. Yet the contradictions embedded in these questions are best crystallized in contemporary art, because of its peculiar position within the social sphere. This historical study aims at outlining the politics (liberal democracy), aesthetics (autonomous art secured by the gesture of the individual artist) and ethics (ideals of absolute freedom and radical individualism) of contemporary art in Armenia in post-Soviet conditions from a critical perspective and in ways that point towards the limitations of the aesthetic

and political horizons of contemporary art in the post-socialist context. Rather than a comprehensive survey, the primary aim of the work has been to define the historical logic of contemporary art in Armenia. This has been done through dealing with the dominant discourses, narratives and forma-tive artistic and exhibition-making practices, an approach that has ultimately resulted in the exclusion of many important artists and their practices from this project. A comprehensive history of contemporary art in Armenia has yet to be written, and this task lies beyond the scope of this book.

The period under discussion starts in the late 1980s and reaches to the early 2000s, roughly comprising two decades. However, the occasional his-toriographical venture will often take us to previous decades formative for contemporary art's development, or bring us to the very present in order to show continuities and breaks within the cultural logic of the late Soviet and post-Soviet worlds. This book does not offer a general survey of contempo-rary art in Armenia: many important protagonists and discourses are not discussed, and a certain historical lineage has been constructed at the expense of other relations. Instead, the book proposes a study of the selected instances of contemporary art – of artistic, institutional and art critical practices – that provide a window to the aesthetic and historical logic that underlies these practices. I call this logic the 'painterly real'. Painting, therein, is considered an underlying condition – even when there is no paint or canvas used – that determines the relationship between everyday life (or reality understood as the empirical field of experience) and the ideal of autonomous art. By drawing from the philosophical debate between Soviet philosophers Evald Ilyenkov and Mikhail Lifshitz, I approach the ideal of autonomous art as a realm of human universality constituted through a material historical process. In this, art becomes an instance of universality.

This book traces the transformations and development of autonomous art in Armenia: from the late Soviet unofficial artists' conception of art as an ideal of emancipation from everything falling under the category of the Soviet experience, to the conception of art as the ideal of the constitutional state in the works of the conceptual artists of the so-called generation of independ-ence, to the conception of the ultimate irreconcilability between autonomous art and the social world from the late 1990s on. Even though in all three instances, art negotiates its autonomy within and from the social world differ-ently, these historical moments of contemporary art share an understanding of art as an ideal, but one that is objective to the extent that it endows art with the ontological status of reality, displacing the empirical world of experience. In short, *the ideal is conceived as more real than reality itself.*

I consider the 'painterly real', taken as a structural support for art, as an ideal that underlies autonomous art as differentiated from other spheres of productive social activity. The 'painterly real' as a structural support for the

ideal has been constituted as such in a historical process. This constitutive process has evolved through capturing the sedimentations of wishes and desires that occur through human engagement with the material conditions of painting (canvas, paint), and turning this engagement into a promise of freedom, understood as emancipation from the unfreedom of the social world. The 'painterly real' as a support structure for the ideal in art and as a marker of its separation from everyday life, I argue, is always present, even when we refer to practices that do not use paint as material. Historically, the 'painterly real' constitutes the relationship between art and everyday life differently at different times: sometimes this logic is more pronounced and present, sometimes it is repressed, only to come back to haunt the practices of contemporary art with a vengeance. Historically, the 'painterly real' as I trace its transformations throughout the book corresponds to the long process of 'the disintegration of the Soviet'[1] as a historical body, as an ideology and as experience.

Cancelling the Soviet: between utopia and nostalgia

This book offers a critical historical reading of the late Soviet and the post-Soviet condition through contemporary art, conceptualizing this condition as a state in between utopia and nostalgia: from perestroika efforts to salvage utopia as a pragmatic *modus vivendi* at the expense of the soon-to-be Soviet past, to a striving to rethink nostalgia as a progressive revocation of the Soviet in the present, to contemporary attempts to eliminate the radical difference of that very past and prevent it from becoming history. There are many ways of conceptually placing the 'former Soviet' between utopia and nostalgia in the so-called post-ideological age, and the examples that follow outline the discursive context in which this book will intervene.

According to a 1996 decree issued by the Ministry of Culture of the Republic of Armenia, the pedestal of what had formerly been Lenin's statue in Yerevan – a pedestal that for more than five and a half decades had proudly borne the leader of the Bolshevik Revolution, before the statue was toppled in the heat of the nationalist anti-Soviet wave in 1991 – was to be preserved, according to international law.[2] Citing the importance of preserving historical monuments regardless of their ethnic, religious or ideological belonging, the ministry's decree called for projects to substitute for the pedestal's original inhabitant, which had first been decapitated and then removed altogether in the now classical move of founding the future of constitutional democracy on the headless body of the 'monarch'. Between 1991 and 1996 several competitions were announced, first to fill in the material and ideological gap that the statue had left, and then to replace the pedestal itself after its ultimate de-installation in 1996 – for the ministry, despite its decree, approved the de-installation, citing the 'financial difficulties' involved in maintaining it. The prominent place that

Lenin's statue once occupied in Lenin Square, subsequently named Republic Square, is still empty, whereas discussions regarding filling this empty space are ongoing.[3] A contested representational space – which has become a symbolic battleground for various historical narratives and ideologies mostly occupying poles between patriotic religious nationalism and consumerism, and often for their marriage – is left empty, an emptiness that marks the absence of a compelling ideology and an inability to come to terms with the legacy of the Soviet experience within the confines of a nation state.

The gradual disintegration of Lenin's monument in Republic Square – its head in storage at the National Museum of History, its decapitated body lying in the courtyard of the museum, the remnants of its pedestal supposedly in municipal storage on the outskirts of Yerevan – bears witness to the disintegration of Soviet ideology. However, the scattered parts of the monument also signal the subliminal material presence of the Soviet historical experience, in the subterranean layers of the national post-Soviet present, in the avenues, universities, institutes, museums, factories and other infrastructure built throughout the Soviet project of modernization. Discursively, the presence of this ideology is ghostly: on the surface, the Soviet Union is an object of either vilification or nostalgia. These two attitudes complete each other, while foreclosing the possibility of revisiting historical experience critically on the one hand, and of proposing an emancipatory vision for the future on the other.

Even months before the collapse of the Soviet Union, most people in the USSR still envisioned the transformation of society within the framework of perestroika.[4] Shortly before the watershed moment of the Belavezha accords and the disintegration of the USSR, the Moscow-based publishing house Progress published an anthology of foreign literature titled *Utopia i utopicheskoe myshlenie*.[5] Edited by Irina Chalikova, the book included texts as varied as a history of utopian thinking,[6] writings of the philosopher Ernst Bloch,[7] Karl Mannheim's 1920s elaboration of the differences between ideology and utopia,[8] and a theorization of revolutionary utopia and utopian revolution[9] alongside fictional literature on dystopian, utopian and anti-utopian techno-myths. *Utopia i utopicheskoe myshlenie* was published in the context of ongoing attempts by the late Soviet intelligentsia to overcome Stalin's legacy and to salvage the concept of utopia from its associations with totalitarianism. But it also attempted to offer an understanding of utopia and ideology that departed from Marxist theory. The book's central premise was that utopia does not impede individual liberty, and the whole can reconcile with the part as long as the latter is granted autonomy from the former.

Chalikova's volume, as a product of Gorbachev's reformist agenda, captures the dilemmas of perestroika in its later years – in its task, for example, of liberalizing politics without abandoning the one-party system, and introducing market relations without embracing capitalism wholesale.[10]

Utopia here is perceived as an active possibility, an operational concept that might emancipate the Soviet subject from its (Stalinist) recent history and the individual from the collective, yet also create a pragmatic political framework for the cohabitation of autonomous individuals. It is this latter premise, which establishes perestroika's liberal pragmatism, that characteristically conceals liberalism's own ideological operation behind the façade of commonsensical individual freedom.

Sixteen years later, in 2007, the socialist ideals of collectivism no longer threatened with their spectre of grand utopias, and the former Soviet republics – once, under the umbrella of the Soviet Union, individually unrecognizable for most outsiders – had reclaimed their specific histories with the aid of the discursive tools provided by nationalism and liberalism, and often by the two together. During that year, *Khudozhestvennyi Journal* [*Moscow Art Magazine*] – a leading publication on late Soviet unofficial and post-Soviet contemporary art in Russia – published a special issue called 'Progressivnaya Nostalgia' in its Russian-language edition.[11] The goal of the issue was to find a concept that could establish a common discursive ground for post-Soviet intellectuals from the various countries of the former Soviet republics. The editorial claimed that one concept that might unify the diverse post-Soviet contexts was nostalgia, albeit a progressive nostalgia, emancipated from its negative connotations as a regressive reactionism and given the meaning of rethinking and revisiting the Soviet past from the position of the post-socialist present.[12] If Chalikova's anthology on utopia aimed at eliminating the discursive reverberations of Stalinism, what was at stake in the 2007 issue of *Moscow Art Magazine* was the disavowal of the perestroika liberalism that had shaped the allegedly post-ideological landscape of the late Soviet and post-Soviet periods.

The editors explained that the need to reconsider the Soviet past came from a growing discontent with the post-Soviet present and a resurgent tendency to recuperate the communist promise of universalism, internationalism and collectivism in many countries of the former Soviet bloc. The issue 'Progressivnaya Nostalgia' was an attempt to go beyond the usual post-Cold-War-era polarities, where 'the East' used every stereotype of the Cold War to characterize its own past 'as totally unique, totally totalitarian', while 'the West' mouthed a standard New Left criticism of capitalism and commodity culture.[13] The editorial claimed:

> Nostalgia for the Soviet can be understood as a form of its new existence and fuller realization. And that is the reason why this nostalgia is deprived of *passéisme* – mourning for an irretrievable past. Rather, it is a form of constructively inhabiting the present and outlining a perspective. That is why in its essence, this is a 'progressive nostalgia'.[14]

The goal of *Moscow Art Magazine*'s 2007 issue was to reconcile two opposing terms – progress and nostalgia[15] – by reversing the temporality of these concepts and by locating nostalgia in the present and progress in the past. This shift of temporality, as a postmodern strategy of delinearizing of time, was thus meant to challenge the common meaning of these two terms, for nostalgia usually comes across as a moralizing prevention of progress for the sake of retrogressive mourning, while progress is seen as a constant reproach of the past. However, the functionalization of nostalgia for the Soviet past 'as a form of its new existence and fuller realization' relies on the assumption that it is possible to reactivate the past in the present without the very material fabric that constituted the Soviet. This assumption turns the 'Soviet' into an apparition, a ghost without a shell, and thus collapses its historical existence. And it was indeed a reading of the Soviet as pure ideology – a reading most influentially offered by Boris Groys – that had informed most scholarship on the post-Soviet condition. The reclamation of the 'Soviet', as the editors of the *Moscow Art Magazine* conceived it, did not bring about a proposition to rethink the Bolshevik project of emancipation as an experience that had actually happened. Instead, it reiterated the 'Soviet' as a generalized term connoting identity, uncomfortably reminding one of the Stalinist-era references to the 'Soviet man' or the 'Soviet homeland'.[16]

In the case of both Chalikova's publication in 1989 and Viktor Misiano's volume of 2007, the historical experience of the Soviet is forsaken. In the first case, a late Soviet intelligentsia haunted by the spectre of Stalinism overcomes the Soviet experience by combining social democracy with liberal pragmatism, while in the second, the past is brought into the present, and thus disavowed as such (this is postmodernism enacted as a historiographical method). While Chalikova's volume predicted the ideological horizon of the 1990s, *Moscow Art Magazine* marked an attempt to historicize that horizon, to think beyond it. And in an uncanny manner, it foretold contemporary developments, in which Cold War dynamics would be re-enacted with the annexation of Crimea and Russia's involvement in the civil war in Ukraine.[17]

As opposed to the examples above, in which the post-Soviet condition is conceived in terms of a rupture from Soviet experience – from the removal of Lenin's statue and the attempt at salvaging a non-totalizing concept of utopia, to rethinking nostalgia as a progressive notion – the present work does not consider the post-Soviet as simply an outcome of some temporally punctual dissolution of the Soviet Union. Consequently, the 1989 collapse of the Berlin Wall and the dissolution of the Soviet Union in 1991 are not regarded only as ruptural events in the sense of being formative and transformative of social and historical life. Rather, these incidences were largely structurally prepared in the long process of the disintegration of the Soviet experience and are seen as 'eventful' only from the perspective of the victorious side – that of

neoliberal capitalism and political liberalism. Indeed, it is within the very structure of global capitalism to swallow 'events around the globe into its own appearance' in what historian William Sewell calls the 'eventful temporality' of capitalism.[18] This eventful temporality of capitalism, with its recurring cycles of 'crises' and 'recoveries', conceals the perpetual reproduction of the same brought about by the universal expansion of capital. The year 1989 has become just such an event, one that has been taken as a moment of radical rupture with the fall of the Berlin Wall, signalling the triumph of the globalization of capital and its cultural logic. However, I hold that in the historical disintegration of the Soviet Union two different temporal regimes converged: an evolutionary and gradual disintegration was combined with the ruptural event of its actual legal and political demise. The convergence of two social and historical temporalities in the breakdown of the Soviet Union calls for an approach that conceives history through a dialectic of rupture and continuity.

History as a horizon of possibility

The dialectic of rupture and continuity calls forth a historical approach to the study of the period. As opposed to a genealogical approach that particularizes concepts and traces their discursive constitution independently from each other, without a larger historical logic connecting these concepts, historiography considers concepts as part and parcel of a historical logic. Historiography connects the discursive as well as material constitution of concepts to a logic that is internal to the development of these concepts, but also contingent upon external material factors. Instead of applying ready-made theoretical models from twentieth-century Western theory to interpret contemporary art in Armenia – an exercise that became paradigmatic in Eastern European scholarship throughout the 1990s and thereafter – this book offers an approach that treats bits of historical evidence as facts, while constructing historical and interpretative bridges between these facts. Here, it is out of a 'thick' historiographical work that theorization emerges.

The historical-theoretical approach developed in this book does not lay claim to being a radical challenge of the Western-centric assumptions of the discipline of art history, one that often arises from the present-day imperative to position so-called non-Western contexts subversively in relation to the Western art canon and the history of art. This imperative for subversion in art history from the supposed geographical margins of the discipline has been shaped, in the wake of identity politics, by the incursion of postcolonial studies, calling for a cultural representation of the Other that might undermine the Western establishment. Its particularization of identity supposedly promises to puncture the universalism of Western modernity and unmask its colonial logic, and by extension, the frameworks of the discipline whose

emergence has been part of the project of modernity. A discourse of subversion, in this way, reduces the contexts unknown to Western European and North American scholarship to the status of cultural tools serving the need for representation and inclusion of the Other, while it robs the Other of universality. As a disciplinary approach, it reduces art history to a politics of representation, of inclusion and exclusion.

Neither can this study be subsumed within emerging discussions on global art history that respond to the increasing globalization of art following the globalization of finance throughout the 1990s (even though the very fact that it is possible to publish this book with an Anglo-American academic press is an outcome of the structural changes brought about by global art history). Global art history often functions as an umbrella term that subsumes inconsistencies and contradictions, a tendency that it has inherited from the 1990s globalism debate. The discourse of globalism – as a product of the globalization of capital and its false universalism which establishes equality among all things – threatens on the one hand when transposed to the field of art history to repeat capital's real abstraction (the reign of commodities) in the field of art-historical discourse by homogenizing this discourse under the heading of cultural difference. On the other hand, it encourages particularism and exceptionalism, understood in terms of identities. Global art history, an offshoot of the discourse of globalism, has often performed a similar operation of simultaneous homogenization and particularization. Here, histories and accounts of contemporary art are often positioned in relation to global contemporary art and its institutional networks, rather than in relation to national traditions of fine arts, avant-gardes and modernism. By severing contemporary art from a historical context and subsuming it within the disciplinary context of art history as a tool and example of subversion, global art history circulates contemporary art from the so-called peripheries of the Western world in a way similar to the increasingly deterritorialized and networked circulation of goods and ideas in global capitalism. Here, for instance, 'contemporary art from Egypt' is not discussed in relation to its constitution vis-à-vis the national fine arts and the cultural politics of the place but as constructed by the art market, art institutions and curators who apply ready-made theoretical tropes such as 'hybridity', 'identity', 'subversion' and so on to situate it in relation to other contemporary art contexts, for example, 'contemporary art in Lebanon'. Thus, this approach cancels the historical dimension of time and spatializes contemporary art from a particular place in a relational network of other 'contemporaries'.

The discourse of 'alternative modernities', the offspring of global art history and postcolonial studies, performs a similar operation of othering and particularization. The basic argument offered by the proponents of this discourse is that modernities are multiple and contextually particular.[19] On

the one hand, it empties modernity of its universalist ethos (liberalism and capitalism) rather than offering an immanent critique, and on the other hand, it dismisses alternative visions of modern universalism. But most importantly, it overlooks the fact that capitalism (and modernity as its product) is ultimately a universal, even if a false one, and thus it pre-empts any critique of this false universalism.[20] The interrelated methods and approaches of global art history, postcolonial critique and alternative modernities have all followed a broader paradigm prominent in the global art world, one that approaches artists from different parts of the world as informants about their specific contexts, and treats artworks as ethnographic objects that can decipher these different contexts for a mobile audience of art curators, dealers, critics, art historians and art lovers.

This book, I hope, intervenes in current art-historical scholarship by offering a specific historical account without claiming any exceptional status for that history. It looks at contemporary art in Armenia in its specific historical context, yet treats that context as one that both participates in and shapes broader discussions on the possibilities of art's autonomy today. Ultimately, this method follows the assumptions coming out of the context of contemporary art in Armenia itself, which has held on to an internationalist project of being part and parcel of the larger world while conceiving of art as a universal possibility for emancipation. In addition, contemporary art in Armenia developed in and responded to a context that did indeed propose a project of universal modernity – that of the Soviet Union. And perhaps, one can come back to the identity-infused imperatives of art history today from the perspective of the collapse of the Soviet universalist project: ultimately, the proliferation of the discourse of cultural 'otherness' is what follows the breakdown of the Soviet project.

This work calls for self-historicization. Such a historical project, I argue, challenges the dominant national discourses in Armenia by showing how the present is constituted historically, instead of locating the present in the homogeneous empty time of ethnic belonging. While participating in broader discussions on art and autonomy taking place today in art theory, history and criticism, it comes to fill an art historiographic gap in the field of contemporary art in Armenia, as very few systematic attempts at historicization exist locally. The art historian Vardan Azatyan's scholarship of the past decade, with which this work engages extensively, is an exception. Azatyan has tirelessly attempted to situate contemporary art within a historical perspective, an attempt that the very protagonists of the contemporary art scene, caught up in the urgency of the present, have often resisted and at times resented, before reconciling with it. The absence of historicization, however, is not simply to be blamed on the context of contemporary art, but is also an outcome of institutional art-historical scholarship in Armenia that privileges

medieval art. In academic institutions in Armenia, contemporary art is not even a legitimate topic for MA and PhD dissertations; no 'serious' scholar would engage with a field that is full of 'dilettantes' who ended up being 'contemporary artists' because they could not paint or draw.[21]

In the above context, the historical approach that this book advocates is a difficult one to take, as there are only a handful of art-historical writings on contemporary art in Armenia, and as little documentation has been preserved from the various exhibitions, actions and discussions that might serve as material for a historical investigation. This investigation involves piecing together otherwise scattered archival material, interviewing artists and cultural actors, collecting journal and magazine articles that deal with art, culture and everyday life in Armenia in the late 1980s and throughout the 1990s, and conducting research in the National Archive to explore the official cultural policies of the period. I hope that in the gap between the striving to achieve historical truth and the realization of its unattainability, a story of a specific period will emerge, one that does justice to the complexity of the epoch. This approach also calls for a difficult attempt to eject the subjectivity of the author from the historical narration, to un-remember a decade formative for my generation, in order to re-remember it as history.

As someone who reached maturity in the 1990s and witnessed the historical sea change from one epoch to another, I realize that the attention this book pays to the decade is partially driven by my own desire to situate my subjectivity and the ethos of my generation historically, to understand the period in ways that are impossible when one lives it as a present moment. While watching numerous VHS recordings of exhibitions and discussions involving the protagonists of this book, in the constant tension between subjective identification with the young protagonists and the distance that the medium created, I found my own historical approach to the documents. This was an uneasy detachment, since my memories of the period are implicated through the very media now mediating my scholarly return to the historical period. The VHS recordings specifically, more than photographs and typewritten or handwritten texts on aged glossy paper, materialize the passage of time and the epochal shifts from the 1990s to the present. The texture of the 1990s for me lies in the texture of the VHS tape's transmission, not simply because this medium was our main mode of visual access to the larger world (by then, most households owned or desired to own a VHS cassette player and almost all television channels used VHS tape recorders), but also because I myself was directly inserted into this grainy world of VHS recording as a host of a weekly television programme called *Bravo Baby* between 1995 and 1997. From my generational perspective today, if the political and aesthetic horizon of possibility in the 1990s was visually constituted through the noisy chroma video signal of the cassette player and its linear audio track, the contemporary

closure of that possibility lies in the pixelated ambit of the digital transmission and surround sound that arrived with the triumph of commercialism and consumerism at the turn of the millennium.

An uneasy subjective detachment from one's own formative period, and a withdrawal of memory, is not an erasure of subjectivity but a temporary suspension of it, so that subjectivity may be situated historically, as intimately as possible, and thus regained. Neither does historicization suppress living memory. Just the opposite: historical writing enables the return of living memory against the forces of the status quo. What is at stake in historical writing is the possibility of denaturalizing the present through the historical work of writing about the past.

The journey of the 'painterly real'

The structure of the book emerges from its strategy of tracing the three main instances wherein the logic of the 'painterly real' as a supporting structure of art's autonomy evolved and manifested itself, albeit differently: the late Soviet and early post-Soviet art practices of the 3rd Floor movement that became paradigmatic for establishing the 'painterly real' as the logic of contemporary art; the conceptual artists' group ACT of the period of independence in the mid-1990s, which strove to break away from this logic and establish a notion of autonomy and of the ideal based on a conception of politics as form; and finally, the post-ACT practices of some of the group's protagonists in the late 1990s and early 2000s, when the 'painterly real' sees a pronounced return. I argue that what has been forfeited, across this peculiar historical trajectory of art's autonomy in Armenia, is the consideration of the everyday life that has time and again come to haunt the logic of autonomy. The historical study of the relationship between art and everyday life in post-Soviet Armenia serves two major purposes. First, it reveals an aesthetic understanding of conceptualism that characterizes the Armenian avant-garde. Secondly, I believe that the critical examination of the constitution of art's autonomy in relation to everyday life in Soviet and post-Soviet Armenia can help us rethink the possibilities and imperatives of art's autonomy today, beyond Armenia's borders. This rethinking is important at a time when the contemporary consciousness of capitalism, which is a post-historical one, threatens this autonomy, while also homogenizing everyday life.

The chapter that follows this introduction offers a conceptual clarification of some of the main terms and categories deployed in this study. This clarification is necessary, given that the actors involved in contemporary art in Armenia – artists, curators, critics and historians – have used a variety of often contradictory terms and concepts for self-designation or as descriptive categories for contemporary art. At first glance these terms – modern, contemporary,

alternative, avant-garde – can be taken for granted by any student of art his-
tory, yet they have functioned in ways that distinguish them from their coun-
terparts both in Western European and North American contexts, as well as
in Eastern Europe. In addition, given that art taken as ideal is a key category
in the version of art's autonomy that contemporary art in Armenia proposed,
a conceptual discussion is dedicated in this first chapter to the notion of the
ideal and to, what I argue, is its dialectical opposite – alienation.

Chapter 2 discusses the practices of the 3rd Floor movement – a cultural
movement active in Armenia in the late 1980s and early 1990s – in the frame-
work of late Soviet perestroika politics and the restructuring of social and
political institutions. The temporality of the 3rd Floor's discourse and aesthet-
ics corresponds to the extended temporality of the post-ideological discourse
of triumphant liberalism, and reaches far beyond the six years of the move-
ment's activities between 1987 and 1994. I argue that the discourse and aesthet-
ics of the movement have had a formative impact, in the domain of Armenian
contemporary art, on the understanding of contemporary art's relationship
with everyday life, the social world and the institution of art. In Armenia, the
3rd Floor's understanding of the 'painterly real' as that which realizes social
dreams through and in art has become paradigmatic of and even synonymous
with contemporary art as such. The 3rd Floor institutionalized the early 1980s
paradigm of an unofficial art that negated painting through painting.[22] The
movement used imagery and styles that denoted Western consumerism and
freedom vis-à-vis the ideological imperatives of official art. For the artistic
movement, the 'painterly real' is constituted through the negation of ideology
through a supposedly non-ideological form of freedom, and of official paint-
ing through the painterly gesture. Thus, it is through this gesture that art as an
ideal is secured. In the movement's practices, the 'painterly real' sets in opera-
tion a complex relationship between tradition and innovation. The 'painterly
real' as the ideal of art configures art's relationship with everyday life, wherein
art is conceived *as more real than reality, and thus ideal.* Here the 'painterly
real' provides a ground amid a loss of all social ontological grounds in the
changing world of the perestroika years.

I argue that the 3rd Floor unwittingly shared the Socialist Realist belief
in the affirmative power of images that uphold the ideal of art's autonomy
(though the content of the image, for the former, was very different from
that of its Socialist Realist counterpart, even its opposite). In this belief, the
image is seen as capturing a utopian promise for the future and actualizing
it in the present through art. However, the movement's aesthetic philosophy
relied on Socialist Realism's adversary, Armenian modernism, and on its aes-
thetic regime. The Armenian modernism of the 1960s and 1970s reconciled
modernist form with national content and conceived of the painterly gesture
as that which exceeded the subjectivity of the artist while at the same time

constituting it. And it is this ethos of the painterly gesture as constitutive of subjectivity that for the Armenian modernists secured the autonomy of art and resisted the social world of the Brezhnev years. The 3rd Floor inherited this understanding of artistic gesture in both its constitutive and resistant aspects. The painterly gesture of negation both establishes the 3rd Floor as the cultural vanguard of the perestroika epoch and allows it to surpass this political context. The discussion of the aesthetics, politics and ethics of the movement situates it within perestroika's cultural politics, the official institutions of art, and the tradition of Armenian modernism that preceded the movement, in an effort to understand the movement not only on its own terms, but also from an art-historical and critical perspective. *Hamasteghtsakan* art – a concept developed by the two protagonists of the movement, Nazareth Karoyan and Arman Grigoryan, to denote an aesthetic of making incommensurable styles, images and techniques cohere – provides a conceptual lens through which the movement is considered.

Similarly, Chapter 3 adapts a key term, 'pure creation'[23] – developed by the protagonists of the mid 1990s' art scene, the group ACT, to denote the foundational processes and materials that go into art-making – as a historical and conceptual lens for considering the artistic practices of the period of independence. The chapter explores the aesthetics, politics and economy of 'pure creation' in the context of paradigmatic shifts in the constitution of social and political structures and of everyday life in Armenia in the period of early independence, after the collapse of the USSR. Operating between 1994 and 1996, ACT faced what I call a crisis of negation, when it became structurally impossible for contemporary art to negate the transformed and still transforming post-Soviet world. Instead, contemporary art was to affirm and embrace this 'brave new world'. However, affirmation was still taking place within art understood as a sphere of autonomous creativity, though one that appropriated forms of politics as forms of art. ACT's aesthetic, and the way the group saw itself in historical terms, creates a temporary rupture from the 'painterly real' and its *hamasteghtsakan* aesthetic of making the incoherent cohere. Yet the group upholds art as the ideal of the political. In mid-1990s conditions of the confluence of contemporary art and the newly constructed state, the everyday is overcome – both by the artists of this generation and by the first president of the independent republic, Levon Ter-Petrosyan – for the sake of art as ideal, and for the state as ideal. And this confluence takes place when the everyday is most present, with its violent perturbations in the drastically changing world. I consider the everyday as the realm of material culture, empirical experience, and social institutions, languages, symbols, mores and norms that are mutually constitutive.

Chapter 4 discusses the return of the 'painterly real' in the aftermath of the collapse of ACT and the failure of the first president Ter-Petrosyan to

institute constitutional democracy. This chapter situates the return of the 'painterly real' as that which informs the dominant mode of historicization of contemporary art. This mode can be characterized as an evolutionary convergence of tradition and contemporaneity. In turn, the reconciliation of the two poles of nationalism and progressivism formed the core agenda of the national cultural politics. I argue that in this particular period of the mid to late 1990s, contemporary art played a vanguard role in sustaining and advancing the national cultural politics through its reliance on the 'painterly real'. This advanced a paradigm of representation, both in contemporary art and in national cultural discourse, that aimed at a difficult reconciliation of democracy and nationalism. Aesthetically and in terms of its own historical self-understanding, contemporary art reconfigured its relationship with the national artistic tradition as one of continuity rather than rupture. Here, the 'painterly real' was re-established via the rearticulation of *hamasteghtsakan* art – a return that marked the temporary alliance of contemporary art and official cultural politics – only to break down soon after as the state abandoned progressive discourse.

The fifth and last chapter considers the transformation of the 'painterly real' in media art and performance into an impossible ideal of autonomous art in the late 1990s and early 2000s. By focusing on the works of two artists – David Kareyan and Narek Avetisyan – in the context of the political crisis and consolidation of consumerism in Armenia, the chapter argues that the painterly real here becomes an 'excessive remainder', in a Lacanian sense, of art's ideal, after a traumatic split is realized to have occurred between the subject and the social, art and democracy, nature and culture, mind and body. If Kareyan's videos and performances of the period attempt to regain the ideal of wholeness through rituals of bodily suffering, Narek Avetisyan's work adopts an opposite strategy of techno-utopian bodily dematerialization that is nevertheless 'stained' by the presence of the body. The works of the two artists are discussed in the context of complex political, social and technological transformations that led to what was experienced by the community of contemporary artists as a condition of crisis. What we witness in the period of the late 1990s and early 2000s is the abandonment of the progressivist pole in the cultural politics of the nation state and the embracing of ethnocentric nationalism with its regressive emphasis on 'One Nation, One Culture'. A consequent and deepening misalignment takes place between national cultural politics and contemporary art: while the former unequivocally embraces nationalism, the latter identifies itself as progressivist. In a way, the contemporary artists who actively produce work in the late 1990s and early 2000s view art as the only sphere wherein the ideal of democracy persists, one that the social world is no longer capable of accommodating.

Notes

1 Vardan Azatyan, 'Disintegrating Progress: Bolshevism, National Modernism and the Emergence of Contemporary Art in Armenia', *ARTMargins* 1.1 (2012), pp. 62–87.

2 National Archives, Folder 80, List 20, File 22. 13.05.96.

3 Angela Harutyunyan, 'State Icons and Narratives in the Symbolic Cityscape of Yerevan', in A. Harutyunyan, K. Horschelmann and M. Miles (eds), *Public Spheres after Socialism* (Bristol: Intellect Books, 2009), pp. 19–29. Most recently, the Yerevan municipality announced a competition for projects in 2012, which did not yield any concrete outcome.

4 Peter Kenez, *A History of the Soviet Union from the Beginning to the End* (Cambridge: Cambridge University Press, 2006), p. 200.

5 Irina Chalikova (ed.), *Utopia i utopicheskoe myshlenie* [Utopia and utopian thought] (Moscow: Progress, 1991).

6 F. Manuel and Fr. Manuel, 'Utopicheskoe Myshlenie v Zapadnom Mire' [Utopian thought in the Western world], in Chalikova (ed.), *Utopia i utopicheskoe myshlenie*, pp. 21–49.

7 E. Bloch, 'Princip Nadejdy' [Principle of hope], in Chalikova (ed.), *Utopia i utopicheskoe myshlenie*, pp. 49–79.

8 K. Mannheim, 'Idealogia i Utopia' [Ideology and Utopia], in Chalikova (ed.), *Utopia i utopicheskoe myshlenie*, pp. 113–70.

9 M. Lasci, 'Utopia i Revolutisia' [Utopia and revolution], in Chalikova (ed.), *Utopia i utopicheskoe myshlenie*, pp. 170–210.

10 The 1988 Law on Cooperatives allowed the operation of private enterprises, though under restricted conditions.

11 'Progressivnaya Nostalgia' [Progressive nostalgia], *Khudozhestvennyi Journal* [*Moscow Art Magazine*] 65/66 (July 2007), http://xz.gif.ru/numbers/65-66/ (last accessed 13 October 2016).

12 In May 2007 the editor-in-chief of the journal, Russian art curator Viktor Misiano, organized the show 'Progressive Nostalgia' at the Centro per l'arte contemporanea Luigi Pecci in Prato, Italy, featuring artists from Armenia, Azerbaijan, Belarus Georgia, Moldova, Russia, Ukraine, and Central Asian and Baltic countries. The curatorial concept introduced *Moscow Art Magazine*'s issue of that year with the following statement: 'This exhibition comes at the right moment because as more time separates us from the fall of the Berlin wall, the wider is the distance that separates us from the previous age, and the more vital becomes the task of understanding that past' (http://www.centropecci.it/uk/htm/mostre/07/nostalgia/progressive_nostalgia.htm, last accessed 28 June 2008).

13 Susan Buck-Morss discusses several meetings between Euro-American academics and Russian philosophers that took place in the late 1980s and early 1990s. In these workshops the Russian intellectuals were trying to find affiliations with what was understood as the monolithic 'West', while the other side was persistently quoting Marx to bring itself closer to what it perceived as the 'East'. Susan Buck-Morss, *Dreamwold and Catastrophe: The Passing of Mass Utopia in East and West* (Cambridge, MA: MIT Press, 2000), p. 237.

14 Editorial, 'Progressivnaya Nostalgia'. Here and elsewhere, translations of Russian and Armenian texts are my own unless otherwise stated.

15 Svetlana Boym's work on nostalgia has been influential for the conceptualization of this issue, even though she is not directly acknowledged. In her seminal 2001 book *The Future of Nostalgia*, Boym considers the notion in three registers: as a symptom of our age, a historical emotion that presents a rebellion against the temporality of modernity, or progressive time; as a longing for a time rather than a place; and finally, as a yearning that is not only retrospective but prescriptive and can be directed towards the future. Svetlana Boym, *The Future of Nostalgia* (New York: Basic Books, 2001).

16 This conceptual recirculation of the term Soviet was ideology at its best, since the concept acts as a substitute for the disappeared and disappearing material conditions that had constituted the Soviet experience. Ironically, a similar recapitulation of the Soviet is taking place today in the dominant discourse of Putinism. Here the Soviet experience itself is forsaken, and only the memory of its imperial grandeur is evoked as a tool of postcolonial critique of the West.

17 Yet a third moment could be identified in the *longue durée* of cancelling the Soviet. The project *Former West: Documents, Constellations, Prospects* was launched in 2008 at BAK (Basis voor Aktuelle Kunst) in Utrecht, The Netherlands and is ongoing. Funded by various European foundations, the project's various iterations invited scholars to contribute to the ongoing debates on Europe's geographical and cultural constitution in the post-1989 era. Over the six years of the project's duration, multiple seminars, congresses and exhibitions were organized and publications emerged, with the participation of more than one hundred scholars, artists and curators. *Former West* first and foremost relied on the premise that the age-old Cold War divisions no longer sufficed to understand and analyse current power constellations and a new political situation, and that a new cultural cartography needed to be drawn up.

18 Angela Harutyunyan and Nadia Bou Ali, 'Discussing the Event: On Thinking of the Present as Radical Transformation', *Beirut Humanities Review* 1.1 (2014), AUB, Beirut (http://www.beiruthumanitiesreview.com/issue-1/, last accessed 22 January 2015); William Sewell, *Logics of History: Social Theory and Social Transformation* (Chicago: University of Chicago Press, 2005).

19 For instance, the blurb for the volume *Alternative Modernities* declares: 'The idea of "alternative modernities" holds that modernity always unfolds within specific cultures or civilizations and that different starting points of the transition to modernity lead to different outcomes.' D. P. Gaonkar (ed.), *Alternative Modernities* (Durham NC: Duke University Press, 2011). Another name for this discourse is comparative modernities, where it similarly relies on the assumption that modernities are multiple, as for example in the case of the Institute of Comparative Modernities at Cornell University led by Salah M. Hassan.

20 Peter Osborne convincingly argues that any discussion of so-called alternative modernities presupposes, without admitting to doing so, a conception of contemporaneity as a totality. He suggests that 'the discourse of nationally or regionally specific "multiple modernities" can achieve theoretical coherence at the level of

the whole (history) only in articulation with the concept of the contemporary – despite the discrete conceptual content of modernity and contemporaneity as temporal ideas. For the idea of an imminently differentiated *global modernity* presupposes a certain global contemporaneity as the ground of its immanent production of the temporal differential of the new.' Peter Osborne, *Anywhere Or Not At All: Philosophy of Contemporary Art* (London: Verso, 2013), pp. 25–6.

21 This is a stereotype without any basis in reality, as many contemporary artists graduated from the Academy of Fine Arts, where they practise artistic craft and learn artisanal skills.

22 This is opposed to the strategies of unofficial late Soviet artists in Russia, who negated Socialist Realist painting through politics. Artists such as Vitaly Komar, Alexander Melamid and Erik Bulatov among others utilized political tools of ideological critique to unmask the aesthetic regime of Socialist Realist painting.

23 In an earlier translation I referred to '*maqur steghtsagortsutyun*' as 'pure creativity'. David Kareyan, 'Pure Creativity', translation and introduction by A. Harutyunyan, *ARTMargins* 2.1 (2013), pp. 127–8. Originally published in Armenian, 'Maqur Steghtsagortsutyun', *Garun* 8 (1994), p. 59. Even though the concept, as theorized by Kareyan, does not make a distinction between the act of creativity and its end result in the form of an artwork, I believe that 'pure creation' is a more accurate translation and is semantically more justified than 'pure creativity'.

1 Between the ideal and a hard place: the conceptual horizons of the avant-garde in Armenia

Art as the avant-garde of the contemporary

This chapter interrogates the historical relationship between 'contemporary art' and the 'avant-garde' from the perspective of late Soviet and post-Soviet cultural discourses. Further, the chapter defines one of the key conceptual figures of the book, the concept of the ideal in a historical materialist understanding. From a historical materialist perspective, concepts do not precede or even coincide with the conditions and discourses to which they refer. Instead, words and terms become concepts only after the 'fact', after the material transformations of the conditions of production have brought about a conceptual engagement with those conditions in order to make sense of them. This engagement takes place through the realization that a qualitative change has taken place from one period to another, one that has brought about a consciousness of these very changes that distinguish one epoch from another.[1] For example, modernity is a belated epochal designation for the consciousness brought about by capitalist modernization; postmodernism is what Fredric Jameson calls 'the cultural logic of late capitalism' that was realized in the 1980s to reflect post-war transformations that signalled the arrival of consumer culture and the emergence of the global finance industry. Following the historical materialist approach, it can be argued that 'contemporary art', whether considered as part of Jameson's postmodernism or as that which subsumes postmodernism, arrives when the set of practices constituting it have been superseded by *another* kind of cultural and discursive paradigm that has not yet been named. It is not accidental that in the past decade a lively debate has emerged on the relations between an epochal contemporaneity and contemporary art, even triggering some to ask, 'What was contemporary art?'[2]

Given that concepts do not simply arise out of previous conceptual relations, but are embedded in the very material historical conditions they belatedly respond to (though this is not to deny relations between the concepts themselves), any kind of work that puts together various concepts in relation to each other should necessarily involve a historical endeavour to situate these

concepts in the conditions of their emergence and circulation. Thus, what I define as my field of historical inquiry by deploying the term 'contemporary art' in Armenia cannot be taken for granted either conceptually or historically. 'Contemporary' is not a given in any context, and especially in a place where it developed according to a different set of assumptions and presuppositions than what we are familiar with from recent art history textbooks that include 'contemporary art' as a periodizing concept. Most pertinently, 'contemporary art' in Armenia as a conceptual entity might not abide by the diachronic distinction between 'modern' and 'contemporary' understood as both epochal and qualitative transformations in twentieth-century Western art. The concept 'contemporary' in the context of art in Armenia enters into a complex synchronic relationship not only with 'modern' but also with 'avant-garde' art, 'alternative' art and 'postmodern' art, at times coinciding with globally assumed designations in the post-1989 world and at other times diverging from these. The complexity arises especially because 'contemporary art' here since the 1980s has identified itself as 'avant-garde art' (and not neo-, retro- or post-avant-garde as in some late and post-socialist Eastern European contexts). Throughout this book I use the terms 'contemporary' and 'avant-garde' interchangeably in order to do justice to their historical mobilization in the Armenian context as well as to show their aesthetic, theoretical and conceptual linkage. And it is precisely because of this uncommon linkage that the two terms with their various historical and theoretical implications need to be situated.

In 1972 an unprecedented kind of museum opened in Yerevan, the first and only museum in the Soviet Union to showcase modern art, meaning in this case aesthetic formalism with a national content. The museum was (and is) called the Modern Art Museum. It seems that there is no tension involved here – the Modern Art Museum showcases modern art. However, in the Armenian language its name is not the Modern but the 'Contemporary' Art Museum. The Armenian Center for Contemporary Experimental Art (the ACCEA), which opened in 1994, more than two decades after the opening of the Modern Art Museum, also uses the word 'Contemporary', in both English and Armenian versions of its name. However, apart from painting and sculpture it showcases art in a 'post-medium' condition, to borrow Rosalind Krauss's terminology:[3] installation, video, photography and performance. Here, both the name and the practices it describes coincide with what is designated in the West as contemporary art, as does the mission of the ACCEA to provide institutional support for and even to construct this kind of art. Even if in Armenian, the Modern Art Museum and the Armenian Center for Contemporary Experimental Art (the ACCEA) share the word 'contemporary' – *ժամանակակից* [*jamanakakic*], they nevertheless focus on different generations of artists and different aesthetic regimes.

The semantic convergence of modern and contemporary can be attributed to the influence of the Russian language, which has only the word *sovremennyi* [*современный*] to designate both. The Armenian language does in fact have two separate words for modern and contemporary – *արդի* [*ardi*] and *ժամանակակից* [*jamankakic*]. The second entered into circulation in contemporary art circles in the early 1990s to distinguish it from modern art, but this distinction is still not reflected in the Armenian name of the Modern Art Museum.

To complicate things further: the Armenian artists who are the protagonists of this book and who are identified as 'contemporary' artists did not call themselves such until at least the early to mid-1990s. The earliest written use of the term 'contemporary' I have encountered is in the announcement of the exhibition *Under the Influence: Contemporary Crossover Art in Armenia*, organized by diaspora Armenian curator and gallerist Charlie Khachadourian in collaboration with local art critic Nazareth Karoyan.[4] Given that the ACCEA was also established by a diaspora Armenian artistic couple – Sonia and Edward Balassanian – perhaps it would not be inaccurate to conclude that the term 'contemporary' first entered into circulation as a concept imported in by diaspora cultural figures.[5] This is not to say that 'contemporary' as a term did not have currency prior to this importation. However, until the early to mid-1990s the term had not designated any understanding of art qualitatively different from what had come before. If in Eastern Europe and in other former Soviet contexts 'contemporary art' was largely imported and institutionalized by the Soros Centers that opened throughout the 1990s, in Armenia it was the diaspora that introduced the term to distinguish so-called 'post-medium' or 'installation art' from national fine arts. What the artists themselves most often favoured in terms of self-designation in the late 1980s and early 1990s was avant-garde and/or alternative art. It was only from the mid-1990s onwards that 'avant-garde', 'alternative' and 'contemporary' started being used interchangeably.

Art historian and curator Octavian Esanu considers the emergence of contemporary art in post-socialist countries in relation to a set of structural and institutional changes brought about by the introduction of a market economy and political liberalism. His central thesis is that what was called 'contemporary art' (this includes the new institutions of art, a new understanding of artistic production and aesthetic experience, the redefinition of artistic skill and so on, as introduced and promoted by the Soros Centers for Contemporary Art across Eastern Europe and the post-Soviet space) represents a qualitatively different artistic experience and institutional structure than that operative in the Soviet system under the aegis of the Union of Artists.[6] 'Contemporary' here is understood as the totality of those institutional practices that are constituted with the aid of managerial tools driven by

models of economic governmentality (where the economic logic governs all spheres of social activity) and their political logic of liberalism. Esanu equates contemporary art with art in post-socialism.

In Armenia the transformations and re-institutionalization of post-Soviet art under the label of the 'contemporary' have been part of broader national processes revolving around the national agenda and linked to cultural figures from the diaspora and their ambition to reshape the cultural politics of Armenia after independence. The precepts of managerialism only played a secondary role in the emergence of the institution of contemporary art, even though curators and artists often borrowed from the toolbox of neoliberalism and the market economy and from the political ideology of liberalism. Even though conceptually displaced, institutionally Soviet art (both official and unofficial) continued to exist during the 1990s in a transformed fashion and under the guise of the national fine arts as an oppositional pole to 'contemporary art'. In Armenia the temporalities of the contemporary, most often a matter of synchronicity with the outside world, and of the avant-garde as a state at the crest of social and cultural transformation, have coexisted alongside the transformed remnants of Socialist Realism in its national articulation.

In the early 1990s yet another conceptual actor arrives on the scene: 'postmodernism'. For some critics, such as Karoyan, the postmodern came to replace the 'avant-garde', since postmodernism was what most accurately described both the cultural conditions of art production (increased communication and globalization) and the strategies and techniques employed in artworks in the late 1980s and early 1990s (such as quotation and appropriation). Karoyan himself utilized the poststructuralist theoretical tools of critical postmodernism only from the mid-1990s on. Prior to his turn to poststructuralist methodologies he regarded postmodernism solely from the perspective of the conservative anti-modernism of Trans-avangardia, New Wild, Neo-Romantik[7] and the like. Karoyan's shift towards postmodernism, which he began to regard as the new cultural condition of avant-garde art in Armenia, was motivated by his interest in art as a cultural and communicative tool rather than an autonomous sphere of creativity.[8] In addition, for Karoyan the 'postmodern' came to replace the term 'avant-garde', which he so much disliked for its totalizing aesthetic and political connotations.

Contrary to Karoyan's insistence on 'postmodernism', the artist Arman Grigoryan insisted on the term 'avant-garde'. Grigoryan used the latter term as both a descriptive and normative category for the unofficial art of the period (though as Chapter 2 shows, 'unofficial' is not a very accurate designation in the context of Armenian art history). Karoyan then came up with the contradictory term 'national avant-garde' in order to reconcile his bias towards postmodernism with Grigoryan's 'avant-garde'. Karoyan's 'national avant-garde' denoted an art that was radical and innovative in terms of its

aesthetic qualities as well as particularly strong in terms of its national content.[9] Thus, for Karoyan, it was an avant-garde without the universalist ethos of the historical avant-gardes.[10] Where Karoyan and Grigoryan agreed, however, was that 'avant-garde' art of the 1990s was an alternative to the official fine arts – an assumption that was institutionalized through the ACCEA's annual festivals of 'Alternative Art' from 1994 onwards, and one that has prevailed until today. In this view, art produced outside of official state art institutions is conceived as forming an alternative to both the official art of the Soviet Union (Socialist Realism) and later on, to its remnants, and to the Armenian modernism of the 1960s and 1970s supported by the Modern Art Museum in Yerevan. Thus we can identify three main artistic paradigms that shared the local artistic scene: the remnants of the Socialist Realism (figurative art in service to a fading and disintegrating ideology) of the late Soviet and early post-Soviet period, Armenian modernism (aesthetic formalism in service to the nation) and contemporary art (post-medium art in service to the liberal understanding of individual freedom). And these three main actors do not succeed each other historically, but often coexist within the same temporal frame while referring to different and often conflicting sets of institutional and artistic practices.

If the main conceptual actors of this book, in turn, are 'contemporary art' and 'avant-garde art', other marginal designations are also at times applied to tease out the conceptual nuances of these two terms. For example, 'hamasteghtsakan art' and 'pure creation' are used in relation to the 3rd Floor's and ACT's practices respectively, whereas the terms 'national avant-garde' and 'national postmodern avant-garde' are used in relation to Karoyan's conceptualization of the 3rd Floor's practices. Throughout the book a nuanced distinction between 'contemporary art' and 'avant-garde art' is drawn: if contemporary art denotes the field of post-socialist artistic production in its broader contours (the institutional, stylistic, theoretical and art practical aspects of art-making), the avant-garde is used on occasions when the actors of the contemporary art scene positioned themselves in the vanguard of the very scene they were part of.

From the perspective of West European and North American art history, 'avant-garde' and 'contemporary art' are regarded as periodization concepts that are intermediated by the High Modernism and the neo-avant-gardes of the 1960s. Depending on the periodization one finds most convincing, their amalgamation in the Armenian context needs to be situated in terms of broader art-historical and theoretical discussions over periodization and qualitative transformations. This is not a mere exercise in identifying chronological boundaries, but is primarily an attempt to discuss the concepts and their relations both theoretically and historically, and in terms of broader world historical shifts. The overarching question in the discussion that follows

is whether the deployment of 'contemporary art' in the Armenian context corresponds to the theorization of contemporary art and contemporaneity in the wake of the art-historical global turn in the last decade or so.[11] And ultimately, this discussion poses the question of what kind of a relationship contemporary art establishes with the world historical notion of contemporaneity.[12]

The temporalities of contemporary, and the avant-garde

Four main approaches can be discerned within current debates on the contemporary as a global historical condition: differential, gradual, ruptural and anachronistic. If the differential approach implies a theory of history in which the contemporary is differentiated from the modern as well as being internally differentiated, the gradual approach considers contemporaneity as having arrived through gradual changes within the modern. The ruptural notion of contemporaneity considers it as a historical (and often a post-historical) stage that is fundamentally different from what preceded it and is marked by a punctual moment of rupture. The anachronistic approach finds in the contemporary a coexistence of different temporalities (pre-modern, modern, postmodern, historical, non-historical, post-historical and so on) that live on within the present, on the one hand, and moments of contemporaneity in the past, on the other. In addition, two main philosophical approaches can be discerned in the treatment of the contemporary: the first views contemporaneity as a historical condition that can be conceptually grasped and dealt with in its totality, and the second considers contemporaneity as a perpetual presentness that cannot be subsumed within generalizable analytical categories. The proponents of the first view take Fredric Jameson's historical materialist approach as a point of departure, accepting to varying degrees the historicization that Jameson enjoins.[13] The proponents of the second view consider the contemporary as that which supplants postmodernism and which is so radically differentiated both from other epochs and internally – through the coexistence of various irreconcilable temporalities– that it cannot be subjected to generalizations. But while these latter theorists claim that the contemporary has supplanted postmodernism, their own method is profoundly postmodern in terms of its fear of totalization.

Art historian and theorist Bill Roberts offers a convincing survey of the notion of the contemporary in recent debates in both art history and philosophy, taking Jameson's seminal *Postmodernism, or The Cultural Logic of Late Capitalism* (1991) as a main point of reference.[14] Roberts situates recent discussions of epochal transformation historically – and takes on art theorists and historians such as Terry Smith, Pamela Lee, Alexander Alberro and philosophers Peter Osborne and Susan Buck-Morss – to ask whether the contemporary surpasses the postmodern or is accommodated within it. He presents

the argument, vis-à-vis these contemporary thinkers, that culture and society have not entered a qualitatively new era since Jameson's conceptualization of postmodernism as the cultural condition of late capitalism. The reason for this is that capitalism itself has not undergone drastic transformations since it entered into its 'late' stage, marked by globalization, the dominance of the financial and knowledge sectors over the productive economy, and so on. In accordance with Jameson, Roberts argues that the contemporary falls under the category of the postmodern, which historically emerged alongside the post-Second World War expansion of US hegemony through mass culture and the global reign of exchange value (this was signalled by the institution of the Bretton Woods system of monetary management in 1944, which required each country to tie the exchange rate of its currency to gold. In 1971 the USA terminated the agreement and established the US dollar as the universal monetary equivalent.) As opposed to this, many of those actively involved in debates on periodization put forward 1989 as the year of the advent of the contemporary as a world historical notion and of contemporary art as a parallel phenomenon either within or exceeding the former.

The main propagators of the ruptural approach are Terry Smith and Alexander Alberro, albeit from different theoretical positions: the first is informed by poststructuralism and postcolonial approaches and the second carries out a Foucauldian analysis. In his article 'Contemporary Art and Contemporaneity' and subsequent book *What is Contemporary Art?*, Terry Smith views the contemporary as an indeterminately extended present moment, and contemporary art as that which poses the question of how to live in the contemporary world ethically.[15] He says that contemporary art is what

> emerges from within the conditions of contemporaneity, including the remnants of the cultures of modernity and postmodernity, but which projects itself through and around these, as an art of that which actually is in the world, of what it is to be in the world, and of that which is to come. Its impulses are specific yet worldly, even multitudinous, inclusive yet oppositional and anti-institutional, concrete but also various, mobile, and open-ended.[16]

According to Smith, the contemporary is qualitatively different from both modernity and postmodernity because of the conflicting and plural temporalities of the pre-modern, modern and postmodern that coexist within it. If modernity and postmodernity are products of the West, with the first as a broader epochal notion and the second as the product specifically of Euro-American art institutions, contemporaneity is a global condition, one that is a mosaic of disjointed temporalities that anachronistically coexist. According to this view, contemporary is the new modern, but without the future-directedness of the former, while contemporary art sits comfortably

within the contemporary, proposing modes of ethical life within, and not outside of it, and reproducing the quality of the era as a 'permanent-seeming aftermath'.[17]

If for Smith the contemporary is a permanent presence in the post-1989 world, for Alberro it has no ontological ground. Instead, the contemporary is an episteme, and the word doubles as a periodization tool that enables thinking about social formations in their totality, under the sign of the hegemony of global capital and neoliberalism.[18] In a Foucauldian move, Alberro proposes thinking about subject positions under this hegemony, both those that reproduce and those that subvert the existing social order. If in Alberro's approach contemporary art both diverts and reproduces the hegemonic operations of the contemporary, in Pamela Lee's *Forgetting the Art World*, contemporary art sits comfortably within and reproduces the logic of globalization; the structures of contemporary art are seen as indivisible from those of globalization processes.[19]

It is in Peter Osborne's theory that the term contemporary is thought philosophically, through the question of how the epoch thinks itself.[20] The contemporary is a fiction insofar as it is a conceptual 'umbrella' notion that subsumes differentiated temporalities within it, but it is also a reality that structures one's very engagement with the world, a reality of which contemporary art is part. In an Adornian move, contemporary art in Osborne's theory is granted a semi-autonomous status within contemporaneity, since art is not reduced to the institutions that produce and circulate it, but is conceived both historically and ontologically as possessing a critical apparatus committed to a certain philosophy of time. As a historical phenomenon, the contemporary for Osborne is not merely a periodizing concept but a philosophical engagement with time, wherein the three main periods of the contemporary – post-1945 (the advent of US hegemony), the 1960s (the dissolution of High Modernism) and post-1989 (the collapse of the Berlin Wall) – represent different intensities of contemporaneity. Unlike those of Smith and Alberro, Osborne's approach is differential: the contemporary, another name for the historical present, is 'a temporal unity in disjunction or [...] a disjunctive unity of present times'.[21] In a way similar to Jameson's approach,[22] for Osborne the contemporary incorporates futurity in the structure of its temporality, even though this futurity is disavowed within and by the very concept of the contemporary. It is here that, with its ability to critique, the contemporary artwork has the potential to unfold in the future, one that promises emancipation. This is opposed to Smith's contemporaneity, understood as a permanent present that supplants the futurity of the modern (Osborne's dialectical treatment of the concept as that which both disavows its futurity and opens up to it, in Smith's theory is reduced simply to the act of disavowal). For Osborne, the contemporary is the temporality

of transnational capital, and the contemporary artwork is capable of obtaining semi-autonomy within this temporality by deploying the transnational character of the time as its own structural device.

Similar to Osborne's, Boris Groys's notion of the contemporary also relies on a differential approach. In Groys's theorization, contemporary art is a 'comrade of time' that exists alongside – and not within – contemporaneity as a condition of permanent return.[23] With the loss of all narratives of progress and teleology that have characterized the modern project, the contemporary is the wasted, excessive time of boredom without an end goal. Within this temporality of permanent return, contemporary art (especially time-based art) for Groys literalizes this wasted, excessive time and thus 'can be seen as initiating a rupture in the continuity of life by creating a non-historical excess of time through art'.[24] To be contemporary, then, does not mean to be in the present, but to be with the present, not to inhabit it, but to cohabit it. Contemporary art for Groys is thus a relational notion established through contemporary art's engagement with world historical time, though not by coinciding with it.

It is in a relational sense that Giorgio Agamben explores the notion of the contemporary, by asking 'of whom and of what are we contemporary?'[25] Drawing from Roland Barthes and Friedrich Nietzsche, Agamben declares 'the contemporary as the untimely' in a Baudelairean reconciling of the fleeting and the permanent. For Agamben, to be contemporary means to not coincide with one's time, to be out-of-joint with the present and its historical or rather chronological logic. He writes:

> Those who are truly contemporary, who truly belong to their time, are those who neither perfectly coincide with it nor adjust themselves to its demands. They are thus in his sense irrelevant [*inattuale*]. But precisely because of this condition, precisely through this disconnection and this anachronism, they are more capable than others of perceiving and grasping their own time.[26]

Agamben's achronistic approach to the contemporary underlies recent achronistic conceptions of historical time in art history as variously approached by Alexander Nigel and Christopher Wood, Mieke Bal and Richard Meyer.[27] In his recent book entitled *What was Contemporary Art?* Richard Meyer offers a non-chronological engagement with the contemporary and locates the contemporary in the instances throughout the twentieth century where 'the work of living artists was at issue' in art history curricula. In his relational view, the contemporary is a temporality that various entities, objects and institutions cohabit and share.[28]

Even if there are differences in the above-mentioned conceptions of the contemporary, they all share a fundamental assumption: the contemporary is the temporality of transnational capital and of the latest stage of globalization.

Or rather, with its presentism, the contemporary spatializes time, and thus cancels historical temporality. In Jameson's words,

> at the very heart of any account of postmodernity or late capitalism, there is to be found the historically strange and unique phenomenon of a volatilization of temporality, a dissolution of past and future alike, a kind of contemporary imprisonment in the present – reduction to the body as I call it elsewhere – an existential but also collective loss of historicity in such a way that the future fades away as unthinkable or unimaginable, while the past itself turns into dusty images and Hollywood-type pictures of actors in wigs and the like.[29]

Within this temporality, contemporary art has varying degrees of autonomy. Sometimes contemporary art entirely coincides with the contemporary, at other times it exceeds it, and at its best it, in an Adornian sense, offers a negative and critical mirror that confronts the temporality of transnational capital with its own image. In the contemporary (and by extension, in contemporary art) time no longer moves forward. In any of the above theorizations, with the exception of Osborne's 'contemporary' and Jameson's 'postmodernity' – whether as a perpetual presentness or out-of-jointness with chronology – the contemporary comes to displace the progressive temporality of the pre-war avant-gardes and marks the dissolution of modernism's medium specificity (Arthur Danto's encounter with Warhol's Brillo boxes in 1964 is a wonderful anecdote that crystallizes the dominant approach that contemporary art starts 'after the end of art').[30] In a way, if the contemporary is part of a binary opposition, its repressed term is not so much the historical past as it is the avant-garde. If the contemporary is the temporality of the perpetual return of the same, the avant-garde is the marker of a progressive and future-directed temporality.

In his survey of modernism and the avant-garde, after discussing the avant-garde's permutations from the mid-nineteenth century to the 1960s, Paul Wood concludes with the question of whether the idea of the avant-garde 'remains a useful device to rethink the relationship between society and modern art, or is […] the symptom of a past that art and society alike have now traveled beyond'.[31] Indeed, when the term 'avant-garde' is evoked today, in the context of the contemporary, it is largely presented either as a regressive or naive return to the universalist ideals of historical progress led by an intellectual elite, or as a ghostly reverberation of a past that can be re-invoked only as a traumatic repetition of lost hopes for universal emancipation. Whether because it is no more than a mourning over an irrevocable rupture between artistic and political avant-gardism, because of its failure, resulting from a false sublation of its emancipatory promise in the culture industry, or as a result of a critique of its universalizing programme by poststructuralism, postcolonial theories and feminism, the assumption remains the same: the avant-garde is

irretrievably lost and is impossible in the present. The avant-garde is incommensurable with contemporary art because in the contemporary condition, art is a 'comrade of time' rather than being ahead of it. This returns us to the initial question the chapter is asking in relation to contemporary art in Armenia: How can the avant-garde and the contemporary coexist in a post-Soviet context? If there is a general agreement that contemporary art is not an avant-garde art in a global sense, how can then Armenian contemporary art be conceived as avant-garde art? If there are unavoidable differences in how contemporary art is conceived, does this mean that 'contemporaneity' in the Armenian context must denote a qualitatively different temporality from that of world historical contemporaneity? In what follows, rather than addressing the second question as a foundation for the first – an undertaking appropriate for an entirely new book – it is the first question that will be addressed, primarily from the perspective of 'contemporary art's temporality', with the second as its backdrop.

The potency of the term avant-garde in post-1980s Armenian art is partially explainable with reference to historical conditions in which the avant-garde (at least the aesthetic avant-garde – the question of the political avant-garde is addressed in Chapter 3) was seen as neither lost nor defeated. The avant-garde of the 1980s in Armenia did not have any historical precedent on the scale of the Russian avant-garde. Even had one existed, it would have been erased by Stalinism and nationalism so diligently and systematically that today we could not even speak of some lost history of the historical avant-garde. This is important to mention, given that many of the contemporary art practices in late socialist and post-socialist periods in Eastern Europe entered into dialogue with their respective 'national' historical avant-garde traditions. For instance, many authors historicizing post-Yugoslav art discuss it in relation to the Yugoslav historical avant-gardes and neo-avant-gardes.[32] By contrast, in Armenia the semi-official art of the 1960s and 1970s – Armenian modernism, which chronologically corresponds to the Yugoslav neo-avant-gardes – grapples with the legacy of the Armenian national style of the 1920s. The latter amalgamated select elements from the medieval art tradition with both modernist forms and the new socialist imperatives of the period following the Bolshevik Revolution of 1917 and the sovietization of the country in 1921. In turn, contemporary art (or the national avant-garde in Karoyan's formulation) dealt with the ongoing legacy of the National Modernism of the 1960s and 1970s in a rather ambiguous manner, through a dialectic of rupture and continuity, while considering itself an avant-garde art. In Eastern Europe in the 1960s, the advent of the neo-avant-garde is linked to the youth culture of rebellion, a rereading of Marx and a theoretical articulation of various shades of socialism, and local scenes well informed about neo-avant-garde practices in Western Europe and North America. In Armenia, however, it

was the revival of nationalism in the 1960s that trumpeted youth rebellion; or rather, nationalism became the horizon for youth rebellion. And it was only in the late 1980s that 'avant-garde art' came to see itself both as the heir of the international historical avant-gardes, and more ambiguously, of the national tradition of modernist dissent against the official art of Socialist Realism. It is through this double reference – to the universalism of the historical avant-gardes and to the national ethos of Armenian modernism – that 1980s 'alternative' art in Armenia saw itself as an avant-garde art, negating the tradition of painting that had come before, but primarily through painting.

The alternative art of the 1980s and 1990s in Armenia strove to situate itself in relation to the international contemporary art of its time (Armenian artists tended to be informed about international developments in a fragmentary manner, and often misconceived the broader picture of contemporary art) and aimed at re-establishing previously severed communication with the outside world, just as this world had already entered the so-called post-historical stage. Yet the temporality of contemporary art in Armenia did not cohere with the world-historical temporality of 'post-history'. Contemporary art in Armenia, instead, saw itself as the vanguard of progressive time, wherein art moves time ahead, into the future, even if this future was one of market economy and liberal democracy. Thus, the avant-garde in Armenia shares certain similarities with Boris Groys's post-utopian art, which came in the aftermath of the collapse of Stalin's utopian post-historical project and sought to resituate itself in history, only to find out that history – the progressive time of ideological fulfilment – had vacated the larger world.[33] Groys's post-utopian art encompasses the post-Stalinist unofficial art of Russia in the 1970s and 1980s, which shared neither the utopianism of Stalinism and the avant-gardes, nor the anti-utopianism of the postmodern age. Appropriating 'the maximum number of signs betokening the "non-Soviet"', it depended on the non-Soviet as the Other and operated on the border between the Soviet and the non-Soviet.[34] Instead of criticizing modern progress, it saw 'a fundamental similarity between modernist and postmodernist projects, that is, the similarity between "making" and "overcoming history", and came to reflect "the utopian ambitions to halt it [modern progress]"'.[35]

Like post-utopian art, contemporary art in Armenia lies on the border between the Soviet and the non-Soviet or Western, and measures itself precisely against this border. However, it is different from post-utopian art, since it subscribes to the temporal logic of the historical avant-gardes and shares their utopian character in its future-directedness. In a way, the Armenian avant-garde has viewed itself as the avant-garde of the contemporary, the latter conceived as the ideal of a world without borders and boundaries.

In this context, the so-called global time of the contemporary, and the local time of the avant-garde that carries forward the abandoned utopianism of the

early twentieth-century avant-gardes, are conjoined. And it is in this sense that the Armenian avant-garde is the avant-garde of the contemporary, since it sees itself in the vanguard of social and political transformations, including those that merge with the global time of the contemporary, through and from the sphere of art. The avant-gardism of contemporary art in Armenia relied on two distinct but interrelated self-definitions of the avant-garde. The first of these derives from an understanding of youth culture as the source of innovation and progress. Curiously, this idea stemmed from the Soviet tradition. If aesthetically, avant-garde art was defeated with the advent of Socialist Realism as an official style in the mid-1930s, official rhetoric continued to support the idea of a political avant-garde led by youth. For instance, the biweekly newspaper *Avant-garde* was the organ of the Soviet Armenian All-Union Leninist *Young* Communist League from 1923 onwards, and even if it has not been a party organ since 1991, it continues to claim to be 'a smithy of the upbringing of youth'.[36] It is quite telling that the youth exhibitions organized at the Union of Artists in Armenia and the so-called 'alternative' artists shared the same cult of youth. Both the 3rd Floor in the late 1980s and early 1990s, and ACT in the mid-1990s, saw themselves in terms of a generational ethos, and conceived youth not simply as a category of age, but as a qualitative category. However, this cultural avant-gardism was also combined with a drive towards formal novelty and originality that contemporary art in Armenia inherited from the Armenian modernism of the 1960s and 1970s. These two intertwined understandings of the avant-garde (progressive vanguardism and formal innovation) shaped the avant-gardism of contemporary art in Armenia and the conception that art's autonomy is socially instrumental to advancing the ideal of emancipation in and through art.

The dialectic of alienation and the ideal

The concept of the 'ideal' is foundational in understanding Armenian art and its striving towards autonomy within the context of the historical transformations that have taken place in the past three decades. However, the concept needs elaboration in conjunction with the notion of alienation. This is in contrast to the common understanding that the opposite of the ideal is the real, or reality. As becomes clear through the philosophical discussion of the concept of the ideal below, the latter is conceived as always already embedded within reality. If alienation is understood as a socially induced condition, or at times as the constitutive condition of the social, then the ideal is the possibility of overcoming this condition. The fundamental aesthetic philosophy of the avant-garde in Armenia has largely relied on the understanding that alienation is a condition induced by the social world, whereas art is a means to overcome alienation by upholding an ideal. And in its very antagonism

towards reality, art's ideal has been conceived as more real that reality itself. In this view, artworks are manifestations of the ideal as well as means of achieving it, however unattainable the ideal is. The movement towards the ideal is an autonomous one, taking place fully within the sphere of art. The understanding of art as an autonomous movement towards its ideal within its own sphere distinguishes the Armenian avant-garde from both the early twentieth-century historical avant-gardes and the post-war Euro-American neo-avant-gardes – with which Armenian artists opened a conversation and from which at times they borrowed aesthetic strategies and formal references. If the agenda of the historical avant-garde was one of profaning art by politicizing it, and if the neo-avant-garde strove to de-sacralize and de-neutralize the institution of art to reveal the powers that shape the institution, the avant-garde in Armenia utilized political visions of progress, emancipation, freedom, posing these universal humanist values as their main artistic ideals. Politically, this meant that the Armenian avant-garde of the late 1980s and 1990s conceived art as the only sphere capable of preserving social ideals; it was the only realm where emancipation was possible, the only realm in which to find escape from a social world infused with corrupt political ideologies. In ethical terms, the programme of the Armenian avant-garde envisioned art as a form of ideal life that promised freedom, even if the latter was conceived solely in terms of the individual's liberation from social and cultural forces of oppression. Aesthetically it pointed towards a reconciliation of differing and at times clashing forms, styles and techniques in order to reach the aesthetic ideal of wholeness, or the reduction of the artwork to its idea and to the material processes of art making.

In political theory that takes both the Hegelian and Marxian understandings of alienation as a starting point, alienation is implicit in a social contract that requires a relinquishing of natural freedom.[37] The German word *Entaussergung*, which appears in both Hegel and Marx, has been most commonly translated as alienation, though literally and etymologically it is closest to 'externalization'.[38] Alienation is indeed a condition of externalization: in Hegel's progressive journey of the Spirit through history, alienation is internal to the Spirit itself, since the latter's movement depends on its objectification in the world through history. With each movement of objectification a higher consciousness arises until ultimately this historical consciousness (the object) coincides with the concept (*Begriff*), and thus, the idea actualizes.[39] In other words, it proceeds by alienation and by the sublation of alienation. But for Hegel alienation is also external to the Spirit, as it is an outcome of the materialization of a particular historical instance: a pre-modern antagonism between the state and religion. Modernity ultimately overcomes this antagonism by sublating this particular historical stage of alienation into higher consciousness.[40]

Through critiquing Hegel's idealism – according to which consciousness finds its reflection in history through objectification – the *Philosophical and Economic Manuscripts* (1844) of the young Marx conceives alienation as a historical outcome of man's foundational social productive activity under capitalism. It is this activity, through which man engages with nature, that brings about consciousness, or as Marx himself put it: 'It is not the consciousness of men that determines their existence, but their social existence that determines their consciousness.'[41]

The constitution of man as a historical being evolves through social labour, which is always an activity of externalization – taking something from oneself and putting it out in the world as a separate object. It is through social labour that man produces his own life conditions and shapes the material world around him. For Marx, labour is an inherently social activity, since the worker deploys socially available means of production, and the products of labour are also socially distributed: 'And lastly from the moment that men work for one another in any way, their labour assumes a social form.'[42] As an outcome of social labour under the capitalist mode of production, alienation – a gap between the sensuous world and thought – can only be surpassed through changes in the material conditions of production, rather than through changes in consciousness, as per Hegel. In the formulations above, be they Hegelian or Marxian, alienation is a result of externalization and of othering, dialectically conceived.

If then, in Marx's understanding, alienation is a result of human productive activity externalized as an object that exercises alien power over the producer of this object in capitalism, how can we define what we have established as its dialectical opposite – the ideal, historically understood as the domain of human 'spiritual' culture, and in the case of the Armenian avant-garde, of art as an autonomous sphere of activity? To provide a theoretical grounding for this concept, the notion of the ideal is treated not through Hegel and Marx directly, but instead through a fascinating and overlooked debate in Soviet philosophy – between Evald Ilyenkov and Mikhail Lifshitz in the late 1970s and the first part of the 1980s.[43] The choice of these particular authors is justified by the fact that they have provided one of the most consistent debates on the concept of the ideal from a perspective of historical materialism while synthesizing Hegel and Marx. Most twentieth-century Western philosophy and theory, by contrast (with the exception of Lacan) has either defined the ideal as a product of the individual mind and of a concern for formal logic or, as with traditional psychoanalysis, as the supra-cultural domain of the superego. The historical materialist approach that Lifshitz and Ilyenkov developed, albeit differently, helps to conceptualize the ideal as an outcome of historical processes, though not reduced to these. This understanding is particularly compelling in relation to art as a concept that actualizes itself historically,

and yet through an autonomous evolvement towards its notion (a theory that recalls Adorno's Marxist-Hegelian approach to autonomous art).

Working through Lifshitz's and Ilyenkov's philosophies to ground the concept of the ideal in relation to avant-garde art practices in Armenia is historically compelling in yet another sense: their philosophies provide an epistemological horizon different from twentieth-century Western theory and philosophy, yet one that is rooted in universal modernity, the Soviet experience of which is being erased and forgotten. With the disintegration of the Soviet Union, the material conditions in which Ilyenkov and Lifshitz worked and which formed the context of their philosophical debates is lost. Yet the persistence of the schematic thinking and narrow identitarianism against which these authors were struggling justifies the reintroduction of their thinking as a critical possibility within current conditions. Utilizing their theoretical understanding of the ideal, rooted in a context that no longer exists, and arguing for its prominence in the aesthetic philosophy of the Armenian avant-garde advances a historical understanding of the latter as an outcome of that lost context. This view is consistent with a theory of history as one of a dialectic of rupture and continuity, one that informs the historiographical method of this book. Even if the avant-garde in Armenia sought to negate the Soviet context, the latter was still formative for its constitution. This historical theoretical approach helps to establish uneven and uneasy links between the Soviet experience and that of the neoliberal present in Armenia, and between the arts of Soviet and post-Soviet Armenia.

In his seminal work 'The Concept of the Ideal' of 1977, published two years before his tragic suicide, Evald Ilyenkov launched a compelling offensive against the modern materialism that designates ideals as mere facts of the brain, and the vulgar idealism for which ideals have primacy over the material world.[44] Instead, by drawing from Marx's theory of the commodity and the value form (wherein the value form is a sort of ideal that has no material relation to the sensuous object whose value it expresses, in that it is a universal equivalence that defines the relationship between objects and humans), Ilyenkov argues that the ideal is a product of human activity, one that confronts the human with its own objectivity. Thus, the ideal is not a fact of the psychology of the individual, as empiricists would have us believe, or a mere imprint of the material world of experience upon the psyche, as positivists would suggest, but is an outcome of essential human activity – of human social labour. Ilyenkov located 'ideality' 'in the historically formed language of philosophy', as 'a characteristic of the materially-established social-human culture'.[45] This latter includes language, symbols, art, social institutions and, more broadly, all forms of collective consciousness that have objective existence prior to the social individual's constitution. Derived from the understanding that the ideal is a product of human labour is the notion of

the idealization of reality. This is a process in which material is transformed into ideal, as part and parcel of humanity's transformation of the material world in the creation of its conditions of life. But,

> It is 'idea' because it does not include a single atom of the substance of the body in which it is represented, because it is the form of quite another body. And this other body is present here not corporeally-substantially (it is found to be 'corporeal' at quite a different point in space), but again only 'ideally', and there is not a single atom of its substance.[46]

Thus, the ideal is a historical product of man's transformation of nature via social labour. The ideal is phantasmagoric, but is constituted historically and it can be only made available through its 'reification, objectification (and deobjectification), alienation and the sublation of alienation'.[47]

Here, in Ilyenkov's theory of the ideal, we have the Marxian move of inverting the Hegelian dialectic: it is man's transformation of nature through labour that brings about transformations in consciousness, through alienation and sublation of alienation at the level of historical change. It is inside man – not as an individual, but as an 'aggregate of social relations' – that ideals exist, because

> 'inside' *man thus understood are all the things* that 'mediate' the individuals that are socially producing their life: *words, books, statues, churches, community centres, television towers,* and (above all!) *the instruments of labour,* from the stone axe and the bone needle to the modern automated factory and the computer. It is in these 'things' that the ideal exists as the 'subjective', purposeful, form-creating life activity of social man, embodied in the material of nature.[48]

Through Lenin, and the latter's reading of Hegel,[49] Ilyenkov conceives the ideal as an objective relationship with the world, outside of the subject, and yet an objectivity that has become such through man's productive activity. The ideal is formed in the relationship between two material objects, wherein the concept of an object is reflected upon an object other than itself (again, the value form exemplifies this relationship). From Ilyenkov's historical materialist conception of the ideal, it emerges that art is another form of social productive activity, and that one needs to deal with it as with all other facts of objective reality that acquire traces of subjectivity, and through which subjectivity in turn is punctured to admit objectivity (since labour that shapes the collective subject also endows that subject with objectivity). Since the ideal and the material in this sense cannot be separated, it follows that while man is creating his own reality, there is an inevitable idealization of reality, of nature and of social relations. This idealization transforms them into a series of images that are not only objectified in language and in social norms, but in collective human culture at large, including 'drawings, models and such

symbolic objects as coats of arms, banners, dress, utensils and so on, every-thing from furniture in the throne-room to children's toys, and so on and so forth. And money, including "real" bars of metal and paper money, and promissory notes, bonds or credit notes.'[50] Thus for Ilyenkov, who follows Marx's labour theory of value as the foundation of the ideal, it is the value form that is the ultimate ideal, since it is both derived from the material sensuous object and represents it, and yet has no material relationship to it. This also implies that all products of human culture, whether art or 'television towers', are ultimately embodiments of ideals. In a way, Ilyenkov's conception of the ideal implies that art is not an autonomous sphere, but one that is part and parcel of human culture as an outcome of social productive activity. It is in this crucial point that, while providing a compelling theoretical alterna-tive both to vulgar materialists who view art as a direct outcome of economic conditions and vulgar idealists who relegate it to the extra-sensuous domain, Ilyenkov's theory diverts from the Socialist Realist conception of art as ideal, supported by its autonomy from the social world. This is the main point of Lifshitz's disagreement with his philosophical interlocutor.

Lifshitz started his homage to Ilyenkov's thought and began elaborating his notion of the ideal several years after the philosopher's death. He takes the perspective that material and spiritual labour are ultimately different spheres of human activity – the first addresses material needs and the second responds to spiritual needs with its promise of liberation from necessity.[51] Lifshitz argues that the intellectual work that is involved in raising conscious-ness and the material work that is involved in creating the material world of objects around us are different, and at times irreconcilable, spheres. The ideal forms are those that have not been subsumed within material relations and remain as ideal in the collective consciousness. Grounded in dialectical materialism's ontology of nature, Lifshitz views ideals not merely as products of human social labour, but as existing in nature, external to man's productive activity. However, he concedes that it is through the socialization of nature that these ideals become available to man and participate in the development of consciousness. If Ilyenkov supports his concept of the ideal by drawing from Marx's conception of value form, Lifshitz builds his nuanced counter-argument with the premise that the adaptation of the value form directly to the discussion of the ideal is a reductionist approach. Ultimately, the relation-ship between man and nature is not always as inverted and oppositional as the relationship between the sensuous object and its representation in the value form. The representation of the value form is historical and characterizes the capitalist mode of production, while the relationship between man and nature is universal and transhistorical. If Ilyenkov considers the social ideal in opposition to the sensuous reception of the material object, Lifshitz argues that form (social ideal) and the material object (sensuous matter) ultimately

are not opposed, and in their dialectical unfolding they strive towards identity with their concept. The ideal thus is not confined to productive human activity, and can be found in nature, in material reality.

Lifshitz says that through his engagement with matter, man discovers those objective qualities that are embedded in nature and develops their ideality through his own labour. Ultimately, there is a difference between money and religious icons, not because of the latter's devotional nature, but because of their aspiration to the kind of beauty and harmony that is found in nature. Money is a false ideal that can be historically superseded, whereas the icons, as part of the world of spiritual needs, aspire to truer ideals. For Lifshitz, if we were to designate all that is produced by human culture as ideal (including false ideals, which are still – if only partial – manifestations of the ideal), then we would have to come up with another word to name the true ideals that correspond to the goodness, truth and beauty found in nature. Lifshitz's more classicist view, taking up Lenin's theory of reflection (according to which products of spiritual culture are mirrors of nature), assumes that the world of material production and the world of spiritual production are guided by different rules: if the first evolves through its own material laws, the second is a reflection, representation, even a mimesis of the objective reality of nature and society in their dialectical intertwining. Hence, the spiritual world is the domain of freedom, and not that of necessity. For Lifshitz, there is an objective truth beneath symbolic systems, standing as an ideal threshold for the existence of all matter. If for Ilyenkov ideals are aspects of culture, for Lifshitz, every true aspect of culture contains an ideal content that has an objective nature. Ilyenkov conceives the ideal as that which develops in the collective human imagination through a long historical process of productive practical activity. And Lifshitz agrees with this, but says that both imagination and human productive activity have objective correlates in nature, and that therefore every attempt to reach the ideal or embody it in human spiritual culture is ultimately a movement towards cohering with the truth of the concept, in a Hegelian sense. If for Ilyenkov, the sculptor carves out a culturally constructed ideal from the marble (though a material historical process, this ideal is still a construction), for Lifshitz the sculpture is already dormant in the marble before the sculptor sets out to reveal it. However, despite Lifshitz's critique, both he and Ilyenkov deal with the ideal in terms of its crystallization in objects of culture through man's engagement with nature and his transformation of the material (and in Lifshitz's case, also spiritual) conditions of his existence. But it was Ilyenkov's genius that not only identified the slippery nature of the ideal as immanent to its very concept (where it can stand both for higher ideals as well as the value form), but tried to pin it down as a concrete and historical phenomenon:

'Ideality' constantly escapes, slips away from the metaphysically single-valued theoretical fixation. As soon as it is fixed as the 'form of the thing' it begins to tease the theoretician with its 'immateriality', its 'functional' character and appears only as a form of 'pure activity'. On the other hand, as soon as one attempts to fix it 'as such', as purified of all the traces of palpable corporeality, it turns out that this attempt is fundamentally doomed to failure, that after such a purification there will be nothing but phantasmal emptiness, an indefinable vacuum.[52]

Ilyenkov attempted to show the reality of this phantasm and the phantasmic character of reality in the same way as for Marx the commodity functioned as an object endowed with subjectivity to the extent that it rendered social relations between subjects more like relations between objects. Nevertheless, it was Lifshitz's notion of the ideal as belonging to a *separate* domain of human spiritual culture that, within the theory of Socialist Realism, supported aesthetic autonomy, at least as it was schematized and vulgarized in Soviet art criticism and aesthetic theory, acting as a general principle for all artistic phenomena.

The above philosophical engagement with the concept of the ideal as a conceptual groundwork supports the argument that the avant-garde in Armenia adheres to art as an ideal (and this is what it shared with Socialist Realism) understood as a distinct realm of spiritual culture. This ideal is materially rooted in the 'painterly real', understood as that which secures art's separateness from the social world. The constitution of the 'painterly real' itself was a historical process that took place alongside the construction of Armenian national culture over the twentieth century, within the cultural logic of the Soviet Union. In reference to the nation as a historical content with its distinct spiritual culture and painting as indices of modernity, the 'painterly real' embodied, as an aesthetic ideal, the merging of the nation with the modern. I argue that aesthetic autonomy supported the 'painterly real' that functioned as a precondition for the existence of the avant-garde in Armenia from the late 1980s until the 2000s. What follows is the art-historical journey of the 'painterly real' within the 'labyrinths of the tradition of alternative art' in Armenia.[53]

Notes

1 Fredric Jameson discusses the belatedness of the recognition of the changed historical conditions in his book *A Singular Modernity: Essay on the Ontology of the Present* (London: Verso, 2002).
2 Terry Smith, *What Is Contemporary Art?* (Chicago: University of Chicago Press, 2009); Octavian Esanu, 'What Was Contemporary Art?', *ARTMargins* 1.1 (2012), pp. 5–28; Richard Meyer, *What Was Contemporary Art?* (Cambridge, MA: MIT Press, 2013).

3 Rosalind Krauss, *A Voyage on the North Sea: Art in the Age of the Post-medium Condition* (London: Thames & Hudson, 2000).

4 *Art Weekly* (Yerevan), 13–20 June 1993.

5 Similarly, the word 'installation' enters the lexicon of contemporary art in Armenia in a 1992 exhibition called 9 organized by Sonia Balassanian, where nine artists presented an 'installation'. Karoyan mentions the word and its novelty as a synonym for 'exhibition' in a short unpublished review of the exhibition. Nazareth Karoyan, untitled text, 1993. Nazareth Karoyan's archive.

6 Esanu, 'What Was Contemporary Art?'

7 For more on this, see Achille Bonito Oliva, *Transavantgarde International* (Milan: Politi Editore, 1982).

8 Conversation between several artists and critics, *Arvest Weekly* (Yerevan) 11–12 (1992), pp. 2–8; Nazareth Karoyan, 'Inch e Hamasteghtsakan arvesty?' [What is *hamasteghtsakan* art?], *Garun* 2 (1996), pp. 95–6.

9 Nazareth Karoyan, 'Andradardz', unpublished (1992). Nazareth Karoyan's archive. In his earlier texts, he identifies the 3rd Floor as a movement that encompasses a variety of 'modernist styles – from informel to conceptualism and minimalism, from Pop Art to neo-fauvism'. Untitled unpublished text, possibly 1989–90.

10 In the text 'Andzradarz', Karoyan uses the term 'avant-garde' synonymously with 'modernism' to denote the early twentieth-century movement that shared 'a desire to adhere to the affirmation of the colour field and flatness as an absolute and self-sufficient value'. In other texts he uses modernism and the avant-garde inter-changeably to designate the practices supported by the Modern Art Museum, where he himself worked prior to joining the 3rd Floor movement. Karoyan, unpublished text, probably 1989–91. Nazareth Karoyan's archive.

11 Most probably this reinvigorated debate signals the arrival of new conditions that have surpassed the notions of contemporary art and contemporaneity under discussion.

12 'Contemporary' and 'contemporaneity' are used interchangeably here and throughout.

13 Even though, for Jameson himself, the contemporary was part and parcel of the cultural logic of late capitalism subsumed under postmodernism. Frederic Jameson, *Postmodernism, Or The Cultural Logic of Late Capitalism* (Durham, NC: Duke University Press, 1991).

14 Bill Roberts, 'Unnaming the System? Retrieving Postmodernism's Contemporanei ty', *ARTMargins* 4.2 (2015), pp. 3–23.

15 Terry Smith, 'Contemporary Art and Contemporaneity', *Critical Inquiry* 32.4 (2006), pp. 681–707; Smith, *What Is Contemporary Art?*.

16 Smith, 'Contemporary Art and Contemporaneity', p. 707.

17 'Introduction', in T. Smith, O. Enwezor and N. Condee (eds), *Antinomies of Art and Culture: Modernity, Postmodernity, Contemporaneity* (Durham, NC: Duke University Press, 2009), p. 3.

18 Alexander Alberro, 'Periodizing Contemporary Art', http://globalartmuseum.de/site/guest_author/306 (last accessed 13 January 2015).

19 Pamela M. Lee, *Forgetting the Artworld* (Cambridge, MA: MIT Press, 2012).

20 Osborne, *Anywhere Or Not at All*.

21 Osborne, *Anywhere Or Not at All*, p. 22.

22 In 1990 Jameson coined the term post-contemporary – left for the most part unexplained – in the series he was co-editing for Duke University Press (Post-Contemporary Interventions) to propose a theory that 'stands for history by its very post-contemporaneity, identifying what is progressive in present-day intellectual trends by projecting their new directions into the future'. *Post-Contemporary Interventions*, Series Editors Fredric Jameson, Stanley Fish, Roberto Dainotto and Michael Hardt, Duke University Press (2005–2013), https://www.dukeupress.edu/Catalog/ProductList.php?viewby=series&id=52 (last accessed 12 May 2015).

23 Boris Groys, 'Comrades of Time', *e-flux* 11 (December 2009), http://www.e-flux.com/journal/comrades-of-time/ (last accessed 13 January 2015).

24 Groys, 'Comrades of Time'.

25 Giorgio Agamben, *What is an Apparatus?* (Redwood City, CA: Stanford University Press, 2009), p. 39.

26 Agamben, *What is an Apparatus?*, p. 40.

27 Alexander Nagel and Christopher Wood, *Anachronic Renaissance* (Cambridge, MA: MIT Press, 2010); Mieke Bal, 'Anachronism for the Sake of History: The Performative Look', keynote lecture delivered at the AAH 40th Anniversary Conference, RCA, London, 2014; Meyer, *What Was Contemporary Art?*.

28 Meyer, *What Was Contemporary Art?*, p. 15.

29 Fredric Jameson, 'The Aesthetics of Singularity', *New Left Review* 92 (March–April, 2015).

30 Danto tells the reader that he detected a qualitative break from the logic of modernism when in 1964 he encountered Andy Warhol's Brillo boxes. However, he conceptualized this break only in the early 1980s. Arthur C. Danto, 'Approaching the End of Art', lecture delivered at the Whitney Museum of American Art, 1985, reprinted in Arthur C. Danto, *Beyond the Brillo Box: The Visual Arts in Post-Historical Perspective* (Berkeley and Los Angeles: University of California Press, 1998).

31 Paul Wood, 'Modernism and the Ideal of the Avant-Garde', in Paul Smith and Carolyn Wilde (eds), *A Companion to Art Theory* (Oxford and Malden, MA: Wiley-Blackwell Publishing, 2007), p. 227.

32 Ales Erjavec, 'Introduction', in *Postmodernism and the Postsocialist Condition: Politicized Art under Late Socialism* (Berkeley, CA: University of California Press, 2003), pp. 1–54; Miško Šuvaković, 'Impossible Histories', in Dubravka Djuric and Miško Šuvaković (eds), *Impossible Histories: Historic Avant-gardes, Neo-avant-gardes, and Post-avant-gardes in Yugoslavia, 1918–1991* (Cambridge, MA: MIT Press, 2006), pp. 2–35. Šuvaković offers a periodization of Yugoslav non- or semi-official art as avant-garde (the 1920–30s), neo-avant-garde (1940–60s) and post-avant-garde (1970s–90s), with the latter being constituted – in opposition to the timeless utopia of the avant-garde and the concrete utopia of the neo-avant-gardes – as post-utopian art, or 'as a posthistoric complex of manifestations that reexamines, presents, destroys, deconstructs, thereby creating an archaeology of modernism, avant-gardes and neo-avant-gardes'. At times this post-avant-garde art coincides with eclectic postmodernism, and then both coincide with and exist

in conditions of post-socialism. Boris Groys's post-utopian art is adapted here, yet without the ambiguities theorized by Groys. If for the Russian critic, post-utopian art arrives in the epoch of post-Stalinism, after the end of history but still driven by an impossible search for it, for Šuvaković the Yugoslav post-avant-gardes more comfortably represent critical postmodernism in conditions of post-socialism and in the wake of the collapse of grand utopias. Boris Groys, *The Total Art of Stalinism: Avant-garde, Aesthetic Dictatorship, and Beyond* (Princeton, NJ: Princeton University Press, 1992).

33 Groys, *The Total Art of Stalinism*, pp. 75–102.

34 Boris Groys, 'A Style and a Half', in T. Lahusen and E. A. Dobrenko (eds), *Socialist Realism Without Shores* (Durham, NC: Duke University Press, 1997), p. 82.

35 Groys, *The Total Art of Stalinism*, p. 81.

36 'Editorial', *Avant-garde Weekly*, http://www.avangard.am/?page=about (last accessed 13 January 2013).

37 C. J. Arthur, *Lukács, Dialectics of Labour: Marx and His Relation to Hegel* (Oxford: Basil Blackwell, 1986).

38 Arthur, *Lukács, Dialectics of Labour*.

39 In Hegel's philosophical system, the concept (or the notion) is both the truth of the origin of the thing and its evolution towards the idea in all its stages, and towards the ultimate coherence with the Absolute. It is 'the absolute whole or universal particularized'. G. W. F. Hegel and William Wallace, *Hegel's Logic: Being Part One of the Encyclopedia of Philosophical Sciences* (1830) (Oxford: Clarendon Press, 1975); Eric Goodfield, *Hegel and the Metaphysical Frontiers of Political Theory* (London: Routledge, 2013), p. 144.

40 G. W. F. Hegel, *Phenomenology of Spirit*, trans. A. V. Miller (Oxford: Oxford University Press, 1977). Chapters IV, VI B and VII C contain the chief historical sources of the concept of alienation.

41 Karl Marx, 'Preface to *A Contribution to the Critique of Political Economy*', in *Selected Writings*, ed. Lawrence H. Simon (Indianapolis: Hackett Publishing, 1993), p. 211.

42 Karl Marx and Friedrich Engels, *Soch.* (Moscow: Isdatel'stvo politicheskoy litera-tury, 2nd edn, 1955–74), vol. 23, p. 81.

43 My gratitude goes to Vardan Azatyan who drew my attention to these debates several years ago, and who, since then, has been tirelessly grappling with this under-discussed philosophical legacy of Soviet Marxism.

44 Evald Ilyenkov, 'The Concept of the Ideal', *Historical Materialism* 20.2 (2012), pp. 149–93.

45 Ilyenkov, 'The Concept of the Ideal', p. 169.

46 Ilyenkov, 'The Concept of the Ideal'.

47 Andrei Maydansky, 'Reality of the Ideal', in A. Levant and V. Oittnen (eds), *Dialectics of the Ideal: Evald Ilyenkov and Creative Soviet Marxism* (Leiden: Brill, 2014), p. 132.

48 Ilyenkov, 'The Concept of the Ideal', p. 192.

49 In his reading of Hegel's *Science of Logic* in 1914–16, after positing Hegel's notion of the ideal against the Kantian transcendental idea, Lenin remarks: 'It is equally

incorrect to regard the Idea as something "unreal" – as people say: "it is merely an idea" ... Secondly, the idea is the relation of the subjectivity (= man) which is for itself (= independent, as it were) to the objectivity which is *distinct* (from this Idea)'. Here the idea is the unity of the ideal and the real. Lenin, 'Conspectus of Hegel's Book *The Science of Logic*', in V. I. Lenin, *Collected Works*, Vol. 38 (Moscow: Progress Publishers, 4th edn, 1976), pp. 237–42. As transcribed on http://www.marxists.org/archive/lenin/works/1914/cons-logic/ (last accessed 13 October 2015).

50 Ilyenkov, 'The Concept of the Ideal', p. 149.
51 Mikhail Lifshitz, *Iskusstvo i Kommunisticheskiy Ideal: Pamyati Eval'da Il'yenkova* [Art and the communist ideal: in memory of Evald Il'yenkov] (Moscow: Iskusstvo, 1984).
52 Ilyenkov, 'The Concept of the Ideal', p. 149.
53 This is Nazareth Karoyan's designation. Karoyan, 'Ailyntranqayin avanduyti kay-atsman bavighnerum' [Within the labyrinths of establishing the alternative tradi-tion], *Ex Voto* 1, *Garun* 2 (1995), pp. 94–6; *Ex Voto* 7, *Garun* 8 (1995), pp. 90–4; and *Ex Voto* 8, *Garun* 9 (1995), pp. 90–5.

2 The 'painterly real' of contemporary art: resurrected ghosts, living heroes and saintly saviours on the 3rd Floor, 1987–94

The cultural vanguard of the officially sanctioned opposition

This chapter discusses the 3rd Floor – an artistic movement[1] of the late Soviet and early independence years in Armenia (1987–94) – in its complex relationship with the cultural politics of the perestroika period, the official art of the Union of Artists of the Soviet Republic of Armenia, and the changing world of the late Soviet years. I argue that the 3rd Floor affirmed the separation between autonomous art and all that falls outside this autonomous sphere – the social world replete with antagonism and discontent. The 3rd Floor proposed two distinct but interrelated notions of autonomy: autonomy of artistic activity and autonomy of art. Autonomy of artistic activity was supported by the liberal ideal of freedom of choice translated into the domain of artistic practice as the artist's right to freely choose media, images and references. This form of autonomy was also supported by the movement's programme of creating its own separate artistic and cultural context. Artistic autonomy was supported by the autonomy of art, as a distinct sphere of creative activity, and of the artwork, as an ideal of the world-to-come. The 'painterly real' as conceptualized in the introduction and previous chapter, and as it materialized in the 3rd Floor's conception of the artistic act as a gestural act, functioned as a condition for securing art's opposition to the social world, while realizing social dreams in art. In this, art was conceived as that which resists the social while harvesting progressive visions within existing political discourses and realizing them in art. I argue that while the 3rd Floor was a product of the perestroika period, nevertheless the autonomy of art supported by the 'painterly real' was what allowed the movement to surpass the conditions in which it operated and secured the longevity of its aesthetic and discursive life beyond the limited period of its activities.

What follows is not a comprehensive history of the 3rd Floor, an undertaking that would require a more detailed and intricate analysis of the movement's exhibitions and activities in relation to each artist's practice and distinct background. Instead, my contextual approach to the movement is an outcome of putting together various material and discursive traces

(artworks, photographs of events, published and unpublished texts, testimonies) in order to link the aesthetics, ethics and politics of the movement and situate its formation and operation within the larger political, institutional and everyday transformations of the period. I do so through the prism of the question of what formally, discursively, ideologically and ethically constituted *hamasteghtsakan* art – a concept that became operational in the early 1990s to designate the practices of the 3rd Floor movement and to stand for aesthetic incoherence as a political and ethical programme. This discussion is carried out in the context of the movement's shifting position within and outside of official art, and in it I ask what kind of a relationship *hamasteghtsakan* proposes between art and reality. The discussion is complex, but limited in the sense that it largely examines the movement through the practices of its most vocal protagonists: the art critic Nazareth Karoyan and the artist Arman Grigoryan. I will not delve into the practices and artistic philosophies of other members, which include over a dozen core participants.[2] Such an undertaking, if pursued, would probably challenge the prevailing narrative of the movement as constructed by Karoyan and Grigoryan. However, this strategic bias on my part aims to outline the *dominant* narrative of what came to constitute 'contemporary art' as it was set forth by the above-mentioned protagonists; a narrative from which the conceptual artists of the 1990s, exemplified by the group ACT, strove to liberate themselves.

The 3rd Floor (1987–94) was the first major contemporary art movement in Armenia, formed in the late 1980s (figure 1).[3] Inspired by Mikhael Gorbachev's programme of perestroika (1984–91) and its appeal for transparency – glasnost (1986–91) – a group of artists embarked upon the reformation of the Union of Artists. They launched their first event in 1987 in the conference hall located on the third floor of the Union of Artists, a space not designated for exhibitions. It was the location of their first convention that gave the movement its name: the '3rd Floor'. The 3rd Floor began to form when several young artists were invited to be part of the youth division of the Union in 1987. They had a mandate to organize and provide content for the annual youth exhibition, which would attract a large public and breathe fresh air into an otherwise stagnant institution, a bastion of official art.

The Unions of Artists were organizational structures of artistic production, representation and reception in the USSR. Along with other professional Unions, such as those of architects, writers, composers, etc., these were instituted in the Soviet Union throughout the 1930s (in Armenia the Union of Artists was established in 1932, two years before Andrei Zhdanov delivered his programmatic speech at the First Congress of Soviet Writers, declaring Socialist Realism to be 'the official style of Soviet culture')[4] as part of a larger Stalinist programme of centralization of culture in the hands of the state,

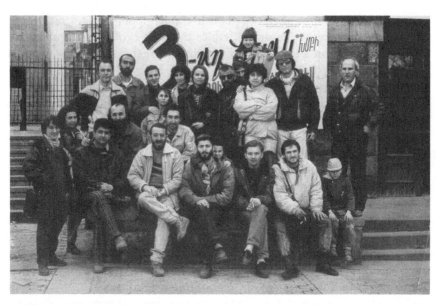

1 3rd Floor, group photograph, 1992

among other spheres of social activity. In Soviet Russia the Unions came to replace the more experimental productivist structures launched during the New Economic Policy period (1921–28), such as InKhuk and VKhutemas. In the republics of the USSR the Unions had formal autonomy.[5] Structurally, the Union was set up with a secretary at the top, followed by an administrative council and a secretariat that oversaw the work of individual sections divided according to disciplines (painting, sculpture, decorative arts, graphic arts). All artistic and administrative decisions were made collectively through committees. In addition, each Union had a production fund responsible for allocating commissions to its members and overseeing the acquisition of new works. The Unions were by and for members, though the annual youth exhibitions were open to non-members, the products of whose creative practice, if approved, could be bought by the state. To become a member of a Union, an artist had to have graduated from an art school and have proven skill and artistic talent.

The young artists associated with the 3rd Floor used the opportunity to be officially part of the Soviet artistic establishment, placing at the heart of their agenda the issue of direct communication with the public and of de-bureaucratization of art's distribution. They were to challenge the traditional representational content of the Union's youth exhibitions, which provided opportunities to young artists to exhibit as long as they affirmed and reproduced the inherited styles, techniques and rules of composition

that had exclusively favoured figuration. Among the most favoured motifs were those depicting modernization in Soviet Armenia, rural themes that aimed to reproduce the colours, brushstrokes and lines of such Soviet Armenian modernist painters as Martiros Saryan (1880–1972) and Yervand Kochar (1899–1979), portraits of prominent intellectuals, and narrative painting with scenes from Armenian history. All these enacted the pictorial and ideological principles of Socialist Realism, mixed with 'typically' Armenian colour choices that facilitated a pretentious and somewhat provincial claim for exceptionality. For the most part, Socialist Realism manifested locally as a painterly style that often went so far as to adapt the formal devices of impressionism and fauvism. This is in contrast to the Classicist principle of the primacy of line over colour, a principle that prevailed in the orthodox variants of Socialist Realism, especially those coming out of Leningrad. Lacking any stylistic coherence, Socialist Realism still acted as a general principle in art production, theory and criticism, at times serving the sole purpose of claiming a position of power for the purposes of artistic legitimation. With its central principle of affirming life in an optimistic rendering (rather than reality in its truthfulness), Socialist Realism presented an ideological representation of life as an image from the future, one that appeared in the present. It was this ideal of the future, possible only as an image rendered in painting in the present, that supported art's autonomy even if the ideological mandate of such art was to be instrumental for progress. This ideal in Socialist Realism had the function of surpassing the very ideological conditions in which it emerged. But with its disdain for actual social realism, Socialist Realism also facilitated the illusion that the everyday, with its contradictions and its actually existing dilemmas, could be transcended. It was this ideal that, despite the prevailing instrumentalization of art under state socialism, supported art's autonomy. The contradiction between autonomous art and art as an instrument for social progress was encapsulated in the incommensurability between the ideal-as-real of Socialist Realism and the everyday reality of empirical experience within actually existing socialism. Stalin had already declared that socialism was realized, and Brezhnev repeated this Stalinist rhetoric in his struggle against the effects of Khruschev's thaw, this time unaccompanied by the dramatic transformations of economy and culture that Stalin had instituted. 'Socialism realized', along with its Brezhnev-era repetition, masked the prolonged erasure of Leninist Bolshevik communist principles from public consciousness.

Since the 1960s an aesthetic and ideological regime had been forming in Armenia in opposition to the doctrine of Socialist Realism and official socialist art. The art historian Vardan Azatyan calls this new regime, which emerged in the unofficial circles of Armenian artists from the 1960s, National

Modernism.[6] This new regime became possible in the post-Second World War period as a result of Khruschev's relatively liberal policies in the period of de-Stalinization after the 1956 twentieth Congress of the CPSU. Based on a marriage of national (understood as ethnic) content and modernist form, in the late 1960s this so-called National Modernism, a phenomenon peculiar to Soviet Armenia, had become a true alternative to Socialist Realism, linked to the mass repatriation of a diaspora population, a situation incomparable to that in any other of the Soviet Republics.[7] I will return to the complex relationship between Socialist Realism and National Modernism that constituted the national fine arts in Soviet Armenia. But I hope it is by now clear that in the late 1980s the 3rd Floor entered an artistic scene that had established two distinct regimes of representation.

In this context, the 3rd Floor's programme went above and beyond a formal and stylistic opposition to local Socialist Realism, and beyond an ambivalent critique of National Modernism. The young artists involved in the movement aimed at nothing less than institutional transformation, and by extension a redefinition of art itself. The artists Arman Grigoryan and Kiki, and the art critic Nazareth Karoyan, took advantage of the Union of Artists' 1987 invitation and organized a ten-day process-based event where 'anyone and anybody could present themselves or be presented as artists, stressing the urgency of communication which can only be resolved between art and reality'.[8] In this they opposed and critiqued the established Union of Artists' policies of selecting the participating artists for annual youth exhibitions through state-organized committees, and aimed at reforming the institution structurally and aesthetically.

The 3rd Floor movement lasted until 1994, and it organized various exhibitions, happenings, performances and discussions that were fluid enough to accommodate literally any medium, style and school, from Pop Art and Abstract Expressionism to Minimalism, neo-Dada performance and to some extent conceptual art (figure 2). Ideologically, it presented a mixture of romantic liberalism, nationalism and libertarianism, anarchist dreams of omnipotence, contradicting ideologies that often worked hand in hand. It is not accidental that throughout the six years of its loose existence, approximately fifty artists (according to Nazareth Karoyan's calculation) participated in the events related to or organized by the movement. Through its broad strategies, which bring to mind the Wagnerian notion of *Gesamtkunstwerk*, the 3rd Floor had the ambition 'to make up for the lack of a contemporary art discourse [by means of] a limited number of exhibitions'.[9]

The artists participating in the movement actively appropriated Western signs and symbols that were often a mixture of high art and middle- to lowbrow cultural icons: from Joseph Beuys to Black Sabbath to the veneration of blue jeans and Marlboro cigarettes.[10] The members romanticized these

3rd Floor, exhibition *Plus Minus*, 1990. General view of the exhibition. Photograph: 2
Karen Araqelyan

symbols to the degree that they came to denote absolute freedom, ideals of individual freedom and autonomy. The critique of the Soviet through its other – signs of consumer culture – situates the 3rd Floor within the intellectual climate of the late Soviet and socialist intelligentsia's romantic alliance with the notion of bourgeois democracy. In the 3rd Floor's practices these ideals were understood from an artistic perspective: the citizen's freedom was equal to that of the artist's 'absolute and universal right to mix different artistic styles and images on the surface of the canvas'.[11] If the ideal of Socialist Realism was based upon a series of prescribed and recommended images, for the 3rd Floor, autonomy meant aesthetic anarchism, understood as the right to mix the images and styles of high and low culture. The aesthetic anarchism that formed the core of the 3rd Floor's artistic method of exhibition-making was combined with the relativization of all value and the dismantling of hierarchies. This anarchic impulse corresponds to the then ongoing constitution of the late Soviet subject (a process that arguably reached its culmination in the 2000s and was ossified in the present-day normative subject of the

post-Soviet Armenian nation) as an autonomous agent devoid of social responsibility. In opposition to the collective subject produced in Soviet ideological discourse (even though this discourse became a mere façade in the years of stagnation), the 3rd Floor insisted on individualism. In their war against banality, be it ideological banality or everyday banality, they insisted on the need to be uncommon. But was this anarchic enactment of artistic freedom merely a matter of radical originality and spontaneity? We can, for example, approach the matter from a different angle: how was the urge for differentiation structurally accommodated within the evolving social world of the perestroika period?

The 3rd Floor's establishment at the margins of the Union of Artists' institutional structure was enabled by a 1987 change of statute that resulted in the inclusion of several soon-to-be artists of the movement in the Union's Youth section. Their incorporation in the official art institution, while they continued to act at its margins as the cultural vanguard of the new epoch, puts them in the trajectory of the discourse of glasnost, as part of the official perestroika reforms aimed at giving a voice to the intelligentsia alienated by a stagnant bureaucracy. It also allows us to designate the 3rd Floor as an avant-garde movement, a term that functioned as a self-designation in the late 1980s as well. The movement did not only fit within the framework of this official programme launched by Gorbachev in 1987 to reform the state institutions, but also structurally reproduced it, or rather formally rhymed with it. The social democratic framework of glasnost or 'socialism with a human face' was a litmus test for the reformist wing of the party led by Gorbachev to negotiate changes within the state and party structure while confronting both conservative resistance and more radical calls for total reconstruction. These latter calls in particular grew louder around 1987–88, when the imperative to transform the system while leaving its foundations intact was combined with the rising nationalist movements across the USSR, including in Soviet Armenia, that ultimately culminated in a war between Armenia and Azerbaijan over the Nagorno Karabagh Autonomous Oblast. As an outcome of glasnost, protests, pickets, demonstrations and strikes materialized in public spaces such as parks and squares. Formally, these were temporary and process-based events. Similarly, the 3rd Floor's exhibitions were all-inclusive, performative and time-based events operating within what Azatyan calls 'the making of history within the regime of urgency'.[12] Grigoryan confirmed this in 1989 when he declared: 'Art should be urgent and not leave [anyone] indifferent.'[13] In this context, transgression is no longer defined in terms of isolation and rejection, or in the existentialist attitude that defined the officially oppositional artistic landscape of the 1960s of the lone hero at odds with a hostile world, but as an act of participation, intervention and inclusion.

Perestroika, glasnost and the ideal of the free subject

At its very foundation, glasnost was characterized as the opposite of the seclusion of power and of the secrecy of its operation, and this included a long list of diverse phenomena – the KGB, closed archives, secret political decisions, bans on discourse on sex and pornography. It aimed at the transformation of existing political structures through revealing the mechanisms of their ideological deception.[14] Glasnost was an attempt to find the supposed truth hidden beneath the layers of ideological deception. I hold that the striving to overcome ideology was part of the liberal framework that presents itself as pure form (frame) without content (speech, discourse, positive liberty) since content is supposedly the domain of ideology. As in perestroika politics the ideology of the common good supported by the Soviet state was being replaced with the liberal notion of formal rights, the 3rd Floor's members adhered to the ideals of negative liberty (freedom as form that does not propose normative content) and of the liberal democratic subject as a free-speaking agent who is empowered through being informed. The ideal and yet-to-be cultivated subject of perestroika coincided with the subjectivity of the artist that the 3rd Floor movement proposed for that critical moment: if the liberal subject emancipated from the constraints of the past, and particularly the Stalinist past, was a perestroika dream, the 3rd Floor was already enacting it in art. Thus, one could claim that the future of perestroika was the present of the artistic avant-garde in Armenia, with the 3rd Floor seeing itself as the cultural vanguard of the new epoch. Certainly Armenia was no exception among other Soviet and Eastern European countries in the late Soviet period, which saw a certain stratum of the intelligentsia in the vanguard of progressive politics. However, unlike most unofficial artists in other countries, most notably the Moscow Conceptualists, the 3rd Floor did not adapt an ironic distance from the perestroika reforms and from Soviet ideology as a whole.[15] Instead, the 3rd Floor began a mission to liberate art and creativity by implementing radical reforms that would address the rampant bureaucratic costs of official art institutions, in particular the Union of Artists.[16]

By the 1970s the official arbiters of creative practice, as represented by artist-bureaucrats receiving public salaries and benefits, presented a perfect mirror for Brezhnev's period of stagnation. These ideologues of Socialist Realism did not match the theoretical and methodological complexity of some of the most rigorous aesthetic theoreticians who defended its principles using Hegel, Marx and Lenin.[17] The main method of evaluation according to which commissions were allocated, exhibitions organized and works acquired consisted of screening artworks and making a selection according to the degree of optimism manifest in their content. Election to the Union's committees was highly hierarchical, based on seniority and a kind of accumulated symbolic

capital that can be summarized in the notion of 'prestige', accreted through institutional conformity, especially during the period of Brezhnev's tenure as the general secretary of the CPSU (1964–82). With bureaucracy contaminating the institution at all levels and calls for reform being heard in all corners of the USSR throughout Gorbachev's reforms, what became an especially contentious issue at the Artists' Union of the Armenian Soviet Socialist Republic were the 1987 committee elections as well as the processes of evaluation during the annual youth exhibition. These two events created the conditions for young artists – eager to carry forth the spirit of perestroika – to become part of the administrative structure of the Union as part of its Youth division.

It is not a coincidence that the Soviet Armenian official cultural monthly Soviet Art's third issue of 1988 printed both a translation of Gorbachev's speech at the XVIII Plenary Session of the CPSU Committee – symptomatically entitled 'An Ideology of Innovation for a Revolutionary Reconstruction' – and statements from the Armenian Union of Artists' Annual Congress. Gorbachev's speech called for democracy, encouragement of innovation, initiative and tolerance, in the interests of the people and socialism.[18] Aligned with the official perestroika programme for liberalization, the statements from the Union's Congress – gathered under the title 'Criticism without Parenthesis' – revealed a new culture of criticism and its discontents. Many of the statements presented a polyphonic choir of various generations, aesthetic and ideological positions and standpoints. The younger generation, represented by Grigoryan, expressed its concern over the cultural politics of the Union from the very stage that the Union had provided him with. As the statements revealed, what was at stake was a crisis of legitimization, as the elders and the conservative wing called for authority and respect. They feared that their legacy was about to be challenged from within the Union, and this challenge came from the reformist margins that were gradually starting to occupy the centre. At one pole of this stagnant institutional structure stood the entrenched artist-bureaucrats who occupied high positions in the Union and who believed themselves responsible for the preservation and reproduction of the representational canon.[19] On the opposite pole were the youth who demanded institutional reform and unmediated access to the means of representation, including the means to organize exhibitions without relying on the decisions of committees and juries controlled by the old guard.[20]

Criticism of the established generation of Union artists was mouthed not only by the reformist youth, but also by the conservative youth who challenged the elders' understanding of Socialist Realism, bringing it closer to social realism; as opposed to the optimistic image of the future functioning as a false representation of the present, these artists proposed to depict social reality with its conflicts and discontent. What characterized the generation of artists who came to prominence in the 1950s–60s and formed the backbone of the Union

in the late 1980s was their wholesale fear of critique. This fear could be attributed to the spectre of Stalinist repressions, to a time when critique (including self-critique of the party apparatus) was both officially encouraged and regarded as a threat to one's career and at times even one's physical existence. It was this spectre that the older generation was continuously evoking in its polemic against the youth. But the evocation of the spectre of repression simultaneously served another function: it was mobilized to maintain one's symbolic capital in the form of prestige as well as the material privileges (summer houses, special access to scarce products and vacation packages) that most of these artist-bureaucrats as master-figures enjoyed within the institutional structure of the Union of Artists, and that perestroika seemed to threaten.[21]

The conservative pole insisted on the preservation and reproduction of figurative compositions and particular themes in accordance with the principles of Socialist Realism, which presented life under socialism in its most optimistic moments. The conservative youth, in turn, contended that Socialist Realism did not mean optimism but called for a representation of reality in all its aspects: for instance, they argued that the devastation of villages due to the effects of urbanization and industrialization was a legitimate theme and was true to the principles of Socialist Realism. The reformist pole as embodied in the 3rd Floor, on the other hand, embraced an understanding of free creativity borrowing from the language of both High Modernism and post-Second World War neo-avant-gardes. In contrast to the slow temporality of the bureaucratic Union, the artists of the soon-to-be movement urged speed; in contrast to the old-guard artists' prescriptive arguments substantiated with descriptive statements, their tone was declarative, aggressive and always polemical; as opposed to the continuity of artistic conventions, they posited their practice of radical rupture, of negation and constant innovation; as opposed to the exhibition regarded as a sterile, controlled and static space, they proposed it as a fluid, dynamic and unpredictable event. In the published round-table cited above, Grigoryan declared, 'art should [...] strike like lightning. We are fed up with artworks that are like dim candle lights.'[22] In another publication of the same period, Grigoryan called for a notion of negative liberty made possible through art: 'artistic freedom stretches as far as it does not impose itself upon the viewer and dictate his truth'.[23] Arguably, what was at stake in this stance of avant-gardist negation was the rejection of the banality of the aesthetic and social conventions that constituted the canon of official art on the one hand, and of bankrupt ritualized enactments of ideological prerogatives on the other hand.

The antagonisms within the Artists' Union of the late 1980s were too complex to set out according to generational divides, since they ranged from modes of institutional operation to types of legitimate theme, to the techniques and styles that could do justice to social reality.[24] Between the conservative pole and the young reformists there were various shades of other positions, 'moods'

and styles ranging from nationalist-romantic to metaphysical painting to existential realism. Arguably, what was at stake was not simply a challenge to one's socially privileged position or a crisis of value and authority triggering institutional resistance to change, but most importantly, a redefinition of realism in relation to the evolving reality. The perestroika transformations sparked new questions, or rather prompted a revisiting of the old questions: should the artist represent reality in all its contradictions, including the devastating effects of rapid urbanization, or the existential solitude of the individual vis-à-vis the social forces of standardization? Does art create its own reality which transcends the social world from which it has stemmed (this transcendence being manifest in a cultural oppositional programme), or is it the artist's task to show only the positive aspects of reality as seeds for a brighter future?

The 3rd Floor's answer was to create a space for artistic creativity that would chime with the changing world of perestroika. This meant de-bureaucratization of art institutions in such a way that the gap between the artist and the audience would cease to exist, and the elimination of the hierarchies of value. For the 3rd Floor conceived the exhibition as a space that guaranteed an immediacy of encounter between the artwork and its audiences (figure 3). Instead of stagnant committees and juries for whom the (politicized) criteria for selection were more important than the mode of presentation, the movement proposed exhibitions as frames without content, which could be interpreted in terms of a liberal fear of content as an inevitable source of ideology. Hence the focus on the exhibition in an expanded sense as that which shows processes of creativity in their immediacy and spontaneity. In the 1988 article 'For those who will replace us, out of today's necessity', Nazareth Karoyan proposes thinking of methods and principles of making exhibitions that would not be merely an amalgamation of artworks.[25] He conceives of exhibitions as fluid spaces for unfolding events – temporary structures that go beyond the specificity of singular artworks.

Exhibition reviews, articles and television programmes inform us how the members of the 3rd Floor engaged in debates with the artist-bureaucrats of the Union. The 1989 issues of the monthly magazine *Mshakuyt* offered the 3rd Floor space to represent itself through statements and artworks. In a special section entitled 'Open Doors' – a section devoted to breaking 'the dogmas of truth' and to establishing a dialogue with the younger generation – many young artists were invited to present their opinions.[26] The aim of this section was to present various phenomena of contemporary reality that were 'out of the norm' and 'out of the ordinary'.[27] These phrases have been and are still being applied by journalists, cultural bureaucrats and other members of the public in order to designate contemporary art practices. Contemporary art's norm as 'out of the norm' performs two operations of differentiation. First and foremost, contemporary art is seen as diverging from the expected norms of the fine arts

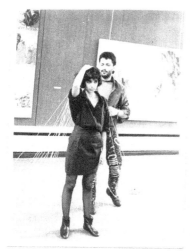
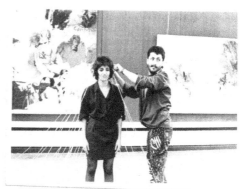
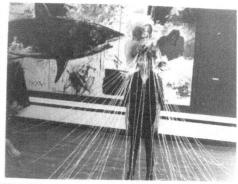
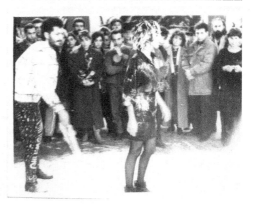

Ashot Ashot, *A Structure of Communication*, 1989. Performance at the exhibition 666 **3**

by denying medium-specificity and artisanal skill. Secondly and for this reason, for its use of 'ordinary' non-artistic materials, contemporary art is considered out of the ordinary in relation to the everyday, since it becomes a distinct sphere of creative activity. In the first instance of differentiation the institution of fine

arts with its insistence on skill and medium-specificity considers contemporary art as non-autonomous and thus as diverging from those conditions that secure autonomy for the fine arts. In the second instance of differentiation, and as opposed to the first, in relation to everyday life, contemporary art is perceived as distinct and thus autonomous, since it performs an un-ordinary operation of making use of non-artistic materials to produce art. There is also a third instance of differentiation: in the perestroika world of increasing individua-tion, it was the artist – with his/her lifestyle usually associated with forbidden freedom and loose morals – that became the marker of 'out of the norm-ness'. The conception of the artist as a lone creator who is marked by difference in a general context of social non-differentiation was not new, and dates back to the 1960s emergence of 'underground' artists. However, with perestroika, this figure became incorporated into official discourse and made 'public'.

The legitimation of what had been 'out of the norm' within official frame-works encapsulated the core of perestroika politics and aimed at eventually shrinking the gap between politically and culturally progressive discourses and the stagnant and outmoded official institutions that were unable to accommodate these discourses. In this context, 'Open Doors' declared the importance of 'listening to others' opinion even if one does not agree with it'.[28] This discourse of free speech and tolerance was part of the liberal promise that arrived with the glasnost demand for openness and the need to reinvent the social as that which was constituted by individuals who engage in com-municative acts. The 3rd Floor artists were given ten pages to present their individual practices and explain how they connected to the ethos of the move-ment at large, without the need to present a collective agenda.

The publication epitomized the constitution of the 3rd Floor and the way its various members related to collectivity as nothing more than the sum of its parts, echoing a perestroika emphasis on individual rights. This was one of the reasons why Karoyan, from the very beginning, insisted that the 3rd Floor was not a group, but a cultural movement.[29] Even if Grigoryan's understanding of the movement's practice – as one that advanced art as an autonomous sphere – differed from Karoyan's 'cultural movement', it did not contradict the latter's conceptualization. For Grigoryan, art understood as a sphere of unrestricted creativity could communicate freedom to the broader society through the sup-posedly unmediated and direct format of the exhibition. Here the exhibition was conceived as the only common platform wherein discrepant practices could meet and coexist. These practices were indeed discrepant, ranging from Sev's metallurgic assemblages (figure 4) to Gits Karo's minimalist abstractions, Karine Matsakyan's Pop Art paintings and Ara Hovsepyan's conceptual works. It all came to constitute the potpourri of the emerging landscape of contemporary art. Karoyan, the self-appointed art critic of the movement and one of its founders, recognized the 3rd Floor's programme of *showing* together but staying apart.

Sev (Henrik Khachatryan), *Object*, 1987 **4**

In the short blurb that Karoyan contributed to issue 2–3 of *Mshakuyt*, he emphasized that the only thing that bound the various artists was the desire to exhibit together. Considering art as a perpetual tradition of negation, the art critic relocates the movement's practice from the domain of aesthetic-artistic considerations to that of social and cultural ones. He identifies the desire to appropriate the tradition of Armenian modernism, but without a stylistic and formal coherence, and only after this tradition had been sanitized of ideology.[30] As a prelude to my discussion of one of the key concepts for the 3rd Floor – *hamasteghtsakan* art – I find it necessary to claim here that its aesthetic incoherence represented the political and ethical programme of the cultural avant-garde of a nascent late Soviet liberalism. And yet the 3rd Floor is both a product of perestroika and at the same time surpasses the very conditions that accommodated the movement's cultural politics. Political antagonism, while already accommodated within the liberalization pro-gramme of perestroika, nevertheless provided the 3rd Floor with foundations for artistic negation. And it is the latter that allowed the 3rd Floor to exceed and overcome perestroika's political programme and its historical closure. In short, perestroika ended with the collapse of the Soviet Union in 1991, and yet the longevity of the 3rd Floor's aesthetics and of its cultural function as a signifier of freedom and resistance persists even in the present. The canvas, and by extension the exhibition conceived as a domain where the individual

freedom of the artistic subject was expressed, provided them with a structural support for aesthetic negation.

The conception of the exhibition as a neutral frame of unmediated encounter, as opposed to the heavily juried and administered exhibitions of the Artists' Union, was to *display* creativity as an unbound sphere of freedom (figure 5).[31] And it is this understanding of the exhibition as a space *to display* free creativity that formed the core of the 3rd Floor's agenda and enacted their aesthetic paradigm – to which I return below – at the level of singular artworks,

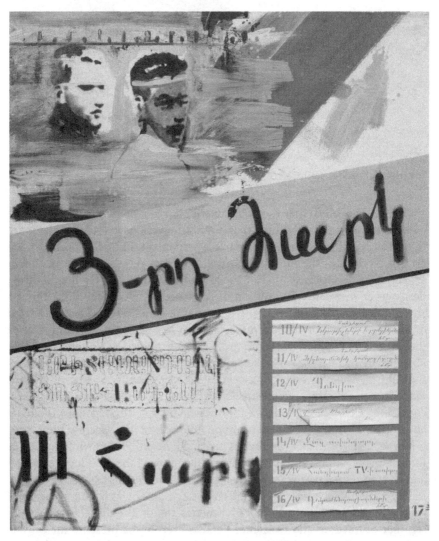

5 Arman Grigoryan, banner-painting of the exhibition *3rd Floor*, 1987

collective exhibitions, interpersonal relations and the specific conception of their role in the history of art in Armenia that they themselves maintained.

Within the framework of the perestroika belief in change from within, the 3rd Floor oscillated on a thin and delicate line between official recognition and rejection, the cultural mainstream and its vanguard margins. The official discourse of the pre-perestroika period of stagnation, identified with the Soviet experience, returned in the practices of the 3rd Floor's members as a trauma never able to be articulated as such but transformed through recurrent returns of various invented and real personages. These personages were born from the anti-Soviet unconscious. Sometimes they occupied the margins of official discourses, styles, forms and techniques, at other times they hid underground from the watchful eyes of the Soviet collective consciousness. The 'Soviet', reduced to coincide with the official presentation of a reality without contra- dictions and its repressed violence, recurred in the haunted figures of resur- rected ghosts and 'authoritarian personages', such as a personage found in the work of the 3rd Floor artist Grigor Mikaelyan (known as Kiki) – Bobo.[32]

Bobo is an abstract and fictional character without any single referent whose name is commonly invoked to scare children (figure 6). In Kiki's series of abstract paintings, Bobo is the secret service agent, the KGB officer, the imma- terial eye that controls: it is the scarecrow for the dissident intelligentsia. An early 1990s song written and performed by the bard singer Ruben Hakhverdyan renders Bobo more concretely in the figure of the policeman whose watchful eyes in the song are denied the pleasure of locating the subject in the field of vision, thus becoming a gaze and petrifying the subject as an object.

The policeman is perpetually denied the pleasure of vision not because the subject outsmarts him and runs or hides, as in Ilya Kabakov's installation *The Man Who Flew into Space from his Apartment* (1984), but because there is no subject to begin with. The one who the policeman searches for does not exist, thus the policeman always finds nothing but an apparition, a ghost that refuses to materialize and thus to be captured. It is not accidental that in the song, the musician constantly shifts the reference to this ghost from the first person 'I' to the third person 'he':

There was a city, and in the city, locked in *his* home
Lived *he, he*, or *his* ghost

Was *he* silent, or was it the ghost speaking,
Whose business is it, is it essential?

A surname was posted on *his* door
And a document that *he* lived in this home,

If the policeman visits *me* one day,
He will be silently met by *my* ghost [emphases mine].

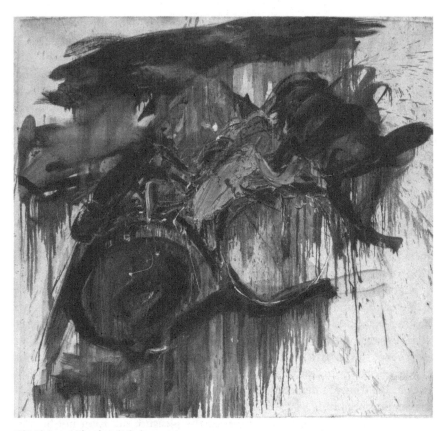

6 Kiki (Grigor Mikaelyan), *Bobo*, 1996

At the end of the song, the neighbours denounce our protagonist to the police, saying that they had seen this non-existent subject in the pub, and he is *officially* announced as 'lost without a trace'.

This song encapsulates the conflict between the subject interpellated in official discourse as mutually constituted by the watchful eyes of the neighbours and the police, and even by one's own shadow, and the bohemian intelligentsia whose gateway to disappearance is the drunken night spent in the pub. Even though the song was written in the early 1990s, the relationship it articulates between the official and what lies beyond the latter's sphere, with fear acting as a structuring device, best characterizes the Brezhnevian stagnation of the late 1960s and 1970s. It was this figure of secrecy that perestroika aimed to bring to the surface and make visible.

Kiki does precisely this: he literally brings to the surface the paradoxical figure of Bobo – an image and an anti-image, a hero and an anti-hero, an abstraction but a material one. This figure had to be constantly reconstituted,

constantly in process, never fully materialized, over more than two decades (the first Bobos appear in the mid-1980s and they occasionally appear even today). It is not accidental that the figure of Bobo could only materialize through an action painting enacted on a canvas spread on the floor, with action painting and abstraction being the prime signifiers of opposition to the Soviet and its cultural politics. The horizontally positioned canvas itself became a site of exorcism of the official and of the ideological as the artist circled around it in mad movements and threw scribbly brushstrokes (or rather 'broomstrokes', as Kiki would always use a broom, that favourite method of transportation for witches) on its surface with intense gestures. Thus, Bobo is a figure or rather an anti-figure of official discourse. The repetitive reconstitution of this personage – whose formal features include two circles created through expressive gestural application of paint, sometimes enclosed in a triangle and surrounded by abstract painterly traces of the performance – reveals the compulsively repetitive structure of trauma, a repetition that paradoxically recurs as a unique event each time it is reproduced. Bobo is itself a figure of paradox: on the one hand it is materialized fear and, on the other hand, the very process of its materialization through the artist's engagement with the canvas provides the artistic subject with the myth of freedom. The canvas appears as a space of psychic discharge upon which repressed demons are recalled, and thus supposedly overcome. Perestroika intended to overcome precisely these demons of the Soviet system and of Stalinism in particular, through publicly orchestrated collective exorcism. However, this exorcism turned Soviet history into a double ghost: as a historical experience this history had already been rendered spectral by Stalinism; whereas perestroika was fighting the ghost that had left the material body of this experience while deceiving its enemies with the empty shell that remained.

Dreams that money can't buy: 'collectively made' individual creation

In the autumn of 1988, the 3rd Floor artists, dressed up as resurrected ghosts like their heavy metal heroes – the musicians from the groups Black Sabbath and Kiss (rock music played a huge role in perestroika youth culture) – walked into one of the Union of Artists' conventional exhibitions and declared the death of official art. In this happening, recorded under two different titles – *The Official Art Has Died* and *Hail to the Union of Artists from the Netherworld*[33] – they walked silently through the exhibition hall (figures 7 and 8), viewed the paintings hung on the walls, and with the realization of the symptomatic significance of their action, took photographs of themselves in various groupings and positions and walked out.

Simply known as 'The Happening', this event reflected several key aspects of the movement's practice: it revealed that the various members of the

7 3rd Floor, *Happening: Hail to the Union of Artists from the Netherworld*. Performance at the Artists' Union, 1988

8 3rd Floor, *Happening: Hail to the Union of Artists from the Netherworld*. Performance at the Artists' Union, 1988

movement had conflicting understandings of the action, thus reinforcing the assumption that the 3rd Floor did not propose a coherent and unified aesthetic programme or agenda. It re-enacted their belief in the incommensurability of art as a space for free creation and the institution ruled by the tyranny of banality: if art was the collectively constructed dream of the underground heroes, the institution was the conventional domain of a properly dead and officially sanctioned reality (the dead heroes of the netherworld were more alive than what belonged to the social world above the ground). Formally, the tone of the happening was aggressive, oppositional, declarative and deprived of prescriptive content. By defying content, it claimed to transcend the domain of ideology. With the metaphor of the netherworld here functioning as what I call the *zero point of ideology*, the 3rd Floor artists strove to discover the pure, socially unconditioned freedom of a radically individualized subject who had managed to overcome the contaminating layers of ideology, and this liberation was possible on the surface of the canvas and, by extension, in the space of the exhibition: often the exhibition as an all-inclusive space was conceived as the three-dimensional materialization of the surface of the canvas as a domain of absolute freedom. By the zero point of ideology I mean a collective belief, perceived as if it were individual and subjective, that political ideology is overcome and transcended in and through art. Through this supposed transcendence, one arrives at art as an ideology-free domain of absolute freedom. In this vision, the future is stripped of the ideological baggage of the past while the present is imagined as a *tabula rasa* to be filled with virtually endless new possibilities. Amid a loss of all ontological grounding, of the 'reality' that had held the world together, the zero point of ideology provides a support. This lost reality had been constituted both by the material conditions that had held the Soviet world together (public property, the public good and a centralized economy among other things) and by the ideology that had supplied content for these conditions. Artistically, what came to supplement the 'loss of reality' and became a marker for the zero point of ideology was the triumph of gesture in the practices of the 3rd Floor. The gestural event or act as a form of resistance became a marker of contemporary art in the early 1980s when several artists, including Vigen Tadevosyan and Kiki, applied abstract brushstrokes as a means to liberate the subject from the constraints of the social and/or from the material as such. Particularly in Tadevosyan's case, the overcoming of painting by painting signified a negation of the social. As will become clear through my subsequent discussion of *hamasteghtsakan* art, it is in the 1980s that gesture becomes a condition of producing art *in general*, no longer confined to the medium of painting alone. It is possible to read this gestural impulse against the grain of the 3rd Floor's own understanding. Instead of securing the author as a subject, perhaps gesture vacates the author of subjectivity and thus acquires longevity, as in the case of the 3rd

Floor whose *hamasteghtsakan* gesture – the painterly gesture transformed to secure authorship, intentionality and freedom – outlived the movement's existence. In Giorgio Agamben's formulation, rather than being an expression of authorial plenitude and pre-existing ontological foundations, gesture precedes the author and marks the impossibility of the author's expression or self-expression in the text. Gesture, then, is that which remains 'unexpressed in each expressive act'.[34] With the loss of ontological grounds to secure the subject in reality, one could argue that the canvas becomes a groundless ground upon which gesture as an excess of authorial intentionality puts into play figures of discourse that cannot be spoken for or represented. And it was on the surface of the canvas and in the space of the exhibition that the other of the official ideology – formerly marginalized subjectivities, images, styles and techniques, those unspoken figures of the Soviet – found a comfortable home.[35] Thus the loss of ontological grounding that at times is associated with the absence of ideology facilitates the triumph of gesture in late Soviet art practices in Armenia. And it is gesture that, by exceeding the situation in which it is put into play, secures the longevity of the 3rd Floor's discourse beyond the historical constitution of the group. The triumph of gesture over reality secured a utopian dimension for art.

At a time of crisis of political and ideological utopias, art became a utopian sphere that replaced the ideologically contaminated everyday. It is this conception of art as a utopian sphere that is secured by the zero point of ideology. The latter is ideological in its very declaration of the absence of ideology. Why was this absence of ideology ideological, and how can we conceive the relationship between the (non-ideological) utopia and utopian ideology, with the former triumphing at the expense of the latter in the context of the late Soviet social world? This question is especially important given that the impulse of perestroika was in essence anti-utopian, in that it did not claim to invent history anew but instead to reappropriate it (and particularly, to reappropriate the lost Leninist project in the early years of perestroika).

If the Bolshevik Revolution was utopian since it intended to achieve a radically different vision of the world in the present, a world as a theoretical possibility awaiting its practical realization on the wings of historical necessity, the perestroika world was the farcical repetition of this utopia. The protests and uprisings that led to the collapse of the Soviet Union conceived the 'new world' as a highly romanticized version of liberalism and the market economy, whose political horizon was that of the nation. It is no accident that the period following the collapse of the USSR was coined a 'period of transition'. This seemingly technical term was ideological *par excellence*, since it concealed the disintegration of public good and public property and implied that the shift from state socialism to a market economy was a *fait accompli*. The 'free' world that was dreamt by the late Soviet dissidents and the intellectual vanguard of the

perestroika was imagined to exist only on the other side of the Cold War curtain, though realizable only if coupled with a national project. Whether really existing capitalism was indeed the world the Soviet dissidents imagined, or was a fantasyland of their projection, is another question. Politically, the zero point of ideology is ideological in itself since it fits perestroika's increasingly liberal programme of transition. Artistically, the zero point of ideology had a utopian impulse since, as an autonomous sphere of creativity, art was conceived as the other of the social world. If the 3rd Floor's agenda politically coincides with perestroika liberalism, its aesthetic agenda with its utopian impulse went beyond the political. And as argued, it is this utopian impulse, which held on to the liberatory promise of the aesthetic sphere, that secured the longevity of the 3rd Floor's aesthetics beyond the period in which the group operated.

The 3rd Floor posited art as a space of liberatory dreaming that could not be reconciled with the necessary repression underlying the constitution of the social world and the banality of the everyday. Grigoryan's brief speech at the Artists' Union in 1987 is revealing: 'If nothing is possible to change in life, we can at least be happy in art.'[36] The sentencing of outmoded official art to a metaphorical death, in the 'Happening' with which this section began, was a negation of not only the Socialist Realist institution of art represented by the Union, but also the social world in which this institution was embedded. The bankruptcy of conventional art was attributed to the identification of art and life, where the former was subjected to the repressive regime of the latter. Thus the 3rd Floor conceived art as an autonomous sphere constituted through the negation of established art institutional and social structures. It is noteworthy that contemporary art historians and critics often misread the movement's programme, from the position of Socialist Realist critique, as one that aimed at heretically dismantling the borders between art and life. This misreading was not accidental since the 3rd Floor *substituted* everyday reality with art conceived as its own reality, whereas late Soviet Socialist Realism perceived reality as an ideal rendered in art. In a 1989 response to the 3rd Floor's blasphemously titled exhibition *666*, art critic Inga Kurtzens accused the movement's artists of bringing art down to the level of life by deskilling artistic technique and introducing readymades and *objets trouvés* in their assemblages.[37] For the art critic anchored in Socialist Realist art criticism and aesthetic theory, the aesthetic ideal is embodied in the specialized artistic skill, and every attack on this skill is an attack against art as ideal. What the art critic protecting the official edifice failed to notice was that everyday materials were appropriated in the practices of the movement and re-inscribed within the domain of autonomous art. But if the conception of autonomy she was defending was one based on art's affirmation of the social world, for the 3rd Floor this autonomy was possible only as and through negation. For the 3rd Floor, the separation between art and life, among other things, was a prerequisite for survival in the face of

the radically transformed conditions of everyday life in the late Soviet years. As Grigoryan states in his 1995 contribution to the catalogue of the survey exhibition of Armenian contemporary art in Moscow a year after the collapse of the movement, 'in order to live in reality, one has to be dead for art'.[38] The 3rd Floor's agenda was to reverse the above dilemma in art's favour: one has to be dead in reality in order to live in art. The potential for art's autonomy obtained through the negation of the social world was a precondition for its life-affirming quality, not of life as it is, but of a life to come encapsulated in art's liberatory potential. With a futuristic pathos, Grigoryan declared at the height of the 3rd Floor's activities in 1988:

> It is no longer possible to look back. We need to rethink the antiquated love for art. We cannot be calm and content since culture and everything which rests on the walls of the museums, in storage and all that is easily classified and labelled in art history books and in the consciousness of our society, no longer satisfies us. [...] We want art which is free from all categories – old and new, low and high, political and spiritual. We want art that does not propagate eternal values materialized in objects.[39]

Radical in its time, when the alternative to the discourse of Socialist Realism was often sought within the romantic lyricism of 1960s art and the 'eternal values' of national historical culture, Grigoryan's text idealizes the figure of a young anarchistic libertarian artist emancipated from the ties of historical consciousness. But the other side of this anarchic call for absolute freedom is the libertine drive of omnipotence; a drive that was encapsulated in the figure of the heroic artist. In its 1988 manifesto the movement declared the victory of a self-fulfilled and self-realized artistic subjectivity; it proclaimed an artistic subject who triumphed through a self-realized and self-legitimized freedom:

> Realizing himself as an actively creative individual, man also realizes that life has one meaning [which is] life. [...] [Life] is a dynamic conviction based not upon external protection but upon spontaneous activism. [...] Only freedom can give such a conviction. Freedom [...] emerges as a subjective individual feeling rather than a result of intellectual, ethical and, certainly, physical superiority. Freedom is the possibility of being with oneself. Nothing and nobody can deprive a human being of his inner subjectivity [sic] and paralyze his self-will.[40]

In this Enlightenment humanism that particularly characterizes Grigoryan's thought, autonomous art both makes the struggle for individual freedom possible and encapsulates this struggle as an ideal.[41] For Grigoryan, the social is a domain of necessity and of repression, or of necessary repression, and all the fantasies of absolute emancipation from the social with the tools and means of the social world results in ideological instrumentalization and tyranny of the One over the many.

One cannot but refer to Freud's *Civilization and Its Discontents* to unpack Grigoryan's conception of culture as necessary repression. Freudian psychoanalysis was popular among the movement's protagonists, as witnessed in their numerous discussions on dreams and the unconscious. After a long silence of over six decades, translations of Freud's works reappeared in Russian in the mid- to late 1980s, not counting the Russian-language publication of Freud in London in 1969.[42] The first reappearance of Freud's texts in Russian in the 1980s was followed by the unprecedented publication and re-publication of his writings in the late 1980s and early 1990s.[43] As evidenced in the iconography of Grigoryan's mid-1980s work, which included frequent visual references to sharks, fish, (dead) dogs, horses and eagles, and a layering of incommensurable images on the surface of the canvas, he was well aware of Freud's translated writings as early as the mid-1980s. His conception of the author as an expressive subject relied precisely on the psychoanalytic theory that the unconscious can be revealed through its effects, such as through the dense and multi-layered images that constitute dreams, or what Freud calls dreamwork in *The Interpretation of Dreams* (1899). These effects, however, were not to be revealed on their own but through the expressive painterly gesture. For Grigoryan, the canvas was a dreamwork that accommodated 'forbidden' images. In a 1991 conversation between Grigoryan and Karoyan, the former proposes that art is a sphere of desublimation. Here the canvas is a surface upon which instincts find satisfaction through the discharge of psychic energies. Grigoryan implies that there are certain recurring images, which he calls 'facts', that appear in his work despite himself. These are unintentional images, hence the artist is not responsible for them: 'I am not guilty of my dreams', says Grigoryan.[44]

What was the substance of these dreams in Grigoryan's works of the period? His canvases are inhabited by contradictory, dense and clashing images that are flattened out to the extent that they make up the surface they occupy: sharks, punks, nudes, dead dogs, bats, all executed in eclectic styles and techniques. In the same conversation Karoyan analyses Grigoryan's work in the following words:

> Futurist fragmentation of colour fields spread all over the clean canvas, postimpressionist autonomy of colour and line, where, if the line has Cubist structure, colour is endowed with Expressionism's sensuality and symbolism. And if we add the hives of multilingual words and expressions characteristic of Medieval Eastern graphophilia, we will get perfect Bretonian surrealism.

If for Karoyan this eclecticism was proof that Grigoryan's 'avant-gardism' was indeed a postmodern strategy of making cohere what does not cohere, for Grigoryan himself the eclecticism was a method of reinventing art and, by this, obtaining freedom.

In exercising their understanding of total freedom in artistic creation and lifestyle (at times these two were identical), the 3rd Floor strove to retrieve the

individual as a bourgeois subject, or rather to retrieve the place of that subject in the domain of autonomous art. The image in a sense acted as a placeholder until this subject could materialize in reality. The 'alternative' personalities, for example, that appear in Grigoryan's works throughout the late 1980s and 1990s – which included medieval knights, homosexuals, nudes, secret police and so on, marked by difference and individuality (this difference itself being a product of consumer lifestyle choices) – were to hold the place of the liberated subject to come (figure 9 and Plate 1).

Historically, it was precisely the bourgeois subject that was doubly eliminated by the two rivals: the historical avant-gardes and Stalinist Socialist Realism. If, in the early years of the Bolshevik Revolution, the historical avant-gardes of the 1920s waged a battle against bourgeois individualism, the 1930s marked a return to bourgeois domesticity both in economic policy and in the state ideology of the Stalinist years, without anchoring this return in the individual subject. The new classless society, peacefully inhabited without antagonism or contradiction by equal social classes of workers, peasants and intelligentsia, had supposedly arrived. This was codified in 1936 by Stalin's Constitution and affirmed in Socialist Realist art. However, in reality the late 1920s and early 1930s Bolshevik and productivist campaign against 'domestic trash' – all those material signifiers of bourgeois homey comfort – was replaced

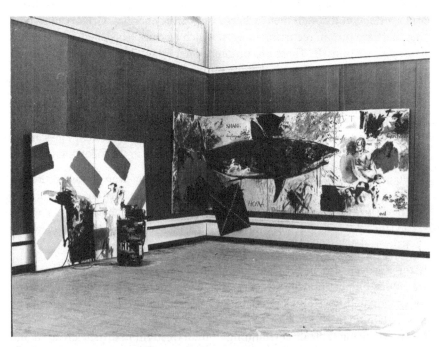

9 Arman Grigoryan, *Shark*, 1989. View of the exhibition *666*

by the campaign for *kulturnost*, denoting acculturation, propriety and good taste throughout the decade of the 1930s. This campaign, though directed at standardization of manners and behaviour, reintroduced bourgeois marks of differentiation in the production and consumption of luxury goods.[45] In a way, from the 1930s onwards the bourgeois subject sees a return in Soviet Armenia as part of larger structural transformations during the period of Stalinism in the Soviet Union, but only the shell of this subject returns via certain attributes of bourgeois culture, and without individualism as its kernel. *Kulturnost* introduced certain manners and behaviours as social collective standards, and prevented individuation of goods and tastes during Stalinism. In the post-Stalinist period, deviation from all that denoted *kulturnost*, including established social manners, came to signify a counter-culture in the 1960s and 1970s, one that entered the public sphere during the perestroika campaign against the ghosts of Stalinism. If in the 1970s the romantic counter-cultural crusade against Stalinist domesticity had transmogrified into the petit-bourgeois culture of the stagnation, perestroika counter-culture fought this domesticity publicly, against existing social institutions.

The 3rd Floor shares certain similarities with the unofficial artists from other parts of the Soviet Union and the Warsaw Pact countries of Central and Eastern Europe, and especially with the Moscow Conceptualists, in particular romantic individualism – a domain traditionally occupied by the bourgeois subject. But this subject was evoked without the class conditions upon which the ideology of romantic individualism could find its material support. The 3rd Floor artists were not bourgeois. Rather they occupied the bohemian margins of the Soviet intelligentsia and enjoyed some of the disappearing remnants of the latter's symbolically prestigious position. Thus the young artists existed in between the 'classless' class divisions of the late Soviet Union in a dialectic of identification and disidentification with both the Soviet intelligentsia and the Soviet working class; entities that were both disappearing as the body of the Soviet state decomposed. What they shared with the intelligentsia was the 'privilege' of forming high cultural values, but without the symbolic and financial remuneration granted to the properly official intelligentsia. And what they shared with the working class was alienation in relation to rampant bureaucracy and the *nomenklatura* of the late Soviet years.[46] It is noteworthy that only a few of the movement's artists had regular jobs or any financial security, mostly surviving by selling artworks.[47] They sustained their material existence precariously, with the help of friends and family members,[48] only occasionally selling work in the 1990s. Several of them emigrated to Western Europe or North America in the mid-1990s.[49] In a 1989 compilation of statements, the members of the movement confess their struggle for survival, yet they also immediately assert their position as one that is above these struggles:

We insist that we will always protest, and this protest should sound like this: 'We live well, but we protest.' This does not mean that we have [financial] security, the opposite. Almost none of us have a studio, apartment or money. These everyday problems don't concern us. 'Uninterrupted and inconsumable abundance – mountains made of marmalades and freedom of choice,' says Ashot Ashot who has none of the elementary conditions for living and working. 'Our one and only true path is to fill the sea with sugar.'[50]

Their rejection of the constitutive power of everyday life as that which structures experience and brings about certain processes of subjectivization for the sake of art's constitutive ethos, combined with their propagation of the individual artist as a self-fulfilled subject, allows us to claim that the 3rd Floor was a collectively dreamt, perpetually evolving happening where art came to replace reality. The 3rd Floor constructed its own context, a collectively made world as a space for individual self-fulfilment, atomized dreams and romantic idealism, a space uncontaminated by the unfreedom of the social and the triviality of everyday survival. The movement's aesthetics of bright colours, huge brushstrokes, large canvases, expressive gestures, assemblages of random objects, interest in garbage as matter, and theatrical pathos conceived of art as a *waking dream* channelling fantasies upon everything betokening the non-Soviet: consumer products, ideologies, technologies and artistic styles (figures 10 and 11).[51]

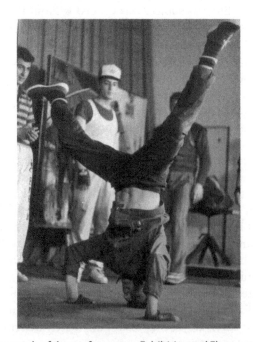

10 *Breakdance*, photograph of the performance. Exhibition *3rd Floor*, 1987

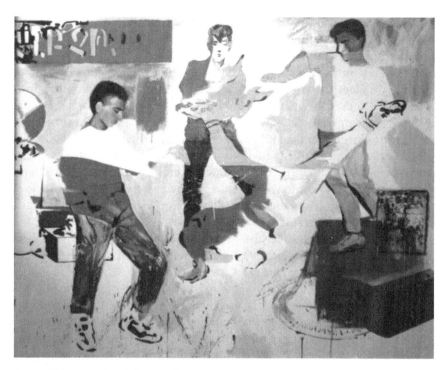

Arman Grigoryan, *Breakdance*, 1987 **11**

Hamasteghtsakan art

The 3rd Floor movement, without a positively conceived agenda or a coherent aesthetic programme, appropriated and incorporated everything that could be conceived as alternative to the conventions of the official institutions. This lack of strategy was what made it possible for the 3rd Floor to incorporate the emerging contemporary art landscape in Armenia under its aesthetic and discursive umbrella beyond its temporarily limited existence. This absorption, arguably, reverberates even today as traces of the 3rd Floor's aesthetic and cultural trajectory reappear in artistic practices and cultural discourses. Just how persistent the 3rd Floor's discourses are even today is best revealed by an exhibition dedicated to the twenty-third anniversary of Armenia's independence, curated by Grigoryan and Arevik Arevshatyan at the Union of Artists in September 2014. Entitled *A Step: Between Transformation and Recreation*, this large exhibition presented a survey of contemporary art in Armenia as it has evolved since independence in 1991, according to a trajectory that the 3rd Floor had outlined in the late 1980s. Apart from the generation of artists who participated in the movement, the

survey included works of the 1990s and 2000s generation of artists who still
adhere primarily to Grigoryan's understanding of art as a sphere of freedom,
without a hierarchy of values and signs.

It was not only the aesthetic landscape and the representational strategies
that the 3rd Floor tried to invent anew that provided a model for future prac-
tices, but also the movement's attempt to construct a discursive field within
which it could operate. There was a common saying in the field of contempo-
rary art in Armenia in the mid-1990s – 'If you don't have your context, you
construct it' – and this saying encapsulates the 3rd Floor's strategies of dis-
cursive expansionism.[52] The much-contested and repeatedly redefined term
hamasteghtsakan arvest, to which I have referred as denoting an aesthetic of
incoherence, encapsulates the way in which the 3rd Floor's aesthetic strategies
define its cultural programme.

Originally translated as 'crossover art'[53] and then retranslated as 'collec-
tively created art',[54] the term *hamasteghtsakan* was coined by Karoyan for the
1993 exhibition 'Beyond Idiom: *Hamasteghtsakan art* in Armenia'[55] to loosely
denote post-conceptualism or counter-conceptualism and to describe the 3rd
Floor's cultural production.[56] The word *hamasteghtsakan* is derived from the
Armenian word *Համաստեղծ* [*hamasteghts*]: Malkhasyan's 1944 *Dictionary*
states the primary meaning of the word as 'to be created together' and the fig-
urative second meaning as 'innate' or 'naturally born',[57] whereas Suqiasyan's
1967 dictionary of synonyms mentions only the second, figurative meaning.[58]
In Armenian, both *ստեղծել* [*steghtsel*] and *Հղանալ* [*hghanal*] denote the
verb 'to create'. *Հղանալ* [*hghanal*] is from the noun *Հղացք* [*hghatsq*], which
translates as 'concept'. Thus creation and concept meet at a semantic level,
marking creation as identical with 'conceptual' art.

Here translated as 'collectively created' and encapsulating the 3rd Floor's
strategy of conceiving the exhibition as a collectively produced environment,
hamsteghtsakan also captures the second meaning of the term *hamasteghts* –
that is, the 3rd Floor's romantic understanding of art as a sphere of natural
or innate creation. In order to preserve all the rich semantic implications
of the term, I will subsequently only refer to the original Armenian word to
denote the 'collectively created' romantic post-conceptualism of the 3rd Floor
in which contradictory words, images, styles and symbols clash. In addition,
the difficulty of fixing the term conceptually is due to the fact that it denoted
more than one thing for the 3rd Floor's protagonists. If, for Karoyan, the
term situated the movement in the postmodernist framework of appropria-
tion, pastiche and communicability that he advanced, for Grigoryan the term
signified the artist's right to mix styles and images as a precondition for a
truly democratic and original art. The operation that '*hamasteghtsakan* art'
performed, in both instances, was to conceptually justify the juxtaposition of
different realities, though this justification served different ends.

Given that he was a philologist, it is not surprising that Karoyan was the one to coin the term. His first use of *hamasteghtsakan* was performative rather than analytical or descriptive. The structure of his 1993 introduction to the exhibition booklet itself is subjected to a *hamasteghtsakan* operation in that the text puts together incomparable realities. His writing playfully juxtaposes the past with the present, tradition with hyper-modernity, a local microanalysis with global macro-commentary while vacillating between standard Armenian and the vernacular language. The article starts with the following statement:

> The new generation strives towards the satellite *Crosna* similarly to the Mediterranean sailors who were striving towards the lighthouse of Alexandria. […] The new generation identifies with Madonna and Schwarzenegger with the same passion and enthusiasm as Ekaterina II fornicating with an entire legion. […] (Dude, how do I get to the airport?)[59]

It was only later in 1996, three years after the collapse of the movement, that Karoyan revisited the concept with the aim of subjecting it to an analytical operation and applying it as a descriptive category to the art practices of the 3rd Floor. Then, the term had acquired a retroactive prescriptive significance and was utilized to distinguish a style in the absence of a coherent style or artistic strategy within the movement's activities.[60] The 1996 text reflects Karoyan's interest in structuralism and poststructuralism, and in this case, the work of Roland Barthes, as he subjects the term to a structural analysis. The goal of this analysis was to shift the semantic focus from 'creative' to 'collective' – as is evident in his efforts to abandon the idea of a single author and emphasize the collective aspects of the 3rd Floor's exhibition-making practices. This was to support Karoyan's conception of the movement's practices in terms of their communicative potential across time and space, with the history of Armenian art on the one hand and with contemporary society on the other. Karoyan discusses contemporary art as information that has restored a severed connection with the national art of previous epochs, similarly understood as cultural information.

With all the humanistic and creational implications of the term, Karoyan claims that the concept is rather a marker of the dissolution of the self-sufficient modernist subject, and this dissolution is no longer taking place in the 'us' of the Soviet collectivity but in the multiplicity of postmodern subjectivities. The authorial 'I' never represents the subject of enunciation or provides transparent access to that subject, but always implies the other, that other being representation, the image that is always already a cultural code, a type of cultural readymade. For Karoyan, the readymade automatically 'deflects the questions of authorship, value and history'.[61] He continues: 'The ready-made image is nothing but an information image, which becomes the subject matter

of *hamasteghtsakan art*. [...] In *hamasteghtsakan* art the ritualistic desacral-
izing strategy of the information-image is the de-ideologized reproduction of
the Soviet anti-propaganda method.'[62] In their turn, readymade images are the
waste products of information circulation, and 'being collective public images,
they belong to the world of feelings, dreams and nightmares'.[63]

Karoyan's was an effort to capture the postmodern paradigm in contem-
porary art in Armenia through *hamasteghtsakan* art. But his conceptualization
in many ways also betrayed his indebtedness to glasnost's politics of free and
accessible information. The latter is highly romanticized in Karoyan's text, in
that the one who possesses information, the artist, is perceived as someone
who automatically has the power to interpret reality for others and to be at
the vanguard of progress. This information space itself is a collage-like dream-
world, a space for 'collective dreaming', as Vardan Azatyan defines it, one of
individual freedom and a purer reality cleared of deceiving ideological masks.[64]

While the text was written in the aftermath of the movement's collapse, it
nevertheless reflects some of the tensions and contradictions that led to the
final disintegration of the 3rd Floor in 1994. Trying to enhance the commer-
cial institutional field of contemporary art in Armenia, Karoyan had become
actively involved in the establishment of the gallery system. Even though offi-
cially part of the Artists' Union and forming its Youth division, the majority
of the 3rd Floor artists preferred to present themselves as anti-establishment.
Hence the institutionalization of avant-garde art, and particularly its com-
mercialization, was opposed by the anarchist wing of the 3rd Floor. The
movement adapted an anti-institutional stance and despised commercialism,
reflecting an affinity to a certain stratum among late Soviet intelligentsia who
cultivated a highbrow attitude towards petit-bourgeois values. A cautionary
note needs to be made here that this anti-institutional and anti-commercial
stance did not mean that these artists were against the market economy and
capitalism. Instead, they were against the existing institutions of the produc-
tion of symbolic value, those that resisted the transformations brought about
by perestroika reforms.

The tensions between various narratives around the core agenda of the
movement became especially tense in the later years of its existence, as sig-
nalled by the discrepant activities of its various members. The 1991 exhibition
Object is especially symptomatic since it proposed a conceptual and formal
coherence, and thus somewhat defied the *hamasteghtsakan* paradigm of
aesthetic incoherence. The show was curated by sculptor Sahak Poghosyan
at the House of the Painter. This was the first time that a 3rd Floor exhibition
was not a fluid and all-inclusive event but rather took a particular medium, in
this case sculpture, as a starting point. Only two months later, Karoyan was to
found the first privately owned art gallery Goyak in Armenia.[65] In a way, when
confronted with a new imperative of institutionalization as part and parcel

of parallel efforts to build institutions for liberal democracy and the market economy in already-independent Armenia, the *hamasteghtsakan* programme confronted a crisis of legitimization.

The tensions between institutionalization and the anarchic ethos, as well as systematic analysis and romantic libertarian dreams of freedom, were encapsulated in Karoyan's and Grigoryan's differing understandings of the term *hamasteghtsakan*. If, for Karoyan, *hamasteghtsakan* art was the local articulation of postmodernism, with its impurity of styles and techniques and rejection of authorship, for Grigoryan it was the opposite: a sphere that enabled the constitution of the main figure of modernism – the autonomous artist who was free to reinvent the painterly surface, and by extension art, through an act of radical negation.

In a lecture delivered at the State Institute of Fine Arts in 1993, three years prior to Karoyan's publication of 'What is *Hamasteghtsakan* Art', Grigoryan had offered his own definition of the term, in which he made a claim for its anarchic implications.[66] In his outline of the essential question of *hamasteghtsakan* art, after setting up the difference between art (as an autonomous sphere of individual creation) and culture (as a weapon in the hands of power or as mass cultural kitsch), Grigoryan stated: 'The main question of *hamasteghtsakan* art is how to resolve the tension between art and culture (or, which amounts to the same, between the individual and society).'[67] Drawing from Jean-Paul Sartre's existentialist humanism, Grigoryan declares: '*Hamasteghtsakan* art is based on the belief that the human is a human's project in the future.'[68] According to his narrative, *hamasteghtsakan* art, in its way of defining art as an autonomous sphere, nevertheless falls, without betraying his dream of an all-encompassing art, into an absolute relativism. It claims to accommodate virtually everything under its aegis: '*hamasteghtsakan* art once and for all liberates creation from the constraints of high and low, old and new, ours and theirs, cheap and expensive, objective and subjective, figurative and non-figurative, styles, schools, techniques and technologies [...] where Walt Disney is as great as Leonardo'.[69] And years later, in 2005, Grigoryan repeats this and reminds us:

> *Hamasteghtsakan* art is based on the belief that freedom means getting rid of lies, illusions and self-deception. All that was before Cubism, we consider as part of culture, but not art. Art is a purely individual practice in defence of the individual while culture is a truly collective communitarian general activism. [...] *Hamasteghtsakan* art regards imagination as a means of prophesying; a possibility of seeing the general through the particular; a way to relive the past and future through the present.[70]

In Grigoryan's theorization, *hamasteghtsakan* art is a dream-space in which art's autonomy and individual freedom capacitate one another, and at

the same time *hamasteghtsakan* art resists the hierarchy of signs, images and values in culture. It is a space for collective creation (true to the word's etymology, *hama-steghtsakan*) but it also maintains the figure of the artist who heroically struggles against the antagonistic and levelling forces of the collective, in the same way that art resists and negates culture. As an illusion of a totalistic environment, *hamasteghtsakan* art comes to replace reality in order to make bearable the tragic schism between human beings and nature. For Grigoyan, it is a truly democratic art.[71] While appropriating styles, techniques and images, the 3rd Floor artist appears as a *translator* of these signs into the local Armenian cultural context, in an uneasy translation that attempts to debunk the commonplace accusations, voiced by orthodox Soviet circles of art critics, of copying outmoded Western styles in the name of originality (ironically, official art copied even more 'outmoded' techniques – from classicism to impressionism and fauvism). It is this levelling of value, or rather the construction of frame rather than content, that made it possible for the 3rd Floor to become an arena for very diverse artistic experimentations, including multiple genres and types of manifestations. If, for Karoyan, *hamasteghtsakan* disciplined the 3rd Floor's unruly practice, for Grigoryan the term crystallized the all-inclusive quality of the movement's exhibitions and specifically Grigoryan's own anarchic cry for absolute freedom within the domain of art. Images, objects and at times ideas, taken from different contexts and decontextualized and then re-contextualized in the space of the 3rd Floor's 'collective dreaming', were viewed as providing the space of freedom, this space being the zero point of ideology filled in with gesture.

It is not accidental that Grigoryan's favourite medium was collage. As a *hamasteghtsakan* device, collage was both an artistic medium and a technique of conceiving the exhibition as a diverse and fluid space that brings together incommensurable realities. In a way, collage becomes the *hamasteghtsakan* artwork at its best, and here I do not limit collage to the actual mixed-media technique of working with materials, but conceive of collage as an artistic strategy of mixing various images and realities upon or within a heterotopic space, a strategy that Grigoryan attributes to the artist's absolute and universal right to mix.[72] Thus Grigoryan's paintings are collages even though he rarely incorporates anything other than paint, in the same way that the 3rd Floor's exhibitions, with their juxtaposition of heterotopic images, are collages in their own right. It has been argued that the collage as well as the readymade, when these reappear in the context of the neo-avant-garde's recapitulation of the historical avant-garde's strategies, are all but inseparable from the late capitalist logic of spectacular consumerism, because they structurally rely on accumulation and over-production.[73] And given that consumerism was a socially unrealized dream in Armenia, but one that was imagined in art, collage became a device to construct the consumerist dreamworld as a

collectively created autonomous artwork. Here art becomes a subjective space of phantasmagoria in which the artists both desired the West as the other and at the same time strove to become the object of the other's desire.

It is by now obvious, I hope, that the contradiction at the heart of the movement extends to the conceptualization of *hamasteghtsakan* as it is defined by Karoyan and Grigoryan. While Grigoryan's practices and those of the majority of the artists of the movement were based on spontaneity, disorganization, rupture, discontinuity and libertarian anarchism, Karoyan was mostly troubled by methodological and conceptual problems in the display of artworks, a task that requires a systematic approach to these seemingly anarchic practices. His concerns were specifically conceptual and curatorial, such as making 'holes in the walls' – which is to say, accommodating specific objects in certain places in order to re-evaluate, accentuate and re-signify distinct aspects and features of already existing and, in the context of late Soviet Armenia, politically charged representational spaces. Karoyan's conceptualization of the practices of the 3rd Floor was perhaps informed by his desire to construct a discourse for art criticism, though at the same time it can be viewed as an extension of his conceptual work. An early artistic action, one of Karoyan's very few, was a *hamasteghtsakan* work *avant la lettre*. In 1987 he first discovered and then meticulously categorized the garbage accumulated under the roof of the Modern Art Museum. Then he created an itinerary and presented this itinerary in a Union of Artists' official meeting, to the distress of many of those present. It is interesting that garbage, as a signifier of contradictions buried behind the beautiful façade of official cultural politics, was not merely revealed but categorized and itemized. Karoyan's structuralist interest was not only in the binaries that shaped life in the late Soviet years, but the categorization and display of these very binaries.

Despite their differences regarding the semantic operation that the concept *hamasteghtsakan* was to perform in relation to the practices of the movement, for both Karoyan and Grigoryan the term at its most basic level of signification designated a diversity of styles, techniques, images and positions. Not only were the 3rd Floor's activities fluid and extremely diverse to accommodate virtually impossible combinations of styles and forms but, as our discussion of Grigoryan's and Karoyan's conceptualization of the term shows, *hamasteghtsakan* was also open enough to accommodate a large spectrum of different perspectives. If Karoyan's elaboration of the term can be viewed in light of his growing interest in poststructuralism in the mid-1990s (in that here he problematizes aspects of borders, frames and binaries), for Grigoryan it denoted precisely his vision of new art: an endless collage of mixed styles, forms and signs.

These contradictions that appear in the redefinitions of the concept reveal the contradictions at the heart of the 3rd Floor's agenda: the individual artist's

subjectivization takes place within the collectively dreamt space of egalitarian signs, symbols, forms and techniques standing in for all that could not be accommodated within the transforming institutions and discourses of the Soviet state. Under these circumstances the avant-garde in Armenia functioned within an extremely fluid institutional framework in which the dominant political ideology that had historically patronized art was threatened, while the market was in its embryonic stage. Thus, appearing between a dying political ideology and the yet-to-be formed structures of the market economy, the 3rd Floor was confronted with the imperative to create a representational and discursive context in which it could function. In a way, it became its own context. What interests me here are the processes of artistic subjectivization that rely upon a self-produced, self-enclosed and self-sufficient autonomy of art, at the expense of everyday life. This power of negating life in order to affirm art relied on a conception of art as totality, as opposed to the partiality and fragmentation of everyday life. In this, art replaces reality as more real than reality itself. This totalizing concept was operational even after the disintegration of the movement, as it helped to establish the terms of discourse on the scene of contemporary art in Armenia. But if we approach the 3rd Floor as situated within the historical trajectory of Armenian art, we find the movement in a more complex dialectic of innovation and tradition, originality and repetition, than the above discussion could afford. And this dialectic evolves around a key question that Armenian contemporary art has been grappling with since the 3rd Floor: how is contemporary art positioned in relation to the discourse of the 'painterly' as a constitutive discourse for the national fine arts? Bringing out some of the historical connections or ruptures with the national fine arts helps us historically trace the constitution of art's negative relation with the everyday and of the romantic conception of art – which contemporary Armenian art shares with Armenian modernism – as spiritual reality. In what follows I trace these connections and ruptures in Karoyan's and Grigoryan's endeavours to historicize the movement both during its existence and after.

The 'painterly real': adventures of the 'national avant-garde' within/as 'national modernism'

In his article 'Disintegrating Progress: Bolshevism, National Modernism and the Emergence of Contemporary Art in Armenia', art historian Vardan Azatyan introduces the term 'National Modernism' in an effort to trace the aesthetic and ideological constitution of contemporary art in relation to Armenian modernism on the one hand and Soviet Socialist Realism on the other.[74] Azatyan claims that it is upon the decomposing body of Bolshevism and its cultural policies of the 1920s that contemporary art in Armenia has

been forming since the early 1980s, both within and against the national fine arts of the 1960s and 1970s. And the key transformation that can be traced in this extended process of disintegration is that of the understanding of the nation and of the modes of representation that grounded the nation in artistic form. The decomposition of Bolshevism was a temporally extended process, Azatyan argues, which went through a variety of phase changes from the 1930s up to the 1990s. The formation of the national fine arts evolves in the context of this extended process and ultimately occupies the mainstream of cultural discourse, both alongside and in opposition to the official art of Socialist Realism in its local variants. This aesthetic regime of opposition, in the 1960s and 1970s, to the Soviet cultural policies of Bolshevism of the 1920s and their bastardization following the rise of Stalinist Socialist Realism is what Azatyan calls Soviet Armenian National Modernism – a key aesthetic regime in relation to which (and this includes both relations of negation and affirmation) contemporary art practices have evolved since the 1980s.

Azatyan arrives at the term Soviet Armenian National Modernism through a complex analysis of the transformations of political and ideological discourses within Soviet Armenia. According to him, what was at stake within the Bolshevik Leninist political and cultural programme of the 1920s was the emancipation of the 'nation' from its contemporary bourgeois understanding of nation and nationalism. With the coupling of nation and class, the former, within Leninist Bolshevism, denoted the common people rather than implying an ethnically bound category. However, this identification of the nation with the people was an imperfect one, as a conception of the nation as ethnicity constantly interfered with it. Throughout the 1920s in Armenia, as the Sovietized country greeted its repatriated intellectuals who had been called upon to participate in the construction of the new society, 'ethno-traditionalism and revolutionary internationalism'[75] went hand-in hand, always in dialectical tension, in the process of conceptualizing national and class liberation. It was this coupling of nation and class that was undone by Stalinist policies and continued in the post-Stalinist era when the nation became one with ethnicity.

The implications of Azatyan's argument run much deeper and are not confined to historical claims about a local context. The dialectical coupling of nation and class in the Bolshevik programme of the 1920s – even if implemented at times with violence and in a non-dialectical fashion – runs against an assumption in the late 1980s that the only way to recuperate the nation is through nationalism, and that 'nationhood' as such was oppressed by Soviet official ethnic policy from the very foundation of the USSR, an assumption shared by anti-Soviet socialist nationalists and liberal nationalists alike. This rhetoric subsequently situates the collapse of the Soviet Union in 1991 as one that was triggered and accompanied by ethnic conflict, implying a conceptual confusion, or rather identification of nation with ethnicity. This identification

triumphs in the 1960s when the post-Stalinist anti-Soviet intelligentsia in Armenia gained traction due to a renewed wave of repatriation throughout the post-Second World War period.[76]

The wave of artists and intellectuals who embarked upon the reconstruction of the country, and who were soon integrated into the new context of the Khruschevian de-Stalinization programme throughout the 1950s and 1960s, propagated nationalism and Europeanism, two identitarian categories that had been annulled by the Soviets earlier in the 1920s as bourgeois. Azatyan describes this anti-Soviet discourse as Soviet Armenian National Modernist, and 'at times indeed [...] Nationalist Modernist'.[77] By decoupling nation from class, National Modernism first and foremost foregrounds 'people' as a wholly essentialist identitarian category. This foregrounding does away with the dialectical tension between nation and class that had characterized the Leninist theoretical and political programme, for it freezes the nation within an ahistorical temporality of ethnic belonging. This ethnocentrism was nourished by a peculiarly Russian orientalism that hinged upon the 'sunny and happy south' and 'cold and austere north' binary. This was the ideological regime of National Modernism. Its aesthetic regime was based upon the combination of modernist form and national themes. National Modernist artists drew their formal resources from Euro-American modernism and medieval Armenian manuscript painting. Bright primary colours stemming from the medieval tradition of manuscript illumination were deemed to capture the essence of Armenianness.

The culmination of the discourse of National Modernism and of the emergence of a paradigm of representation that was conceived as both national and modern was the foundation of Yerevan's Modern Art Museum in 1972 by Henrik Igityan, who had studied in Russia. The museum, founded with the official approval from Moscow that any undertaking at such a scale would require, housed artworks by local artists who had studied in Leningrad, by Armenian artists from Tbilisi and by those who had repatriated in the 1940s and 50s. This was the first instance when an institution challenging the Union of Artists' hegemony emerged. The artistic development of those showing at the Modern Art Museum had mostly taken place in diaspora Armenian communities in the USA, Europe and the Middle East at the height of High Modernism and the Cold War politics surrounding it. The diasporic dilemma of preserving ethnic and religious identity while being part of a progressive international culture was to be enacted at the level of form as 'national' colours coincided with the universalized formal language of High Modernism.

The museum consolidated this reconciliation of modernist form with national spirit, and as Azatyan argues, through the founding of the museum in 1972, National Modernism started to occupy the mainstream of officially oppositional cultural discourse: 'Culturally, the museum marked the point of

institutionalization of National Modernist discourse. Politically, it symbolized the final break by local communists with Leninist politics'; and aesthetically it promoted art that was 'contemporary in form, Armenian in spirit'.[78] National Modernism foregrounded form in national content, wherein geography was endowed with an essentialist ethnic attachment to the soil of the country (Plate 2).[79] In short, this was formalism with ethnic content.[80] Here the referent was not sought in a descriptive relationship with the world, including the social and political circumstances in which this style emerged, but aimed at creating an autonomous painterly reality of form, one that would foreground the abstract notion of ethnic content.[81] National Modernism, while a result of the concrete policies of Khruschev's de-Stalinization programme which aimed at preserving the one-party system while foregrounding communism in national specificity,[82] was consolidated in Brezhnev's years of 'stagnation' (1965–82) when official discourse lost its ideological function and dissident discourse gained a semi-official status.[83]

Apart from the repatriates, National Modernism was nourished by the Tbilisi Armenian painters of the same generation, who grounded their exploration of formal painterly elements in the 'realism' of nineteenth-century Tbilisi Armenian painting, and especially in portraiture. A generation of 1960s artists who constituted a specific school of Soviet Armenian modernism from Tbilisi, Georgia (this included Lavinia Bajbeuk-Melikyan, Armen Dilbaryan and Robert Elibekyan, among others)[84] retreated into a seemingly non-ideological space of circus acrobats, theatre actors, carnival heroes and bathing women, where they hid their discontent with social reality behind abstract and de-individualized figures, thick impasto and earthy tones, in a style that in 1992 art critic Poghos Haytayan called formalist realism (Plate 3).[85]

Drawing painterly resources from the earlier generation of Tbilisi school painters, the 1960s and 1970s generation came to complete the decline of Socialist Realism as the dominating aesthetics, but also unwittingly contributed to the reproduction of stagnation. It came to crystallize the overlapping desires of state and society. As Karoyan claims:

> If illusion and the stage were necessary for the former [the regime] to extend its existence, then the latter [society], in its turn, was trying to forget the decades of nightmarish Stalinist oppression. But within the figurative images of multiple mirror reflections, theatrical games and ritualistic performances [on the canvases of the Tbilisi school painters], the traces of the decomposition of the Soviet regime's ideological-political and socio-economic system could be traced.[86]

The brushstrokes of the Tbilisi artists are short and abrupt, and their figures hide behind a thick impasto of earth tones. But rather than having a referential

relation to the figure, the painterly mark becomes an autonomous signifier of the traumas the subject experiences in its collision with the official Soviet world. For the artists of the 1960s, the carnival and theatre, frozen on the two-dimensional space of the canvas, provide the only retreat from a social sphere that is equated with the official sphere. The latter, despite the liberalization programme during the thaw, was still tainted with the Stalinist version of Socialist Realism in which representation had to adhere to the principles of *partynost* (party) and *klassovost* (class), *ideynost* (idea) and *narodnost* (the popular).[87] But most importantly, Socialist Realism, even without stylistic coherence, continued to act as a general principle of power in the sphere of art, and this applies to art production as well as to theory, criticism and historiography. Thus it had to be rejected in its totality, not as an aesthetic sphere alone but as part and parcel of life under the alienating ideological conditions of the post-Stalinist era.

Rather than be absorbed into the social sphere, the Tbilisi school painters relied on subjective isolation and enclosure as the only means by which it was possible to produce a space for resistance to what they experienced as an ideologically monolithic social and political environment. Opposing what was the institutionally dominant painterly regime throughout the Soviet years, Socialist Realism, the Tbilisi school painters presented a variant of National Modernism and rejected Socialist Realism wholesale. The latter, in turn, was not monolithic, and had locally specific variations that grounded the doctrinal demand for revolutionary content in the specific achievements of the Soviet Armenian people and preserved the painterly approach deriving from the 1920s national style. By the 1970s and 1980s the local iterations of Socialist Realism grounded realism in content derived from vernacular culture: village scenes, harlequins, dancers and actors. As opposed to Socialist Realism, which laid claim to representing reality in its optimistic truthfulness and thus supposedly occupied the sphere of the everyday, National Modernism constructed an autonomous painterly regime as more real that reality itself.

Painterly truth was to be grounded in the subjectivity of the artist as evoked through the gestural application of paint on canvas. By the early 1980s this subjective gesture became so radicalized that it was perceived as more objective than the ideological world of deceptions on the one hand and the banality of the everyday on the other. In the 1960s this war on banality had acted as a form of cultural critique of Stalinism and of the effects of *kulturnost*,[88] and was meant to purify the contaminated social world through painterly form. It is here that the application of paint on canvas came to be seen as an opportunity for the subject's liberation from the social. And if in the 1960s campaign against Stalinism the possibility of purifying some of the tenets of the Revolution acted as a larger cultural catalyst for alternative discourses, the 1970s revival of Stalinist discourses in the context of Brezhnev's

epoch of stagnation buried these seeds of change. Liberation was now sought in the interiority of the subject, which could be truly achieved only in painting. It is in the 1970s that the Soviet division between public and inner life becomes most intense, with the public as the sphere of official mass deception and the inner life standing for a sphere of untainted psyche.

The emergence of contemporary art in the 1980s cannot be considered except through an often ambivalent engagement with National Modernism which, by the time the young artists of the 3rd Floor arrived on the scene, had been inaugurated as the 'official' opposition to the properly official institutions – as exemplified in the establishment of the Modern Art Museum as well as the periodical *Garun* a few years earlier in 1967.[89] In short, if the National Modernists of the 1960s and 1970s defined their agenda against the Bolshevik cultural politics of the 1920s, 1980s contemporary art similarly established itself in opposition to the disintegrating body of this Bolshevik programme, thus partially identifying with the National Modernists. Early to mid-1980s practices in Armenia came to form an alternative to both the official discourse of Socialist Realism and to its recognized opposition in the form of National Modernism. Azatyan's complex historical argument points to the relationship between National Modernism and contemporary art as one not of continuity but of negation, a relationship understood as the identification with the enemy (Bolshevism) of the enemy (National Modernism).[90] Arguably, the 3rd Floor positively identified with National Modernism as well. It inherited from the latter an understanding of art as a sphere of subjective liberation. If for National Modernism the medium for liberation was paint gesturally applied on the canvas, for the 3rd Floor the medium-specificity of painting is dissolved as the gestural act is extended to the exhibition conceived as a space for freedom. Even if paint might not be used as material, the gestural excess of the painterly mark, as argued earlier, becomes formative for the late Soviet artists' movement.

What the 3rd Floor shares with National Modernism is first and foremost the dilemma of being modern and international in form and ethos, yet grounding oneself in tradition. It is noteworthy that attempts at situating the movement within a broader trajectory of the fine arts tradition in Armenia on the one hand, and of international modernism and the post-war neo-avant-gardes on the other, manifest themselves to varying degrees throughout the existence of the 3rd Floor. Most notably, Karoyan's critical writings reveal the presence of the above dilemma in his attempts to reconcile the avant-gardism of the group with the historical trajectory of both the national fine arts and of Euro-American postmodernism in art. Even though his efforts at drawing the movement's historical trajectory become systematic after the dissolution of the 3rd Floor, already in the late 1980s his critical writings expose a desire to connect the movement to a certain historical logic.

Both avant-garde and national

Karoyan's philosophy of (art) history articulating a historical logic for contemporary art consistently informed his numerous writings, his curatorial work and his endeavours at institutionalizing contemporary art in the late 1980s and throughout the 1990s. His art-critical method of historical evaluation was not confined to texts, and was often extended to cover exhibition-making practices. Karoyan's historiography presents a peculiar amalgamation of the Hegelian understanding of history as a manifestation of the stages of the realization of the Spirit with the postmodern historicity that becomes more and more dominant starting in the mid-1990s. What characterizes Karoyan's texts and exhibitions is the use of large and sweeping brushstrokes to outline the history of art in Armenia, to the point that these endeavours often work as general surveys of Armenian art. However, his writing and curatorial work, which comprise neither typical surveys nor case studies, move back and forth between macro and micro views on selected art practices, in an attempt to situate the *hamasteghtsakan* art of the 3rd Floor in a trajectory broad enough to incorporate cave paintings, Euro-American modernism, medieval art and National Modernism in Armenia. This method, while penetrating the depths of the past, does so only in order to bring the past into the heterotopic space of the present. Here the past occupies the temporality of the present *as if* it were the present. In short, it is a historical method that does away with history by turning time into space. One could indeed call this a *hamasteghtsakan* method of conceiving history, if we recall that *hamasteghtsakan* brings on to the same surface incommensurable temporalities. It is not surprising therefore that Karoyan is much more convincing as a curator than as a historian since curating can be conceived as a practice of subjecting time to the dictates of space.

In Karoyan's *hamasteghtsakan* version of historicity, Arshile Gorky appears as part of a lineage going back to the medieval traditions of Armenian art, one shared by the National Modernists of the 1960s and 1970s,[91] while the 3rd Floor is seen as the loyal heir of this lineage.[92] Notably, after 1990 Karoyan frequently used the term 'national avant-garde' in relation to the 3rd Floor, in an attempt to 'tame' the internationalist and avant-gardist rhetoric of some of the artists contributing to the movement and to situate the 'avant-garde' within the aesthetic trajectory of postmodernist aesthetics, such as that of Italian Transavangardia. In other writings, he presents the national avant-garde as a culmination of a millennium-long crisis of representation that had to do with an ambiguity with regard to the pictorial representation of the divine, debated within Armenian ecclesial discourse over centuries.[93]

The curious term 'national avant-garde', to which I referred in Chapter 1, requires elaboration as it helps both to ground the 3rd Floor within and

oppose it to National Modernism. It is noteworthy that the supplement 'national' in relation to the avant-garde has repeatedly functioned as the marker of difference that supported the Armenian avant-garde's originality and saved it from being considered as a belated imitation of Western art. In a Derridean sense, the supplement that is the 'weak' term has guaranteed the self-sufficiency of the privileged term in the binary pair.[94]

The supplementary term 'national' has been repeatedly mobilized, both against local accusations of imitating Western styles in the name of innovation (an accusation recurrently voiced by orthodox Socialist Realist artists and critics in the 1980s)[95] and in response to the international art market's demand for local specificity in the 1990s.[96] But most importantly, as already mentioned, the supplementary term 'national' came to support Karoyan's project of situating the 3rd Floor within postmodernism.

The dialectic of combining the forms and strategies of the post-war neo-avant-gardes with a national and local specificity is manifest in the international reception of the movement's practices. One of the first responses came from the diaspora Armenian literary theorist Marc Nichanian, whose conceptualization of the avant-garde in Armenia relied on a Foucauldian theoretical and critical framework. He argued that the 3rd Floor's, and by extension the Armenian avant-garde's, national specificity can be attributed to the local conditions in which it evolved. This specificity, for him, was a product of history rather than of any essential understanding of the nation, and was encapsulated in the fact that Armenian art throughout its modern history lacked a tradition of innovation outside of the national framework. For Nichanian, the main achievement of the movement was precisely its introduction of a culture of innovation, even if, or precisely because, its initial effect is one of shock.[97]

The second response came from the Russian critic Igor Chirikov who wrote on the movement twice, the first time in the aftermath of the 1990 exhibition *666* at the Union of Artists in Yerevan, and the second in response to the *Armenian Postmodernism* exhibition of 1992 at the Moscow House of Painters. In both instances, Chirikov refutes accusations of pastiche and situates the 3rd Floor within the international avant-garde's ethos of universality, albeit one that is grounded in national specificity.[98]

The term 'national avant-garde', as it was coined and circulated by Karoyan, was not exactly an updated version of 1960s and 1970s National Modernism. In his approach to history which combined postmodernism with Hegel, the term reinforced the particularization of identity demanded by postmodernism while at the same time connecting this particularization to a larger universal ethos embodied in the term 'avant-garde'. His was not the postmodernism that critically engages with history, and particularly with the history of modernism, but postmodernism as a cultural condition. Combined, the words 'national' and 'avant-garde' supported Karoyan's

conception of the 3rd Floor as a postmodern movement, similar to the Italian Transavantgardia of the 1980s to which he liked to refer.

In a 1990 essay Karoyan conceptualizes 'national avant-garde' as a historical appearance – if more evolved – of the essential notion of art, where art is both universal and specific.[99] While the ethos of the avant-garde is internationalist at its core, for Karoyan a repressed national consciousness comes to haunt this internationalist ethos. It is with postmodernism that the historically repressed national specificities see a return, as in the case of the Italian Transavantgardia or the national avant-garde in Armenia of the late 1980s, where the avant-garde is overcome as a historical experience as soon as it is recalled in radically changed contemporary conditions. If National Modernism foregrounded the nation in ethnicity, from Karoyan's postmodernist perspective the nation was the repressed historical specificity that was experiencing a return.

Karoyan sees the development of art in terms of an autonomous transhistorical evolution. The only way to detect the teleological movement of art's inner essence is through observing the evolution of form as the exterior appearance of that essence. Art, or art's essence, encounters periods of crisis where the course of its autonomous development is violently halted. Socialist Realism was one such instance, and the *rocaille* style – the foliate ornament – that emerged in the years of stagnation, as a 'false' national style, is another. This Hegelian historical logic, however, is combined with a postmodernist approach that looks at art as part of the larger culture. In Karoyan's writings, autonomous art is conceived as encapsulating cultural information whose essential content can be decoded. For Karoyan, the term 'national avant-garde' serves to reconcile two imperatives of Armenian national culture – those of ethnic identification and of cultural progressiveness. If the first upheld the pole of tradition, the second resolved the complex (in a psychoanalytic sense) of speaking from a peripheral location in relation to world culture.[100] The historical task of the 1980s generation of avant-garde artists, according to Karoyan's schema, was to reconnect with the historical ethos of the national culture that had been severed first by Stalinism and Zhdanovschina and then by Stalinism's return in ornamental form in art and architecture in Armenia in the 1970s.

In Karoyan's method there is an antithesis between autonomous art and art conceived as cultural information; there is also an antithesis between tradition and progressive innovation. Both are supposedly resolved at the level of form, and particularly of painterly form as embodied in abstractionism. The common denominator for all these binaries is the iconoclastic impulse of abstractionism. He locates abstraction in the space between European Informel, US Abstract Expressionism and the national tradition of ornamentation. Karoyan concedes that abstractionism in Armenia does not lay claim to art for art's sake or to medium-specificity. Rather it is aimed at solving a

cultural problem by way of opposition to official aesthetics. It is as if the exposure of the ideological nature of High Modernism in the USA that surfaced in the early 1980s new Marxist debates[101] had been consciously assumed by the 3rd Floor in an inverted way and as a political weapon against properly official art. 'Yes,' Karoyan's claims imply, 'we understand the ideological nature of Abstract Expressionism and we enact this form with all its ideological implications from within the Soviet Union as a tool for identification with the West, since we embrace the Western liberal ideal of freedom.'

Karoyan's Hegelian teleology, subjected to the postmodernist cultural turn, provides an analytical framework for the aesthetic and ideological agenda of the 'national avant-garde' vis-à-vis state institutions. More simply put, Karoyan's *hamasteghtsakan* method suggests that the essential and internal evolution of art as manifest in form is a cultural programme for the emancipation of the subject from the outmoded institutions of state socialism. In yet another contradictory move, the medium-specificity of abstraction as a modernist imperative is turned upside down: reappearing in the postmodernist musings of the late Soviet artists' cultural movement, abstractionism marks the dissolution of art's autonomy and its integration into the sphere of larger culture.

Karoyan located, in the post-historical moment of the collapse of Soviet and Western Enlightenment projects alike, a transhistoricity: what comes after history is that which transcends history. In Karoyan's rendering, it was the newly emerging alternative art, crystallized in the national avant-garde, that came to complete and consummate the historical development of art in Armenia. Karoyan's idiosyncratic and often contradictory transhistorical method of historicization – his sharp shifts, for example, from the panoramic (encompassing centuries and geographies with large brushstrokes) to the specific (zooming in on specific practices), his spatialization of history as he brought together images and styles belonging to very different periods – was enacted methodically, both in texts and in exhibition-making practices. If the artistic practices of a given period are manifestations of the essential notion of art, then the exhibition is the best medium to *show* that notion. Back in 1989, Karoyan had already stated: 'The value of the individual work is secondary to the exhibition as a whole.'[102] This statement can be read in the context of the 3rd Floor's programme of *showing together* and of the exhibition understood as a vehicle for the de-bureaucratization of the means of representation and reception. If the discourse of the painterly as constructed since the 1960s provides a support structure for art's negation of reality, the exhibition is the perfect form through which negation acquires a capacity for resistance.

In Karoyan's writing the 3rd Floor is endowed with the same status in relation to the official structures of representation and value-construction as the mid-nineteenth-century *Salon de Refusés* in Paris enjoyed in the wake

of modernism.[103] Refusal, rejection, subsequent resistance and artistic self-legitimation became the pillars upon which contemporary art in Armenia grounded itself institutionally, in the 3rd Floor's time and beyond. Practices influenced by the 3rd Floor, presided over by the spectre of its *hamasteghtsakan* strategy of absorption, oscillated between negation and affirmation, disavowal and embrace, the impulse to achieve a critical stance and the difficulty of doing so. This positional ambiguity was what characterized National Modernism in the 1960s as well, though this ambiguity has been obscured by the struggle over who had the right to occupy the privileged position of the dissident and the *refusé*; an often implicit struggle that developed between the 3rd Floor movement and the artists of the 1960s and 1970s supported by the Modern Art Museum. The way the older generation of modernists reacted to the activities of the 3rd Floor was always ambiguous: on the one hand they shared the common enemy that was Socialist Realism, and on the other their aesthetic and political programmes were rather different, if not oppositional.

In the early 1990s debates on representational politics, the older generation of modernists became sympathetic adversaries of the younger artists' cultural avant-gardism. The general attitude was that of sympathetic patronization,[104] as the older generation of the 1960s painters viewed the 3rd Floor's experimentation as officially permitted and thus felt that they could not claim the privileged position of heroic resistance. This is an argument made by art critic Poghos Haytayan in a conversation with the members of the 3rd Floor,[105] and is one repeated by Martin Mikaelyan, a National Modernist artist and art critic of the 1970s generation, in a 3rd Floor exhibition review of 1990.[106] While the National Modernists defended the national avant-garde's experimental spirit, as well as the typical pairing of 'contemporary in form and national in content', this defence was nevertheless always cautious and reserved, so as not to allow for any identification between the two.

The 3rd Floor's self-understanding in relation to National Modernism was not uniform or unanimous. Some adopted an attitude of radical avant-gardist negation, while others directly referenced post-war Euro-American art as a resource for their own artistic production. Some of these conflicts are evident in a conversation between Grigoryan and Karoyan dating from 1991. In this extensive dialogue Karoyan continuously attempts to historicize Grigoryan's artistic work as a postmodernist recapitulation of 1960–70s Armenian modernism, whereas Grigoryan considers his practice as one without a legacy or a historical precedent, and thus within a modernist ethos: 'I understand avant-gardism,' he says, 'as something deprived of tradition and which cannot create a tradition.'[107] Karoyan's repeated attempts to expose the 'mythological' thinking behind Grigoryan's defence of originality, authorship and art as a sphere of freedom fails as the latter strategically embraces those myths as guarantors of art's liberating promise in relation to the unfreedom of the social.[108]

If I were to summarize Karoyan's complex system of transhistorical histo-ricity, it would schematically appear as follows: the true ethos of art is encap-sulated in a specific evolution of iconoclastic impulses, from the Middle Ages to the present. The National Modernism of the 1960s is one such instantiation of this ethos. The national avant-garde of the 1980s and the contemporary art of the 1990s both embody and consummate this ethos in that they present the last stage of the historical evolution of the essence of art. But what is interest-ing in his Hegelian understanding of history is the opening up of art towards the larger culture. The friction between form and context provides an open-ing that for Karoyan, and by extension for the *hamasteghtsakan* paradigm of the 3rd Floor, potentiates art into a broader notion of creativity. In turn, this space for creativity is that which is capable of resisting the cultural context it stems from until this context itself is fundamentally transformed to become *hamasteghtsakan*. When discussing Karoyan's philosophy of history, one needs to keep in mind that this is a history that escapes the art-historical methods of causal narrativization, stylistic comparison and detection of his-torical ruptures. Karoyan's method of ahistorical historicization is first and foremost an artistic *hamasteghtsakan* gesture rather than a methodological practice within the disciplinary demands of art history. As argued earlier, *hamasteghtsakan* art, as a critical method of encompassing incommensurable styles and images, has the ambition of incorporating contradictory signs and symbols, temporalities and experiences on the heterotopic terrain wherein all hierarchy is dismantled. It also has the tendency to absorb discourses and practices that remain outside of its domain.

The question arises as to why the most truthful instantiation and mate-rialization of art's transhistorical ethos is believed to have erupted at the particular historical moment of the late 1980s, since Karoyan, as argued earlier, does situate the consummational quality of the Armenian 'national avant-garde' in a specific historical instance. For him, and for other artists of his generation (from both the official art and alternative art camps), the perestroika generation had a substantive quality that distinguished it from any other. Youth became conceived as *the* historical agent of that particular moment. Qualitatively different from the preceding generations, irreducibly specific and not defined by age, this youth was seen as capable of carrying out its historical mission of going beyond history (the age of the 3rd Floor mem-bers around the late 1980s ranged from early twenties to mid-thirties). In a 1989 statement Karoyan makes this explicit: 'Yesterday elders could mandate: "Listen, I was also young, but you were never old," whereas today they can assert with full right: "I was young in a world where you have never been and will never be."'[109] The idea of a youth culture as a substantive break from what precedes it was not the 3rd Floor's invention. Within the larger perestroika rhetoric of change, youth was attributed with a transformative agency. Free

speech, rebellion, blue jeans, rock music – all became the lifestyle markers of this generation. These markers characterized the 1960s generation both in the West and in the East. However, while these signs of social freedom and sexual liberation received their full expression in the West, in the East the subcultures of the 1960s and 1970s became the mainstream in the 1980s, and only then were they able to express themselves fully in the newly evolving liberal public sphere of the perestroika period.

Cultural and literary periodicals of the late 1980s and early 1990s were flooded with articles introducing various Western rock bands, snapshots of consumerist lifestyles, and histories of products such as jeans, combined with the newly emerging culture of market-driven commercials.[110] However, even within this outwardly anarchic cultural identification and Oedipal rebellion, the 3rd Floor justified its place in the vanguard of the youth's substantive rupture in a dialectical relationship with tradition. This is revealed not only in its various members' historical references to the national past, but also their formal adaptations of visual codes drawn from the tradition of National Modernism.[111] However, as argued, this identification was not easy or free from contradiction, but rather enacted a dialectic of rupture and continuity by positioning the binary poles 'tradition' and 'innovation' in a constant tension. At times, the line between the mainstream and the alternative, the official and the oppositional became so thin that contemporary art seemed to coincide with official discourse. If in the 1980s and early 1990s the *hamasteghtsakan* tension between tradition and innovation tended towards the pole of negation and rupture, in the 1990s the *hamasteghtsakan* programme overlapped with the official cultural politics of representing Armenia as a progressive nation, though one that had deep historical roots.

With all the claims to resistance and subversion, the central argument of this book is that the specific historical situatedness of the Armenian avant-garde, in relation to official politics and national culture, constructs an often ambiguous, contradictory and almost always uneasy relationship between the margins and the centre, the politics of resistance and that of affirmation. This ambiguity forms the very core of the *hamasteghtsakan* paradigm, as the latter proposes itself as an all-encompassing neutral framework, infinitely subject to change and transformation. But there are also differences between how the 3rd Floor itself enacted the *hamasteghtsakan* paradigm and the latter's posthumous reverberations in contemporary art in the late 1990s and early 2000s. If in the framework of perestroika the movement attempted to reform the official institutions from their margins, by the late 1990s contemporary art in Armenia had largely vacated the official institutions. In a way, contemporary art is now a parallel and oppositional structure to those that remained properly official institutions (this includes the old actors such as the Union of Artists, the National Gallery and the Academy of Fine

Arts). Structurally, this follows the fate of liberal democracy in Armenia: in the context of perestroika, the 3rd Floor was the cultural vanguard of a liberal democracy yet to be instituted. With independence and the ongoing construction of a constitutional liberal democracy in the mid-1990s, the Armenian avant-garde's political and aesthetic programme coincided with that of the nation state's. From the late 1990s until now, the Armenian avant-garde has been the bearer of the ideals of liberal democracy that the state betrayed and abandoned.

The rift between the official cultural mainstream and contemporary art – though their relationship is still mediated by a difficult (dis)identification with National Modernism – has grown and is now insurmountable. Arguably, the mid-1990s aesthetic and political programme of ACT, to which the next chapter is dedicated, was the last attempt, in the contemporary art sphere in Armenia, to constitute a properly official discourse, away from identification with national culture on the one hand or with its dialectical opposite – the *hamasteghtsakan* paradigm – on the other. If the 3rd Floor encapsulated perestroika's romantic liberalism with its emphasis on negative liberty and rights (as opposed to the common good), ACT as the offspring of the new constitutional state, aimed at stripping art and politics of all romanticism and reconciling the positivist understanding of art with a similarly positivist understanding of politics. The next chapter explores ACT's artistic proposition in the political sphere, and its failure in the framework of the construction of the new state in Armenia.

Notes

1 Designating the 3rd Floor as an artistic movement contradicts its own self-perception as a cultural movement. I concede that the 3rd Floor had an explicit cultural agenda, but one that employed artistic means towards artistic ends.

2 The artists largely passed over in the present work include Sev, Ashot Ashot, Karo Mkrtchyan, Heriqnaz Galstyan, Ara Hovsepyan, Kiki, Karine Matsakyan, Arax Nerkararyan and dozens of others.

3 In 1984 the first contemporary artists' collective, remembered as *Black Square*, was formed and lasted until 1986. In the two short years of its activity, it variously comprised the artists Kiki, Armen Hajyan, Vardan Tovmassyan, Martin Petrosyan and Sev Hendo, who joined towards the end. At times joined by Edward Enfiajyan, Nazareth Karoyan and Grigor Khachatryan, who participated in the group's exhibitions, *Black Square* challenged figurative painting with predominantly abstract art.

4 A. A. Zhdanov, 'Soviet Literature – The Richest in Ideas, the Most Advanced Literature', delivered in August 1934 at the Soviet Writers' Congress, https://www.marxists.org/subject/art/lit_crit/sovietwritercongress/zhdanov.htm (last accessed 7 December 2014).

5 For a concise review of the Soviet Artists' Unions, see M. Lazarev, 'The Organization of Artists' Work in the USSR', *Leonardo* 12.2 (1979), pp. 107–9. Lazarev summarizes the function and role of the Unions as follows: 'The Union of Artists of the U.S.S.R. is a trade union of men and women active in the various fields of visual art, and thus, is unlike most other trade unions elsewhere. Artists who belong to the Union are committed to certain ethical, aesthetic and ideological objectives, which are defined by the constitution of the Union. The Union provides its members with conditions favorable for their active work. It also furthers the dissemination of art and seeks to make art an integral part of everyday of the people of the U.S.S.R.' It is noteworthy that in the Armenian context the word նկարիչ [*nkarich* – painter] came to stand in for the more genre-inclusive word 'artist'. Thus the literal translation of the Union would be the Union of Painters [Նկարիչների միություն – *Nkarichneri Miutyun*]. However, given that this translation would not reflect the multiple disciplines represented in the Union, I translate the name as the Union of Artists. The more inclusive word արվեստագետ [*arvestaget* – artist] became increasingly popular throughout the 1990s to distinguish the contemporary artist from the traditional painter.

6 Azatyan, 'Disintegrating Progress', pp. 62–87.

7 According to Soviet data, between approximately 1946 and 1948 alone, 100,000 Armenians repatriated to Soviet Armenia. Mary Allerton Kilbourne Matossian, *The Impact of Soviet Policies in Armenia* (Leiden: Brill, 1962).

8 Arman Grigoryan, 'Nor hayatsq: Irakanutyun ev arvest' [New vision: reality and art], in *Hayastani jamanakakic arvest, 1980–1995* [Contemporary art of Armenia, 1980–1995] (Moscow: Moscow Central House of Artists, 1995), pp. 5–12.

9 Vardan Azatyan, 'Art Communities, Public Spaces, and Collective Actions in Armenian Contemporary Art', in Mel Jordan and Malcolm Miles (eds), *Art, Theory, Post-Socialism* (Bristol: Intellect Books, 2008), p. 46.

10 Azatyan, 'Art Communities, Public Spaces, and Collective Actions', p. 46.

11 'Cucadrum e 3rd harky' [The 3rd Floor is showing], *Arvest* 11–12 (1992), pp. 3–8.

12 *Cucahandesy vorpes aprelakerp* [Exhibition as a mode of life]. In *3rd Hark. Yntrany* [The 3rd Floor. A selection], ed. Vardan Azatyan, forthcoming.

13 Arman Grigoryan, '3rd Hark: Irenk irenc masin' [3rd Floor: them about themselves], *Mshakuyt* 2–3 (1989), pp. 54–7.

14 Glasnost also claimed the freedom and right to information of every Soviet citizen. It is ironic that in his 2003 article 'Informed but Scared', Grigoryan retroactively attributes fear to the one who possesses information in the late Soviet years. This narrative contradicts the *official* policies of glasnost: in many ways the late Soviet citizen was defined by his/her ability to be informed, though information was scarce and fragmented. Grigoryan's retroactive attribution of fear to the possessor of information presented the late Soviet avant-gardist artist within the framework of Stalinist discourses of oppression and persecution for being accused of knowing more than one was supposed to know. Arguably, this is also an attempt to reclaim the status of dissident for the perestroika artist in order to present the development of Armenian contemporary art as a history of a heroic struggle against political oppression. I will return to the contradiction between

official accommodation and this rhetoric of resistance later in this chapter. But here it is noteworthy that Grigoryan wrote this article for the catalogue of the survey exhibition of contemporary Armenian art *Adieu Parajanov* in Vienna, Austria in 2003. The exhibition followed 'the oppressed unofficial artists' narrative that defined dissident Russian discourse, the discourse that became so familiar in Western Europe throughout the 1990s. Within this light, Grigoryan's article participates in the retroactive construction of the myth of a late Soviet underground art scene in terms of a heroic struggle against the all-powerful and omnipresent state. Arman Grigoryan, 'Informed but Scared: The "Third Floor" Movement, Parajanov, Beuys and Other Institutions', in Hedwig Saxenhuber and George Schöllhammer (eds), *Adieu Parajanov: Contemporary Art from Armenia* (Vienna: Springerin, 2003), pp. 13–15.

15 A seminar on non-official art entitled 'The Art Holiday, Narva-88' took place in the Estonian town of Narva, bringing together non-official artists from Armenia (Grigoryan was among the participants), Belarus, Georgia, Kyrgyzstan and Russia. Ivana Bago, Vít Havránek, Jelena Vesić and Raluca Voinea, 'Parallel Chronologies: An Archive of East European Exhibitions', http://tranzit.org/exhibitionarchive/the-art-holiday-narva-88-%E2%80%93-seminar-on-non-official-art/ (last accessed 7 December 2014). Grigoryan remembers that Narva was crucial for him in working out that he had nothing to do with Russian unofficial art. Grigoryan, 'Informed but Scared', pp. 13–15.

16 The official decrees and the minutes of meetings that I came across in the State Archives of the Ministry of Culture between 1988 and 19993 witness broader calls for institutional restructuring that included decentralization, relative autonomy for cultural institutions in decision-making processes as well as pressure to find means and sources for self-funding in conditions of economic crisis. 1992–93, folder N. 80, list 20, file 22, Ministry of Culture, State Archives, Yerevan. In the early 1990s, these efforts at institutional restructuring shifted from reform to reconstruction. The cultural policy of the independent state (as opposed to the perestroika politics of reforming state socialist institutions) emphasized market economics as a viable source for the operation of public institutions, and eliminated museums and cultural centres dedicated to the Bolshevik Revolution or any other historical events from the previous seventy years. These were institutions that preserved the memory of historical instances deemed ideologically loaded and outmoded. For instance, with a decree on 4 April 1991, the Museum of the Revolution with its branches in the provinces was amalgamated with the Museum of History in Yerevan, whereas the Museum of Communist Youth was eliminated altogether. Decree 145, 4 April 1991, p. 81.

17 Mikhail Lifshitz and György Lukács were the most prominent theoreticians to develop an aesthetic theory consistently based on Marxian and Hegelian principles wherein art was conceived as human labour activity, but one that exceeds the conditions of production through ideality. Doctrinarian Socialist Realism schematized this theory as a universally applicable framework wherein art was conceived as a direct outcome of the conditions of production.

18 *Sovetakan Arvest [Soviet Art]* 2 (1988), p. 1.

19 The master–disciple relationship in which the student reproduced the styles and rules of composition favoured by the teacher was (and is) quite prevalent in the fine arts education provided by the main public institution, the State Institute of Fine Arts and Theatre. It was commonplace to identify the teacher according to the style of painting students submitted to the juried exhibitions. For the 3rd Floor artists, many of whom attended the Institute, the rejection of the master's signature was a precondition for originality.

20 In a published round-table discussion, artist Edward Isabekyan, who by then had occupied some of the most important positions in the official art sector (secretary of the Artists' Union, director of the Armenian National Gallery and of numerous other museums), complained that criticism coming from the younger generation and directed at the established artists failed to show respect for the experience and accomplishments of the older generation. Refuting artist Ferdinand Manukyan's earlier remarks about a painting by the prominent artist Sargis Muradyan (then the secretary of the Union), who had dared to paint the shirt of a negative character in red – the colour of the October Revolution – Isabekyan claims that such remarks were once potentially dangerous, and then goes on with a disciplinary sermon directed at the youth, calling for respect for elders. 'Qnnadatutyun` aranc pakagrseri' [Criticism without parenthesis], *Sovetakan Arvest* 3 (1988), pp. 14–18.

21 For a brilliant juxtaposition of the state-sponsored art system in the socialist period and the emerging neoliberal art system of the post-socialist era in the context of institutional transformations, see Esanu, 'What Was Contemporary Art', pp. 5–28.

22 'Qnnadatutyun` aranc pakagrseri' [Criticism without parenthesis], p. 17.

23 *Sovetakan Arvest* 8 (1988), p. 6.

24 In the second 1988 issue of *Sovetakan Arvest*, art critic Vahan Harutyunyan wrote an extensive review of the controversial Union of Artists' 1987 youth exhibition called 'The Youth of the Country'. The exhibition and the published polemic preceded the 3rd Floor's first exhibition. Harutyunyan's response was entitled 'Pokharinoghneri masin` apagayi mtahogutyamb' [About those who will replace us, concerned for the future]. The art critic offered a forceful criticism from the position of Soviet art criticism. He attacked the lack of realism and the striving towards innovation that characterized artworks of the new generation. By analysing the genre of landscape painting that curiously held a dominant position within the representational spectrum of this exhibition, the author critiqued either the lack of formal realism ('Vesimir Grigoryan's landscape titled "The City is Being Built" […] dams up the city under a dense web of lines and colours') or the disconnect between Soviet modernity and painting ('Old houses and court-yards were inhabited by elders […] some of the artists see in this [image] typical features of the nation whereas the highest of aims [of searching for national speci-ficity] can be achieved by bringing the modern quality of the nation, the realistic truth of its life and its subject, into art'). But the most severe of all sins, according to Harutyunyan, was the lack of humanism that characterized the masterpieces of revolutionary realism, a humanism that had been sacrificed on the altar of

formalism. Professionalism and skill were replaced by deskilled form, academic completeness by sketchy incompleteness, thematic content by form as an end in itself, truthfulness to life by primitivism, and ideological commitment by decadent individualism. The larger implication of this decline in artistic quality, according to the writer, was that art had lost its pedagogical role in society. *Sovetakan Arvest* 2 (1988), pp. 36–9. Interestingly, the same issue of the periodical opened with soon-to-be 3rd Floor art critic Nazareth Karoyan's article from the opposite camp. The two essays had similar titles: Karoyan's was 'For those who will replace us, out of today's necessity.' Karoyan did not praise the youth exhibition, which he found mediocre, but attempted to get to the bottom of the controversies that the seemingly conventional event triggered. For Karoyan, unlike the conservative adversaries of the exhibition, the 1987 show was business as usual, with outmoded methods of exhibition-making and selection procedure. However, what differed was that this time the jury was composed of art critics as opposed to artists. Karoyan argued for new means of exhibition-making and reinforced the argument made by Grigoryan at the Union of Artists' Congress that 'youth' was not a category of age, conveniently established for administrative and economic purposes (taking care of young artist-to-be-bureaucrats by granting them studios, apartments and commissions), but a qualitative category that applied to the degree of innovation and freedom exercised in one's art. *Sovetakan Arvest* 3 (1988), pp. 4–6.

25 *Sovetakan Arvest* 3 (1988), p. 4.
26 'Bac drner' [Open Doors], *Mshakuyt* [*Culture*] 2–3 (1989), pp. 44–5.
27 'Bac drner', pp. 44–5.
28 'Bac drner', pp. 44–5.
29 Karoyan states this in one of his earlier attempts to provide a comprehensive overview of the movement's cultural politics. '3rd Hark. Ovqer en nrank. Hamakrogh arvestabany nranc masin' [The 3rd Floor: who are they? The like-minded art critic about them], *Mshakuyt* 2–3 (1989), pp. 45–52.
30 Karoyan, '3rd Hark. Ovqer en nrank', pp. 45–52.
31 It is noteworthy that Henrik Igityan – art critic, propagator of Armenian modernism and founder of the Modern Art Museum in Yerevan – had proposed to showcase young artists without a jury in 1967, in the aftermath of Khruschev's programme of liberalization and in the wake of the constitution of Armenian modernism as an official opposition to Socialist Realism. See Henrik Igityan, 'A Carelessness? Not Only', *Sovetakan Arvest* 4 (1967), pp. 40–1.
32 Nazareth Karoyan, 'Entre politique et esthétique: *Discours et figure dans l'art contemporain d'Arménie des années 1960–1990*', in N. Karoyan and D. Abensour (eds), *D'Arménie* (Quimper: Le Quartier, 2008), p. 25.
33 The double title reflects an ambiguity in the aims of the happening as it was conceived by two members of the 3rd Floor – Kiki (Grigor Mikaelyan) and Arman Grigoryan. Forthcoming in Azatyan (ed.), *3rd Hark. Yntrani*. While Kiki's anarchic position relied on a literal identification with the heroes of the netherworld (the figure of Bobo being one of them), Grigoryan shifted the conceptualization of the event towards a metaphorical appropriation of death as the termination of official art and of its underlying ideology.

34 Giorgio Agamben, 'Author as Gesture', in *Profanations* (New York: Zone Books, 2007), p. 66.

35 Azatyan, 'Art Communities, Public Spaces, and Collective Actions', p. 44.

36 Arman Grigoryan, 'Qnnadatutyun arants pakagtseri' [Criticism without parenthesis], *Sovetakan Arvest* 3 (1988), p. 17.

37 Inga Kurtsens, 'Kyanqi ev arvesti sahmanagtsum. Mtorumner eritasardakan cucahandesi shurj' [On the threshold of art and life: thoughts about the youth exhibition], *Sovetakan Arvest* 7 (1989), pp. 18–21.

38 Grigoryan, 'Nor hayatsq: Irakanutyun ev arvest', p. 5.

39 Arman Grigoryan, 'Eritasardutyan Anunits' [In the name of youth], excerpt from the speech delivered at the Congress of the Painters' Union in 1987, *Garun* 12 (1988), quoted in Karoyan, 'Entre politique et esthétique', p. 23.

40 'Manifest', *Garun* 10 (1992), p. 96.

41 Arman Grigoryan defends this point particularly in his article 'Azatutyunn aysorva arvestum' [Freedom in today's art], *Gegharvest* 8.4 (1994).

42 Sigmund Freud, *Izbrannoe* [*Ausgewahlte Schriften*], ed. Evgeniy Zhiglevich (London: Overseas Publ. Interchange, 1969).

43 Several Russian editions of Freud's writings appeared in 1923. Since psychoanalysis was censored in the Stalinist Soviet Union and thereafter as a bourgeois discipline because of its focus on the individual psyche, it was only during the years of Brezhnev's controlled freedom and subsequently during perestroika that Freud's writings reappeared in Russian. The unofficial Soviet intelligentsia was drawn to Freud's theory of dreams and the unconscious, as these provided analytical tools to understand reality without reverting to rationalist explanations. *Kharkovskoe Psychoanaliticheskoe Obschestvo, Knigi Zigmunda Freidan a Russkom Yazyke*, http://psychoanalysiskharkov.com/?page_id=79 (last accessed 20 September 2014).

44 Nazareth Karoyan and Arman Grigoryan, conversation, unpublished, 1992, unpaginated. Nazareth Karoyan's archive.

45 Jukka Gronow's study of everyday life in the Stalinist Soviet Union discusses the introduction in the 1930s of luxury goods such as caviar, champagne and perfume among others as a state-orchestrated policy of producing a new class of consumers of luxury goods. These new consumers were not only the *nomenklatura*, but the middle classes with whom Stalin made a pact of mutual support. This pact is what Vera Dunham characterizes as 'Stalin's Big Deal'. Jukka Gronow, *Caviar with Champagne: Common Luxury and the Ideals of the Good Life in Stalin's Russia* (New York: Berg, 2003); Vera Dunham, *In Stalin's Time: Middle Class Values in Soviet Fiction* (Durham, NC: Duke University Press, 1990).

46 In relation to the resurrection of the bourgeois subject by the avant-garde dissident intelligentsia in Russia, cultural critic Keti Chukhrov writes: 'This is a subject that keeps the constitutional solidarity with other citizens but anthropologically and biologically is too auto-erotic to imagine the Other in a private space of its enjoyment, or more precisely, of self-enjoyment. It was this very subject that "died" in Soviet anti-bourgeois consciousness.' Keti Chukhrov, 'Deideologizatsia Sovetskogo' [De-ideoligization of the Soviet], *Khudozhestvennyi Journal* [*Moscow*

Art Magazine] 65–66 (July 2007), special issue 'Progressivnaya Nostalgia', http://xz.gif.ru/numbers/65-66/keti-chukhrov/ (last accessed 8 October 2014). The 3rd Floor's aesthetic of mixed styles, signs and symbols, heroes and ideals, even though a shared collective space, could be regarded as one defined by auto-eroticism, protecting the self-fascination and self-enjoyment of the subject within the space of art which they themselves improvised. However, the birth of this bourgeois subject did not take place overnight in the 1980s but was constituted gradually through the revival of the cultural attributes of this class since Stalin's programme of *kulturnost* in the 1930s.

47 Nazareth Karoyan, private correspondence, 18 December 2014.

48 Karoyan's (failed) solution to this economic precarity was his attempt at establishing a commercial art sector by founding several relatively short-lived galleries throughout the 1990s.

49 This included Kiki, Sahak Poghosyan, Martin Petrossyan and Sev Hendo who left for the USA and Ashot Ashot, Armen Hadjian and Karo Terzian who moved to Paris, as well as Gits Karo (Mkrtchian) who moved to Stockholm.

50 Grigoryan, '3rd Hark. Irenq irenc masin', pp. 54–7.

51 Vardan Azatyan talks about the misreading of 'Western' signs in the context of the 3rd Floor's practices in 'Art Communities, Public Spaces, and Collective Actions', p. 45.

52 Angela Harutyunyan, 'Espaces de l'art contemporain arménien et utopies expansionistes', in Karoyan and Abensour (eds), *D'Arménie*, pp. 67–73.

53 The word 'crossover' appears in the 1993 exhibition announcement for 'Beyond Idiom: Contemporary Crossover Art in Armenia' at the American University of Armenia.

54 Both Vardan Azatyan and myself have translated the term as 'collectively created' art, since it best reflects not only the etymological origins of the word but also its specific semantics in Karoyan's conceptualization.

55 In a later article of 1996 Karoyan traces the first usage of the term as a noun (collective creation) to a 1990 article in *Mshakuyt* monthly. Karoyan, 'Inch e Hamasteghtsakan arvesty?'.

56 It is noteworthy that the English title of the exhibition organized in collaboration with the American-Armenian artist Charlie Khachadourian that took place at the American University of Armenia in 1993 read 'Beyond Idiom: Crossover Art in Armenia', whereas the literal translation of the Armenian is 'Subjective Integration: Hamasteghtsakan Art in Armenia', thus putting the issue of communication and integration at the heart of the Armenian avant-garde. Forthcoming in Azatyan (ed.), *3rd Hark. Yntrani*.

57 Stepan Malkhasyants, *Hayeren bacatrakan bararan* [Dictionary of Armenian], vol. 3 (Yerevan: ASSR State Publishing House, 1944–45), p. 28.

58 Ashot Suqiasyan, *Hayots lezvi homanishneri bararan* [Dictionary of synonyms of the Armenian language] (Yerevan: ASSR National Science Academy, 1967), p. 358.

59 Nazareth Karoyan, 'Subjektiv Integratsia: hamasteghtsakan arvesty Hayastanum' [Subjective integration: *hamasteghtsakan* art in Armenia], exhibition booklet (Yerevan, 1993).

60 Karoyan, 'Inch e Hamasteghtsakan arvesty?'.

61 Karoyan, 'Inch e Hamasteghtsakan arvesty?', p. 97.

62 Karoyan, 'Inch e Hamasteghtsakan arvesty?', p. 97.

63 Karoyan, 'Inch e Hamasteghtsakan arvesty?', p. 97.

64 Azatyan, 'Art Communities, Public Spaces, and Collective Actions', p. 46.

65 In order to reveal the logic behind the foundation of this commercial private enterprise it is important to situate this venture within Karoyan's attempts to advance the commercial gallery system in Armenia not only in the early years of independence but also within the broader context of emerging market relations around the time. The following anecdote that Karoyan circulates connects these two processes rather directly: 'The founders of Goyak [Karoyan was one of them] wanted to take advantage of the devaluation of the Soviet rouble and receive financial credits from the first government of the newly independent state. We wanted to contribute the profit received from the investment of these funds into a business enterprise, in art. At the end, this speculative strategy turned against art. The founders of the gallery (artist Karo Terzian, who shortly after the establishment of the venue left everything and emigrated to France, and [who is] the author of these lines) soon afterwards went bankrupt due to the unforeseen devaluation of the rouble and had to reimburse the artists' commissions with dozens of boxes of imported cigarettes.' Karoyan, 'Entre politique et esthétique', p. 22.

66 Published as Arman Grigoryan, 'Inch e hamasteghtsakan arvesty?' [What is *hamasteghtsakan* art?], *Garun* 1 (1994), pp. 63–5.

67 Grigoryan, 'Inch e hamasteghtsakan arvesty?', p. 63.

68 Grigoryan, 'Inch e hamasteghtsakan arvesty?', p. 63.

69 Grigoryan, 'Inch e hamasteghtsakan arvesty?', p. 63. A call for the dismantling of all hierarchies was made in Grigoryan's 1989 text in *Mshakuyt*, which complies with the key concept at the heart of the 3rd Floor – art as a space of absolute freedom driven by self-sufficient artistic subjectivity as the origin and the source of freedom. *Mshakuyt* 2–3 (1989), pp. 57–8.

70 Arman Grigoryan, 'Azatutyuny ev arvesty' [Freedom and art], *Gegharvest* 4.4 (2005), p. 8.

71 He also made this assertion in a published round-table a year earlier. 'Cucadrum e 3rd Harky', *Arvest* 11–12 (1992), pp. 3–8.

72 'Cucadrum e 3rd Harky', p. 6.

73 Craig Owens, *Beyond Recognition: Representation, Power, Culture* (Berkeley, CA: University of California Press, 1992), and Boris Groys, 'Capital, Isskusstvo, Spravedlivost' [Capital, art and justice], *Khudozhestvennyi Journal* [*Moscow Art Magazine*] 60 (2005). If we put together the 3rd Floor's advocacy for the aesthetics of the readymade and collage as innocent of historical baggage, with their tendency to romanticize Western capitalism and consumer culture, we can easily claim that for the late Soviet Armenian alternative artists collage was neither innocent nor non-ideological. Instead, it was the most suitable medium to convey the consumerist dreamworld that they strove to produce in art. In a way, in late Soviet years collage bore the logic of consumerism in the absence of the

structures of consumerism. In and of themselves these strategies are not inherent to capitalism alone. The historical avant-gardes utilized collage, montage and readymades to change the very conditions of production.

74 Azatyan, 'Disintegrating Progress'.

75 Azatyan, 'Disintegrating Progress', p. 67.

76 On 21 November 1945 the Soviet government issued a decree authorizing the repatriation of Armenians from the diaspora to Soviet Armenia. Ronald Grigor Suny, *Looking Toward Ararat: Armenia in Modern History* (Bloomington, IN: Indiana University Press, 1993), p. 168.

77 Azatyan, 'Disintegrating Progress', p. 73.

78 Azatyan, 'Disintegrating Progress', p. 84. It is noteworthy that throughout the 1960s the official monthly *Sovetakan Arvest* published several rounds of critical debates between the propagators and critics of the emergent National Modernism in the works of the younger generation of artists such as Minas Avetisyan, Vruyr Galstyan and Lavinia Bajbeuk-Melikyan. In 1970 the periodical for the first time published reproductions of Avetisyan's work among those of other modernists that accompanied the art critic Igityan's text. Minas Avetisyan, whose work is an epitome of Armenian National Modernism, was a founding member of the officially sanctioned oppositional periodical *Garun* which started in 1967. By 1970 his works had been shown abroad and had been acquired by the State Gallery in Yerevan and the Tretyakov Gallery in Moscow. In 1969 he had his first solo exhibition in the House of the Painter in Yerevan. Tamar Gasparian-Chester, 'Qnnadatakan iravichaky 1960-akenneri verjin u 1970-akanner skzbin' [The state of criticism at the end of the 1960s and the beginning of the 1970s], *Revisor* 1 (2007), http://2012.revisor.am/2007/no1/National%20Formalism%208.html (last accessed 8 October 2014).

79 For instance, Minas Avetisyan wrote the following commentary on his fellow artist Alexander Bajbeuk-Melikyan's work: 'The constantly changing landscape was not national painting for him. He never strove to appear modern in terms of directly adapting modern forms. Above all, he preferred finding solutions to problems in painting through his personal temperament. He made fun of those vulgar nationalists who considered that if a painting excludes the known geographical location, the national painter immediately disappears' (translation mine). Minas Avetisyan, 'Anmnatsord ayrvogh nkarichy' [The artist that burns the candle at both ends], *Garun* 4–5 (1968), pp. 98–102. Quoted in Armenian in Gohar Vardanyan, 'Lchatsum, qnnadatutyun, eritasardutuin. Xorhrdahay modernizmi knnadatutyuny 1960-akanneri verjin u 1970-akanneri verjin' [Stagnation, criticism, youth. Soviet Armenian criticism of modernism in the late 1960s and early 1970s], *Revisor* 1 (2007), http://2012.revisor.am/2007/no1/stagnation.html (last accessed 8 October 2014).

80 To describe Ruben Adalyan's work of 1957, *The Girl with a Ball*, art critic Poghos Haytayan said: 'It was neither Cubism nor Abstractionism. It was realism that was formal in its principles.' He claimed that in the 1960s, unofficial artists' experiments do not seem daring from a contemporary perspective, but given the ideological conditions of constraint, they were more radical than the 3rd Floor, since

they operated in political conditions of oppression and censorship. According to Haytayan, what could not be accepted in the works of 1960s modernists was the peculiar amalgamation of formalism and realism. While this style never did away with the referent of the abstract notion of ethnicity, it was nevertheless formalist since it aimed at creating an autonomous painterly reality without its descriptive grounding in geography. 'Cucadrum e 3rd Harky', p. 4. For a detailed discussion on 'national formalism' in the 1960s and the formation of the art-critical discourse corresponding to the new style, see Tamar Gasparian-Chester, 'Azgayin formalism: xorhrdahay modernizmi knnadatutyuny' 1960-akanneri Sovetakan Arvest amstagrum' [National formalism: the criticism of Soviet Armenian modernism in the monthly *Soviet Armenia* in the 1960s], *Revisor* 1 (2007), http://2012.revisor. am/2007/no1/National%20Formalism.html (last accessed 8 October 2014).

81 In the 1960s–1970s the binary terms used to characterize the opposing camps of National Modernists and Socialist Realists were 'decorativists' vs. realists, formalists vs. realists. Gasparian-Chester, 'Azgayin formalism'.

82 Vardan Azatyan, 'National Modernism', in R. Arevshatyan and G. Schöllhammer (eds), *Sweet Sixties: Specters and Spirits of a Parallel Avant-Garde* (Berlin: Sternberg Press, 2014), pp. 107–20.

83 Gohar Vardanyan discusses this ambiguity, in the context of 1970s art-critical discourses in Armenia, in the dynamic between the official *Sovetakan Arvest* monthly and its officially oppositional counterpart, the literary monthly *Garun*. Vardanyan, 'Lchatsum, qnnadatutyun, eritasardutuin'.

84 The three generations of Tbilisi Armenian artists often included dynastic lineages. The Elibekyans included the father Vagharshak and the sons Robert and Henrik; the Bajbeuk-Melikyans included the father Alexander, the two sisters Lavinia and Zuleika and the son Vazgen. And if we add Hovsep Karalyan, Gevorg Grigoryan (Giotto), Albert Dilbaryan (Dilbo) and Gayane Khachatryan, the list of the Tbilisi school painters is more or less complete.

85 If at the height of the thaw in 1963, artist Babken Kolozyan could argue in the pages of *Sovetakan Arvest* that there is no abstractionism in Armenia but instead certain formalist tendencies that expand the borders of Socialist Realism, by the end of the decade the connection between formalism and Socialist Realism was supposedly severed. Babken Qolozyan, 'Arvesti bardzr gaghaparaynutyan u joghovrdaynutyan hamar' [For art's highest ideality and popularity], *Sovetakan Arvest* 2 (1963), p. 6. Quoted in Gasparian-Chester, 'Qnnadatakan iravichaky'.

86 Karoyan, 'Entre politique et esthétique', pp. 9–23.

87 The five main principles of Socialist Realism declared by Zhdanov at the 1935 Congress of Soviet Writers were *partynost* (party loyalty), *klassovost* (class loyalty), *narodnost* (loyalty to the people) and *ideynost* (loyalty to the idea). As a result of Khrushchev's de-Stalinization programme, only *narodnost* remained, though deprived of its class connotations.

88 Svetlana Boym, *Common Places: Mythologies of Everyday Life in Russia* (Cambridge, MA: Harvard University Press, 1995), p. 64.

89 See note 78 and Chapter 3 for an in-depth discussion of the periodical.

90 Azatyan, 'Disintegrating Progress', p. 87.

91 The National Modernists saw in Arshile Gorky – a genocide survivor and one of the founders of the New York School – what they were searching for: a synergy of the national and the modern.

92 Nazareth Karoyan, 'Andradardz', unpublished, 1992. Nazareth Karoyan's archive.

93 Karoyan, 'Andradardz'.

94 Jacques Derrida, *Of Grammatology* (Baltimore, MD: Johns Hopkins University Press, 1998), p. 195.

95 In a 1987 television talk show symptomatically titled 'Alternative', the 3rd Floor members were invited to debate innovation and tradition in art alongside the defenders of tradition and orthodoxy, including central figures in the Union of Artists such as Zorik Mirzoyan (secretary of the Union's administration responsible for the Youth section) and Sargis Mouradyan (president of the Union), as well as art students. While commending the youth for searching for new directions, the officials of the Union also accused them of imitating 'outmoded' Euro-American styles from three decades before, under the banner of innovation and originality. Sargis Muradyan, who encouraged the young artists to participate in the governance of the Union, also made the contradictory argument that authentic art never ages. Television programme, 1997, Vardan Azatyan's archive. A similar critique from the position of Soviet art criticism by Inga Kurtsens appeared in 1989, also mentioned above. The difference between the two opposite critical discourses – that of the orthodox Soviet art criticism of the 1980s and of its avant-gardist adversary – is not only obvious in terms of argumentation, but is manifest at the level of language. Kurtsens preserves the traditional scholarly 'we', whereas Karoyan consistently uses the first person 'I'. The declarative tone of the 3rd Floor here contrasts with the detached scholarly analysis of the art critic. Kurtsens, 'Kyanqi ev arvesti sahmanagtsum', pp. 18–21.

96 For instance, in the catalogue of the 1993 exhibition *Beyond Idiom: Contemporary Crossover Art in Armenia*, artist and exhibition organizer Charlie Khachadourian makes the supplementary role of the 'national' quite explicit. The Armenian-American art collector confesses that in his first encounters with 'avant-gardist' works in Armenia in the late 1980s, he considered them bad and amateurish imitations of Western modernism and Pop Art practised by information-starved artists. Only later, through studio visits, did he discover their roots in ethnic belonging, and that was how he 'salvaged' them. Charlie Khachadourian, *Beyond Idiom: Contemporary Crossover Art in Armenia* (Yerevan, 1993), p. 2. In the same catalogue, Ara Mgrdichian argues that the avant-garde in Armenia is born of scraps of information collected from non-Soviet spaces. Subsequently the avant-garde reconnected 'these bits and pieces, in which each fragment becomes an icon, a divine representation of the West. The communication with the other leads to self-discovery'; here the 'self' is understood in terms of its ethnic belonging. 'What awaits Armenian artists,' states Mgrdichian, 'are confrontations with their environs, themselves, their localities, distorted and idealized, aiming at a mastery, creating a transcendental vision and product.' *Beyond Idiom*, p. 5.

97 Marc Nichanian, 'Erevani 3rd Harky Parisi mej' [Yerevan's 3rd Floor in Paris], *Haraj* 14–15 (1989). Reprinted in *Garun* 2 (1990), pp. 66–7.

98 I. Chirikov, 'Start s tretego etaja. Armyanski postmodernism v zalax na Krymskoy naberejnoy' [A start from the 3rd Floor. Armenian postmodernism in the halls of the Krymskoy river bank], *Nezavisemaya Gazeta* 7.10 (1992), p. 7. Forthcoming in Azatyan (ed.), *3rd Hark. Yntrani.*

99 Karoyan, 'Andradardz'.

100 Karoyan, 'Andradardz'.

101 In the late 1970s and early 1980s Marxist art historians such as T. J. Clark, Benjamin Buchloh, Thomas Crow and Serge Guilbaut launched an ideological critique of modernism. Guilbaut's work in particular became influential in tracing a social history of High Modernism in the context of the Cold War. Guilbaut's and his colleagues' work achieved wide resonance via the 1976 CAA Annual conference, the 1983 Vancouver conference 'Modernity and Modernism' and Guilbault's own book of the same year, *How New York Stole the Idea of Modern Art: Abstract Expressionism, Freedom, and the Cold War* (Chicago: University of Chicago Press, 1983). I am not suggesting that either Karoyan or any of the 3rd Floor members were familiar with this scholarship. But the instrumental adaptation of Abstract Expressionism towards more than artistic ends resonates with Guilbaut et al.'s ideological critique of High Modernism.

102 'Bac drner', pp. 44–5.

103 'Bac drner', pp. 44–5.

104 Arman Grigoryan mentions that Henrik Igityan, the first and only director of the museum from 1972 until his death in 2009, greeted an earlier 1982 performance by Grigoryan, Karine Matsakyan and Gagik Vardanyan at the museum with the following remark: 'Our people do not need your art.' Grigoryan, 'Informed but Scared', p. 10.

105 See note 81.

106 Martin Mikaelyan embraced the 3rd Floor as the continuation of National Modernism in terms of the spirit of experimentation and innovation. At the same time he claimed that because of tighter political and ideological control, even slight formal heterodoxies in the 1960s were more scandalous than the truly scandalous work of the 3rd Floor in the late 1980s. According to him, truly interesting art is born of limitations, whereas absolute freedom does not pose a challenge to creativity. Martin Mikaelyan, '3rd Hark: Plus Minus', *Arvest* 7 (1990), pp. 39–40. Forthcoming in Azatyan (ed.), *3rd Hark. Yntrani.*

107 Karoyan and Grigoryan, conversation.

108 Karoyan and Grigoryan, conversation.

109 Nazareth Karoyan, unpublished typewritten text, undated, probably 1990. Nazareth Karoyan's archive.

110 *Garun* number 8 of 1988 introduced Led Zeppelin, while issue 2 of 1989 published an essay on Deep Purple. In the same issue we have a polemical address by a Yerevan State University student who calls upon youth to become the active agent of transformations. These articles were juxtaposed with exposés of secret stories hidden in closed archives, artists' essays on freedom and images of provocative works such as Artak Baghdasaryan's drawing of condoms applied to fingers making a peace sign. Even the official cultural periodicals

such *Sovetakan Arvest* presented entries on music and lifestyle critiques such as the one entitled 'Rock. Opinions and Debates' in *Sovetakan Arvest* 8 (1988). These are only a few examples of the larger signs of transformation that interpellated 'youth' as an agent for historical change. Many of the debates within the mainstream cultural periodicals centred on the question of freedom in relation to innovation: whether there is such a thing as absolute freedom, or whether freedom is possible only within social constraints. The ideological spectrum of these debates was large enough to accommodate libertarians, conservatives and conservative libertarians. The voice of this last species, which calls for the acceptance of youth's demand for freedom while finding means to channel this newly found freedom into social productivity, was especially loud. For instance, a music critic named Ruben Terteryan in the above-mentioned issue of *Sovetakan Arvest* presents an argument that various subcultural groups need to be recognized by the mainstream in order to be reintegrated into the ideals of the broader society. The state and society, according to him, have a responsibility to provide the youth with 'high culture', even with high-quality rock music, in order to gain an upper hand over various subcultural energies. Structurally, mass media in the late 1980s and 1990s started actively advancing the liberal notion of the public sphere, while reconceptualizing itself as an ideologically neutral framework that merely provided a platform for debates, never taking sides or positioning one view as superior to another. Hence, we have a proliferation of 'open forums' and discussions both on television and in print media. By the early 1990s artists were frequent guests on television shows, and even had television programmes that documented exhibitions but also presented early examples of video art produced specifically for TV. A prominent example of this is the series *Town* directed by artist Grigor Khachatryan, a novel genre between video art and experimental film with the duration and structure of commercial interruptions. These programmes developed their own formal vocabulary. For example, while a 1987 TV show on public television that broadcast a discussion after the 3rd Floor's first exhibition in the Artists' Union followed the conventions of Soviet broadcasting (soft classical music in the background, interlocutors seated on chairs and formally addressing each other, steady camera and linear editing), in the 1990s independent commercial channels overturned these conventions and adopted experimental and edgy forms when broadcasting programmes on contemporary art (heavy metal music, shaky camera and angular shots, interlocutors moving around or squatting informally, addressing each other with the informal 'you'). In my early teens, I myself, inspired by 'avant-garde' culture, started a TV programme that included interviews with artists and talk shows on responsibility and citizenship alongside a special section on heavy metal. I recall that my director and editors insisted on informal address, unconventional editing and special video effects while encouraging me to wear ripped jeans and a bandana.

111 *Sovetakan Arvest*'s eighth issue of 1988 presents a concise version of a round-table discussion, following the 3rd Floor's exhibition at the Modern Art Museum, where the artists debate their position within the binary of tradition

and innovation. 'The Youth are Showing, Speaking and Debating', *Sovetakan Arvest* 8 (1988), pp. 6–11. In *Mshakuyt*'s 1989 issue Grigoryan states that even the negation of tradition means the latter's continuation. 'Bac drner', *Mshakuyt* 2–3 (1989), p. 44.

Suspending the 'painterly real': ACT's procedures of 'pure creation', 1993–96

In 1994 we are at the threshold of a new way of thinking about art as having been overcome, and with its principal basis – 'pure creation' – now being *displayed*. I am placing special emphasis on the word *display* because if creation is not fixed, it remains in the unconscious and does not enter our worldview and belief system.

David Kareyan, 1994[1]

Through transparent walls it becomes possible to touch, examine and control the environment. The sanitary function of the stream ACT involves [solving] the problems of cleaning up the inside and the outside, supplementing, editing and if necessary stabilizing the stream.

David Kareyan, 1996[2]

To answer each question in the present tense means to constantly speak from the position of the present.

Hrach Armenakyan, 1996[3]

Between autonomy and a hard place

This chapter is dedicated to the conceptual artist group ACT,[4] which operated briefly in Armenia in the mid-1990s, in the context of the construction of the new state. Its historical investigation of the group's aesthetic strategies attempts to situate them within those structural changes that took place in the aftermath of independence following the collapse of the USSR in 1991 and defined the trajectory for this decade. I investigate, describe and critically revisit those spaces and possibilities that emerge in the gaps between 'pure creation', a key concept developed by artist David Kareyan and made operational throughout the group's existence, and the intensity of everyday life in Armenia in the mid-1990s. I argue that the concept of 'pure creation' emerges in the clash between autonomous art, which the concept implies, and the intensity of turbulent transformations affecting everyday life and penetrating into the otherwise 'pure' space of creation. It is this clash that

transforms the agenda of 'pure creation' into a political-artistic programme. I address the specific conditions within which the discourse of 'pure creation' both emerged and functioned. I subsequently attempt to identify the reasons behind ACT's young members' strategy of articulating dogmatic and rigid ideals, even fanatical beliefs in art's capacity to transform all spheres of human activity, and behind their totalizing discourses about conceptual art's function within the institution of art on the one hand and within larger social and cultural conditions on the other. A consideration of the underlying structural conditions of artistic practice informs my discussion of ACT's vision of the newly emerging relations between art and society, as well as the group's claims of developing new modes of artistic production, representation and reception. I argue that the group's example, within the specific context of post-Soviet transformations and the emergence of the new state in Armenia, has the potential to challenge reified interpretations in Euro-American academia of the function of politically and socially engaged art in society. The interpretations of modernism, the historical avant-gardes, the neo-avant-gardes and of contemporary art that have prevailed in the critical discourses of art history over the past sixty years have largely centred on the fragility of art's autonomy in the face of either state-ideological or market powers, which threaten this autonomy by dissolving art into larger social relations of production.

Through ACT's example I want to argue that art's autonomy is irrevocable, even if – or precisely because – art self-consciously positions itself within the framework of the discourses of the newly constructed state. ACT identifies artistic practice with the political practice of procedural democracy, and by this claims a central role for art in constituting social relations. However, while borrowing tools and strategies from proceduralism, ACT nevertheless holds on to democracy as a political ideal, one that is identical with the ideal of autonomous art. This is diametrically opposed to the rhetoric of resistance that, for the 3rd Floor in the late 1980s and early 1990s, was supported by the 'painterly real'. Even if in both cases art's autonomy was upheld, in ACT's case this autonomy has the function of affirming the changing social world rather than negating or resisting it. I argue that there is a paradox in the concept of 'pure creation', one that turns a methodical self-identification of art with the procedures of liberal democracy into a possibility for art's autonomy. 'Pure creation' radically politicizes art, yet it also provides a support structure for its autonomy.

ACT's example can arguably challenge the dominant interpretations of post-communist art, as exemplified by Boris Groys's writing about Russian dissident and post-dissident artistic practices, where these are taken as a general theory for post-socialist art and culture. The Russian art theorist argues that art's autonomy serves to resist the social world, no matter whether this

resistance is directed against the instrumentalizing forces of political ideologies, or the market-driven dissolution of art into the entertainment industry and design culture. In short, art's autonomy, which Groys affirms as a real possibility, relies on its immanent ability to resist power.[5] Other art historians and critics of post-communist and post-socialist art, less nuanced in their discussion than Groys, have consistently presented the evolution of contemporary art in the 1990s as an outcome of unofficial art's strategies of resistance against the Soviet regime. This narrative has presented contemporary art as a triumphant heir to heroically dissident art, one that draws its resources of political subversion from its predecessor, albeit in new conditions of liberal democracy. Consequently, according to this institutionalized narrative, the 1990s mark the arrival of contemporary art, now liberated from ideology and free to enter the logic of the market. In short, the narrative of ideological resistance has often become both a symbolic and a monetary currency through which late Soviet art practices have been institutionalized in the post-Soviet era.[6]

ACT's position within the newly emerging state discourses and the rhetoric of objectivism they adopted is the opposite of the 'Romantic Conceptualism' identified by Groys as characteristic of the unofficial art of the Moscow Conceptualists in the 1970s, and which could arguably be extended to include the 1980s conceptualists and their younger counterparts of the 1990s generation. The designation 'Romantic Conceptualism' was Groys's Russian equivalent to the Western notion of art for art's sake, or aestheticism, and stood at a pole opposite to dry Soviet officialdom on the one hand, and to the rationalism and positivism of the early conceptual art of the 1960s and 1970s in the USA and the UK on the other.[7] Replete with poetry, mysticism and pseudo-religious elements, Moscow Romantic Conceptualism operated in a context where 'mystical experience … appears quite as comprehensible and lucid as does scientific experience. And even more so. Unless it culminates in a mystical experience, creative activity seems to be of inferior worth.'[8] ACT did not share the somewhat existential and quasi-religious elements that defined the conceptualists in Russia. Nor did it share the trangressive impulse of the post-Soviet actionists such as Oleg Kulik and Alexander Brener. Instead, ACT affirmatively embraced the constitution of the new liberal democratic state along with its dry proceduralism and calculated rationalism. Their affirmative stance was a result of what I call a 'crisis of negation', a situation wherein political and social critique was structurally difficult to realize. However, this difficulty triggered an exploration of a new and previously unheard-of dialectic of political affirmation and aesthetic negation in Armenia.

The emergence of ACT, first and foremost, marked a generational as well as an epochal shift from the late Soviet to the post-Soviet periods, a shift that can be illustrated by contrasting ACT with the 3rd Floor. As opposed to the

3rd Floor's declarative tone, grandiose gestures and aesthetic eclecticism, the young artists of ACT appeared more as pragmatic politicians of few words and fewer works. As opposed to the dominant mode of artistic subjectivity articulated in the 3rd Floor's exhibitions and writings, in which freedom was an end in itself, ACT considered freedom as a continuous engagement with the social through purely artistic means. The subject they imagined in art and life was not the anarchic libertarian subject dreamt by Grigoryan, but a disembodied network of bureaucratic, economic and cultural possibilities. This subject was the new citizen, the informed agent, to a lesser degree the new consumer, with specific socially inscribed roles and functions. As they believed, this subject not only contributed to the formation of the new state but was also capable of standing at the vanguard of the formation of the public sphere. With the withering away of the rhetoric of resistance in the ACT group's work, we have a temporary suspension of *hamasteghtsakan* art's 'painterly real' as a romantic possibility for autonomy. As opposed to the painterly gesture as a structural support for autonomy in the practices of the 3rd Floor's artists, ACT's conception of autonomy was supported by a broader conception of form that included social and political form, in the conditions of the crisis of negation

What was novel and remarkable in ACT's vision was the newly articulated relation between art and democracy, both understood as procedure: a complex system of legitimation and institutionalization. This was a vision possible only in the context of the construction of the new independent state in Armenia. By adopting the concept 'pure creation', ACT understood art and politics as separate institutions both constituted by procedural mechanisms, and aimed at demystifying these mechanisms. The different protagonists of the group, however, understood demystification differently. If for David Kareyan – who was the first to propose the term 'pure creation' – demystification meant the destruction of specialized artistic labour for the sake of a larger and seemingly foundational notion of creation, for Hrach Armenakyan the concept 'pure creation' supported his argument that the artist is merely another functionary in the larger social sphere, securing the unhindered operation of the system.[9] If the 3rd Floor's dominant artistic subject was the libertarian anarchist, for ACT artistic and political subjectivization – the becoming of a politically conscious citizen capable of making choices – was perceived as taking place through calculated and rational processes, without leaving a space for unpredictable possibilities. But the 3rd Floor and ACT shared more than they were ready to confess: what they had in common was an ideal of autonomous art as a potential for subjective freedom. Where they differed was in the matter of what to do or not to do with this freedom. Most fundamentally, they shared an understanding of art as a sphere more real than reality itself, and one that displaces reality. In a way, the differences between these two movements with the most formative impact on the discourse of contemporary art in Armenia

had less to do with artistic positions and aesthetic programmes (though these differences did exist, and they are sharp and many) than with changes in social structures such as the advent of liberal democracy and the market economy upon which these positions were situated. The crisis of negation is a condition wherein wholesale and radical criticality is structurally impossible, or at least very difficult to realize. However, this is precisely a crisis of negation rather than of critique as such, because it was the historical paradigm, in play since the 1960s, of negating the social and political world in its entirety that was facing a crisis. Negation implies a wholesale disavowal, whereas critique connotes more specific articulations of negativity while pushing the boundaries of the existing conditions. What did change in the 1990s were the structural conditions within which the relationship between political power and the avant-garde intelligentsia had functioned for more than three decades.

In the face of the crisis of negation, the question arose: how could art occupy a vanguard position if the state itself was the avant-garde of social and cultural development, aiming to provide a vision for the entire society? Emerging from what I call a crisis of negation that the late Soviet generation of artists and intellectuals confronted in the mid-1990s, this generation adapted strategies of affirmation. Contemporary art as a self-constructed context for practice and discourse in the 3rd Floor movement's *hamasteghtsakan* paradigm relied on the negation both of the institutionalized artistic canon and of the social world of the late Soviet years (although, as argued, a negation of the dominant politics was already inscribed in the changing world of perestroika reforms). The contemporary art of the independent republic, on the other hand, was faced with a different set of questions, wherein negation and the 'great refusal' were no longer viable strategies to confront aesthetics or politics. It is this difficulty for achieving critique, along with the necessity of maintaining an aesthetically avant-garde position in relation to an evolving social world, that contemporary art practices in Armenia faced in the mid-1990s.

A crisis of negation

Armenia gained independence from the Soviet Union in September 1991. A few months later, in December of the same year, the Belavezha accords signed by the presidents of Russia, Ukraine and Belarus declared the end of the Soviet Union as a political unity and announced the establishment of the Commonwealth of Independent States (CIS). This new, vaguely defined and, as time would prove, dysfunctional political entity included the former republics of the Soviet Union, excepting Georgia and the three Baltic republics which declined the offer to join the new union. During this time, in the early 1990s, Armenia was facing a rapid social and economic transition from

a centralized economy to one based on capitalist free market relations,[10] while the governing structures of the Soviet republic, formerly only part of the centralized government ruling from Moscow, were being transformed into apparatuses of a sovereign state. The collective body of the 'Soviet Man' was in the process of being restructured: officially propagated communitarian collectivist relations were replaced by social and political structures based on the ideals of individual accountability.

These structural transformations were taking place against the background of a severe economic crisis, a war with neighbouring Azerbaijan in the breakaway Nagorno Karabagh region mostly populated by Armenians, a flow of Armenian refugees previously living on the territory of Azerbaijan, a blockade of Armenia's two borders, electricity and gas shortages, humanitarian problems stemming from the earthquake in the northern regions and the start of mass emigration to the USA, Western Europe and Russia. But this was also a time of hope, since it saw the construction of a new independent state and the institutionalization of the ideas of citizenship, democracy and free speech – all fused with the hopes and sentiments of a 'national liberation' obstructed during the seventy years of 'the communist experiment', as it was often described. At least, thus spoke the dominant historical narrative of official culture. The collapse of the Soviet Union now officially marked – yet again, after Stalinism's first overcoming of history – the end of the progressive time of historical development. Time once again stood still, but now it was the empty time of late capitalism.

In the early years of Armenia's independence, there was a sense that the future was now, and that all that was required to achieve happiness for all was to contribute individually to the formation of the newly emerging state (the more 'pragmatic' and prevalent approach was the emergent attitude that 'everyone should look after herself or himself'). Articles from various journals and newspapers of this period display an abundance of prescriptive arguments on the role of the individual in the construction of the new society; the perils of political romanticism and the importance of pragmatism and political realism; the relationship between intellectuals and power (as one of mutual benefit rather than antagonism); the opportunities created by free market relations; the need to learn lessons from history for the sake of the present moment; and a newly circulated argument that culture was a sustainably manageable resource (an argument generally accompanied by the 'sister' argument that Armenia could survive economically by only exporting mineral water), among other recurring themes.[11]

The new political and national subject was perceived in terms of a freely participating individual. This belief resonated in everyday life, with the fragmentation of the hitherto collective social body, the demise of communitarian affiliations, and the division of public property and the emergence of

free trade and commerce as the ultimate instruments of social harmony – as revealed in public policy and as propagated by politicians and statesmen and disseminated through mass media. The large industrial and collective farms, which required communal labour and which were the dominant mode of production during the Soviet years, were soon overcome by a massive proliferation of private micro-businesses, fly-by-night enterprises, and unlicensed commerce. Every citizen could open his or her own 'table-shop' to sell imported Turkish and Iranian candies, waffles, chewing gum or sunflower seeds.[12] These were local interpretations of the newly available structures of the free market economy combined with the emergence of consumerism. However, with economic collapse and widespread poverty, this was a consumer society without a consumer.[13]

The total restructuring of social, political, economic and interpersonal relations – all of which stressed the values of private property, individualism, democracy and citizen participation – as well as a great wave of resurgent nationalism beginning in the late 1980s that capitalized on the national 're-awakening' of the 1960s, had a profound impact on the aesthetic avant-garde's relation to politics in the early 1990s. In order to understand the specific triadic relationship between the artistic avant-garde, political power and the everyday life of the late Soviet and early independence years, it is important to stress yet again that with the success of the nationalist anti-Soviet protests, their main instigators and orchestrators became politicians and statesmen. They were now cultivating a new state and a new life. At least for a while, this situation conditioned a total belief in the newly consolidated state apparatus. These very structural transformations of avant-garde opposition into state power were partially responsible for the ultimate belief of the artists in the transformative capacity of agency in the new conditions of independence. The 3rd Floor's paradigm of avant-gardist political negation and its rhetoric of resistance became unviable in the conditions of the construction of the new state. Unlike the modernists of the 1960s and 1970s, or the Soviet non-conformists who critiqued the state, the avant-garde of the 1990s in Armenia came forward with a positive programme.

The transition from the late Soviet to the post-Soviet period was not one of revolutionary rupture, introducing a qualitative break from the past and creating a need for new content,[14] but one of reformist transformation that often came in the form of 'shock therapy' that had its origins in the perestroika programme of restructuring social and economic life within existing structural conditions. Now, these transformations were combined with a neoliberal logic of reform and transition. However, this reformist logic was in fact sold as revolutionary because, when confronted with the actual conditions of the collapse of an entire productive and ideological machinery, it led to drastic and cataclysmic transformations. What seemed like shocking changes (rapid

privatization and the abysmal devaluation of currency caused particular distress), presented by the government under the rubric of 'systematic reforms', although the state never had full control over the consequences of its decisions, were instituted alongside declarations of their historical inevitability.[15]

No historical document better crystallizes the structural dynamics of these transformations during the crisis of negation than the literary monthly *Garun*, for the most part the mouthpiece of the avant-garde in Armenia. The publication had historically positioned itself with the cultural and at times the political avant-garde, yet this position was always the officially licensed one. *Garun* was directly plugged into the discourses and representations of National Modernism in the late 1960s and 1970s; subsequently it went through a period of recession and reflected the modernist and anti-modernist existentialist tendencies of the late 1970s and early 1980s; finally the periodical played a key role as the official organ for the cultural avant-garde of the perestroika period. It is noteworthy that before the early 1990s the editors of the magazine were always artists and writers who directly stood with the official opposition to the properly official discourses.[16] The periodical is crucial for uncovering the changing relationship between the artistic and political avant-gardes in the context of rapid social transformations, because of its pivotal position between the artists and the state over several decades.

From its first appearance in 1967, *Garun* positioned itself as an opponent or at least an alternative to mainstream official publications such as *Sovetskoe Iskusstvo* (Soviet Art). From its inception its various editors consistently relied on the publication's original agenda: remaining at the vanguard of literary, political and artistic discourses, acquainting readers with contemporary international literature through translations, and representing the culture of youth, understood in terms of a substantive break from the Soviet cultural politics of Socialist Realism. As an outcome of the years of Khruschev's thaw, and emerging at a time when national culture was being consolidated as a mainstream counter-official discourse, the magazine operated at the margins of and in opposition to the official discourse of state socialism and its cultural sphere. If this sounds too much like the trajectory of Soviet Armenian National Modernism in Azatyan's formulation of it, as discussed in the previous chapter, it is because the magazine was established and operated by some of the latter's most prominent protagonists, including artists Minas Avetisyan and Alexandre Grigoryan.

Garun encapsulated the dilemmas of its time during the period of its inception and beyond, as the magazine operated on the shifting terrain between the centre and the margins, the official and the oppositional, and this pertains particularly to the first two and a half decades of this publication.[17] With all its claims to marginality and dissidence, *Garun* was 'blessed' by prominent figures of official national culture such as composer Aram

Khachatryan, physicist Sergei Mergelyan, writer Marietta Shahinyan and the hero of the Great Patriotic War (1941–45), Marshall Hovhannes Baghramyan, who sent generous greetings to its inaugural issue.[18] Since then, *Garun* had become something of a repository of officially sanctioned yet unofficial discourse, publishing translations of foreign literature, publicist pieces, and works of local and diaspora artists and writers. These were works that epitomized the already consolidated discourse of romantic nationalism and liberalism (figure 12).

As a product of the thaw, *Garun*'s core agenda reflected the mainstream cultural discourse of the period of Khruschev's relative liberalization, which built upon the desire to *discover* a world beyond the closed Soviet cultural sphere that had come about as a result of Stalin's 'socialism in one country' policy. This programme of liberalization was combined with the post-Stalinist imperative to revive the national ethnic identities that had been aborted by the early Bolshevik programme. During the late perestroika years, the magazine was at the vanguard when it came to publishing essays on democracy, liberalization and national belonging,[19] or historical investigations of dark and secret episodes of Soviet oppression during Stalinism and beyond. The magazine presented the 3rd Floor as a movement, but also included separate features on many of its individual artists, and promoted writing that recovered events of the national past that had been erased from the official cultural policy of the Soviet state. In short, the magazine was the mouthpiece of the late Soviet anti-Stalinist liberal nationalist intelligentsia, and remained truthful to its mission to represent the culture of youth.

The issues of *Garun* of the second half of 1994, upon close examination, reflect a certain unease with the profile and identity of the periodical, which had been running for almost three decades. This unease or even anxiety can be formulated in the question of how the publication could continue to pursue its established artistic, literary and political avant-gardism as the mouthpiece of the unofficial and semi-official intelligentsia after the former had finally come to power in the aftermath of Armenia's independence from the USSR on 21 September 1991. What I identify as a crisis of negation had largely to do with the fact that most of the contributors and editors of this semi-official magazine in various years were now occupying some of the highest ministerial posts in the independent republic.[20] It was as in a Saint-Simonian utopia, where writers had come to hold key positions of power.

Following the shift of state power from the hands of the Soviet *nomenklatura* to the late Soviet oppositional intelligentsia, the issues of *Garun* published in the mid-1990s arguably reflect the culmination of a certain crisis of the rhetoric of dissident opposition, a rhetoric that had peaked in the discourses of the cultural and literary avant-gardes of the perestroika period. As I argued in the previous chapter, the cultural movement known as the 3rd

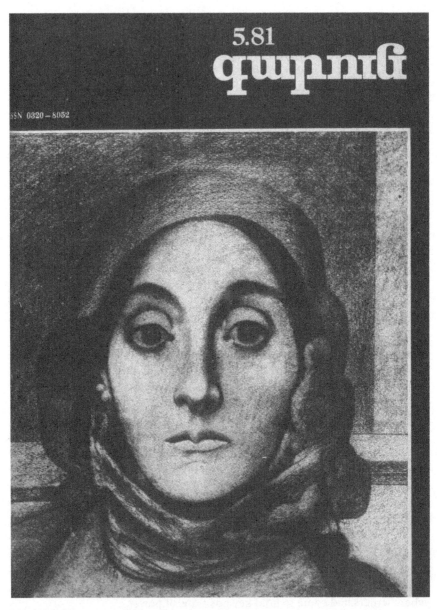

5.81

qupnιG

SN 0320 – 8052

12 Magazine *Garun*, cover, May 1981

Floor epitomized and embodied the position of the dissident opposition from the stance of an avant-gardist negation and resistance. And even if this oppositional stance was politically licensed by glasnost, nevertheless it provided solid foundations for the aesthetic negation of properly institutionalized art

and for the institutional negation of artistic bureaucracy by adapting the exhibition as a form that calls for immediacy.

Between 1992 and 1995 *Garun* consistently published round-tables, articles and opinion pieces on democracy[21] and elections,[22] and polemical essays on the urgency of adopting a new constitution[23] after four years of independence. Published under the rubric 'Publicism', these articles almost always betrayed a pedagogical tone combined with pragmatic recipes providing techniques for survival in the new socio-economic conditions. Discussions of the mechanisms and procedures of democracy were coupled with increasingly pessimistic projections for the future that considered the ongoing mass emigration, economic pressures and the war with Armenia's neighbour Azerbaijan. Here the price of hope was anxiety, and as the new state in formation confronted the imperative to make pragmatic decisions in dire economic conditions, the initial enthusiasm for 'independence for the sake of independence' was being replaced with a question: 'independence for what?'

The crisis of negation, while a process whose temporal parameters are not easily fixed, can be nevertheless framed between the years 1994 and 1998, from the months preceding the adoption of the first constitution in Armenia to the nationalist soft coup in 1998, a period when this crisis intensified and becomes most visible in its manifestations. Remarkably, during this period, the government occasionally organized retreats, inviting artists along with governmental officials to debate various urgent issues. One such forum was organized in 1993 by the president of Armenia at the time, Levon Ter-Petrossyan. Alongside the president, the ministers of the Interior and Culture, the presidents of the Writers' and Architects' Unions, contemporary artists, musicians and composers were invited. According to the artist Hrach Armenakyan, the forum did not have a specific agenda for discussion. Neither did the authorities bring together writers, artists, musicians and other cultural workers to debate issues of cultural policy and practice. Rather, the participants, from the young artists to the highest officials of the Republic, as Armenakyan's account testifies, came together merely 'to party, eat, drink and communicate with each other without a specific reason'.[24] Nevertheless, these types of meetings and forums occasionally held in the mid-1990s gave the artists a chance to meet in person, in mundane settings, the highest governmental officials, officials who had been their peers just a few years before, creating the impression that it was possible for artists to participate directly in the constitution of the state. This participation was imagined in terms of a concrete input in shaping the cultural policies of the newly formed state and its institutions, but also in terms of forming its ideological orientation and larger political, social and economic programme-making.

During this time, administrators and politicians alike called for public, and specifically intellectual and artistic, participation in political and social

processes. As we have already seen, the new government, comprising former academics, scientists, historians and writers, placed high hopes in the young artists, triggering the belief that the path to political power lay in artistic activism and participation that affirmed the political changes instituted by the state. A famous quotation from the mid-1990s thus somewhat sarcastically refers to these artists' and intellectuals' hopes to acquire political power through art-making. Referring to the then mayor of Yerevan and the soon-to-be Interior Minister (previously a writer), a popular saying arose among the intelligentsia: 'Don't insult the young writers. One day they will grow up and become ministers.'[25] Rather similarly to the experience of the Russian avant-garde of the early twentieth century, ACT perceived artistic practice as a pathway to politics, which would overcome art and expand the notion of creativity to encompass all spheres of human activity.

Towards new institutions

With the formerly semi-official intelligentsia now comprising the bureaucratic and ideological echelons of the newly established independent state, *Garun* became the official organ of the forward-looking political and cultural elite.[26] This repositioning resonated with a larger shift that the contemporary art scene in Armenia was undergoing from the early 1990s onwards, a shift from its semi-institutional status, as exemplified in the 3rd Floor's relationship with the Union of Artists in the late 1980s, to the institutionalization of contemporary art independently from the Union and other public structures.

In the context of the ongoing structural changes, the new generation of artists in the 1990s saw art practice as an extension of a larger transformational programme. The aesthetic programme of the 1990s avant-garde in Armenia was to partake in the formation of the new institutions of the independent state. This participation was a deliberately cold, bureaucratic, iconoclastic, rationally calculated and strategized project in which artistic subjectivity was perceived to be a mere mechanism within the predefined functions of the political and social body. Similarly to the construction of state institutions, artists were confronted with the need for an institutional structuring of contemporary art that would support the production, representation and dissemination of artworks in and beyond the borders of Armenia. This institutionalization would primarily support the local need for communication with a larger public on the one hand, and the presentation of Armenia as a modern nation and part of the larger international community on the other.[27]

Faced with the urgent need to define a cultural identity and *present* it to the world – an identity that could accommodate both contemporary and older images of Armenia – the Ministry of Culture began, through the early to mid-1990s, to support exhibitions of Armenian contemporary artists abroad,

alongside displaying and promoting artefacts and artists who were directly referenced in the key discourses of national identity. Some of the usual suspects included carpets, medieval manuscripts, Martiros Saryan's paintings and Sergey Parajanov's films, collages and assemblages.[28] It is in this context that the idea of culture as export commodity, which would not only represent the nation but also secure its material survival (since Armenia was lacking in natural resources), was circulated officially.[29] National culture, both ancient and contemporary, was to become an answer to several important needs: as commodity it would encourage tourism; for the newly independent nation under blockade by Turkey and Azerbaijan because of the war in the breakaway region of Nagorno Karabagh, it would resolve the need for communication with the outside world; and internally, it would sustain the former prestige of the cultured class of Soviet intelligentsia who had started emigrating from Armenia in the face of economic hardship.[30] While faced with the persistent conservatism of the Artists' Union, of the Academy of Fine Arts and of other official institutions, the Ministry of Culture of the new state sought and found support in the contemporary art milieu, with which the ministry shared a similar agenda – that of communicating with the outside world through culture.

It was in this context that the young Armenian artists came to desire not merely to change the newly emerging state institutions, but to adopt a formally declarative stance of revolutionary newness by supplying the ongoing top-down transformations with content. The artists themselves saw their art within an evolutionary, rather than a revolutionary, logic.[31] For the young artists of the 1990s generation, identification with the state and its institutions was accompanied by artistic nonconformism in relation to artistic tradition.

Nazareth Karoyan's efforts as an art critic, art dealer and curator to provide institutional support for evolving contemporary art practices in the early 1990s can be identified as a pioneering work towards institutionalization outside of the structures of the state. It is noteworthy that while *Garun*'s fifth and tenth issues in 1994 published Arman Grigoryan's polemic 'The Great Refusal of the Movement *DEM*',[32] from 1995 onwards avant-garde tendencies in art were exclusively represented under a rubric entitled *Ex Voto*, run by Karoyan. Curiously, Karoyan's editorial intention to run the art section of the journal came as an extension of his curatorial and critical practice and his efforts towards establishing a commercial gallery system in Armenia; Ex Voto was also the name of a short-lived gallery directed by Karoyan in the mid-1990s. On the pages of *Garun* specifically, but also within the larger landscape of Armenian contemporary art, it was becoming clear that the 3rd Floor's *hamasteghtsakan* paradigm of 'great refusal' was losing its all-encompassing grip on the local artistic scene.

The years 1992 and 1993 were seminal in terms of laying the foundations for institutions that would become formative for the contemporary art scene

in the 1990s and 2000s. The future Armenian Centre for Contemporary Experimental Art got its start when the American-Armenian Sonia Balassanian organized the exhibitions 9 in 1992 and *Identification* in the following year; a section of the Modern Art Museum known as 'the barrels building' became a venue for avant-garde exhibitions and became a point of departure for the HAY-Art cultural centre in 1997; and Karoyan ventured into establishing several galleries, with Goyak Gallery in 1991–93 followed by Ex Voto in 1994–96.

ACT's formation as a group was partially a response to the above efforts at the institutionalization of contemporary art practices in Armenia. These efforts emerged in the context of what I have described as a crisis of negation, and structurally paralleled the construction of the institutions of the state, an endeavour that fixed and territorialized the results of perestroika in the framework of the nation state. These processes were complex, haunted both by the spectre of late Soviet hyper-bureaucratization and the emerging institutional models of market capitalism. The imperative to build modernized state institutions went hand in hand with the quest for national identity, a quest pursued by the 1960s–70s generation of nationalists and the newly repatriated diaspora Armenians in the 1990s. The new émigrés engaged in active institution-building in all spheres of cultural and political life. Notably, and especially in arts and culture, the remnants of old bureaucracies (the Artists' Union, the National Gallery, the State Institute of Fine Arts and Theatre, and so on) were often left intact while new parallel institutional structures started emerging as alternatives to them. It is remarkable that the 3rd Floor disintegrated in 1994 partially due to the fact that the anti-institutional ethos of some if its members was confronted by the increasingly active institutionalizing efforts of others.

The larger political discourse of the formation of the new state and a new life on the one hand, and the need to confront the 3rd Floor's domineering aesthetic and discursive legacy on the other, motivated a group of young artists in their early twenties to come together with the aim of articulating a new notion of creativity and envisioning a future for both art and politics in the face of uncertainty and disorder in everyday life. Gatherings among the artists, then students at the Terlemezyan College of Fine Arts, began informally, in their apartments, around 1993. Those who regularly attended the meetings included all of the ten future members of ACT – Naira Aharonyan, Hrach Armenakyan, Vahram Aghasyan, Narine Aramyan, Narek Avetisyan, Diana Hakobyan, Samvel Hovhannisyan, David Kareyan, Rusanna Nalbandyan and Arthur Vardanyan – together with the artists Mher Azatyan and Harutyun Simonyan, who chose not to join the group when it announced its foundation in 1995 (figure 13). The informal format of these gathering did not prevent its members from establishing concrete aesthetic and philosophical parameters for their emerging art practice.

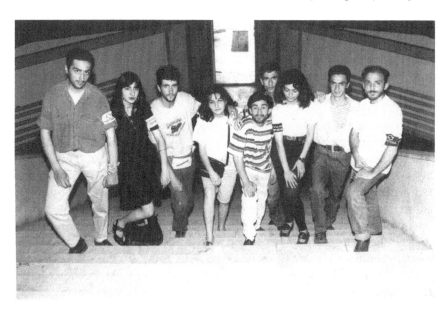

ACT, group photo, 1995 **13**

'Pure creation', a concept developed by David Kareyan, became the aesthetic 'device' that glued the members of the group together. It was made operational through intertwined and inseparable aesthetic, political and economic functions wherein the concept came to signify the overcoming of everything that was external to art combined with the paradoxical move of reclaiming non-art as a domain of autonomous art. 'Pure creation' is also, then, an art-historical device of my own, which I use to discuss the practices of ACT in the context of the turbulent transformations of the 1990s.

The aesthetic operation of 'pure creation'

First developed as part of his diploma work at the Terlemezyan College of Fine Arts in 1993, Kareyan's short text 'Pure Creation' was published in August 1994, informed by the active discussions and seminar sessions he initiated at the Academy of Fine Arts, where he enrolled upon graduation from Terlemezyan. Kareyan claimed:

> In 1994 we are at the threshold of a new way of thinking about art as having been overcome, and with its principal basis – 'pure creativity' – now being displayed. I am placing special emphasis on the word display because if creation is not fixed, it remains in the unconscious and does not enter our worldview and belief system.[33]

'Pure creation' designated the creative processes that go into art-making, wherein 'purity' was understood as characterizing an act detached from subjective attachments and devoid of subjectivity as such.[34] Kareyan thought of pure creation as the most fundamental issue of art, surpassing those of skill, material and medium, with the Duchampian readymade as the epitome of this 'pure creation'.

According to the philosophy of art developed by Kareyan through the notion of 'pure creation', the creative process was a calculated operation of 'fixing' ideas, of framing and displaying them through rational thought processes.[35] This notion of creativity insisted on the empirically verifiable 'this' that works in the domain of language as both the physical and non-physical substrate for art-making. This is quite different from the *hamasteghtsakan* operation, the 3rd Floor artists' post-conceptual gesture of mixing styles, images and techniques, an act that signified freedom. Kareyan replaces this *hamasteghtsakan* gesture with procedures of rational choice exercised in the positivist act of naming. Thus if, for Grigoryan, art was a conduit to the unconscious, Kareyan and other future ACT members were interested in a behavioural psychology that relied on the premise that the psyche could be explained through behavioural observation.[36]

'Pure creation' as an underlying philosophy incorporated all the artistic procedures utilized by Kareyan along with his young peers, procedures that he called 'fixation (inscription)', 'intervention', 'inspection' and 'display'. Inspection is the act that 'demarcates a terrain by fixing the external layer of the material, documents and conserves traces and accumulates information'. It is a rational process of observing and documenting those phenomena that usually go unnoticed.[37] Intervention is an 'activity in a situation … that allows one to expose the mythological sides of facts'; fixation (also referred to as inscription) is a technique of recording 'non-contingent contingencies' during a particular action (figure 14).

First performed at the 1993 youth exhibition at the Artists' Union, where the artist linguistically inscribed all the materials that went into the making of the exhibition, the method consisted of 'fixing' the linguistic signifiers of the materials used for that very 'fixation'. 'Display' shows, as it occurs, a process stemming 'from the desire to communicate, exchange experience, display conclusions and reconsiderations, and involves inspection, intervention and fixation'.[38] Through these procedures art is presented as a linguistically transparent phenomenon wherein the linguistic terms used to designate the materials utilized in the process of documentation enter into semiotic relations. From 1993 to 1996, Kareyan documented these materials, thus documenting the process of documentation. For instance, one such work was affixed to a piece of paper attached to a wall. It read: 'paper, ink, transparent paper, emulsion, thread', which were the very materials used to construct it

David Kareyan, *A Document of Fixation*, 1993. Image from the project *Fixating the Body of Friendship* **14**

(it was hung upside down and probably hand-dated by fellow artist Samvel Hovhannisyan).[39] Other inscribed texts by Kareyan read: 'Inscription as a Manifestation of Pure Creation. David Kareyan, 11.04.94 (hand-signed)', or 'Discovery as a Principle of Inscription. David Kareyan, 10.05.94 (hand-signed)', or 'Pure Creation. 21.03.94 (hand-signed)'. The words and sentences used in these simple 'inscriptions' were to form a constituent part of ACT's vocabulary: they were explained and decoded in many texts and writings, and used in a number of art pieces.

If we attempt to define 'pure creation', the basic definition points towards the act or the action that goes into the making of the artwork and the materials used in the process of making. By 'purity', Kareyan understood creativity that is devoid of the need for externalization in any specific form or medium. The concept was a separating device, on two counts: it performed a separation between autonomous art and everyday life on the one hand, and on the other, designated ACT's aesthetics as different from those of the other actors on the contemporary art scene, and specifically from *hamasteghtsakan* art. This is not to claim that the concept of 'pure creation' itself was incommensurable with *hamasteghtsakan* – in fact, the two were similar in many ways. However, 'pure creation' was mobilized as a marker of autonomy from the 3rd Floor's discourses. An unpublished text by Kareyan that preceded the publication of 'Pure creation' in *Garun* reads:

A constantly changing situation
That has overcome art,
That shows only the creative side of art

Which is both local and spontaneous
Which has eliminated the concept of 'artwork'
Where there is neither school nor style
Neither form nor content
Where gesture is important
Where there is constant surprise
Where one does not dream but debates ...[40]

This quote strikingly recalls Arman Grigoryan's conception of a *hamasteght-sakan* art that 'once and for all liberates creation from the constraints of high and low, old and new, ours and theirs, cheap and expensive, objective and subjective, figurative and non-figurative, styles and schools, techniques and technologies'.[41] Nevertheless, while for Grigoryan the goal of new art was to achieve total freedom from culture (understood as a prison that confines subjective freedom) by giving voice to creative spontaneous impulses, for Kareyan the liberation of art was not from culture but from art's own material constraints, for the sake of the triumph of its concept. Echoing the newly independent state's process of constructing the institutions of liberal democracy, this very liberation was not a spontaneous explosion but a methodical, rationally calculated and functionalist elimination of art's boundaries for its own self-realization, wherein 'one does not dream but argues'. The aesthetic operation of 'pure creation' as a rational act of selection and display was to be re-enacted in the exhibitions and actions, in some cases *avant la lettre*.

The exhibition *Remember Malevich*, a collaboration between Vahram Aghasyan, Mher Azatyan and Rusanna Nalbandyan, took place in 1993 at the House of Journalists in Yerevan. It was one of the first attempts, before the formation of the group, to emerge from the limited sphere of apartment discussions and exhibit together.[42] For the first time the small exhibition brought to the public eye the generational and aesthetic problems that would come to define ACT's conceptual programme. In the absence of documentation for the works in the exhibition, I have had to rely on Aghasyan's and Azatyan's accounts and descriptions.[43] Aesthetically and formally, an economy of means was evident in the exhibition, with the bare minimum of materially present objects. The presented artworks oscillated on a fine line between tangibility and intangibility while withdrawing from retinal experience. Nalbandyan made a performance during which she blew feathers into the air during the opening. She also hid objects by wrapping and sewing them in newspapers. Azatyan's work consisted of burnt paper pressed between two glass sheets, while Aghasyan showed metal spirals detached from clothes pegs and hung on a rope, as well as burnt matchboxes scattered on the walls. A newly emerging aesthetics of ephemerality and of objects reduced to their basic materials sharply contrasted with the gestural and stylistically eclectic painterly practices

of *hamasteghtsakan* art. This aesthetics also differed from the conceptual prac-
tices of some of the 3rd Floor artists, such as Ashot Ashot, for whom conceptual
art was a search for the origins of creativity, or Ara Hovsepyan, whose version
of conceptual art escaped the linguistic positivism and self-referentality of both
the declarative statement 'This is art' and its tautological structure ('Art is art is
art'). Those artistic practices within the 3rd Floor that drew from conceptual art
had taken up the neo-avant-garde strategy of dissolving medium-specificity as
the main programme of conceptual art per se. In this, 'conceptual art' implied
phenomena as diverse as happenings, assemblages, objects and anything that
went beyond painting or sculpture. In addition, the 3rd Floor's 'conceptual
wing' did not abandon visuality. Instead, it worked towards establishing con-
ceptual art as an artistic practice radically distinct from those preceding forms
and genres that relied on or advocated medium-specificity. As opposed to this,
the artists participating in *Remember Malevich* had the agenda of establishing
conceptual art as distinct from other forms and genres that merely challenged
medium-specificity, and by conceptual art they understood art that had over-
come art through language and the idea.[44]

The young artists mobilized Malevich in this exhibition while evoking the
iconic avant-gardist's legacy as a negation of the entire tradition of art, and
triumphantly declared the end of art as we know it by a radical gesture of
reducing this very declaration to the bare minimum of formal articulation.
The black square on a white canvas came to stand for a form that borders
invisibility and intangibility; a tabula rasa upon which the artists could con-
struct their own teleology of art's concept. To have recourse to Malevich's
legacy, at the same time, was to secure authorial and paternal legitimization
for the young artists' first exhibition. We should ultimately not overlook the
generational factor in the emergence of these artists in their early twenties on
a scene that was replete with large artistic personalities, on a scene that was
haunted by the spectre of inherited painterly skill which defined the Soviet
Armenian academic tradition of painting, and continued to inform both art
education and the 'painterly real' of the 3rd Floor. A radical deskilling, then,
took place in ACT's practice, in the face of the authority of artistic tradition
understood as a compilation of inherited skills. It is notable that the young
artists were all in the process of receiving their formal art education at the
College of Fine Arts or the Academy of Fine Arts, and were directly exposed
and subjected to the authority of academic tradition.

It is tempting to read *Remember Malevich* within the larger Eastern
European and former Soviet context of ongoing reclamations of the Russian
avant-garde's aesthetic and political legacy from its Euro-American institu-
tional appropriation and canonization. Malevich's reception in the United
States in the 1960s in particular, alongside that of his fellow avant-gardists
through Camilla Gray's seminal *The Great Experiment* (1962),[45] had arguably

stripped the Russian avant-garde of its radical political context.[46] Reclaiming Malevich in Russia and Eastern bloc countries in the 1980s and 1990s came to stand for a desire to reconnect with the Eastern European and early Soviet historical avant-gardes, perceived as violently interrupted by Stalinist Socialist Realism. And one of the first historical instances when institutional attempts were made to come to terms with the severed legacy of the Russian avant-garde in Soviet Russia was the 1979 *Paris-Moscow* exhibition, in which the Russian unofficial artists encountered this legacy through the eyes of the West.

Throughout the 1980s and 1990s, there were many versions of Malevich, and one simply got the version one wanted. For the Armenian unofficial artists of the early 1980s, Malevich's *Black Square* served to identify art with life in its existential dimensions – an interpretation embodied in the short-lived group 'Black Square'. Meanwhile, the various 'returns' to Malevich in the former Yugoslavia – as exemplified by the anonymous artist who chose the pseudonym Belgrade Malevich – were often aimed at subverting the codes of originality and authorship through which Malevich's author-function was constructed in the Western history of modernism. The Slovenian group IRWIN's ironic 'Black Square on Red Square' was both a tribute to Malevich and a critical engagement with the institutionalization of his legacy.[47] The 1990s generation of Armenian conceptualists mobilized Malevich's name to opposite ends. Aghasayan, Azatyan and Nalbandyan's reading of Malevich as a master of self-referentiality was mediated by the reception of the Russian avant-gardists in the US post-war context. In their Armenian exhibitions, citing his *name* as a unique *author* was to legitimize the young artists' venture. Recognition by the artists of the 3rd Floor was crucial in order to gain access to the discursive arena of contemporary art in Armenia, which in 1993 was still largely defined by the 3rd Floor's expansive practices and its *hamasteghtsakan* paradigm.[48] This ambiguous position, of seeking the 3rd Floor's recognition while attempting to overcome the movement's legacy and that of its separate members, was occupied by ACT throughout most of its projects and collaborative initiatives. And perhaps more importantly, Malevich was mobilized to claim that these practices were a continuation of the modernist legacy rather than succumbing to what the artists perceived as *hamasteghtsakan* art's postmodernism. The question of autonomy was so pressing for the young artists that, according to Aghasyan, they had to plan their next exhibition *P.S. Evolution* in utter secrecy so as not to allow the infiltration of intrigues and politics from the broader field of contemporary art.[49]

Partly because of the inevitability of dealing with the legacy of the 3rd Floor, the young artists' informal circle had to define itself as representing a discourse distinct from and even opposite to that of this late Soviet artists' movement: to the 3rd Floor's eclectic postmodernism they opposed their own idea of pure modernism in the guise of the 'pure' conceptual art of the

idea; they replaced the gesture with processes of selection and display; to Grigoryan's ideal of absolute freedom they opposed their prescriptive understanding of individual liberty as an instrumental notion for the construction of the new state.

The second exhibition to present the works of the new generation took place in the following year, in 1994, at the editorial office of the periodical *Arvest*, with the participation of five artists: Samvel Hovhannisyan, David Kareyan and Vahram Aghasyan together with Mher Azatyan and Harutyun Simonyan.[50] Its title, *P.S. Evolution*, was symptomatic. If *Remember Malevich* was a belated engagement with the idea that art had ended, through references to the historical origin of this eschatological narrative, *P.S. Evolution* posed the question of what was supposed to come after the end of art. In a self-produced video documentation by the artists, the young art critic Lilit Sargsyan declares in front of the camera: 'Everything that was to happen in Armenian art has already happened, and this exhibition is happening after all that has happened ... the boys wanted to overcome the postmodernist situation in Armenian art.'[51] *P.S. Evolution* presented key approaches to the idea of pure creation: the indexicality of the trace, intervention in and transformation of space, 'fixation', use of assisted readymades and linguistic referentiality. But more importantly, this exhibition outlined a stylistic trajectory for ACT's future practices: an economy of means, conceptual laconism, the importance of 'operation' and 'fixation' over expression and gesture, over-rationalization and, above all, the imperative within the group to remain consistent to one's methodology of choice. This remained the group's stylistic trajectory even though Azatyan and Simonyan eventually did not join ACT, since the first was uncomfortable with the presence of a political programme and the second with their positivist approach (Simonyan's work was concerned with dreams, the unconscious, memories and subjective experiences).

For *P.S. Evolution*, Kareyan performed an 'intervention' by cutting a fire extinguisher and a coffee can into two parts and displaying them as 'split objects' (figure 15). In the first case he exposed the inside of the object, while in the second case the two different external sides of the can were displayed. Both manipulated objects were fixed on a stretched canvas. Above them a hand-written inscription described the state of the objects after the artistic intervention: 'The coffee [can] both from the front and from the back' and 'The fire extinguisher from inside.' The empirical verifiability of the object in its three dimensions was taken literally here: the 'this' of the object was exposed in its 'authenticity', while the subjective perceptual limitations of vision were exposed and supposedly overcome.

In his second work in the show Kareyan performed an operation of 'fixation',[52] which was to become a consistent strategy in his practice of the period. Kareyan inscribed the dimensions of a piece of sponge posted on the wall

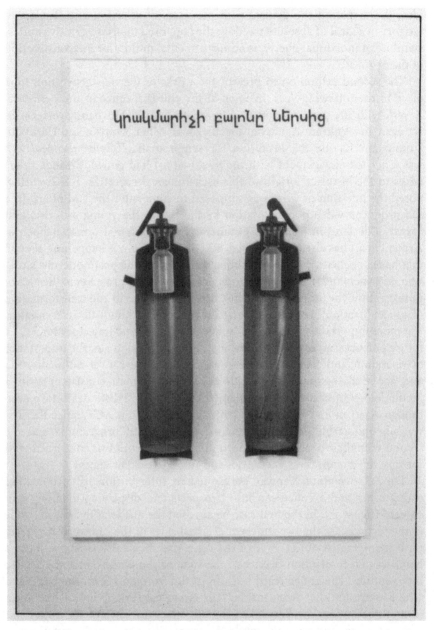

15 David Kareyan, *A Fire Extinguisher from Inside*, 1994. Exhibition *P.S. Evolution*, Arvest Gallery

upon the sponge itself. Then he fixed each inscription recursively incorporating its predecessors on the wall until this chain reached the floor and continued from there.

Aghasyan's work *A Display of Material and Object* complied with a method that the artist later described as 'sanitary-hygienic'.[53] Two frames, the first fitted with a glass pane and the second with an inscription that read 'Glass', hung next to each other. Another pair included a framed cut-out from a parquet floor and a rectangular cut from a newspaper. The full page of the newspaper with the cut-out part missing was displayed without a frame underneath the framed piece as a kind of photographic negative juxtaposed with its framed 'positive'. The newspaper itself, however, framed a part of the empty wall, thus questioning the separation between the work of art, its frame and what is supposedly external to it – the spatial and institutional context of representation.

Azatyan 'overcame' art by mixing Malevich and Ad Reinhardt. His series of four black squares, done in collaboration with the other artists in the exhibition, acquired a temporal dimension as the black colour gradually took over the white background, with the fourth painting being entirely black without any white margins. A quote from Reinhardt declaring the end of art by way of its transcendence of time, space and form stood at the beginning of the series, while another Reinhardt quote – 'Arvesty vorpes Arvest' [Art as Art] – authoritatively hovered above the black squares (figure 16). With the exception of Hovhannisyan's collage of pornographic black and white images selected from newspapers and Simonyan's installation of outmoded furniture and old photographs ('too personal to explain')[54] the exhibition presented an aesthetic coherence unheard of in the 3rd Floor's events. In addition, the exhibition established a different idea of the new than the 3rd Floor aimed to achieve.

If, for the 3rd Floor, the function of the new was to establish a qualitatively conceived temporal differentiation between National Modernism, Armenian Socialist Realism and contemporary art, for the young artists of the 1990s generation the new was both a temporal and a spatial notion. The 'new' in the 3rd Floor's practice was identified with absolute freedom, crystallized in the artist's right to mix historical and contemporary schools, styles and images on the same canvas. Thus the new was established upon taking culture as material for appropriation and recycling it, and this was made possible by the avant-garde youth of perestroika. In ACT's case, however, the generational qualitative break from the past secured by 'youth' was arguably combined with a spatial function of the new, as that which secured an institutional separation between art overcome by the idea of art ('pure creation') and an everyday life contaminated with impurity. The binary opposite of 'pure creation' had a repressed counterpart: 'dirty [empirical] reality', or everyday life. As with any discourse of purity, this one had to be constantly policed, reasserted and reframed, so as

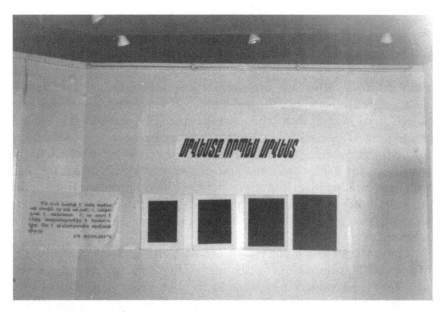

16 Collaborative work of the participants of *P.S. Evolution, Art as Art*, 1994. Photograph: the editorial team of *Arvest*

not to allow the infiltration of unwanted elements. The very need for a constant reaffirmation of the term indicates its vulnerability and fragility, for the equivocal relationship of 'pure creation' with everyday life was to constantly haunt ACT's exhibitions, discourses and interpersonal relations. And as any ambitious concept, pure creation both succeeded and failed.

'Pure creation' and everyday life

Through methodically establishing rigid boundaries that separated the space of artistic creation from everyday life, ACT situated the discourse of the new in direct relation to the space and institutional context of displaying art. In addition to their evolutionary understanding of art as an idea teleologically fulfilled through emancipation from its own material boundaries, for the young conceptualists art was also a *space* for fixing an object as art, and this space was to safeguard 'pure creation' from the banality of everyday life. Here the discourse of the new is carried forth both by the telos of history and by the spatial separation of autonomous art from all that is external to it.

This artistic teleology went hand in hand with the dominant cultural narrative of the new nation state as the historical culmination of the Armenian nation's age-old struggle for self-determination in a particular space/territory. Ultimately, the state was conceived as the spatialization of the nation's

temporal evolution. Even though there are structural similarities between the spatialization of time in the nation state and the spatialization of art's telos after the end of art, the relations between the two are neither direct, nor derived from each another.

Since the advent of art's claim to autonomy in the mid-nineteenth century, this claim has been secured by the substantive notion of the new as a wholesale negation of tradition as such. Art's historical progression towards its self-realization forecloses, on the one hand, a regressive return to a state of pre-autonomy, and on the other, a post-autonomous undoing of the laws of its constitution. Autonomy can be threatened (in the case of ACT, this threat comes from everyday life, from subjectivist approaches to art production, and from postmodernist impurity, among other things) but never revoked. Their direct inspiration for the conception of autonomy was Joseph Kosuth's linguistic-analytical conceptualism,[55] in which art is sublated in the idea as it frees itself from anything that is external to it.

ACT mobilized the understanding of the new both as a temporal marker of novelty vis-à-vis what came before, and as a spatial marker of separation between art and everyday life. In *P.S. Evolution*, art was seen to be overcome by reclaiming its irrevocable autonomy through its concept (hence the Reinhardt reference) by way of spatially separating objects from everyday contexts. This is a dynamic that was to shape ACT's practice in 1994–96, and one that was paradoxically subjected to pragmatism to ensure survival in the harsh conditions of everyday life. In the video recording documenting the exhibition, and as a postscript to the presentation of his work, Kareyan half-seriously and half-ironically presents a 'quick, easy and efficient way to knot a tie'.[56] Is this meant to be a performance, a work of art enacted in the exhibition space and documented on video camera, or is it simply a 'how-to' recipe for everyday life? The answer is not one or the other, but both: in Kareyan's understanding, an artwork as an autonomous sphere doubled as a 'how-to' recipe for survival in the harsh conditions of everyday life, a technique borrowed from the survival toolbox of the newly forming liberal democratic state.[57] But this also shows the importance of choosing one's method and staying true to it, which ACT's members did with varying degrees of commitment.

The domination of texts over all other media and the self-reflexiveness of artworks vis-à-vis their own constitution, along with ACT's iconoclastic tendencies and its austere minimalist sensibilities, contrasted with the 3rd Floor's idea of spontaneous creation. For the alternative artists of the 1980s, spontaneity was equated with youthfulness itself. As opposed to this, the exhibition *P.S. Evolution* was more of a 'laboratory of art', as Kareyan described it in a conversation with me in 2008. The stylistic and formal contrasts with the 3rd Floor were so striking that the 3rd Floor's artists accused the younger artists of producing art that, as Kareyan recalled, 'was elderly in its style'.[58]

Kareyan's solo action shortly after the exhibition *P.S. Evolution* took place in July 1994 on Abovyan Street, one of the busiest locations in downtown Yerevan. The action defined another artistic strategy, that of 'inspection'. The action, which some remember by the title *Pure Creation* and others by *Inspection*, was in fact called *Invisible and Insignificant Objects: Fixed*. The confusion over titles is not accidental, since at the time Kareyan was aesthetically and theoretically developing three interrelated procedures simultaneously – 'fixation', 'inspection' and 'pure creation' – as part of his graduation work at the Fine Arts College in Yerevan. This action is key for expounding upon the interrelated strategies introduced above. An action meant 'to start a conversation about art as pure creation',[59] it presented a collection of waste: 'insignificant' objects from the street classified and displayed on a public announcement board behind glass. The 'fixed' found objects were accompanied by their linguistic descriptions: 'a garlic peel', 'a piece of dust', 'copper wire', 'chewing gum', 'a piece of plastic' and so on. The video documentation of the work is quite revealing, as Kareyan directs the cameraman to focus on specific 'fixed' objects that have been 'inspected', in other words selected and displayed by the artist. As the camera lens travels from the ground, which is covered with similar but unfixed objects, before it focuses on one of the artist's selections, Kareyan asks the cameraman not to miss the sunflower seeds on the ground. Thus, through the camera a similar operation of inspection – selection and display – is performed, following the artist's command.

This reveals the dialectic of art's autonomy and its contingency upon what is external to it. The distinctness of the objects *displayed* from the millions of indistinguishable, insignificant objects that constitute the material landscape of our everyday is established dialectically, in relation to those very 'insignificant objects' that are outside the frame of this display. The sunflower seeds to which the artist points as 'recordable' frame that separation via his act of declaration. The sunflower seeds constitute the very frame, even if porous, that demarcates the spatial separation of art and everyday life, of the new and the banal. In an Adornian move, autonomy is established through heteronomy. For Kareyan, inspection was an operation of assigning everyday objects the status of pure art objects, in which the artist becomes an 'assigner' who identifies 'pure creations' lacking any artistry or manual skill – absolutely non-artistic objects – as absolutely artistic objects.

The youth exhibition of 1994 at the Artists' Union, which became an immediate prelude to ACT's formalization as a group, shows not only that it was impossible to keep art separate from everyday life, but also that within the artistic scene itself the young artists' attempts to separate their 'pure' discourse from other dominant artistic discourses were haunted by a failure to maintain this separation (figure 17). Moreover, the exhibition was testimony to the impossibility of realizing rationally calculated goals, purposes, out-

Youth exhibition *69*, general view, 1994, Artists' Union **17**

comes and modes of reception, since the clash with the everyday manifested, time and again, the radical contingency of the production, representation, reception and especially afterlife of 'autonomous art', in a context that was constantly changing in unpredictable ways.

As mentioned in the previous chapter, youth exhibitions held annually at the Artists' Union in the Soviet era had come to stand for emerging alternative artistic trends in contemporary art in Armenia, ever since the 3rd Floor intervened in and organized the youth exhibition of 1987. With its loud manifestations, enthusiasm and specific aesthetics that came to represent youthfulness, the 3rd Floor took over the organization of youth exhibitions until 1993. These exhibitions, which later on found an equivalent in festivals of alternative art organized at the Armenian Centre for Contemporary Experimental Art from 2000 onwards, came to glorify youth as a substantive generational category, rather than merely a chronological one. It is quite telling that the artist Anita Arakelyan, at the time in charge of the Youth Department of the Union of Artists, invited artists Kareyan and Aghasyan, along with Hrach Armenakyan, Narek Avetissyan, Narine Aramyan and Diana Hakobyan – all soon to-be-declared members of ACT – to organize the 1994 edition.[60] This act of invitation is in and of itself a recognition that a generational change had take place: the 3rd Floor are no longer the youth of the new decade.

The new 'official' youth conceived the exhibition as a 16-day long and per-petually changing event, subject to daily modifications, with new works dis-played every day. The list of participating artists was rather diverse in terms of age and generation, and included several artists formerly associated with the 3rd Floor such as Arax Nerkararyan, Ara Hovsepyan and Karine Matsakyan.[61] But a clear preference was given to the various conceptual tendencies preced-ing ACT.

According to one of its organizers, Vahram Aghasyan, the exhibition was 'untitled', with the working title 69 as a provocation signalling the arrival of a new generation of rebellious youth on the contemporary art scene in Armenia.[62] The handmade banner for the exhibition was a very large collec-tively made collage of newspaper cuttings, various product labels, scrap paper and other found material, with 69 discreetly appearing on the left-central part of the panel, and 'Youth Exhibition' handwritten on the upper cen-tral part of this DIY poster (figure 18). The banner itself was made by 'fixing' the found materials that accumulated over the five days of the exhibition as it changed with each day. Even the performative elements in the 1994 exhibition, including the decision to change the exhibition every day, were calculated and pre-organized interventions into the very process of the exhibition as an ongoing event.

Two things need to be noted here: first, ACT's banners, posters and often invitation cards were largely handwritten; and secondly, everyday objects, 'insignificant' materials and garbage were used both by the 3rd Floor in the late 1980s and by ACT in the mid-1990s, though in rather different ways. In 1987, the year when the young artists of the perestroika generation were negotiating their place within the art institutions of the time, Nazareth Karoyan performed the action 'Garbage' (figure 19). Whereas Karoyan's action of categorizing and displaying garbage was meant to expose the 'dirty reality' behind the late Soviet official ideological façade of the beautiful life, the collection and 'fixation' of garbage was presented by Kareyan and his peers as an act of 'pure creation', an act that refers to nothing but itself. If the first action of 1987 is a critique of the art institution as that which masks its own ideological commitments, in the second case the action is a procedure that affirms art as an institution. In Karoyan's action, garbage signifies the unconscious of rationalized institu-tional (re)presentation, whereas in Kareyan's fixation, found material is the signifier of the triumph of rationality in the figure of the artist who makes calculated choices. This hyper-rationalization, which characterized ACT's practice, served as a means of identifying with the ongoing transformations of the state structure, as I will argue in the next section of this chapter.

Referring to the instrumentalization of artists by ideology in the Soviet context, the young artists wilfully put their practice in the service of the construction of the new state based on principles radically different from

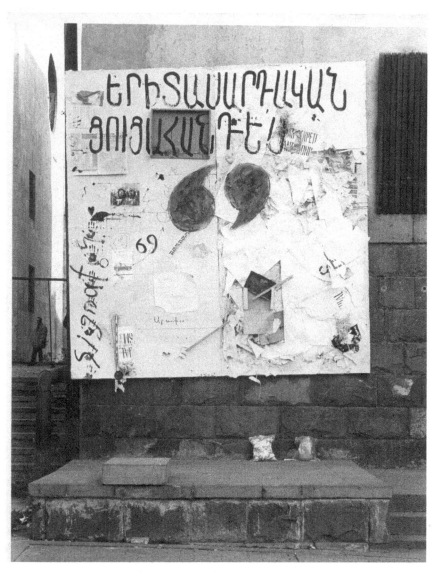

Youth exhibition *69*, general view, 1994, Artists' Union **18**

what came before. As I argue later in this chapter, they juxtaposed pure creation with pure constitutionalism. This voluntary self-instrumentalization was taken to such an extreme in ACT's practices that it led Grigoryan to make an analogy between the young artists of the independence era and a stereotypical Soviet artist who both participated in and constructed the 'rigid pseudo-positivistic definitions of demagogic operationalism of "scientific communism"'.[63] The

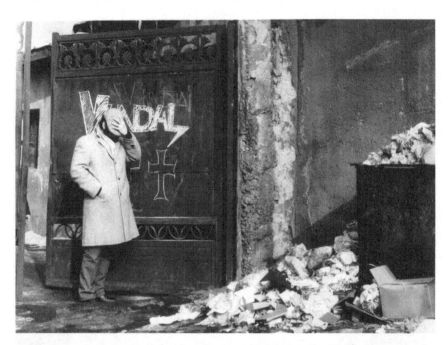

19 3rd Floor, group photo session and performance. Exhibition *Plus Minus*, 1990.
Photograph: Karen Araqelyan

degree of self-instrumentalization and reduction of individual subjectivity to narrowly confined functions is evident in the aesthetic procedures the group adopted. In a handwritten note signed by Aghasyan and dated 1994, the reduction of subjectivity to its social functions takes an extreme form: 'I see myself as a particle in the system who examines, discovers, edits, adds and continues. [I am] someone who possesses alternative, experimental and sanitizing functions.'[64] A paragraph by Hrach Armenakyan from 1995, entitled 'Post-Art Condition: Logical Syntax', is even more extreme in declaring:

> The transformations of thinking processes throughout time are prerequisites for progress, and this progress is realized through the functionalization and materialization of the idea, which should be conducted by different specialists within the system. They, in turn, are a part of this total system, operating and regulating it.[65]

The difference between a romantic 'dreamer' and a pragmatic liberal who rationally and logically argues does not merely illustrate the difference between a 3rd Floor artist and an ACT artist, but more importantly reflects the difference between the late Soviet context of perestroika in the late 1980s and the operational-functionalist discourses of new statehood in the early 1990s.

While, for Grigoryan, art was a vast collage of different images, styles and schools in which everyone could freely *choose* to be an artist, for Kareyan, art's annihilation of itself for the sake of 'pure creation' was an aesthetic/political programme that needed to be propagated and instituted. As such, it was to adopt the procedural and formal elements of liberal democracy for its own legitimation. It is therefore not accidental that from 1993 onwards, Kareyan was developing a project called POLIT-ART. This project involved three different aesthetic strategies that were directly borrowed from the political procedures of liberal democracy: referendum, demonstration and agitation. Even though most of the projects that actually emerged from this triad were realized as individual artistic initiatives by Kareyan, they largely became possible within the context of ACT's self-declaration as a coherent collective after the youth exhibition of 1994. I will refer to these specific artistic-political manifestations in more detail in the following section of this chapter. However, here it is worth noting that, for the youth exhibition, Kareyan intended to carry out a performance that utilized the tools of political propaganda to talk about art in ways that brought the artistic proceduralism of pure creation close to the political proceduralism of liberal democracy.

Kareyan arranged to be interviewed live on a radio programme (his father worked at a radio station) that would coincide with the opening of the exhibition. The interview would be aired through loudspeakers for the audience in the exhibition hall, an example of Kareyan's strategy of 'agitation'. Everything seemed to be running as planned, except for the moment when the artist Grigor (Grisha) Khachatryan, known for his humorous provocations, entered the exhibition hall and filled it with his loud, extravagant and already well-recognized laughter.[66] Khachatryan's intervention was accompanied by chants of 'Hare Grisha' (a mocking version of 'Hare Krishna' referring to the then-popular cult of Krishna).

This spontaneous and situational intervention in the space of Kareyan's thoroughly planned and pre-announced radio action introduced a gap between the artistic intention to disseminate a specifically structured message and the failure to accomplish it. Kareyan, using the tools of propaganda and agitation, planned to 'talk about serious things, like arts and politics', as artist Narek Avetissyan recalls.[67] However, without an attentive and receptive addressee, propaganda turns into what an Armenian idiom terms a 'poor man's radio': a speech that is constantly and incessantly uttered but is not heard. But it is not the specific message intended for the exhibition audience that failed to reach its addressee (here the content of Kareyan's address does not really matter), but precisely the form of the speech authoritatively coming out of a loudspeaker and intended to encompass the sonic space of the exhibition – which broke apart once it encountered a lack of addressee. Ironically, ACT's exhibitions and actions are full of examples where artistic

intentionality fails to carry forth its programme when confronted with the contingency and unpredictability of everyday life.

Rusanna Nalbandyan's work in the exhibition was to literalize the separation of art from everyday life and the art object from the audience. She stretched an almost invisible rubber string from one corner of the exhibition hall to another, cutting the space diagonally and thus producing a visually undetectable but tangible barrier between the artworks and the audience. Some of the audience members did not notice the barrier and fell on to the other side, accidently appearing on the side of 'art'.[68] The accidental transgressor appeared in the position of both victim and perpetrator, culpable for violating the physical boundary set by the artist.

The rigid separation of art and everyday life, and the subsequent impossibility of clearly demarcating the boundaries between the two, was one of the reasons why the exhibition was forced to close down six days after its opening, instead of the original fifteen days. The cause of closure was an act of censorship. Samvel Hovhannisyan presented a series of provocative pornographic drawings of oral sex (figure 20). The work was tolerated by the Union of Artists, the venue of the annual youth exhibitions, until some of its members figured out exactly what the drawings represented. According to Avetisyan, in their complete ignorance of the pornographic nature of the drawings, the conservative and moralistic artists of the Union only identified their obscenity when the art historian Poghos Haytayan told his colleagues what they signified. Consequently, several members of the Union vandalized the drawings, labelling them as 'anti-aesthetic and pornographic and renounc[ing] the new generation as "plagued"'.[69]

As the journalist Christina Ter-Sargsyan reports in her unpublished notes, there were even fistfights between the Union's members and the artists of the youth exhibition. She also comments: 'the older generation, *which suffers from being uninformed* [italics mine], described the exhibition as pornographic … this attitude produced revolutionary feelings in the young artists and served as the impetus for the youth movement called ACT.'[70] The act of censorship becomes a dividing line between the older generation of Soviet artists and the younger ones of the post-Soviet period, and it is a barrier defined by being informed. In addition, the conflict triggered 'revolutionary feelings in the young artists' towards the outmoded values of the older generation. In terms of conceiving of information as value in itself, as well as in the generational struggle that marks youth as qualitatively different from what came before, ACT's formation echoes that of the 3rd Floor, albeit in different conditions of art production and reception. It is noteworthy that both collectives (the first a spontaneous movement and the second an art group) emerged in the aftermath of the Artists' Union's youth exhibitions and marked a generational shift in the art scene. Though using different means, the younger generation of artists of

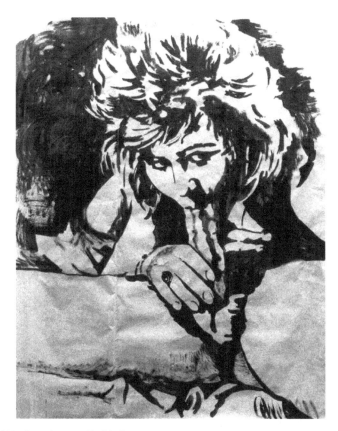

Samvel Hovhannissyan, *Untitled*, 1994 **20**

the 1990s were similar to their late Soviet avant-gardist counterparts in that they conceived of their artistic practice within a regime of urgency, wherein the present (defined as an ongoing moment of transformation and change) triumphs over the past (the stagnant values of the older generation). The past is not merely conceived as that which transforms itself into innocent history but as that which, as Groys puts it, 'stands between us and our present', preventing the subjects operating in the regime of urgency from exposing themselves to the true promise of the actual moment of the here and now.[71]

ACT's manifesto, written in February 1995 by Hrach Aremenkyan and Samvel Hovhannisyan, reads like a glorification of the present. Here the artists come forward as the messiahs of the moment: 'Only one who can feel uncontrollable energy in himself in the present situation can perform a surgical intervention in time.'[72] These 'surgeons of time' were supposedly the possessors and controllers of a limitless flow of information: 'The flow of information

is no longer outside of us. It is present in our actions and activities. Time races axing [*sic*] days.'[73] The importance of the present moment shines through in the need to construct a new life, a new environment and new social relations. As opposed to the decadence of the dead past and the vagueness of the future, time is accelerated in the present. Time is not conceived ontologically, as abstract and external to experience, but as embodied in the subject as the agent of temporality and as the carrier of movement and change:

> The new generation cannot leave its deeds to time since time is in [the new generation] and through it [time] reveals its transformations ... The new transformation that we carry out and manifest in our practice is what we call ACT ... We are no longer calm; neither will be the flow of time that is conditioned by us.[74]

Perhaps it is not accidental that it was precisely during the time of the 1994 youth exhibition, when the generational conflict intensified, that the young artists decided to coin the term 'Actual Art' in relation to their self-proclaimed group (which they would soon drop in favour of the laconism and sharpness of ACT). It is not that the young artists were confronting the older generation of master painters for the first time. As students at the Fine Arts College and at the Academy of Fine Arts throughout the 1990s, they were fully exposed to the tastes, values, aesthetics and techniques of their instructors. The latter, as they appeared in the previous chapter, were conservative members of the Artists' Union who had resisted perestroika cultural reforms.

The first exhibition of the ten members of the group was entitled *Act* and opened in April 1995 in Nazareth Karoyan's Ex Voto Gallery. It was dedicated to the expansion of the notion of 'pure creation' as a programmatic aesthetic approach, which would define the group until Kareyan and several others left it little more than a year later. The exhibition showed that the notion of 'pure creation' was differently understood by the various members of the group, and is indeed a good example of the ways in which 'pure creation' was constantly haunted by its other – everyday life, subjective experience and, quite literally, dirt. The exhibition *Act* aimed at 'presenting the pure idea which serves as the basis of the youth movement'[75] through active interventions in the processes of art production.

Upon entering the space of the exhibition, the viewer must have been confused, since it looked like a chemical lab rather than an art event. The space greeted the viewer with Aghasyan's multiple pink arrows on the walls and floor, pointing everywhere and nowhere, at each other and at various architectural elements of the room. Narine Aramyan's *Transformation of Material Through Phases* presented lab containers and various paste-like materials on glass shelves, and was a chemical experiment with matter in solid, liquid and gas states. Armenakyan's work was something between a minimalist

structure and a utilitarian object. On a transparent platform stood a white-painted small wooden cabinet covered with mirrors. The coldness of the white functional object disappeared when the viewer opened the cabinet door and revealed trash inside the outwardly sanitized box. Kareyan remained truthful to his procedures of fixation and inscription. His triptych consisted of a Plexiglas light box and two Plexiglas sheets with texts on them. The light box, titled 'Agitpoint', announced 'Transformation of Surface. Replacing the Canvas with Organic Glass', and described the work as the process of making that very work. The other two glass sheets contained inscriptions such as 'POLIT ART', 'Referendum', 'Agitation' and 'Demonstration', and *Actayin hosank* [Actual wave]. The same inscriptions were typewritten on pieces of paper and thrown out on to the street from the open window of the gallery, as a means of 'agitation' (figure 21). Arthur Vardanyan's work was an assemblage of a metal box with a peephole and the word 'look' on it, a light bulb and an English text. Naira Aharonyan presented *Decay of the Fact*, a series of clothes hangers decaying through a process of gradual reduction of their form until only the head (which reads like a question mark) remained.

The clash between ACT's dominant artistic philosophy of evacuating subjectivity, on the one hand, and everyday life, on the other, from the creative process and the end result became most pronounced in Diana Hakobyan's, Narek Avetisyan's and Samvel Hovhannisyan's works in this exhibition. Narek Avetisyan's work, with its porosity, allowed aspects of everyday life to intervene, despite the artist's own intention. His project involved him walking from his home in downtown Yerevan to the Ex Voto Gallery with a tape recorder documenting the street sounds on his way. In the exhibition venue, the audience could rewind the tape and replay the recording. The participatory promise of this *Audio Fixation* tempted several rock musicians to subvert the work by changing the audio recording and putting on rock and roll music instead. The following dialogue between the artist and audience members was recorded:

> Avetisyan: 'What are you doing?'
> Audience member: 'We are changing the tape.'
> 'But this is *my* work.'
> 'What? We thought this was an action.'
> 'But this is my action. I don't need others' interventions.'
> 'What kind of a free artist are you if you are not letting others participate in your action?'
> 'If you want to make your own action, go ahead. But this is *my* action.'[76]

Another example from this exhibition, revealing the rigidity of artistic boundaries as defined by ACT, in which the only valid intervention was the action of pure creation, had a more tragic consequence. Samvel Hovhannisyan,

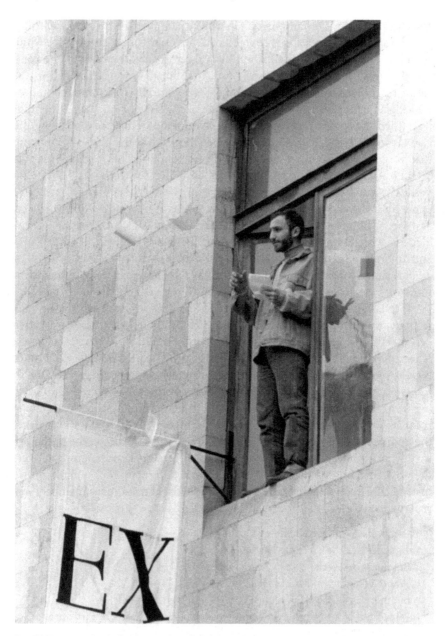

21 David Kareyan, *Art Agitation*, action. Exhibition *Act*, 1995, Ex Voto Gallery

playing with the notion of citizen responsibility, installed two quick-heating irons of Soviet production facing each other. Between these unplugged irons he installed a living parrot trapped in a cage (figure 22). Several of the group expressed their discomfort about displaying this work, opposing the underlying cruelty of this act and arguing that it had nothing to do with the purely conceptual questions posed by ACT. Nevertheless Hovhannisyan went ahead. And indeed, someone from the audience turned the irons on, and the bird was rapidly burnt to death. Soon the artists found the dead bird decapitated and its head put on the cage. This was a violent and brutal penetration of the everyday into the sanitized space of ACT's 'pure creation'. Society, which in ACT's imaginary construction ran on citizen responsibility and social awareness, would collapse time and again when confronted with the actuality of the everyday.

In *The Flight is Normal*, Diana Hakobyan used photocopied sheets of A3 paper that shared a common background: a found photograph of a close-up of a child's face next to an aeroplane window (figure 23). A text handwritten using gouache that recorded each minute of a nine-hour sequence was layered on the image. Each image was repeated on the wall fifty-six times, in the form of a grid, and each image registered a different record of time. *The Flight is Normal* captures time in its literariness, just as time is registered in

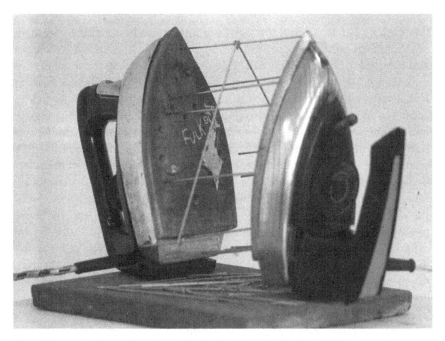

Samvel Hovhannisyan, *Experiment*. Exhibition *Act*, 1995, Ex Voto Gallery **22**

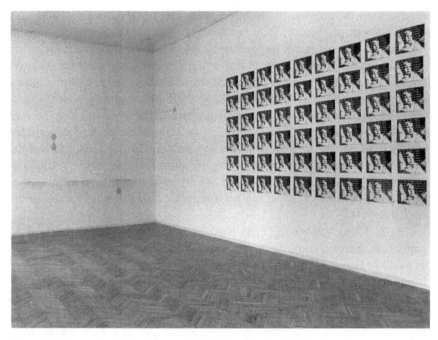

23 Diana Hakobyan, *The Flight is Normal*. Exhibition *Act*, 1995, Ex Voto Gallery

the black box of an aircraft through communication between the command centre and the pilot. The repetitive temporal record juxtaposed with a clipped and enlarged magazine image of a child delivers the work in the form of mass information, yet without the latter's sensational and scandalous content. Hakobyan's work introduces the normalcy of the everyday into the field of aesthetic experience through banal and repetitive statements that register non-action. In *The Flight is Normal*, the everyday is estranged from the subjective experiences of those very actors who participate in and constitute it. As records of time, these statements de-subjectivize the experience of temporality to the extent that the objectivization and abstraction of time dialectically return the subject to history. Subjectivity as such is suspended here within the objective record of temporality, between writing as trace and the found photograph that registers absence. Yet this suspended subjectivity has the capacity to threaten and rupture the record, which functions as a pillar of normalcy. This threat will not materialize through a revolutionary rupture about to explode the homogeneous flow of time, but through the subtle differences between the various grainy reproductions of the photograph and the fragile lines of the handwritten text. It is this sense of implied but immaterialized threat and of the promise of the overthrowing of the regime of normalcy that distances Hakobyan from ACT's dominant objectivist approach.

In a way, Hakobyan's work, in its recollection of the ordinary and the quotidian and its evocation of subjectivity, is in itself a record of ACT's temporality and experience, one that registers the group's aesthetics as if it were being looked at from the perspective of the future. In a manner that is self-reflexive, the work captures and shows to the other artists what they had to suppress in order to claim objectivity for the sphere of art. Subjectivity that is recorded in its extended moment of suspension is the subjectivity absent from the dominant aesthetics of the group, and this suspension was soon to be followed by the return of the subject with a vengeance after the collapse of ACT.

The 1995 *Act* exhibition, a project in which all ten artists presented together as a group for the first time, illustrates the ambiguity of 'pure creation' as a rational action that contains its own radical opposites – the everyday, the ordinary, subjectivity and contingency. It is in this sense that the concept is inherently political in that it exposes the impossibility of policing boundaries. Kareyan's definition of pure creation, with which the other members were working as well, implied both the abandoning of the formal qualities of art as defined by its specific media and a discursive and aesthetic expansion of art to encompass other spheres of activity. But paradoxically, 'pure creation', while detaching objects and phenomena from their indigenous contexts and granting them the status of art objects through separation, emerges from specific contexts, situations and experiences embedded within the everyday. It is a procedure that secures a contingent autonomy, one always haunted by heteronomy.

Politics of 'pure creation', pure creation of politics

Now that I have outlined the main aesthetic programme and strategies that informed the constitution of the group during the mid-1990s in Armenia, in what follows I will explore those frictions that emerged in the incommensurability between art and politics, between aesthetic strategies of pure creation and formal procedures of liberal democracy, between art as a sphere for autonomous creation and its constant contamination by the contingencies of everyday life. I hope to show some of the ways in which ACT identified with the prevailing political discourses in Armenia of the time and the ways in which it constructed its mechanisms of self-legitimization within the body of these discourses. I argue that the notion of 'pure creation' rearticulated the relationship between art and the state. While pure creation supported a notion of art's autonomy that was inevitably political (since it affirmed the boundaries between art and life while exposing the impossibility of maintaining an absolute separation), at the same time it offered an articulation of aesthetics as inherently embedded in politics. What ACT's identification of

pure creation with the construction of the state exposed, even unintentionally, was the ways in which the mechanisms of the liberal democratic state operate through form, as well as the aesthetic horizons of its political vision. ACT, I argue, exposed the constitutional state as being procedurally identical with the artistic processes of pure creation.

In a speech delivered on the occasion of the Pan-Armenian National Movement's 7th Congress[77] on 26 December 1995, the first president of Armenia, Levon Ter-Petrosyan, declared:

> The Constitution adopted in an all-national referendum on July 5 [1995] has fixed the system of governmental and economic institutions and defined the authority and spheres of function of legislative, executive and legal powers as well as the right of private property and free business. But the duty of the state is not only to take care of the construction of state and economic structures but also of the creation of social and political institutions. Therefore, the creation of political parties as the main institutions of democracy is one of the most important tasks of the state.[78]

This speech was delivered approximately six months after the referendum on adopting the first Constitution of the Republic of Armenia on 5 July 1995. What is peculiar in the paragraph quoted above is the president's declaration that it is the duty of the state to carry out the work of instituting political parties, an important component of civil society in liberal democracies. At first glance, this seems to run in opposition to the fundamentals of the ideology of classical liberalism to which Ter-Petrosyan as well as his Pan-National Armenian Movement adhered. Classical liberalism advocates the radical reduction of the state's function as a prerequisite for the formation of the public sphere and civil society. It is liberal conditions, taken as a given, that make the emergence of civil society possible without the need for the state's interference.

The notion of the public sphere, most comprehensively formulated by the German social theorist Jürgen Habermas, implies that the public sphere and civil society are precisely constituted by the lack of interference by the state.[79] According to Habermas's conception, the public sphere historically emerged when, in the nineteenth century, economic capital in France that had accumulated in the hands of the emergent bourgeoisie was being transformed into intellectual capital. As a result of the complex processes involved in this transformation, the bourgeoisie established itself as the dominant class, and facilitated the emergence of an urban intelligentsia as one of its strata. The coming of age of the bourgeoisie as a cultured class was fostered by the development of print media as well as other modes of communication through which private individuals could come together to discuss ideas, exercise judgement and criticize contemporary politics, culture and society. For Habermas, the

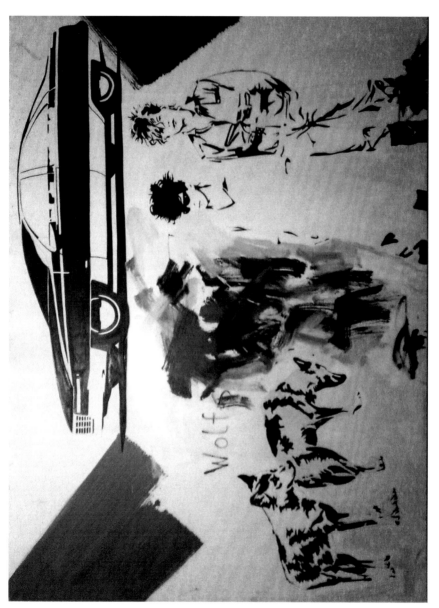

1 Arman Grigoryan, *Wolves*, 1992

2 David Kareyan, *Uncontrolled Desire to Disappear*, installation at the exhibition *Crisis*, 1999

3 David Kareyan, *The World Without You,* video installation at the exhibition *Beyond Icons,* National Gallery of Armenia, 1999

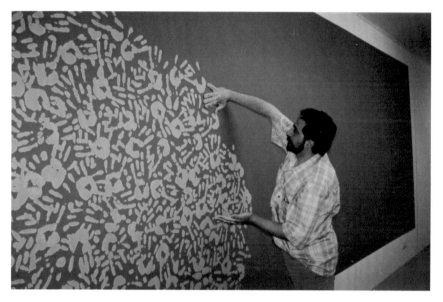

4 Narek Avetisyan, *Spaces of Light and Trace*, 2006

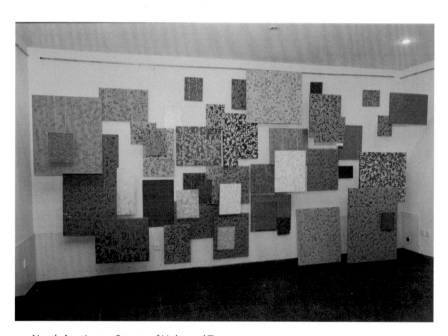

5 Narek Avetisyan, *Spaces of Light and Trace*, 2006

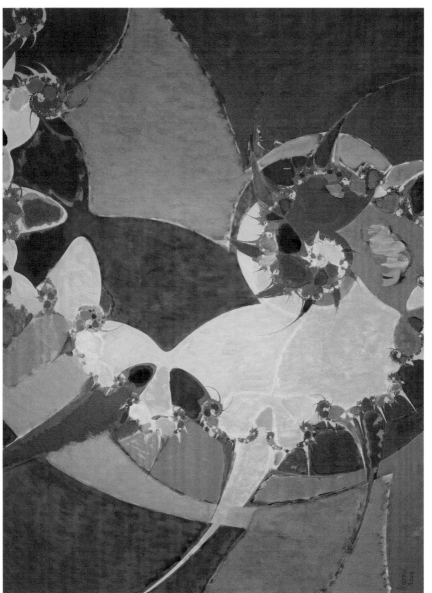

6 Narek Avetisyan, *Interfraktal N. 2*, C print, acrylic, canvas, 2010

7 David Kareyan, *Incomplete as Usual*: *New Locality*, solo exhibition, ACCEA, 2009

8 David Kareyan, *Incomplete as Usual: New Locality*, solo exhibition, ACCEA, 2009

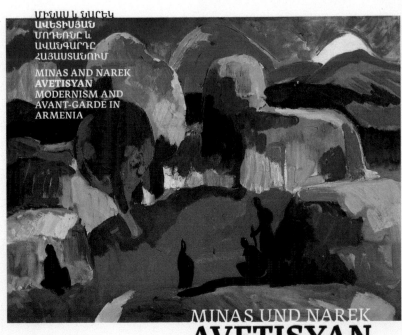

9 *Minas und Narek Avetisyan: Moderne und Avant-garde in Armenien*, exhibition catalogue cover, Kunstmuseum Moritzburg, Halle-Saale, Germany, 2014

public sphere is precisely the sphere constituted by the communicative acts of the urban intelligentsia in Europe during the age of developed capitalism. In short, the Habermasian notion of the public sphere was historically attached to the advent of the bourgeoisie as a social class seeking expression and representation. Thus, as a zone of state non-interference, the public sphere was in itself an opening created by the 'withering away of the state' – not as in Lenin's understanding of the disappearance of the state as part of a historical process that makes it redundant, but as a temporary suspension, so that the bourgeois public sphere could reach a consensus to ultimately legitimize the political power of the liberal democratic state. Thus the constitution of the Habermasian public sphere was dependent upon the temporary suspension of the state's influence on a particular configuration of communicative individuals, allowing these individuals to reach consensus through debate.[80] In its liberal rendering, politics is constituted through the communicative acts of rational individuals who come together to debate.

Historically, in the USSR the public sphere developed and functioned without the civil society and market relations that characterized the Habermasian formulation. The gradual and belated evolution of the bourgeois public sphere in pre-Revolutionary Russia (and by extent, the peripheries of the Empire) in the late nineteenth and early twentieth centuries[81] was violently halted as the October Revolution changed the course of Russia's history. Cultural institutions were rapidly nationalized and the formation of the proletarian public sphere was carried out by the political and artistic avant-gardes alike as a consistent programme: the public sphere materialized in schools, libraries, factories, universities, in the pages of books and newspapers and in the spaces of artistic workshops.

The Bolshevik anti-bourgeois public sphere was, however, short-lived. With Stalin's accession to power in 1924 and the consolidation of his cult of personality throughout the second half of the 1930s, the state, embodied in the figure of one man, methodically eliminated the proletarian public sphere and the public as such. Subsequently, in the periods of de-Stalinization after 1956 and of Brezhnev's stagnation from the mid-1960s to the early 1970s, various private escape routes from the dominant ideology were planned.[82] And when the public sphere began to coincide with the possibility of the public representing itself in the public space through the perestroika reforms, the unique Bolshevik marriage of public property and the public sphere had been long forgotten and erased. The perestroika public sphere was based instead upon radical individualism and a collective unconscious – the dreamworld of private property and consumerism. Here the political was confined to representation and free speech, while property relations were being transformed from the state and the public to the private sphere. With the victory of the perestroika artistic and political avant-garde at the collapse of the USSR and

the imperative to construct nation states, dissident negation, as argued above, became institutionalized as statist affirmation. And it is for these historical reasons, I argue, that the state, though following the liberal version of constitutional democracy, found itself in the vanguard of creating conditions for a public sphere and instituting civil society. It is in this context, as Ter-Petrosyan's speech demonstrates, that the state and civil society, that is the state and the public sphere, coincided.

If we contextualize Ter-Petrosyan's speech within the newly materializing liberal discourses of the independent state, it becomes clear that there was an obvious identification of the state and the public sphere: it was the state that considered itself the public sphere. Structurally, this was possible since the former perestroika avant-garde was more progressive than those who ran the still persisting institutions of the stagnant bureaucracy. For instance, the reformist agenda instituted by the ministries of Culture and Education in the early 1990s often met harsh conservative critique from those still holding on to the prestige and power inherited from the pre-perestroika age.

The identification of the state and the public sphere is arguably one of the more important markers of the so-called post-socialist condition, which it is crucial to mention if we are to understand ACT's claims to public political participation within the discourses instituted by the state, while simultaneously claiming art as a space for autonomous creativity. It was within this context, where the state and the ruling party, at least in the beginning, promoted the establishment of parties politically opposed to their own rule in order to satisfy the whole spectrum of multi-party and multi-opinion democracy,[83] that ACT strove to form part of the state-orchestrated public sphere through artistic means. They did this by adopting forms of manifestation that normally characterize political participation in representative democracies. These methods of artistic-political manifestation were especially characteristic of Kareyan's work of this period, and some of the actions he initiated were carried out as collective actions by ACT artists. If the artistic procedures of 'pure creation' included inscription, fixation and inspection, its formal political procedures were the referendum, public agitation and authorized peaceful demonstration.

In January 1995, Kareyan presented his piece *Art Referendum* at an exhibition of Armenian art in Bochum, Germany. The work was a transparent ballot box with the label 'referendum' on it (figure 24).[84] A rare photograph, reproduced in several newspapers and periodicals, shows the artist standing behind the box, with a pen in one hand resting on a stack of papers, and inserting a folded paper into the ballot box with the other hand. The action is carried out with the uttermost seriousness as the artist's gaze is fixed upon the action he is performing. Narrative accounts claim that audience members were invited to fill in a questionnaire about various mundane issues and drop

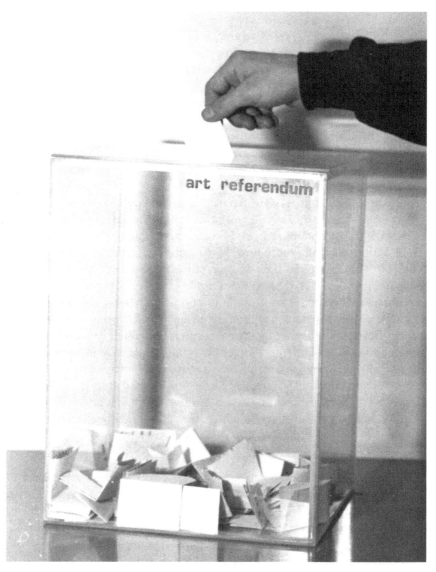

David Kareyan, *Art Referendum*, action, 1995. Image copied from *Grakan* monthly, **24**
January 2011

it into the box.[85] Mimicking political participation in liberal democracies, the installation, I argue, exposes this participation as a purely formal act while presenting a political form as an art form. This work renders both art and representative democracy as institutions constituted through convention, and through procedures of legitimization and social consensus. And it is the social

agreement to perform certain rituals, including casting a vote, that constitutes the institution through repetitive and naturalized daily habits.

Both Azatyan and I have read this work in the past as a manifestation of the formal understanding of both the arts and politics that dominated the artistic scene of post-Soviet Armenia. What this formalist understanding entailed, we argued, was a rigid separation between art and politics wherein the ballot box was elevated to the status of a fine art object.[86] However, if we were to do justice to Kareyan's dedication to the notion of 'pure creation' and to the various artistic strategies he developed as procedures for enacting the concept, it becomes clear that the encounter of the political form with the art form renders politics itself as an aesthetic form. Kareyan's interactive work points towards a peculiar marriage of art and politics, where the political form is utilized to construct an artwork. His strategy of political-artistic manifestation was adopted in ACT's collective practices throughout 1995. These actions formally reproduce the constitution of the liberal democratic state, but they do this in the name of 'pure creation', which reveals a marriage not merely between art and politics in general but between the specific discourses of Ter-Petrosyan in politics and of the young artists of ACT in aesthetics. These discourses, without referring to or following from the other, coexist horizontally and mutually constitute one another in such a way that pure politics meets 'pure creation'. This peculiar marriage in the context of neoliberalizing Armenia is brilliantly discussed by Azatyan in his seminar series 'Image-inings of Armenian Reality'. After showing the connection between ACT's rhetoric hinting at neo-positivism and that of Ter-Petrosyan's operationalist thinking fed by Enlightenment presumptions, Azatyan argues:

> At the end of the 1980s and the beginning of the 1990s, with the 3rd Floor and ACT respectively, we witness two different approaches to Ter-Petrosyan's discourses. If the first romantically perceived Ter-Petrosyan as an embodiment of Freedom and the destroyer of the Soviet Union, implying an anarchistic rhetoric, from the point of view of ACT, embedded in the discourses of the 1990s, he was conceived as someone who used cold and calculating logic and acted as a guarantor of the state's realization. In the first case … art, remaining autonomous, discovers its prophetic potential in Ter-Petrosyan's politics, while in the second case art strives to be synchronous with politics, rendering politics itself as an aesthetic practice.[87]

Relations between art, politics and economics are neither straightforward nor simple. Often, aesthetics transforms politics into its own mirror-image, in which what is perceived as politics proper appears in an inverted way, sometimes distorted and often blurry. In a project planned in 1994 that never came into being, politics appears as its own mirror-image through its transposition into the artistic domain. A manuscript, representing a sketch

of a future project, outlines an imaginary newspaper called *Facts*. The newspaper was to be a political/aesthetic platform through which the artists of ACT could construct their own imaginary politics relating to culture, society and economy. This would be a space where the 'facts' of ongoing political events could be turned upside down. Referring to the most pressing issues on the current political and economic scene in Armenia, ACT's newspaper would feed its readers with imaginary constructions. Some of the headlines included: 'A Meeting between Ter-Petrosyan and Chiller',[88] 'Opening of the Three Units of the Nuclear Power Plant',[89] 'The Socialist Bloc has been Established', 'Armenia as a Transit Route for Cultural Communication', 'The State Apparatus is Turning from Active to Hyper-Active' and, finally, 'All Facts are to be Questioned – Part I.' These assertions were conceived as potential political projects that would have been impossible for Ter-Petrosyan to carry out at the time: diplomatic relations between Armenia and Turkey were on ice; the nuclear power plant was to reopen later that year without prior notice; and Armenia had no prospects of becoming a hub for cultural communication, as the country's two borders were blockaded.

'Pure creation', which had secured art's contingent autonomy, allowed ACT to articulate certain visions of the future as actual in the present.[90] The strategy of endowing art with a reality function, as argued in the previous chapter, had also characterized the 3rd Floor's and particularly Grigoryan's work since the 1980s. In the self-designated style of *Armenican Pop Art*, he painted canvases entitled *Love Parade in Beirut's Burj Hamoud district*, *To the Nudists of Los Angeles's Little Armenia*, *To the Punks of Giumry*, and so on, all representing Grigoryan's dreamworld of total individual freedom, expressed within the social sphere. The signifiers of libertarian freedom – punks, nudists, practitioners of free love and homosexuals – were located in culturally conservative clusters in Armenia and the diaspora wherein identity was defined in terms of ethnic belonging. However, if Grigoryan was inverting facts by juxtaposing irreconcilable realities through heterogeneous images, ACT's strategy involved textual and factographic juxtapositions. They claimed to register empirical reality by exposing facts, but they were doing this in order to release the unactualized potentiality latent in these facts. And it is here that ACT's identification with the state turns against itself while revealing their conception of both art and politics as ideal. ACT attempted to root their factographic dreamworld in the empirical world of politics.

No collective action better crystallizes the intersections of the politics of 'pure creation' with the pure creation of politics than the seminal action *Art Demonstration* organized by ACT in the summer of 1995 (figure 25). The idea belonged to Kareyan and can be attributed to his ongoing engagement with 'pure creation'. It is possible that not all of the group members at the time were enthusiastic about the concept and the format of the demonstration,

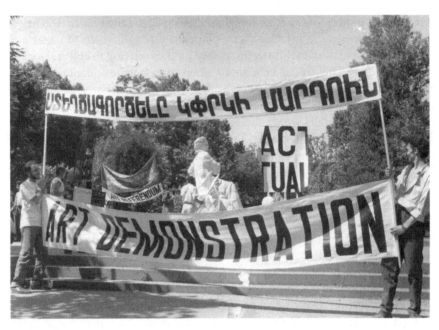

25 ACT, *Art Demonstration*, action, 1995

though their scepticism may also be attributed to their retrospective reading of the action.[91] One way or another, to the outside world they presented an image of convinced and united collectivity.

Art Demonstration was organized as part of the *Yerevan-Moscow: The Question of the Ark* exhibition at the Museum of Modern Art. A unique instance of collaboration between Armenian and Russian conceptual artists, the exhibition came together with the institutional support of the Armenian Centre for Contemporary Experimental Art and the Contemporary Art Sector under the Russian Ministry of Culture.[92] The curatorial theme was proposed by the Russian side and reflected a nostalgic and somewhat orientalist desire to return to a lost biblical land. The metaphor of the lost land functioned as a narrative frame for the Russian artists – around ten Russian conceptualists of the 1980s generation and their younger counterparts of the 1990s generation – who produced largely thematic works related to the concept of the show. The issue of the lost common home (both in a biblical sense and in terms of the recent historical rupture of the collapse of the Soviet Union), the imperative to re-establish the severed communication between two formerly 'brotherly' nations, and the problems of everyday survival under drastically new conditions ran through the works of Konstantin Zvezdochetov, Gor Chahal, Alexander Petrelli and others. The Russian artists even came to the 'land of the Ark' with sugar, bread, oil and other necessary groceries for survival.[93]

As opposed to this thematic treatment, the Armenian contribution consisted of a panoramic survey of conceptual tendencies since the 1980s: Karen Andreassian, Grigor Khachatryan and Manvel Baghdasaryan's semiotic engagement with historically loaded materials and rituals was juxtaposed with the *hamasteghtsakan* post-conceptualism of Arax Nerkararyan, Ara Hovsepyan and Sev, with the younger generation of ACT artists and their friends representing the latest trends in 'pure' conceptual art. Andreassian's statement in a TV programme asserts the commonality of artistic language across the board[94] and seems to emerge from a discovery that the Other, previously seen as drastically different, suddenly appears as the same. This runs counter to the position assumed by the late Soviet Armenian avant-garde of the 1980s, which attempted to establish itself as radically different from the unofficial artists of other republics of the Soviet Union, especially the Moscow Conceptualists and Russian Sots artists (Sots Art was recalled with special contempt).[95] As opposed to the late 1980s imperative to position Armenian practices as radically different from other perestroika-era alternative art practices, the discourses and cultural imperatives of the 1990s demanded that communication be defined as taking place through a common language – the language of a contemporary art now in the process of globalization, with the curated exhibition as its medium. ACT took the issue of communication most literally when it organized its collective action on the occasion of the exhibition, by producing works in English as well as expanding the space of 'pure creation' to incorporate the street.

On 12 July 1995, during the opening of the exhibition and exactly one week after the constitutional referendum in Armenia that approved the first constitution of the independent state, ACT, together with several other artists, marched along the main avenue in Yerevan. Interestingly, they covered the area between the statue of the early twentieth-century Armenian modernist painter Martiros Saryan (and the site of early youth exhibitions in early 1980s) and the Museum of Modern Art. Approximately twenty people carried contradictory slogans in Armenian and English, almost always in black letters on a white background, including signs calling for 'Interventions into Systems', 'World Integration', 'Polit-Art', 'Decentralization', 'Market Relations in Art and Economy', 'Realization', 'No Art', 'Art Referendum', 'New State, Art, Culture' and 'Demythologization', or demanding 'Expel the Information Monsters from Rationality', or proclaiming that 'Every Small Mistake Can Result in Big Catastrophes' or that 'Creativity Will Save Humanity'. After reaching their final destination, the museum, the artists hung the banners on the wall as part of the Yerevan-Moscow group exhibition. In this action, the politics of 'pure creation' directly meets the pure creation of politics, as the slogans were both formal interventions in the art institution as well as manifestations of pure democratic proceduralism in the form of a public demonstration on the street.[96]

I have already argued that 'pure creation' required an act of calculated and deliberate artistic intervention rather than a ready-made presentation of social phenomena, one where the act of intervention was understood as an intervention into the process of creativity, demarcating the boundaries between autonomous art and what was external to it.[97] While both the understanding of politics as a formal procedure (slogans and a demonstration in a public space) and art as an autonomous domain for pure creation problematize a straightforward reading of the work as an instance of social activism, nevertheless I believe that the action connects political procedures with institutional ones that establish art's autonomy while revealing the mechanism of the mutual constitution of art and politics. The reading of this action as a socially engaged work is further complicated by the fact that the slogans were contradictory ('New Art', 'No Art', for example), and taken from the reservoir of ACT's positivist inspirations, which nevertheless refused to become messages without specific political content. It is noteworthy that in a television interview, a journalist asked the artists whether the demonstration was for or against something, to which Aghasyan responded: 'This is simply an action: neither pro, nor against.' Armenakyan, however, responded that sometimes it is pro and at other times it is against.[98]

Even if the action lacked a clear political stance at the level of articulating a message, it is important to mention the affirmative character of the demonstration. It was not an act of nonconformity, disobedience and protest against existing power structures and life conditions. Neither was it an act of 'Great Refusal', to borrow Grigoryan's term.[99] Artists claimed that the aim was to challenge the established conception of the traditional artist confined within the walls of the studio and to bring the question of communication between the state and its citizens into the public domain through art. In a way, they aimed at artistically shaping this process of communication. In many ways, the public march was organized *in support* of the newly formed constitutional state. That is why it was important for the group to receive formal legal permission from the city council to license the demonstration, which in turn required that the municipality provide them with an emergency and police escort. In their application for a licence, they wrote that 'contemporary art is not dangerous' and that 'we are only affirming what is already in process' (figure 26).[100] The march was carried out within the full legal requirements of the new constitutional state; it was 'strictly legal'.[101]

The stamped paper was a guarantee that the artists were a constituent part of the new state as civic agents who had their say in its formation, but also that this contribution was to be purely artistic. Hence the licensing of the action by the state becomes an important part of legitimizing the artistic intervention as a political act, one that also artistically legitimizes politics. Here, both the constitution of procedural democracy through its rituals of legitimization

ՀԱՅԱՍՏԱՆԻ ՀԱՆՐԱՊԵՏՈՒԹՅՈՒՆ
ԺՈՂՈՎՐԴԱԿԱՆ ՊԱՏԳԱՄԱՎՈՐՆԵՐԻ ԵՐԵՎԱՆԻ ՔԱՂԱՔԱՅԻՆ ԽՈՐՀՐԴԻ
Գ Ո Ր Ծ Ա Դ Ի Ր Կ Ո Մ Ի Տ Ե Ի

Կ Ա Ր Տ Ո Ւ Ղ Ա Ր

375013, երևան — 15, սր. Գրիգոր Լուսավորչի փող. թիվ 18
Հեռ. 58-68-90

12.07.95. 03/4-635

Ձեր ...

ԵՐԵՎԱՆԻՉԿԻԿԻ ԳՈՒԵԿՈՒՐ ԵՉ
ՎԱՐՉՈՒԹՅԱՆ ՊԵՑ ԳԻՆ Ա.ՉԱՇԱՐՅՈՒՆԻՆ

ԱՌՈՂՋԱՊԱՀՈՒԹՅԱՆ ՎԱՐՉՈՒԹՅԱՆ ՊԵՑ
ԳԻՆ Ա.ՀԱՐՈՒԹՅՈՒՆՅԱՆԻՆ

Մ/Թ Հուլիսի 12-ին ժամը 15⁰⁰-ին ,,Ակտ,, խումբը կազմակերպում
է եբխասարդրական խաղաղ երթ՝ Հեռայալ երթուղով՝ Առյալտի արձանի
մոտից մինչև ժամանակակից արվեստի թանգարան /Մարտոզի ողզազո/:
Խնդրվում է ձեռնարկել անհրաժեշտ միջոցներ երթը կազմակերպ-
ված անցկացնելու համար:

Ա.ՄԱՐՏՅԱՆ

Authorization of *Art Demonstration* by the municipality of Yerevan, 1995 **26**

and the constitution of art as an autonomous sphere are exposed as identical processes of institutional recognition. Without the guarantee of a stamped legal paper, the *Demonstration* would remain a purely artistic intervention in public space or a political action in the space of the exhibition. Without this guarantee, as Armenakyan states in his interview, the young artists would not believe that they were capable of contributing to larger social and political discourses.[102] *Art Demonstration* functions through art's identification with political discourses and procedures, directly translating political forms into the realm of aesthetics while at the same time rendering politics as a procedure of pure creation. And by this, ACT's politics of pure creation unintentionally strips the political rhetoric of liberal democracy of its truth-value and renders its procedural (and thus, constructed) mechanisms visible. However, while doing this, it also upholds democracy as an ideal.

When autonomous art adopts the political forms of public manifestation, and reclaims politics as a domain for pure conceptual creation, at the same time it contributes to the profanation of the political power of the state apparatus through its total identification with the latter. This mechanism of identification was not simply an artistic strategy, but had a philosophical grounding in neo-positivism as an underlying philosophy for the construction of the new state. Azatyan argues that ACT's fascination with logical positivism and its enactment as an artistic method bore uncanny resemblances to Armenia's first president's consistent attempts to strip politics of myths. To understand the politics of 'pure creation' as well as the pure creation of politics, it is important to expand upon the underlying philosophical programme that informed ACT's practices and some of the historical reasons why neo-positivism might have been attractive for the young artists while it also underlay Ter-Petrosyan's politics.

Developed in early twentieth-century Vienna and based on the writings of Henri de Saint-Simon and later Auguste Comte, neo-positivism appealed to the artists and to the country's president alike with its promise to objectively decode reality.[103] Inspired by the early writings of Bertrand Russell and Ludwig Wittgenstein, one of the basic premises of neo-positivism was that it was possible to code all knowledge in a standardized scientific language, and that all valid and meaningful knowledge was necessarily empirically verifiable. It is remarkable that most of the philosophers of the Vienna Circle were also politically active, some of them representing a version of neo-Marxism, without the dialectic, and holding to the belief that specific social arrangements of facts are the most powerful driving forces of history. In agreement with the nineteenth-century French philosophers Saint-Simon and Comte, the Vienna neo-positivists believed that the social world was governed by natural laws, and that all a social scientist could do was to identify these laws.

The basic premise of neo-positivism is the belief in a universal scientific language that can describe social phenomena, and this description itself is believed to be empirically driven and verifiable. It was particularly this premise that empowered the ACT artists to reassert the objective impact of their artistic actions during a time of economic hardship and social chaos. Throughout their short life as a group, ACT's young members developed often contradictory, but almost always dogmatic and rigid propositions regarding the role of the artist in the new society, as suggested in published and unpublished texts, personal notebooks and manifestos. These propositions were formulated while reading and discussing Russell's work and especially Wittgenstein's early writings. Neo-positivism provided them with the doctrine of methodological individualism which holds that all social phenomena can be explained as outcomes of individual behaviours.[104] It is with these

aspirations that ACT called for the artist to be a participating agent whose actions necessarily impact on society at large.

In his text 'Post-Art Situation: Logical Syntax', Hrach Armenakyan offers an attempt to define what he calls the 'post-art situation' while theorizing the artist's function within the newly emerging social and economic relations. Unlike Kareyan's somewhat romantic notion of a 'pure creation' that reveals the post-art condition through artistic processes, Armenakyan focuses on the artist's authorial function in a society that has overcome art:

> After the development of the raw idea the latter manifests itself within the atmosphere without authorial participation. The author only needs to maintain control in order to tilt the scale of thought. However, within the evolving process of the holistic logical structure the author is as detached from the already functional idea as anyone else. The circulated and thus functionalized idea, in turn, is nothing but a part of a whole, that is to say, it is not a discovery, but a detail in a concealed reality. One of the author's most important tasks remains the activation and circulation of the developed and systematized idea whereby he is in control of the application of its content, but whereby the form undergoes a multiplicity of transformations by any individual who realizes that same idea.[105]

Here ideas are presented as yet another type of product to be developed, cultivated and serviced through systems of non-hierarchical and transparent informational/economic distribution enabled by the supposedly unlimited possibilities of contemporary technologies of dissemination. The author's function is the distribution of these ideas. Armenakyan states:

> The qualitative and quantitative growth of the artist's intellectual influence will make it possible for him to impact larger social and political transformations. The comprehensive framework of the artist's intellectual abilities has the potential to create a hyper-mobile and strong structural system, which will form a basis for the new intelligentsia. The latter in turn will become a determining factor in evolving social life, and a source for serving society with innovation and knowledge.[106]

Armenakyan's recollections confirm the programmatic elimination of the author from the work that ACT was trying to introduce, and the ways in which this depersonalization of the author was connected with their battle against subjectivism. But this battle had its true basis in the social and economic conditions of the time, conditions that prompted the development of techniques of daily survival. And Armenakyan, years later, confesses to this:

> We were trying to liberate ourselves from the joy of authorship. If I came up with an idea today, it could also have been yours tomorrow … We were thinking alike to such an extent that we would often be unsure whose idea it

was ... this was a way of being together. Our president advised us to survive by borrowing [money and commodities] from each other ... there is a direct connection between these things.[107]

If one examines Ter-Petrosyan's political philosophy of the period, a persistent rhetoric that aims at demythologizing politics and history emerges. Similarly, ACT strove to demythologize art by reducing it to a rationally calculated procedure, and to demythologize the figure of the artist as a romantic dreamer.[108] For the president, a philologist and historian of the Middle East, politics was a philological operation that could be argued solely within the domain of rational language. While ACT frequently used the term 'demythologization' in their slogans and unpublished texts to demystify the figure of the artist, for Ter-Petrosyan, demythologization was a means of establishing the positivist myth of a constitutional state without 'any myths and puzzles'.[109] Hence, Azatyan argues:

> The constitutional state is a 'pure creation' devoid of the romanticism of the individual creator. It is cold and iconoclastic; it is anti-humanistic, stern and logical, black and white. Ter-Petrosyan's campaign against myths comes forward as a strategy of conceptual art in the sense of being purely procedural and impersonal.[110]

Thus for Azatyan, the new constitutional state imagined the construction of the state apparatus as a rationally calculated and implemented conceptual task, while the avant-garde artists' group imagined pure creation as a gateway to politics. Armenakyan confirms this point in his interview:

> We thought that there would be a time when we would come to power and would inherit the country ... And when the time really came when we could appear at the vanguard of power, we destroyed this opportunity ... We were not ready for our own ideas ... We were destroying each other methodically, like a doctor.[111]

What both the president and ACT shared was a conception of democracy as an ideal. And it is at this level that avant-garde art and post-socialist liberal democracy shared the same terrain for the young conceptualists of the period of independence.

The economy of 'pure creation'

As mentioned in the section dedicated to the aesthetic operation of 'pure creation', the idea behind the term is that art is not identical with the art object but is constituted by the act of making the art object. This presupposes that art does not find any ontological support in the materiality of the object, and

is identified with the idea made functional by the deliberate artistic act of naming. This artistic act of naming puts the idea in circulation in the larger social sphere as an autonomous entity that marks, in turn, the category of 'art'. The strategies of fixation (inscription), intervention, inspection, referendum and demonstration are instances of this functionalization. This artistic act dissociates the concept from the physical support that secures the art object as such, and replaces the imperative of materialization with the act of declaration. This echoes Lawrence Weiner's 'Declaration of Intent' made almost three decades earlier:

1. The artist may construct the piece.
2. The piece may be fabricated.
3. The piece need not be built.[112]

However, as opposed to Weiner's shift from production to reception, ACT insisted on the production side of art, understood as an act of dissociating the concept from the physicality of the work. What this dissociation achieves is the promise of the unbound mobility of the artwork as idea, which turns the artwork into an exchangeable sign as well as a sign of absolute exchangeability. As with all signs, the artwork 'functionalized' in the idea and released from its material constitution enters into circulation and acquires exchange value.

The consequences of this 'liberation' of the idea are manifold: first, the institution, including the art institution, is no longer defined as a permanent site, a building with walls safeguarded by bureaucrat-gatekeepers. The institution can be constituted and reconstituted through the act of artistic declaration at different points in time and at various sites. Thus this liberation is ultimately a cultural-political move that strips the established institutions of art of their monopoly over the definition and production of value. Secondly, it allows the work to enter and intervene in multiple contexts of representation and circulation, meaning-production and meaning-reception, simultaneously, while the boundaries between the original artwork and mechanical reproductions are erased. In this way, the artwork becomes multi-functional, thus increasing its supposed societal impact. However, the social impact of the artwork is not facilitated by the dissolution of its concept into social technique, but precisely by the opposite – by maintaining art's autonomy. Thus the autonomous artwork is rendered siteless and nomadic, capable of 'materializing' in various contexts, and intervening in these contexts by confronting them with the mechanisms of their own constitution, such as in the case of *Art Demonstration*. Thirdly, the detachment of the idea from the physicality of its material substrate echoes the structural conditions of the free-market reforms that Armenia was undergoing at the time. Aimed

at freeing the production and consumption of commodities from central-ized regulation, at releasing price controls and replacing a production-based economy with a service and consumption-based economy, Ter-Petrosyan's reforms were similar acts of dematerialization. Factories that had been sites in which production was embedded were dismantled and augmented through privatization, and became technically dysfunctional. With the proliferation of various local exercises in free-market economy, to which I will return shortly, capitalist exchange value infiltrated all spheres of life.

Ultimately, for ACT, the liberation of the artistic idea from fidelity to any specific form was conceived as the possibility of circulating this idea as a kind of pure information within an economy of ideas. Similarly to signs and com-modities, ideas were also to enter circulation and acquire exchange value. Thus, since it did not belong to anyone, the value of the idea would not be determined and inscribed through its one-time production or materialization as an art object. Instead, it could be an exchange product constantly repack-aged and recirculated. Since ACT dealt with the process and idea of creation rather than the end product in the form of an art object, the artistic/economic circulation of their art had to find an adequate format to allow its continu-ous packaging, dissemination and circulation. To resolve this contradiction between making art objects and propagating the dematerialization of art, ACT member Vahram Aghasyan came up with a project of forming an art agency.

In the summer of 1995, Aghasyan officially registered the agency 'Gorts'.[113] It was conceived as a unique type of information/news agency dealing solely with art. The agency was to create an 'art collection' of ideas, which could be materialized in any form by anyone willing to sign a contract with the agency. Aghasyan often referred to this collection as '"Pure creation": A Private Collection'.[114] The ideas were collected from artists by signing contracts with them in which they agreed to give up authorship of their ideas and license the realization of these ideas to any person willing to enter a legal agreement with the agency.[115] A collection of ideas would be formed, and the agency would disseminate the 'items' in its collection as information and find a clientele for them. This institution was imagined as a legally functioning enterprise with the purpose of separating the work of art, or rather the immaterial idea, from the artist, stripping the latter of authorial rights and granting authorship to others through a legal contract. Here authorship is directly and literally rendered as a bureaucratic act, constituted by a legal agreement. This detachment of the idea from its producer questioned the reified status of an art object within the institutional discourses of its representation. It also challenged the notion of singular authorship in an attempt to reject the 'joy of authorship' that the 3rd Floor had embraced.[116] ACT's short-lived history is full of internal disagree-ments – a sword of Damocles hanging over the group – over the authorial signature and over the idea of collective and anonymous production.

Throughout ACT's lifetime the agency functioned only on one occasion, when Aghasyan himself organized a small exhibition of the collection in Moscow, at the Armenian Embassy in 1995. Later, in 1997, the agency 'displayed' the collection in the geological museum of the town of Yeghegnadzor in southern Armenia. Hardly any documentation is preserved from the Moscow iteration of the collection, but the Yeghegnadzor exhibition left behind a video recording documenting the opening of the show, and several reviews published in newspapers.[117] The exhibition materialized each of the fifteen items in the collection, and put them on sale for prices ranging from US\$250 to US\$700.[118] The works in the exhibition, presented without the names of their authors, included a minimalist white vertical sculpture composed of three separate blocks of plywood, each a ready-made sculpture stand found in the basement of the museum; an L-shaped beam situated slightly off the wall; serial photographic prints fixed on the wall and gradually decreasing in size; white and light-blue monochrome canvases; a blue banner only partially fixed to the wall; a black fabric; and textual 'fixations'. All these minimalist forms were mobilized towards the ambitious task of 'prompting the viewer to re-evaluate his or her life one more time'.[119]

The reception of the exhibition reflected the conflict between the state of art institutionalization in Armenia in the mid-1990s along with its dream of art's successful commodification, and dire daily conditions in the aftermath of free-market reforms. Despite Grigoryan's reading of the collection as an attempt to overcome bourgeois efforts to establish an art market (he makes an implicitly critical reference to Karoyan's ongoing efforts throughout the 1990s) and to raise purely artistic questions, the very format of the collection hints at a desire for bourgeois acquisition and accumulation. But Grigoryan is right when he interprets the collection as one belonging to the future rather than representing accumulated artefacts from the past.[120] The collection is future-oriented in the sense that hopeful expectations for the free-market reforms had already proven unfounded, and that increasing disenchantment with the brave new world – due to continuing economic hardship – had turned the enactments of the mechanisms of liberal democracy and of free-market reforms into pure conceptual acts directed to the future. In a way, Aghasyan's collection, along with Kareyan's *Art Demonstration*, crystallized the dreams of the new world of political democracy and free-market capitalism, here enacted in the sphere of art *as if* it were reality. And this is what ACT fundamentally shares with the 3rd Floor: art as a space of dreaming, and endowed in this way with a reality function.

By 1995, general economic conditions, and a redistribution of wealth through the privatization of large industrial complexes, factories and all other forms of public property, had already shown that the hasty free-market reforms carried out in Armenia had involved major oversights and flaws. A

recession, in other words, followed the so-called 'shock therapy', which had taken the form of neoliberal reforms, introduced and carried out in many former socialist countries by the propagators of free-market economy such as Jeffrey Sachs, an advocate of Hayekian economics and of the Chicago School.[121] Reform programmes involved concrete economic policies such as the instant removal of governmental control over prices and the value of currency, as well as the withdrawal of subsidies from social services. These actions not only resulted in major shifts in the economy but also brought about a dramatic restructuring of the social body. The redistribution of property within the emerging free-market relations, instead of creating conditions for equal economic competition as its pundits had argued, helped to accumulate a large amount of formerly public property in the hands of a few – mostly former managers of Soviet industrial plants – thus planting the seeds of oligarchy in Armenia.

From early 1994, the government welcomed the incursions of the IMF and the World Bank, which started to conduct programmes of financial micro-management. While as part of the process of privatization, vouchers for shares in big industrial complexes had been distributed among the population, in the face of economic hardship, daily survival problems, monetary devaluation and the de facto dysfunction of these industries, the vast majority of Armenians holding these assets ultimately had to deliver them at extremely low prices into the hands of a few.[122] Even though after 1994, following the ceasefire with Azerbaijan and through a series of reforms, the economic decline was halted, the rate of unemployment within the huge and dysfunctional industrial sector remained very high.[123] This resulted in mass emigration, mostly to North America, Russia and Western Europe. In the mid-1990s, the majority of those who left were the intelligentsia seeking economic opportunities elsewhere or trying to recover from the loss of their formerly prestigious social status by starting a new life.

Economic and social conditions for the intelligentsia were especially harsh since the education and skills that many had gained within the Soviet system were deemed outmoded in the new social and economic order, even as the words 'manager' and 'marketing' acquired an aura of mystery and were endowed with arcane powers.[124] Different social groups varied in their success in adapting to the new situation and smoothly shifting their professions, becoming, for example, organizers of small businesses. The intelligentsia, however, as a result of their prejudices against those who had conducted private commerce in Soviet times (condescendingly called *spekulyanti* – speculators), failed to adjust to the new conditions created by free-market reforms. The intelligentsia, whose main source of capital in the Soviet era was symbolically accumulated 'prestige', saw its own cultural and economic demise, and the loss of its social status as an elite. In many ways, it was not only the Stalinist

programme of *kulturnost* – so-called acculturation – that was coming to an end, but the entire project of Soviet enlightenment. No longer fully supported by the state, which had sponsored and commissioned cultural and intellectual production, artists, writers and intellectuals found themselves in a doubly disadvantaged position. They felt intimidated by the world of private commerce and, in addition, there was a drastically decreased demand for cultural and intellectual production. In the face of such profound economic and social crisis, art was perceived by many as a luxury which one had to be able to *afford*. Artistic and cultural production was even viewed by many as something immoral in the face of daily survival issues, in that it was seen as deflecting the real problems of daily existence (ironically, the soap operas that became popular at the time were exempted from this category of immoral luxury).

It was within such conditions that ACT's artists stubbornly exploited the idea of art as luxury and pretended that they could afford it. For them, art as a space of 'pure creation' was a special sphere of intellectually privileged youth who were capable of making this sphere operational and intervening in the broader realm of social production. But there was a great discrepancy between ACT's strategic optimism about the ongoing construction of the present and the artists' daily material existence. Armenakyan confesses in his interview with Azatyan in 2008: 'Figuratively speaking, if we were fed twice a day, we would be able to move mountains.'[125] Avetisyan also confirms his disillusionment when faced with the actual conditions of everyday life. The traumatic clash with the banality of the everyday is exemplified by his experience in the army during his two-year mandatory military service:

> In our art we were striving towards the elimination of the individual. But when I faced what this really meant in the army, I came to be very disillusioned. I was disappointed that they would shave heads of young people like me … and drag us to the army. I was disappointed with people's primitiveness and the level of their intellectual development.[126]

Caught up between the harsh economic conditions in Armenia, the ongoing market reforms with all their problems, and optimism towards the dominant political ideology, ACT's practices presented a peculiar coupling of political propaganda with a desire for free-market relations both in art and in the broader economy. As opposed to Boris Groys's distinction between the propagandistic political art of the communist East and the art that forms a constituent part of 'Western' capitalist market relations, ACT's self-instrumentalization in service to the existing political power, combined with their desire to construct an art market, challenges Groys's interpretative paradigm. ACT associated themselves with the dominant neoliberal free-market relations to such an extent that they saw themselves as an instrument for implementing these relations in (the economy of) art.[127]

As opposed to typical propaganda art, ACT aimed at selling the dominant ideology of market capitalism, not only in the sense of ideological dissemination, but also in the literal sense of selling ideas for money, thus combining the propagation of status quo politics with the desire to construct an art market. This echoed the Ter-Petrosyan government's economic policies, which consisted of a series of market-related reforms in the early to mid-1990s and reduced the state's regulatory function in the economy to the minimum. Moreover, loyal to the rhetoric of their unique role in contributing towards the construction of the new state, the artists preferred to 'create and construct their own context, their own criterion',[128] rather than to work within already existing structures. Armenakyan claims that ACT wanted to construct their own commercial system of representation, since dealing with already existing galleries and art venues also meant dealing with the specific policies, histories and agendas of these galleries; something that they were trying to avoid in the quest for their own autonomy:

> We were mostly interested in selling our products rather than getting sponsorship from someone else. We believed that the sponsor – whether in the public or the private sector – would not allow us to operate freely. Even Nazareth [Karoyan] had preconditions for allowing us to show our works in his gallery. He viewed his gallery not merely as a physical space but as a place with specific approaches and policies.[129]

The desire to preserve the autonomy of the group from other structures and discourses while mimicking the larger political and economic conditions in their artistic acts can be considered an extension of Kareyan's notion of 'pure creation' to the institutional sphere of contemporary art. I have argued throughout this chapter that 'pure creation' functioned as a structuring device bringing together ACT's aesthetics, politics and economics. Significantly, 'pure creation' was also a fertile source of discontent among the group members and, arguably, one of the reasons for the collapse of the 'first ACT' in 1995, when several members, namely Kareyan, Hakobyan and Aghasyan, left the group to practise individually.

ACT's pseudo-scientism and technologism: 'pure creation' undone

Discussions over the boundaries of 'pure creation' became a major source of disagreement between the artists: how to define what is pure and what is impure? Does pure creation need to materialize? If so, what is the form that corresponds to the concept? The idea of 'pure creation' was both dogmatic and vague, escaping any concrete definition. In addition, in a way akin to the notion *hamasteghtsakan*, it was totalizing in its ambition to incorporate anything and everything. While Kareyan, who was responsible for the

formulation of the concept, considered Hovhannisyan's and Armenakyan's works too 'dirty' to fit into the idea of pure creation,[130] most of the group members believed that Kareyan and Aghasyan themselves had contaminated the idea of pure creation by introducing direct political elements through *Art Demonstration*. Moreover, apart from personal conflicts over influence and leadership in the group between Kareyan and Armenakyan, Armenakyan's 'faction' – what would become the 'second ACT' in 1996 – blamed the others for bringing in elements of postmodern aesthetics, and particularly for allowing 'contamination' of ACT's 'pure' modernism by the 3rd Floor's *hamasteghtsakan* post-conceptualism. For them, this appropriation contradicted the very idea of creating art driven by local conditions. Postmodernism was perceived as a gloomy and pessimistic global perspective on art, culture and society, and for the young and optimistic avant-garde artists it was simply impractical to 'import this global depression, called postmodernism' into their enthusiastic and affirmative practices.[131] With their modernist insistence on purity combined with avant-gardist pathos, ACT refused to look back to the past. And the 3rd Floor for them was already relegated to the dustbin of history, since the movement's rhetoric chimed rather with the perestroika era. The insistence on the present moment as an ontological ground upon which ACT justified the urgency of their practice is revealed in a manifesto drafted by Armenakyan and Hovhannisyan:

> Realizing the necessity of endowing emerging values with reality, we come together to enter a new relation with life, the environment, and the present situation and time. The goal is to overcome idols and dreams through a constant consummation of the present ... there is no greater impulse than the one to see the reality of consummated time.[132]

For them, the past was a dusty closet that could offer nothing relevant for the present moment. Hence the past had to be rejected as decadent, with its romantic ideals petrified into the dead ornamentations of architectural monuments and the reek of the painter's studio. This studio, with 'strange parts and objects, old and untouched fashion magazines' anachronistically lying in its forgotten corners, was conceived of as a place where 'the present loses its most characteristic features'.[133] History was viewed as a 'recycling of unnecessary, alien and useless objects, canvases, emotions turned into memory and other accessories', which brought in melancholy and shut the doors to progress.[134] To the seemingly melancholic and passive work of historical remembering, they opposed the imperative of action in the present.

During the 'second ACT' after the departure of the three main original protagonists, the nature of action itself changed: active interventions were no longer to take place in the public space but in what they called 'closed systems'. The neo-positivist discourse they adopted in the first year of their

activity was to become more rigid, totalizing and assertive, while the rhetoric that emerged from their constant traumatic clashes with the everyday would take on what I describe as *methodological seriousness*. This rhetoric acquired a kind of circularity, having to constantly prove its legitimacy in the face of an already emerging disillusionment with the construction of the new life. In a way, in the constantly reasserted rhetoric of embracing the present moment at the expense of the decadent past, the 'second ACT' faced the decadence of their own positivistic discourses, as exemplified especially in the title of their last project, 'Beautiful Progress', at the ACCEA in 1996.

After the fragmentation of the group, those members who remained developed the themes and approaches that had evolved earlier. These themes and strategies included the elimination of authorship, the priority of 'pure' idea over its materialization, and participation within the ongoing discourses of the construction of the new state. But it also marked a departure from the earlier practices of the group, a departure evident in the specific methodologies they utilized in practice and in the radicalization of their totalizing neo-positivist rhetoric.

A handwritten manuscript from late 1995, which outlined the schedule of planned exhibitions and projects for the upcoming year of 1996, is exemplary. These projects, most of which were never realized, included a planned action at the border between Armenia, Georgia and Azerbaijan; a spontaneous intervention at a slaughterhouse; non-subversive interventions into systems of communication, such as airport communications and the postal system; and a multidisciplinary scientific project at the astrophysical observatory on Mount Aragats.[135] If in its 1995 newspaper blueprint of fictitious news mentioned above the group were satisfied with reversing political and social facts, in this latter project their ambition was to make the news themselves and to construct facts.

The events planned for 1996 showed a shift in ACT's discourses towards the importance of constructing events within what they described as 'closed systems' – political, economic and cultural institutions that were closed to the public. After the successful realization of *Art Demonstration* as an example of appropriating a public space for artistic ends, ACT's six members shifted the focus to 'interventions into closed systems', including tightly regulated communications structures, forbidden laboratories and border points. With their earlier success in getting the official municipal permit for *Art Demonstration* that legitimized their artistic action, now it seemed possible to intervene and create 'events' in closed and regulated environments. Yet again, neo-positivism informed their artistic strategy. By 1996 these positivist inspirations, now without the shades of romanticism afforded by Kareyan's 'pure creation', had turned among group members into a fanatical defence of a rigid system of thought, particularly in the form of the logical positivism theorized in numerous unpublished texts by Armenakyan. For the latter, concepts such

as creativity and motivation could be logically analysed through a precise and accurate deductive method, which in turn could be empirically measured. The ultimate goal of such an empirical approach was to predict future developments and transformations. In an unpublished manuscript entitled 'Systematic Structural Analyses', Armenakyan declares that 'with the principle of consistent development, it is possible to communicate with the future inscribed in the present-continuum and outline future processes and their possible orientations'.[136]

If for ACT of the earlier period, 'pure creation' was an underlying philosophy with all its contradictions, in the vocabulary of ACT of the later period we encounter frequent references to the 'event'. It is noteworthy that while Armenakyan's early 1995 manuscript defines notions such as 'inscription', 'fixation', 'display' and 'discovery', all of which refer to 'pure creation', his late 1995 and 1996 manuscripts are largely concerned with conceptual clarifications of notions such as 'fact', 'event' and 'systemic structure'. In his neo-positivist vocabulary, the facts that structure reality regardless of our perceptual capacities call forth a systemic rational analysis. This analysis, in turn, has the power to challenge beliefs and the irrationalism inherent in them. For him, art is a social fact, similar to other verifiable facts. These verifiable facts, after they undergo logical systematic analysis, construct events: 'After the [operation of] traversing, examination and completion [of analysing the fact], the action and activity towards the fact evolves into an event – eventa.'[137] The positivist disavowal of myths and beliefs, as well as the acceptance of social reality as ultimately empirically verifiable and predictable according to the ideology of ACT in this later period, has consequences on a civilizational scale: 'the human appears in the foreground with his cognitive and creative problems … The beginning of all of this is a revolution in communication and knowledge, which is the biggest achievement of our times, the event: eventa.'[138]

Artworks as 'empirically verifiable facts' give rise to the imperative to 'functionalize' the idea (in this case, the artistic idea) by constructing events that put this idea into motion and produce direct social change. Armenakyan's understanding of the artwork as fact had always been quite literal. In the 1995 *Yerevan-Moscow: Question of the Ark* exhibition he had displayed various sculptural fragments of religious symbols of different art-historical periods and civilizations (the Virgin Mary, Buddha, etc.). These white objects made of gypsum and fixed on to the white wall were dissected in ways that made the texture of the material tangible. These sculptures were accompanied by 'objective' scientific facts, which consisted of a chemical analysis of the gypsum and its behaviour at different temperatures and in relation to other materials. To make sure the message was understood, the artist declared while facing the camera: 'If reality is examined objectively there will be no more myths in the future.'[139]

UՒ2ՍԱՍՏՈՒԹՅՈՒՆ ՓԱԿ ՅԱՄԱԿԱՐԳՈՒՄ
INTERFERENCE IN PRIVATE SYSTEM

27 ACT, *Intervention Into Closed Systems*, invitation to the exhibition, 1996, at the Mars factory of robotic technology

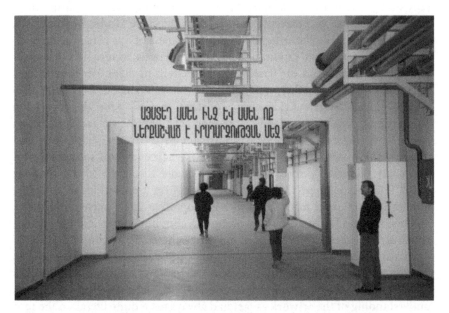

28 ACT, *Intervention Into Closed Systems*, 1996, Mars factory of robotic technology

The 1996 exhibition *Intervention Into Closed Systems* is the most significant project that the second ACT carried out. The exhibition was meant as an active intervention in an alien space in order to construct an 'event' (figures 27 and 28). Ideas were functionalized to enable 'the intellectual and the artist to reveal, discover, control and classify reality'.[140] The rigid neo-positivism that facilitated an almost fanatical belief in the artists' capacity to change society as a fulfilment of their designated function was once again proposed from within the sphere of art's autonomy, wherein an avant-garde proposition

for the future is enacted as if it were already reality. In a way, this autonomy, which preserves art as ideal, was a necessary one for this ideal to be actualized in the future. One of Armenakyan's works at the exhibition, a fixed banner on the wall, symptomatically reads 'A Specific System Can Serve as a Model for Creating Other Systems. But Currently it is a Display.'

The most remarkable aspect of this exhibition was its context. The artists managed to get permission to 'intervene' on the site of one of the most intriguing factories of the late Soviet period: the so-called 'Mars' factory for producing robotic technology. Construction of the factory began in the late 1980s, with the investment of 400 million dollars by a British company, and marked the largest ever industrial deal between the USSR and the United Kingdom.[141] However, the enterprise never functioned at more than 10 per cent of its capacity, and this dysfunctionality captures the problems that huge centralized industrial complexes faced during the move towards privatization in Armenia after the collapse of the Soviet centralized economy. The factory, where access was regulated according to strict codes of prohibition, was a 'closed environment' at its best.

Desiring to break away from conventional exhibition spaces, the artists proposed that the director of the factory grant them permission to 'intervene in this closed system' with their 'event'. But in order to do so, they would need to legitimize their action in the eyes of the factory administration and its staff, to educate them about contemporary art, to argue for its enlightening function within society, and to prove that it was neither subversive nor destructive. As the artists remember, Armenakyan had to show photo documentation of Christo and Jeanne-Claude's *Wrapped Reichstag* in Berlin (1995) and to argue that this grandiose action of wrapping the German parliament was *permitted* by the German state.[142]

The exhibition in general and its separate 'interventions' in particular became barely identifiable amid the overwhelming size and machinery of the factory. The artists, loyal to their neo-positivist adoption of universal scientific language to making art, turned artistic production into yet another component by which the scientific-technological discourse of industrial progress could function. Specific examples are quite telling. Armenakyan put a sign reading 'Yellow Room' on the walls of a closed laboratory room with yellow fluorescent lighting, which the audience could observe only through a glass partition. This intervention neither 'opened' the closed lab, which had restricted access, nor transformed its function. Instead, the sign transformed the scientific lab into a temporary art object: a minimalist object to be looked at from the outside. Arthur Vardanyan produced extremely small typewritten words that could only be read and deciphered with the microscopic equipment the factory produced, revealing a technological fetishism and fascination with scientific equipment that the young artists shared. Narek Avetisyan's audio intervention

was perhaps one of the few works that functioned as an alien body within the factory setting and brought in a different frame of reference. He created an audio installation composed of different combinations of noise recorded outside. It is remarkable that, according to Avetisyan, one of the factory administrators, unaware of the artists' interventions, thought that the factory space had been rented for a gathering of a religious sect: various sects, from Jehovah's Witnesses to worshippers of Krishna, were mushrooming in Armenia in the mid-1990s. The text accompanying Avetisyan's installation, however, resonated with the late nineteenth- and early twentieth-century trust in technological progress, a trust that had been asserted in Soviet rhetoric of growth and progress as well; it read 'The Mechanization of Work Spares Time For Individual Creativity.' It immediately made the confused director feel at home.[143]

This example shows the marginal status of contemporary art within Armenian society, in which it was perceived as a type of alien sect. ACT's interventions, directed at transforming sites not specific to art, resulted in art's subsumption within these very sites. The failure to match rhetoric with the actual results of actions exposes a dilemma that contemporary art in Armenia faced throughout the 1990s – the clash between its ambitious transformative programme and its marginal status in relation to larger social structures as well as to the dominant art institutions. It is this clash that, as I argue throughout this work, has reinforced the notion of art as more real than empirical reality.

Perhaps realizing that the clash of scale between the material dimensions of the factory and the subtle artistic interventions within it resulted in the absorption of the latter by the former, the artists organized a follow-up event in a gallery space. The exhibition reproduced the works featured in *Intervention Into Closed Systems* in a shared space rented by the Ex Voto and TAAK galleries from the Charents Museum of Literature and Art, a public institution that rented out its space so as to survive in the circumstances of a lack of state funding. The group's scientific-technological discourse on art, previously materialized in the factory, was transported back to a proper art institution and presented with the title *Post-Factum: Event* (figure 29). If *Interventions Into Closed Systems* aimed at interfering in the space of industrial-technological production treated as a closed environment and 'opening it up' through art, *Post-Factum* accidentally turned into an intervention in the private gallery system or, more precisely, into the rights of private property, if we are to trust the artists' recollections. Avetisyan remembers:

> Since the original renters [of the space] – Karoyan and Arakyan from Ex Voto and TAAK galleries – were away, we managed to convince the museum director to sublet the space to us for the duration of one week, despite the fact that we did not have the original renters' agreement … When we set up the exhibition

Վերջփասփ
Իրադարձության քննում զարգացում
Postfactum
"The Investigation and Development of the Event"

Arthur Vardanian

Նասդեն՝ Երևան, Արամի 1
ե. Չարենցի անվան գրականության և արվեստի թանգարանի սրահ:
Address: Yerevan, Arami 1
Hall of the "Literature and art museum", named after E.Charents

ACT, *Post-Factum*, investigation and development of the event, invitation, 1996 **29**

[in the galleries], a job search office rented the very same exhibition space we had rented, bypassing both the original renters and us, and put a computer in the middle of the exhibition hall … We viewed them as part of our exhibition while they viewed our exhibition as part of their office setting. A few days later we had to answer a police officer's questions since the job search office was not registered legally and they fled … while all we wanted to do there was to produce pure art.[144]

This recollection hints at the incommensurability between ACT's idea of 'pure creation' in its various understandings – be they scientific, romantic or scientific-romantic – and the turbulent social and economic context of the independence years. If the 3rd Floor's dreamworld was that of an absolute freedom actualized on the physical surface of the canvas and within the space of the exhibition, ACT's ideal was the social and political environment in which the new state was being constituted logically and rationally. The orderly positivist universe that ACT constructed in art was constantly contaminated by everyday life. As the 1990s were rolling towards the second part of the decade, there appeared an ever-increasing gap between their imaginary construction of the newly independent state as an orderly structured universe, and the fluid, ever-changing and unstable conditions of everyday life. However, as the title of the next and last exhibition shows – *Beautiful Progress*, an audio project realized at the ACCEA in 1996 – ACT's rhetoric of triumphant present faced its own decadence: progress was no longer the optimistic 'conceptual' march in the present but merely a beautiful idea. Ironically, this was the last project conceived by Avetisyan that ACT put together as a group, before several of its members emigrated to Russia to find jobs and survive economically. In a way, with ACT's demise in 1996 and the resignation of Ter-Petrosyan from the presidency two years later, the 1990s as the epoch of the independence generation came to an end.

The state as politics as pure thought

Throughout this chapter I have addressed some of the ways in which ACT resorted to various positivist and logical positivist philosophical traditions in order to provide a foundation for their artistic practices. Nevertheless, in order to understand the relation between the aesthetic and political avant-gardes in Armenia in the mid-1990s, it is important to discuss some of the specific connections between ACT and the political progressivist discourses of the state in light of the positivist assumptions underlying both. This discussion helps to articulate a relation between art and the state that can offer new avenues for conceptualizing the turbulent relations between autonomous art and social relations beyond Armenia's borders.

It is not my intention here to discuss the philosophical discourse of neo-positivism in detail. Rather, I would like to address the reasons why at this particular point in time and in the specific context of Armenia it was neo-positivism that informed both political and aesthetic avant-gardes. It was within conditions of uncertainty, a loss of ontological grounding for the social world, shifting social status, new and drastically instituted economic relations, and emerging state structures that ACT adopted the ideas of neo-positivism. The latter provided a ground, helping ACT members to make grand claims and have their arguments heard – in conditions in which intellectuals and artists could freely operate without ideological censorship and participate in ongoing public discourses, but at a time when there was neither social nor political demand for their input. Moreover, the first president Ter-Petrosyan's progressivist political ideology had underlying positivist tendencies and rationalist disavowals of 'all myths and puzzles' – all of this being placed at the foundation of the young Armenian state. The question arises here: in what ways did neo-positivism come to serve the discourses of the artistic avant-garde and inform the constitution of the state? How did it function in the face of social chaos and of a total reconstruction of life?

In his 1995 article 'Post-Art Situation: Logical Syntax', Hrach Armenakyan adopts what he calls a universal language of science to talk about the historical development of art, which he argues triumphantly culminates in the 'post-art condition' as exemplified by ACT.[145] In this condition, rather than being an 'anachronistic painter' or a subversive artist of the 1960s, the artist becomes someone who engineers social processes. His or her function is thus 'to document reality as it is', then to know it, and by knowing it 'regulate and change it through active intervention ... using the informational resources at [his] disposal ... This is the process of *functionalization* [italics mine] of the idea.'[146] And here he attributes an exceptional role to artists and intellectuals as both the backbone and the avant-garde of society.

In the face of the demise of the old world and indecision as to what new values and ideologies to embrace, both ACT artists and Armenia's first president Ter-Petrosyan referred to operationalist discourses in order to create a measurable sense of order in which they could situate themselves as mere instruments for the maintenance of this larger order. Along the lines of the positivist doctrine derived from the Enlightenment ideas of Saint-Simon, ACT attributed agency to artists while Ter-Petrosyan endowed intellectuals with the capacity to act at the vanguard of social progress. Since both the president and the young artists had the common agenda of fighting against what was perceived as mythic pre-modern popular consciousness, which relied on transcendental notions of the nation and historical spirit, they needed a radically secular metanarrative rooted in modernity. This metanarrative would oppose what they considered to be folkloristic and pre-modern social imagery, a metanarrative through which Armenia could represent itself to the world culturally. The dilemma here is that the only historical precedent for such a secular metanarrative for Armenia was the Bolshevik praxis, at the expense of which the new state was constructing the present of the nation. Another such secular and modernist metanarrative was the liberalism of the capitalist West filtered through the late Soviet avant-garde's romanticism. The generation of young artists of the 1990s embraced the latter, but without the anarchic spirit of their predecessors. Ultimately, they belonged to a time not of destruction but of construction and restructuring.

It is interesting and might even seem contradictory that ACT's embrace of liberalism in art and politics alike was carried out through strategies of self-instrumentalization in the service of a state that was viewed as implementing the ideal of democracy. And historically, this self-instrumentalization, in the context of Soviet Armenia, had been characteristic of the artists' role during the communist regime as part of a larger transhistorical ethos, even though in the case of the Socialist Realist artists this was not an artistic strategy but a political and ideological imperative. The contradiction lies in the fact that ACT's political and artistic programme advanced the liberal notion of self-sufficient methodological individualism and the ideals of a freely speaking subject fortified by positivism. This represents a unique hybrid in which two projects of modernity – the Soviet project declared to have failed with the collapse of the USSR and the Western liberalism now triumphing as the victorious ideology – came synergistically to coexist in ACT's practice at the level of artistic technique. Politically they had neither nostalgia for the Soviet past, nor an interest in re-evaluating that past critically in the present. And this coexistence of a self-instrumentalization of practice for a liberal political vision and a negation of previous art is a symptom of the crisis of negation I defined at the beginning of this chapter.

ACT's self-instrumentalization for the sake of liberal ideals of freedom, in turn, comprised two contradictory but at times overlapping notions of freedom. In his seminal article 'Two Concepts of Liberty', Isaiah Berlin distinguishes between two different but at times overlapping notions of liberty: negative and positive.[147] This distinction lies within the two different questions that they pose. The first merely defines the domain within which the subject is free to operate without the state's and other subjects' interference, and does not offer any positive idea of what this liberty should be for: 'By being free in this sense I mean not being interfered with by others.'[148] This conceptualization entails a critical separation between private life and public authority, which characterizes liberal democracies. As opposed to this, the positive notion of liberty, instead of defining the form of freedom, seeks to identify the sources of control and interference. Positive liberty, for Berlin, is a striving for both self-mastery and absolute self-realization through a larger ethos: 'And … this entity may be inflated into some super-personal entity – a State, a class, a nation, or the march of history itself, regarded as a more "real" subject of attributes than the empirical self.'[149] Positive liberty thus creates a danger of splitting into two selves: the super-natural self and what Berlin calls 'the empirical self', which should be mastered, controlled and disciplined. It is both a destruction of the individual self and a total self-identification with a specific ethos, a doctrine, ideal or principle. For Berlin, freedom in its positive sense can be instrumentalized by specific ideologies more easily, eventually resulting in forms of authoritarianism or even totalitarianism, with the individual's total identification with the whole. Saturated with the paranoia of any totalizing political ideology, a trait that characterized Cold War liberal thought (his article was first published in 1958), Berlin's notion of negative liberty privileges liberalism as an ideology that is supposedly ideology-free and that has to wage an antagonistic battle against all those totalizing ideologies that subjugate the individual to the collective, and subsume the self within a larger ethos.

The question of negative and positive freedom encapsulates the shift of larger discourses from the struggle for liberation (freedom for the sake of freedom) in the late Soviet years in Armenia to the operational aspects of freedom ('Freedom to what end?' or, 'What is to be done with freedom?') when Armenia gained its independence. Translated into the artistic field, if the 3rd Floor strove to establish the artist as a liberated subject, ACT questioned the relevance of this free subject in the new social, political and cultural context of the already independent Armenia by referring to the operational (positive) aspects of freedom. I hold that although ACT represented a version of positive liberty with their identification with the state and the ideal of democracy, in the post-Cold War era their ideal of freedom presented a peculiar hybrid between positive and negative senses. While adopting a

functionalist and operationalist rhetoric, ACT never abandoned the ideal of radical individualism rooted within the discourses of classical liberalism, and with it the ideals of negative liberty. The paradox resides in their belief that negative liberty (freedom for the sake of freedom) should be instituted by the state, that is, through the positive mode of freedom. According to ACT, art serves to implement or impose this paradoxical ideal. And if the state fails to carry out this programme, art as an autonomous sphere of 'pure creation' can hold its promise for the future. From this discussion it follows that the identification of the state with the public sphere, as described above, was a peculiar condition in post-Soviet Armenia, and it is this identification that lies at the foundation of the positive conception of negative liberty. This, in turn, may explain how ACT could voluntarily self-instrumentalize and simultaneously propagate 'pure creation' and art as an autonomous sphere uncontaminated by everyday life.

Both the orderly and logical 'reality' which Ter-Petrosyan imagined in politics and the 'pure creation' that ACT imagined in art were a secession from the ever-present dilemmas of the everyday. In both cases, the imaginary functioned as a reality for this artists' group in independent Armenia and for its first president. The inevitable culmination of this peculiar *imaginary realism* could be nothing else but its total demise when confronted with the traumatic conditions of the everyday. Perhaps this is the reason for ACT's disintegration in 1996 and for the failure of Ter-Petrosyan's politics, resulting in his resignation in early 1998; two different but strikingly similar processes.[150] While the group collapsed in large part because most of the artists of the second ACT could no longer survive in the harsh economic conditions in Armenia and had to emigrate to Russia,[151] Ter-Petrosyan had to resign due to the insurmountable gap between his own ideals and nationalist 'mythological' sentiments in larger society.

As an imaginary space constructed by art and politics and reasserted as reality in order to disavow the 'false ideology' of mythological and primordial understandings of history and nation, this 'reality' cannot but disintegrate and collapse when confronted with the actuality of the everyday and the ideology that permeates it. Similarly, when aesthetics follows the ideological trajectory outlined by political power, it cannot but face disillusionment and disappointment when the political programme fails in practice. What follows is nothing but silence, and silence creates new myths. Aghasyan's 'inscription' for a 1996 exhibition at the ACCEA reads 'A non-existent text on a non-existent plane', and from today's perspective this work is an uncanny signal of the arrival of an age emptied of politics, or rather, an age of politics replete with mythological consciousness. Herein the 'plane' (read as the context) is no longer able to subtend the text (read as discourse). Similarly, Kareyan's work from the same exhibition already marks a crisis of politics in its rational-

analytical operation. His inscription 'You Are in the Logic Trap' was to resurface in different formats in his later work of the early 2000s, mixed with other signs signifying a somewhat apocalyptic end of the political (figures 30 and 31). Armenakyan's acknowledgement in a recent interview is more overt:

> After Ter-Petrosyan left … a whole generation of artists, writers and activists felt deceived … but they were distressed precisely because they allowed themselves to be deceived; because they believed [in politics], they started blaming themselves for blurring the boundaries between art and politics, art and life. And perhaps this was the reason why many of them, all of them, abandoned activism, all kinds of activism.[152]

I hold that, operating within the specific cultural and social landscape of the mid-1990s in Armenia, ACT conceived of art as a means to emancipation within society by defending the autonomy of creativity at a time when maintaining this autonomy was the most difficult task. The emigration of many of their members to Russia and the shift in the aesthetic and political agendas of those who stayed allows us retrospectively to attribute ACT's collapse to the clash between reality and the sphere of autonomous art that they tried so hard to maintain. ACT were unwilling to face the everyday. They consistently and methodically identified 'pure creation' with pure liberal proceduralism, while refusing to face the contingency, chaos and disorder of the everyday. And perhaps ACT also collapsed because they ceased to acknowledge that what they shared with Ter-Petrosyan's project for the construction of the new state was the struggle for recognition in the face of a society and culture antagonistic to vanguardist programmes. While they were caught up in this very struggle, they pretended that they were above it and that they could *afford* to be beyond this struggle. The identification of the aesthetic constitution of autonomous art with the political constitution of democratic institutions carried out with methodological seriousness ultimately resulted in a traumatic outcome, when the model of the liberal democratic state failed in the late 1990s. Nevertheless, I hold that ACT's total identification with politics is that which eliminates the possibility of failure. This impossibility resides precisely in ACT's identification with the state, understood as a democratic ideal rather than an apparatus with constitutive power. In a way, both ACT and Ter-Petrosyan, albeit through different means, constituted the state in thought rather than objectively. ACT equated the analytical operation (hence their neo-positivism) and thought (or truth procedures considered subjectively) with politics, in the same way that Ter-Petrosyan equated politics with what Azatyan calls a 'philological operation' of constructing the desired state discursively through rhetoric replete with rational analysis and argumentation. In both cases, this resulted in a non-distinction between doing politics and thinking politics. Thus politics taken as thought allowed

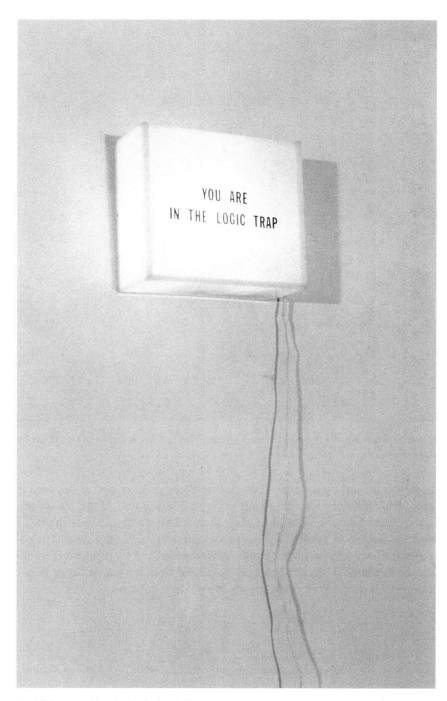

David Kareyan, *You Are in the Logic Trap*, 1996 **30**

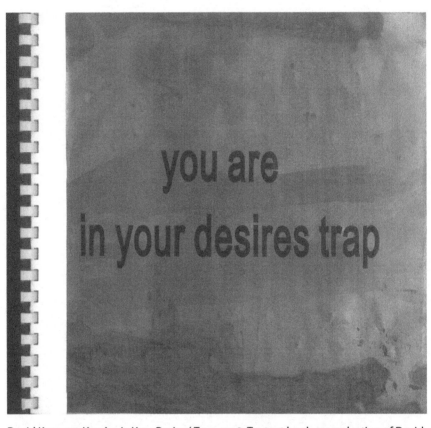

31 David Kareyan, *You Are in Your Desires' Trap*, 1998. Text art book, reproduction of David Kareyan's work

both politics and thought to exist subjectively as singularities, as opposed to objectively in relation to the object of a pre-existing state.[153] ACT's specific conception of autonomous art in their identification with the state (politics), and Ter-Petrosyan's political programme of a democratic ideal, were temporary ruptures – the first from *hamasteghtsakan* art and its troubled relationship with National Modernism, and the second from the nation (as an ethnic category) as the final determinant for any political horizon.

Notes

1 Kareyan, 'Pure Creativity', p. 127.
2 David Kareyan et al., 'Actayin hosanq' [Actistic wave], *Ex Voto* 13, *Garun* 4 (1996), p. 92.
3 Hrach Armenakyan, unpublished handwritten statement, dated 17 March 1996.

4 The artists of the group and their colleagues referred to the group by different names – Actual Arvest (Actual Art), Actual Arvesti Hosanq (Actual Art Stream), ACT, Act or 'Act'. Given that ACT was conceived as the acronym of Actual Art as much as a word on its own, and given the fact that the name has already circulated in English-language publications as an acronym, I consistently refer to the group in the latter way.

5 Boris Groys, *Art Power* (Cambridge, MA: MIT Press, 2008), pp. 13–20.

6 Examples of this majority approach are numerous since the discovery of Eastern European art in the 1990s. I will mention only a few prominent examples here, without doing full justice to the predominance of this institutionalized narrative. L. Hopman and T. Pospiszil (eds), *Primary Documents: A Sourcebook for Eastern and Central European Art since the 1950s* (New York: Museum of Modern Art; Cambridge, MA: MIT Press, 2002) is framed around this narrative of oppression and resistance. Apart from the specific selection of documents and case-studies that frame this narrative, the book opens with a full-page image of Croatian artist Dimitrije Bašičević Mangelos's painting *Energija* of 1978, which depicts a man with his index finger at his mouth hinting towards the silencing gesture of censorship. Similarly, the exhibition *Body and the East* at Moderna Galerija in Ljubljana in 1998 relied on the premise that the body in its particularity was that which was repressed during Soviet rule. Other publications that have reproduced this narrative of resistance and subsequent liberation include Marina Gržinić and Günther Heeg (eds), *Mind the Map! History Is Not Given: A Critical Anthology Based on the Symposium* (New York: Revolver, 2006); the IRWIN group's *East Art Map: Contemporary Art and Eastern Europe* (London: Afterall Books, 2006); Erjavec (ed.), *Postmodernism and the Postsocialist Condition*; D. Djuric and M. Šuvaković (eds), *Impossible Histories: Historic Avant-gardes, Neo-avant-gardes and Post-avant-gardes in Yugoslavia, 1918–1991* (Cambridge, MA: MIT Press, 2003); and Maja and Ruben Fowkes's ongoing 'Translocal Project' and 'SocialEast Forum'. I am also complicit in reproducing this narrative. See Angela Harutyunyan et al., 'Timeline of Socialist and Post-Socialist Body Art: Interstices of History', in A. Jones and A. Heartfield (eds), *Perform, Repeat, Record: A Critical Anthology of Live Art in History* (London: Routledge, 2011). This is not to say that the unofficial artists did not resist the Soviet regime, or that the latter was not often oppressive, but rather to claim that this institutionalized narrative offered very few nuanced discussions on the ways in which artistic strategies and discourses of resistance coincided with those adopted in positions of power. It has also failed to offer a critical re-evaluation of the institutionalization and subsumption of contemporary art under market conditions, with its own ideology and politics of representation.

7 Boris Groys, 'Moscow Romantic Conceptualism', *A-YA* 1 (1979), reprinted in Hopman and Pospiszil (eds), *Primary Documents*, pp. 162–81; Octavian Esanu, *Transition in Post-Soviet Art: Collective Actions before and after 1989* (Budapest: Central European University Press, 2013); Jorg Heiser, 'Moscow, Romantic, Conceptualism, and After', *e-flux* 29 (November 2011), http://www.e-flux.com/journal/moscow-romantic-conceptualism-and-after/ (last accessed 24 December 2015).

8 Groys, 'Moscow Romantic Conceptualism', p. 164.

9 These emerging discourses triggered Grigoryan's critique of ACT's strategies of hyper-rationalization and bureaucratization of art. Grigoryan, 'Nor hayatsq: Irakanutyun ev arvest'.

10 Market economy and private enterprise models as an alternative to the centralized state economy were emerging already during the years of perestroika. Continuing Khruschev's and Kosygin's struggles against over-centralization of the economy (which meant giving more decision-making power to factory directors), Gorbachev's economic reforms went much further than the Soviet centralized model could accommodate. Kenez, *A History of the Soviet Union*, p. 249. With the 1987 Law on State Enterprise, enterprises achieved financial independence, as they were now in charge of revenues, taxes and profits. Furthermore, the 1988 Law on Cooperatives allowed private ownership of businesses, thus creating an economy parallel to the Soviet centralized system. Padra Desai, *Perestroika in Perspective: The Design and Dilemmas of the Soviet Reform* (Princeton, NJ: Princeton University Press, 1989), p. 39. Even cultural institutions such as the Artists' Unions were to have their adjacent cooperative enterprises that would provide financial resources for the operation of the Unions, apart from the annual public funding allocated to them. When in October 1991 the Ministry of Culture and Enlightenment of the now independent Republic of Armenia issued a decree on 'New Economic Administration of Art and Cultural Institutions', the decentralization of funding for cultural institutions already had its roots in the perestroika experiment of cooperative enterprises as self-financing economic models of production. 'Strategic Planning', 10 June 1991, National Archive, Ministry of Culture collection, 80-15-55.

11 In a 1991 speech delivered at the Council of Ministers, Minister of Culture Perch Zeytuntsyan declared that culture might be the only resource Armenia could export. 2 October 1991, RA Council of Ministers, National Archives, folder 55, 80-15-55.

12 In the 1990s, with the proliferation of free commerce and a shift from a production- to a consumption-based economy, it was common to see unlicensed private individuals selling consumer goods on small tables on the streets.

13 The Bulgarian philosopher and cultural critic Luchezar Boyajiev argues: 'Neo-capitalism is characteristic of the post-socialist condition and is defined by redistribution of national/public wealth among private individuals. Neo-capitalism [in the post-socialist condition] is a consumer society without a consumer … [marking] the birth of the consumer from the corpse of the heroic worker … Here advertising does not sell a product but a neo-bourgeois image.' Luchezar Boyajiev, 'Disfunctional'nost', *Khudozhestvennyi Journal* [*Moscow Art Magazine*] 61/62 (May 2006), http://xz.gif.ru/numbers/61-62/disfunktsionalnost/ (last accessed 15 February 2015).

14 In *The Eighteenth Brumaire of Louis Napoleon*, Marx anticipates the proletarian revolution as that which leaves the past behind and establishes its own content, unlike the bourgeois revolution that founds itself upon the 'recollections of past world history'. For Marx, 'The revolution of the nineteenth century must let

the dead bury their dead in order to arrive at its own content. There the phrase went beyond the content – here the content goes beyond the phrase.' Karl Marx, *Eighteenth Brumaire of Louis Bonaparte* (Rockville, MD: Serenity Publishers, 2009), pp. 11–12.

15 Angela Harutyunyan, 'Rethinking the Public Sphere: The Constitutional State and the ACT Group's Political Aesthetics of Affirmation in Armenia', *Art and the Public Sphere* 1.2 (2013), pp. 159–73. Octavian Esanu discusses the ideology of transition and transformation in all spheres of social activity in the former USSR in the 1990s, in light of the political and economic theories of 'transformation studies' and 'transitology' that arose from modernization theories in post-Second World War Anglo-American academia and were applied to post-authoritarian and post-totalitarian contexts across the world. However, this is not a mere academic discipline but a technology of political science and a science of politics (to borrow Eric Goodfield's description of the Janus face of political science), one that subjects the world's peripheries to capitalist modernization and to its ideology of liberalism. Esanu, *Transition in Post-Soviet Art*; Eric Goodfield, *Hegel and the Metaphysical Frontiers of Political Theory* (London: Routledge, 2014).

16 Azatyan, 'Disintegrating Progress'.

17 While select examples of foreign literature were translated and published in the very early days of the magazine, introductions to foreign artists' work started appearing rather late in the magazine's art section. In 1987 we have entries on Dalí, Ingmar Bergman and Michel Legrand. In mid-1988 a section called Open Door appears, and issue 10 of the same year is entirely dedicated to perestroika. From 1988 the 3rd Floor as a movement and its individual members become regular guests in the pages of the magazine. In issue 10 (1988) 3rd Floor 'pop artist' Edward Enfiajian appears; 'conceptual artist' Ashot Ashot has a feature in issue 11 of the same year, followed by Grigoryan in issue 12. In 1989 and 1990 the magazine regularly featured other 3rd Floor artists – from presenting their work to publishing manifestos, exhibition reviews and artists' writings. From late 1990 the pages of the magazine are saturated with articles on fresh beginnings and include didactic essays addressing the concept of independence, acquainting its readers with the United Nations in light of Armenia's forthcoming role in the organization, and including a special section called 'Glasnost-mlasnost'. Essays on social solidarity and national identity became regular features. The 1990–91 issues focus on questions of survival, and 'What is democracy?' is asked in almost every issue.

18 *Garun* 1 (1967), pp. 7 and 22.

19 As opposed to *Garun*'s liberal nationalist stance, publications such as *Kultur-Lusavorakan Ashxatank* [*Cultural-Enlightenment work*] (1961–89), published as the bulletin of the Armenian SSR's Ministry of Culture, and *Sovetakan Arvest* [*Soviet Art*] (1932–80, 1991–94), published by the state committee of cinematography, presented the official orthodox variant of cultural politics and art criticism.

20 For instance, *Garun*'s long-time editor-in-chief and writer Vardges Petrosyan (1966–75) presided over the Armenian Cultural Foundation between 1988 and 1994 and served as an MP in 1990–94; other members of the editorial team

serving at various periods of the magazine's publication who in the 1990s and 2000s occupied high posts in the government included writers Razmik Davoyan (Council to the President of Armenia, 1999–2003), Perch Zeituntsyan (Minister of Culture, 1990–91), Hakob Movses (Minister of Culture, 1991–95), Ashot Bleyan (Acting Minister of Education, 1994–95), Vazgen Sargsyan (Minister of Defence, 1991–92 and 1995–99, and Prime Minister, June–October 1999), Vano Siradeghyan (Minister of Internal Affairs, 1992–96, Mayor of Yerevan, 1996–98, and MP, 1996–99) among others.

21 'Inch e joghovrdavarutyuny?' [What is democracy?], *Garun* 8 (1992), pp. 4–12; Lyudmila Harutyunyan, 'Brnapetutsyan akama meghavorners' [The unintentional culprits of tyranny], *Garun* 11–12 (1992), pp. 7–16; 'Qaghaqakan pahi tvabanutyun' [A calculus of a political moment], *Garun* 1 (1993), pp. 2–14; 'Ishxanutyun ev ynddimutyun' [Power and opposition], *Garun* 9 (1993), pp. 22–32; Lilia Grigoryan, 'Hayastani kaghakakan ujery' [Political forces of Armenia], *Garun* 4 (1994), pp. 4–16.

22 Karine Khodikyan, 'Mi yntrapayqari patmutyun' [A story about an election contest], *Garun* 10 (1992), pp. 2–10; Lyudmila Harutyunyan, 'Yntrutyan tari' [The year of elections], *Garun* 1 (1993), pp. 29–30.

23 'Inchu e ushanum sahmanadrutyuny?' [Why is the constitution delayed?], *Garun* 10 (1992), pp. 24–30; 'Sahmanadrutyany spaselis' [Waiting for the constitution], *Garun* 6 (1994), pp. 4–20; Hakob Paronyan, 'Sahmanadrutyan ogutnery' [The benefits of the constitution], *Garun* 7 (1994), pp. 90–5; Lilia Grigoryan, 'Mer sahmanadrutyunn u hanraqven' [Our constitution and referendum], *Garun* 9 (1995), pp. 4–21.

24 Hrach Armenakyan, interview, 23 January 2008.

25 Quoted in *Ex Voto* 1, *Garun* 2 (1995), p. 1. The section was edited by Nazareth Karoyan. Between 1995 and 1996 *Ex Voto* had twelve issues in *Garun*'s pages.

26 This also positioned *Garun* differently in relation to the formerly official publications such as *Arvest* and *Mshakuyt*.

27 Based on the above, there are many similarities between the 1960s American conceptualism that Benjamin Buchloh designates as 'the aesthetics of administration' and the conceptual practices of ACT. Benjamin Buchloh, 'Conceptual Art 1962–69: From the Aesthetic of Administration to the Critique of Institutions', *October* 12.55 (1990), pp. 105–43. Corresponding to corporatization and to the emergence of new state structures, and similarly to the conceptual artists of the 1960s in the USA, ACT aspired towards collaboration with these new institutional structures and at times even identification with them. And by mimicking the subjection of aesthetic experience to the Adornian 'totally administered society' (a society that was still an ideal in the early years of independence), ACT's practice was anti-mnemonic, since it attempted to erase the last remnants of artistic skill. However, as opposed to the artists that Buchloh discusses, ACT did have a utopian vision for society and culture that was to be carried out within and from the sphere of autonomous art.

28 Decrees issued by the Ministry of Culture of the Republic of Armenia between 1992 and 1996 testify to the fact that those artists who could present the Armenian

nation with a modern face were especially exported. Martiros Saryan's paintings and filmmaker Sergey Parajanov's collages and films were in especially high demand. In addition, in 1990, a year prior to independence, a special commission was established within the Ministry of Culture to oversee the export of artistic and cultural artefacts from Armenia. Nazareth Karoyan, 'To Allow Export, or Not?', unpublished article, 16 September 1993. Karoyan's archive.

29 See note 11.

30 In a 1992 speech delivered at the Council of Ministers, the Minister of Culture Hakob Movses stressed the need to redefine 'national culture' and addressed the issue of its dissemination at home and abroad. RA Council of Ministers, Hakob Movses, folder 55, 80-15-55, National Archives, Yerevan. In 1993 the Ministry of Culture commissioned a research project entitled 'The Figure of the Creator of Culture'. With a 1994 decree an informational-analytical department was established within the ministry that had the task of 'mapping, monitoring and efficiently utilizing informational flows'. Folder 56, 23.03.1994. National Archives.

31 Vahram Aghasyan, *Chernovik* (in Russian), unpublished notes. Aghasyan's archive.

32 Arman Grigoryan, 'DEM sharjman metsaguyn hrajarumy' [The Great Refusal of the movement *DEM*], *Garun* 4 (1994), pp. 90–4. *Dem* in Armenian means 'against'. It is noteworthy that in the mid-1990s, Grigoryan's attempt to found a new art movement upon the premise of negation and refusal, after the disintegration of the 3rd Floor, failed.

33 Kareyan, 'Pure Creativity', pp. 127–8.

34 David Kareyan, untitled and unpublished text, 11 April 1994. Vahram Aghasyan's archive.

35 Kareyan, 'Pure Creativity', p. 125.

36 Azatyan remembers that Vahram Aghasyan had a book in his library, in Russian, which was a collection of essays on psychology, almost all of whose authors were behavioural physiologists. Vardan Azatyan, pers. comm.

37 Kareyan, untitled and unpublished text, 11 April 1994. Vahram Aghasyan's archive. Kareyan, 'Pure Creativity', p. 125.

38 Kareyan et al., 'Actayin hosanq', p. 92.

39 Hrach Armenakyan identified this as Hovhannisyan's handwriting in a private conversation with me.

40 Mher Azatyan's archive, in Armenian.

41 Grigoryan, 'Inch e hamasteghtsakan arvesty', p. 63.

42 While Aghasyan and Nalbandyan were later to become members of the 'first ACT' (1994–95), Azatyan, although actively participating in group discussions and largely agreeing with ACT's aesthetic agenda, was never formally affiliated with the group. Interview with Mher Azatyan, 11 January 2007.

43 Interviews with Vahram Aghasyan, 22 October 2007, and Mher Azatyan, 11 January 2007.

44 In an interview, Aghasyan mentioned that one of the seminal exhibitions of the 3rd Floor in the heyday of its activity – *Plus Minus* of 1990 – presented all the

diversity of the 3rd Floor's repertoire, except that the 'zero' between the plus and minus was missing. The young artists of the 1990s generation were in search of precisely that missing 'zero', Interview with Vahram Aghasyan, 22 October 2007.

45 Camilla Gray, *The Great Experiment: Russian Art 1863–1922* (New York: Abrams, 1962).

46 The culmination of Russian avant-garde's appropriation was the tragic fate of the Khardzhiev Collection. Compiled over several decades by the art critic Nikolai Kharzhiev and hidden from official eyes in the Soviet Union, the collection consisted of more than 1500 artworks representing the early twentieth-century Russian avant-garde. After the collapse of the USSR, the 85-year-old art critic and his wife emigrated to Amsterdam. The collection was partially confiscated by Russian customs while on its way to the 'promised land'. The remaining pieces became subject to financial speculation by art dealers in Europe who bought the couple's trust and then betrayed them by selling off the collection. The fate of the collection is exemplary of the ways in which artworks become 'homeless' without the historical revolutionary context that had supported them: they belong neither to present-day Russia, nor to the contemporary West. More on the Kharzhiev Collection can be found in Tim Golden, 'For Collector of Russian Art, the End of a Dream; A Murky Trail Behind Rediscovered Works by Malevich', *New York Times*, 31 March 2003, http://www.nytimes.com/2003/03/31/arts/ for-collector-russian-art-end-dream-murky-trail-behind-rediscovered-works. html?pagewanted=all&src=pm (last accessed 29 December 2013).

47 In 1985, an exhibition entitled *The Last Futurist Exhibition by Kazimir Malevich* took place in Gallerija Škuc, in Ljubljana. Curated by Marina Gržinić, it represented anonymous author Belgrade Malevich's works. Throughout the 1980s an artist with the nickname Belgrade Malevich effectively worked to deconstruct the myth of Kazimir Malevich as a unique author-creator and modernist icon. Among numerous Eastern European artists who actively referred to Malevich throughout the 1980s and 1990s was the Slovenian group IRWIN. In 1992 as part of the 'Moscow Embassy' project, IRWIN performed the action 'Black Square on Red Square'. In this ironic evocation of Malevich, they unfolded 22 square metres of black cloth on Moscow's Red Square. IRWIN (ed.), *East Art Map*, p. 324.

48 This analysis is confirmed by Narek Avetisyan, a co-founder of ACT. He remembers that many of the 3rd Floor artists were unapproachable, and at times arrogant: 'If you were to ask Arman [Grigoryan] about Pop Art, he would not care to answer you. You would have to do Pop Art a few times before you could even approach him.' Narek Avetisyan, interview, 18 October 2007.

49 Vahram Aghasyan, interview, 27 October 2014.

50 All the artists in this exhibition were male. According to Kareyan, the homogeneous gender constitution of this exhibition helped the group to become aware that women artists were not invited to participate, and resulted in the inclusion of five women artists in ACT. David Kareyan, interview, 3 November 2008. It is hard to determine whether this was a conscious decision by the male artists to 'invite' women artists, or whether the group was formed without the gender of individual artists being an issue. The artist Diana Hakobyan, Kareyan's wife,

mentioned that she played a secondary role in the group, mostly supporting Kareyan in his artistic initiatives and personal battles with other group members. Diana Hakobyan, interview, 6 November 2008. When Kareyan left ACT in 1995, Hakobyan also left the group. One has to be cautious not to take at face value statements made by a former protagonist of the group almost one and a half decades after its demise, given that the present always informs the way in which one remembers oneself as a protagonist in the events of the past.

51 Video documentation. Vardan Azatyan's archive.

52 The 3rd Floor artist Ara Hovsepyan had proposed 'fixation' earlier. In a 1989 short unpublished text he says: 'What I do is a possibility of living for me, both fragmentary and complete, both big and small, comparing that which is conditionally indefinable [sic]. This method is fixation. I call myself a researcher.' Ara Hovsepyan, 'Chem tesnum sahmany kyanki ev arvesti mej'. Forthcoming in Azatyan (ed.), *3rd Hark. Yntrani.*

53 Vahram Agharyan, untitled unpublished note. Mher Azatyan's archive.

54 Video documentation. Vardan Azatyan's archive.

55 On the occasion of the 1993 youth exhibition at the Union of Artists, Aghasyan presented a version of Kosuth's famous *One and Three Chairs* (1965), with a 'local' addition of a fourth element. He copied each of the three elements of Kosuth's work – the actual chair, a photographic representation of the chair and a dictionary entry – but also posted a caption that read 'The Mother See of St Edjmiatsin'. Edjmiatsin being the seat of the Armenian patriarch, the highest ecclesial body in Armenia, the title literally translated would be 'The Mother *Chair* of St Edjmiatsin', thus ironically adding another, locally specific 'chair' to the US conceptual artist's three representations of a chair. *Garun*'s *Ex Voto* section in March 1995 published a feature on Joseph Kosuth's 1990 exhibition *A Play of the Unmentionable*, five years after it took place at the Brooklyn Museum of Art.

56 Video documentation. Vardan Azatyan's archive.

57 It was common to see government officials and even the president of Armenia going on TV and advising their constituents on ways to survive. One example was Ter-Petrosyan's advice on getting by through borrowing money from one's neighbours.

58 David Kareyan, interview, 4 November 2008.

59 Christine Ter-Sargsyan, report from the action, unpublished text, 1994. Hrach Armenakyan's archive.

60 Exhibitions in Armenia were mostly organized by the artists themselves. Curating as separate from artistic practice emerged in the late 1990s and was connected with the specific representational politics of the ACCEA. Karoyan's practice throughout the late 1980s and 1990s can be designated as critical and curatorial, though he himself viewed this as an extension of his conceptual art practice. For a detailed analysis of the emergence of curating and its significations in Armenia, see Angela Harutyunyan and Eric Goodfield, 'Theorizing the Politics of Representation in Contemporary Art in Armenia', in Malcolm Miles and Monica Degen (eds), *Culture & Agency: Contemporary Culture and Urban Change* (Plymouth: University of Plymouth Press, 2010).

61 A handwritten document that I obtained from Hrach Armenakyan's archive, unpublished, undated.

62 Vahram Aghasyan, interview, 22 October 2007.

63 Grigoryan, 'Nor hayatsq: Irakanutyun ev arvest', p. 11.

64 Vahram Agharyan, untitled unpublished note. Mher Azatyan's archive.

65 Angela Harutyunyan, 'Document, Armenakyan, "Post-Art Situation: Logical Syntax"', *ARTMargins* 2.1 (2013), p. 133.

66 The artist Grigor Khachatryan, who in the mid-1990s was famous for his radical and subversive performances, had adopted a unique ironic and sarcastic laugh, which became one of his main identifiable features both in his artistic and personal life, which were often the same.

67 According to Narek Avetisyan, Grigor Khachatryan, faithful to his strategies of irony, commented on Avetisyan's work *Pure Creation* – which consisted of water in a pot – by saying: 'It could become a real work of pure creation if you had presented pure alcohol, instead of water.' Narek Avetisyan, interview, 18 October 2007. This comment had specific cultural implications derived from the mid-1980s, when Gorbachev introduced an anti-alcohol law, known as the 'dry law', in his efforts to combat social non-productivity and lack of motivation to work. Some found an alternative in homemade alcohol, while others turned to industrial lubricants or even shoe polish. Pure vodka was a rare and highly desirable commodity, 'pure creation' *par excellence*, which served as a 'shock absorber' in the context of 'the true misery of everyday Soviet life'. Alexey Bayer, 'Vodka Part II: Sobering up the USSR', *The Globalist*, 31 May 2006, http://www.theglobalist.com/StoryId.aspx?StoryId=3038 (last accessed 7 May 2008). See also Kenez, *A History of the Soviet Union*, p. 250.

68 I base this on Avetisyan's recollections, interview, 18 October 2007.

69 Christina Ter-Sargsyan, unpublished undated notes (approx. 1995). Hrach Armenakyan's archive.

70 Christina Ter-Sargsyan, unpublished undated notes.

71 Groys, *Art Power*, p. 28.

72 Armenakyan and Hovhannisyan, 'ACTy vorpes sharjum: manifest', unpublished text, 17 February 1995. Nazareth Karoyan's archive.

73 Armenakyan and Hovhannisyan, 'ACTy vorpes sharjum: manifest'.

74 Armenakyan and Hovhannisyan, 'ACTy vorpes sharjum: manifest'.

75 Christine Ter-Sargsyan, unpublished notes, 1995. Hrach Armenakyan's archive.

76 *Ex Voto* 3, *Garun* 4 (April 1995).

77 The Pan-Armenian Movement was founded by Levon Ter-Petrosyan and others in 1988. It organized anti-Soviet demonstrations until the declaration of independence in 1991. In 1990 the party won an overwhelming majority in the Parliament of Soviet Armenia, successfully sidelining the communists from power, and remained the governing political force until Ter-Petrosyan's resignation from the presidency in 1998.

78 Levon Ter-Petrosyan, *Collected Works* (Yerevan: Archive of the First President of Armenia, 2007), p. 502 (in Armenian).

79 Jürgen Habermas, *The Structural Transformation of the Public Sphere: An Inquiry into a Category of Bourgeois Society* (Cambridge, MA: MIT Press, 1991).

80 Harutyunyan, 'Rethinking the Public Sphere', pp. 164–5.

81 The abolition of serfdom took place rather late in Russia compared to Western Europe, in 1861, in an agrarian reform initiated by Tsar Alexander II.

82 Russian social theorist Viktor Voronkov distinguishes between public and official spheres in the USSR. While the public sphere largely functioned in private spaces, such as kitchens, the official sphere colonized public space. Victor Voronkov, 'Life & Death of the Public Sphere in the Soviet Union', in Tatiana Goryucheva and Eric Kluitenberg (eds), *Debates & Credits: Media, Art, Public Domain* (Amsterdam: De Balie Centre for Culture and Politics, 2002).

83 In the same speech Ter-Petrosyan states: '[Our party] has nothing to hide from people. Our ideology is based upon the values of liberal democracy, free market economy and the protection of the rights to private property and free business. We believe that people's welfare and the state's prosperity depend upon these values ... But we realize that apart from the rights to private property, there are also social rights ... We also need a socialist party operating alongside our party that will advance the people's social cause.' Ter-Petrosyan, *Collected Works*, p. 502.

84 Karoyan claims that the work was inspired by Grigoryan's and Kiki's first 3rd Floor manifesto. Karoyan, 'Ailyntranqayin avanduyti kayatsman bavighnerum', *Ex Voto* 1, *Garun* 2 (1995), p. 96. The manifesto read: 'Objective Art / non-existent art / tired art / funny art / miserable / poor / finished / prostrated / full-bellied / clever / naked / militaristic art / hopeless art / grave art / cold conformist / non-conformist art / bad art / killer art / dead art.' Kiki and Arman Grigoryan, 'Manifesto', forthcoming in Azatyan (ed.), *3rd Hark. Yntrani.*

85 David Kareyan, interview, 3 November 2008.

86 Angela Harutyunyan, 'Redefining the Public Sphere through Artistic Practice in Armenia', in Stefan Rusu (ed.), *Artă, cercetare în sfera publică / Researches in the Public Sphere* (Chisinau: KSAK, 2011), pp. 388–96; Azatyan, 'Art Communities, Public Spaces, and Collective Actions', pp. 43–54.

87 Vardan Azatyan, 'Image-inings of Armenian Reality', unpublished lecture series, Yerevan, Utopiana Association, 2008.

88 Chiller was the Turkish prime minister at the time. With the lack of diplomatic relations between Armenia and Turkey, such a meeting would have been impossible.

89 Due to safety concerns after the 1988 earthquake, the government was forced to shut down the nuclear power plant in 1989. However, the energy crisis forced the Armenian authorities to reopen it in October 1995.

90 Azatyan, 'Image-inings of Armenian Reality'.

91 Avetisyan stated in the interview: 'I did not share the idea that *Art Demonstration* was a relevant form of manifestation ... I was tired of aggressive behaviour ... Instead of marching with them, I showed my own work during the exhibition.' Narek Avetisyan, interview, 18 October 2007. Hakobyan also expresses a similar attitude: '*Art Demonstration* was simply a reason to do a collective work. But the

idea was David's. I was simply writing posters.' Diana Hakobyan, interview, 6 November 2008. Aghasyan claims: 'David was enthusiastic about making public works ... *Art Demonstration* reflected his personal interests.' Vahram Aghasyan, interview, 22 October 2007.

92 It was collectively curated by Susanna Gulamiryan, Karen Andreassian, Samvel Bagdasaryan, Leonid Bazhanov and Andrei Filipov.

93 *Ex Voto 7*, *Garun* 8 (August 1995), p. 96.

94 Documentation of the exhibition. Vardan Azatyan's archive.

95 Grigoryan attributes the origin of this schism to a 1987 conference in Narva, Estonia, of avant-garde artists from all over the Soviet Union. For Grigoryan, this was largely a political schism with aesthetic consequences, as his Beuysian dream of mixing American capitalism with Soviet socialism was not shared by Russian avant-garde artists stuck in 'Stalinesque nostalgia', or 'Petersburg "mistiks" [who] were not able to get over their hangovers'. Grigoryan, 'Informed but Scared', pp. 11–12.

96 The action has been largely misread by Armenian artists, curators and critics, myself included, as socially engaged public art practice at its best. I had previously argued that *Art Demonstration* was an instance in which Armenian artists explored the socially communicative potential of art and the possibility of actively contributing to the formation of the public sphere; a paradigm that ended with the 1990s disillusionment with political participation. Angela Harutyunyan, 'On the Ruins of a Utopia: Armenian Avant-Garde and the Group Act', in Mel Jordan and Malcolm Miles (eds), *Art and Theory after Socialism* (Bristol: Intellect Books, 2008), pp. 34–43. The curator Ruben Arevshatyan retrospectively referred to the action as a 'socially oriented [action] ... where social phenomenon [*sic*] as such could be considered as art without any artistic interference.' Ruben Arevshatyan, 'Between Illusions and Reality', in H. Saxenhuber and G. Schöllhammer (eds), *Adieu Parajanov: Contemporary Art from Armenia* (Vienna: Springerin, 2003), p. 17.

97 Vardan Azatyan was the first to argue that ultimately the action was about art in its formal understanding, since 'the socio-political messages of *Art Demonstration* turned into the examples of pure art inside the walls of a museum as they installed their slogans on the walls like pictures. Thus the slogans became commodified elements of the exposition.' Azatyan, 'Art Communities, Public Spaces, and Collective Actions', p. 46. While I agree with Azatyan's earlier reading that the action had a formalist agenda, I think he is too quick to consign the banners to the status of commodities, especially given that, even with the introduction of market reforms, artworks were slow to acquire exchange value. He is also too dismissive of the communicative potential of the action by focusing on the afterlife of the slogans on the walls of the exhibition as that which turns them into museumized objects.

98 Video documentation (Arpen Movsisyan's program). Vardan Azatyan's archive.

99 Grigoryan, 'Nor hayatsq', p. 5.

100 Hrach Armenakyan, interview, 23 January 2008.

101 Christine Ter-Sargsyan, unpublished notes, 1995. Hrach Armenakyan's archive.

102 Hrach Armenakyan, interview, 23 January 2008.

103 With the political upheavals in Europe during the advent of Nazism in Germany and Austria, Vienna Circle members Hans Hahn, Moritz Schlick, Otto Neurath and Rudolf Carnap emigrated to Britain or the United States, and became influential in the Anglo-American analytic philosophy advanced by Quine and Kuhn. 'Logical Positivism', *Routledge Encyclopedia of Philosophy* (London: Routledge, 1998).

104 This assertion of neo-positivism was instrumental for the behaviourist philosophy in psychology.

105 Harutyunyan, 'Document, Armenakyan', p. 133.

106 Harutyunyan, 'Document, Armenakyan', p. 133.

107 Hrach Armenakyan, interview, 23 January 2008.

108 Azatyan, 'Image-inings of Armenian Reality'.

109 In his famous 1997 article 'War or Peace?', published just two months before his resignation from the presidency, Ter-Petrosyan rationally refuted all 'myths and puzzles' regarding those foreign and domestic policy issues for which he had come under fire from his opponents. Ter-Petrosyan, *Collected Works*, p. 195; Azatyan, 'Image-inings of Armenian Reality'.

110 Azatyan, 'Image-inings of Armenian Reality'.

111 Hrach Armenakyan, interview, 23 January 2008.

112 Lawrence Weiner, 'Declaration of Intent', in *Statements* (New York: The Louis Kellner Foundation and Seth Siegelaub, 1968).

113 Aghasyan refers to the agency as 'Act' even though it was legally registered as 'Gorts' [Work, Business]. According to the artist, the state registration agency demanded a bribe to register Aghasyan's agency under the name Act since the latter was a foreign word. In the end, Aghasyan registered the agency as Gorts but continued to refer to it as Act. Vahram Aghasyan, interview, 27 October 2014. 'Gorts gortsakanutyan kanonadrutyuny' [The statute of the agency 'Gorts'], Vahram Aghasyan's archive. The date of registration is not mentioned in the document. It is noteworthy that the agency is officially registered as an information agency under the umbrella of the periodical *Avant-Garde*. The statute mentions the gathering, translation and dissemination of world news in Armenia, and of Armenian news in the world, as the main function of the agency.

114 Folder 'Pure creation. A Private Collection'. Vahram Aghasyan's archive.

115 Contract with Aram Khachatryan Foundation, 23 February 1995. Vahram Aghasyan's archive.

116 Hrach Armenakyan, interview, 23 January 2008.

117 Tsovinar Chilingaryan, 'Maqur arvesty Eghegnadzorum' [Pure art in Eghegnadzor], *Aravot Daily*, 14 June 1997.

118 Vahram Aghasyan, preliminary prices of the works (the list is in Russian). Vahram Aghasyan's archive.

119 Aghasyan, video documentation. Vardan Azatyan's archive.

120 Aghasyan, video documentation. Vardan Azatyan's archive.

121 Kenez, *A History of the Soviet Union*, p. 279.

122 Twenty per cent of shares in public property, including factories, were given to

factory workers for free. The remaining 80 per cent from each enterprise was sold on the open market. However, due to the devaluation of the currency, ordinary people could not afford to buy shares. Soon most privatized factories fell into the hands of their former directors and managers. David Zenian, 'Armenia on the Slow Road to Economic Recovery', *AGBU News*, 2 January 1995, http://agbu. org/news-item/armenia-on-the-slow-road-to-economic-recovery-armenia/ (accessed 20 October 2014).

123 Unemployment stood at more than 35 per cent in 1995, according to UNDP's report *Growth, Inequality and Poverty in Armenia*, 2002, http://www.undp.am/docs/publications/publicationsarchive/gipa/main05.htm (last accessed 22 May 2008).

124 For instance, English language and computer skills became essential preconditions for being employed in the service sector. Nowadays, these preconditions are complemented by the demand that one be female and under thirty-five years of age.

125 Hrach Armenakyan, interview, 23 January 2008.

126 Narek Avetisyan, interview, 18 October 2007.

127 Groys, *Art Power*, pp. 1–12.

128 Narek Avetisyan, interview, 18 October 2007.

129 Hrach Armenakyan, interview, 23 January 2008.

130 These included Armenakyan's work for the 1994 exhibition *P.S. Evolution*, where he stored garbage in a sterile white box covered with mirrors; Samvel Hovhannisyan's burnt parrot from the exhibition *Act* was considered another 'dirty' work.

131 Narek Avetisyan, interview, 18 October 2007.

132 Armenakyan and Hovhannisyan, 'ACTy vorpes sharjum: manifest'.

133 Armenakyan and Hovhannisyan, 'ACTy vorpes sharjum: manifest'.

134 Armenakyan and Hovhannisyan, 'ACTy vorpes sharjum: manifest'.

135 Handwritten and unpublished document. Hrach Armenakyan's archive.

136 Hrach Armenakyan, 'Systematic Structural Analysis', unpublished text, 20 April 1996. David Karoyan's archive (in Armenian).

137 The author simply means 'event' but for a reason unknown to me, he writes 'eventa'.

138 'Fact', Hrach Armenakyan, unpublished text, 20 March 1996.

139 TV programme. Vardan Azatyan's archive.

140 Armenakyan, 'Systemic Structural Analysis'.

141 Zenian, 'Armenia on the Slow Road to Economic Recovery'.

142 Narek Avetisyan, interview, 18 October 2007; Hrach Armenakyan, interview, 23 January 2008.

143 Narek Avetisyan, interview, 18 October 2007.

144 Narek Avetisyan, interview, 18 October 2007. Renting spaces for private use from public institutions, legally or illegally, became common in these years of economic survival and the 'endless possibilities' provided by free commerce. A 1991 decree issued by the Minster of Culture reprimanded the security guard and other employees of the National Gallery for renting out a space in the gal-

lery and organizing a wedding and a number of parties on its premises. Decree 279, 08.07.1991, 80-15-16. Ministry of Culture Collection, National Archive of Armenia.

145 Armenakyan, 'Post-Art Situation'.

146 Hrach Armenakyan, 'Act as a Way of Thinking', unpublished text, 5 May 1995. David Karoyan's archive (in Armenian).

147 Isaiah Berlin, *Liberty: Incorporating Four Concepts of Liberty* (Oxford: Oxford University Press, 1968).

148 Berlin, *Liberty*, p. 134.

149 Berlin, *Liberty*, p. 134.

150 The crisis in Ter-Petrosyan's politics was already showing itself in 1996. I address this in detail at the beginning of the next chapter.

151 It is instructive that those who emigrated to Russia – Armenakyan, Vardanyan, Hovhannisyan and Aharonyan – completely abandoned artistic practices. Avetisyan considers himself the only one who more dogmatically continued ACT's pseudo-scientific and technological discourses with an added futuristic rhetoric until the beginning of the 2000s.

152 Hrach Armenakyan, interview, 23 January 2008.

153 Here I am drawing from Alan Badiou's proposition of politics as thought without an object. Alan Badiou, *Metapolitics* (London: Verso), 2005.

4 The revenge of the 'painterly real': national post-conceptualism, 1995–98

The tradition of Armenian painting that was started with Saryan and continued by Minas [Avetisyan] and [Harutyun] Kalents reaches its culmination in my work presented here. [I could call these] Armenian textual colorations.

David Kareyan, 1996[1]

I remember that these artists called their earlier works 'ideas'. But what is an idea? It is our desire that tries to catch up with reality. We constantly live within a fluid time and in a fluid space. These artists approach reality while many amongst us run away from it.

Charlie Khachatryan, 2000[2]

National in form, progressive in spirit

In Chapter 2 I discussed the paradigm of the 'national postmodern avant-garde' that the 3rd Floor termed *hamasteghtsakan* art, a paradigm most dominantly operative in the late 1980s and early 1990s, and one that constituted the cultural avant-garde of the perestroika period. It presented a postmodern amalgamation of various styles, symbols, signs and media, and acted as a marker of the youth culture of the period. *Hamasteghtsakan* art, as I argued, functioned in a complex relationship with institutional Soviet Armenian art on the one hand and with National Modernism, as the official opposition to the former, on the other. I presented the argument that *hamasteghtsakan* art survived beyond the temporal frame of the 3rd Floor, and can still be traced in the artistic discourses, styles, gestures, and most importantly, in the structural relationship between art and politics on the one hand, and art and everyday life, on the other. For *hamasteghtsakan* art, I argued, art's autonomy was supported by the painterly gesture, and it was this gesture that also constituted the understanding of art as ideal. Stylistically, *hamasteghtsakan* art signified a postmodernist appropriation of various styles and movements of post-war Euro-American art. In terms of aesthetic theory, it proposed an avant-gardist negation of a repressive regime of culture for the sake of absolute freedom

found in art. Politically, it facilitated a belief in absolute artistic freedom achieved by overcoming ideology through the supposedly non-ideological framework of liberal democracy.

Moving on to the 1990s, Chapter 3 argued that a new generation of artists emerged in the aftermath of the declaration of independence in 1991, one that broke away from *hamasteghtsakan* art. This generation was confronted with a structural crisis of negation wherein critique was no longer easily achievable in relation to the constitution of the state. The group ACT, as the offspring of the independence period, supported the constitution of the liberal democratic state as an ideal through artistic means. Their understanding of autonomous art as it was articulated through the concept of 'pure creation' adopted an operationalist logic, wherein the autonomous domain of art was proposed as one of the crucial institutional pillars of the modern state. I argued that 'pure creation' was a paradoxical concept, which allowed the artists to pursue the avant-gardist imperative of aesthetic negation while being confronted with the structural impossibility of political negation. The aesthetic, political and economic operations of 'pure creation' were aligned with larger social relations but also had to negate the everyday in order to establish art's autonomy.

As opposed to the 3rd Floor's grand gestures, ACT's artistic language was austere and minimal; as opposed to the movement's engagement with iconicity, the group's text-based work was iconoclastic; instead of the 3rd Floor's 'national postmodern avant-garde', ACT referenced the analytical-linguistic conceptualism of Joseph Kosuth and his peers. But what ACT shared with the 3rd Floor was a stance of artistic negation through the radicalism of 'newness', the sustenance of the youth cult as a manifestation of a daring new generation that triumphantly challenges societal taboos, and a belief in art as the inverse image of reality. However, if in the 3rd Floor's case this inversion meant that art was the negative image of reality (art is that which reality is not), in ACT's paradoxical identification with the state through 'pure creation', art was conceived as the positive image of reality (what reality should be is conceived as if it already were). ACT conceived both the state and art as democratic possibilities that were being realized in the present.

The conflict between art and reality, both in its negative and positive inversions, at times coexisting and at times clashing, was to follow the collapse of ACT and characterize contemporary art in Armenia in the late 1990s. The incommensurability between art and reality was to rely on various formal, aesthetic and conceptual binaries – between word and image, historical consciousness and mythological consciousness, national identification and 'progressive' art, *hamasteghtsakan* art and a version of 'pure creation'. These aesthetic convergences of opposing and at times irreconcilable binaries were taking place against the backdrop of the consolidation of a national representation of Armenia as a modern state with a long national history. Drawing on

these sets of binaries, this chapter presents the argument that the collapse of ACT marked the return of the 'painterly real', which, for a moment, coincided with the state's cultural politics. It is the goal of this chapter to investigate how the above-mentioned binaries came into conflict and were reconciled at the aesthetic level in the period following the collapse of ACT (1996–98), a period that is marked with what I call the revenge of the 'painterly real' in the works of former ACT artists David Kareyan and Diana Hakobyan. This chapter situates the return to the 'painterly real' within the then-dominant mode of historicization that characterized contemporary art as an evolutionary convergence of tradition and contemporaneity – a mode that attempted to reconcile tradition with progressivism and justify national identification in an increasingly globalizing world, one supposedly without communication barriers. I argue that contemporary art played a vanguard role in sustaining and advancing this logic. What took place in the second half of the 1990s was a gradual alignment of the ideal of the Armenian avant-garde with the ideal of the nation state, and within this alignment, the 'painterly real' obtained a cultural function in national cultural politics.

The question of the national representation of Armenia as a contemporary state explicitly defined the agenda of the Ministry of Culture, which throughout the mid- to late 1990s consistently supported and sponsored the representation of Armenian art abroad, including contemporary 'alternative art'. These efforts intensified in the mid-1990s both internally and externally. To the outside world Armenian art was represented by Armenia's first official participation as an independent republic at the Venice Biennale in 1995, and by exhibitions of Armenian art in Bochum, Cyprus and Moscow in the same year, both overseen by the Armenian Centre for Contemporary Experimental Art. Inside the country, the ACCEA organized a festival dedicated to the fifth anniversary of Armenia's independence in 1996. In these exhibitions, and in terms of institutional agendas, contemporary art was largely positioned within a trajectory of historical continuity as the latest instance of the age-old Armenian spirit crystallized in form, now conversing freely with the world. Ironically, this narrative promoted by the Ministry of Culture was one that went hand in hand with and was even foretold by the increasingly similar philosophies of art history developed by Arman Grigoryan and Nazareth Karoyan. In the mid-1990s their attempts at historicizing contemporary art converged with the institutional agenda of the ACCEA (even if neither, especially Karoyan, were part of it), an increasingly central venue for alternative art exhibitions at the time. And in all these exhibitions and attempts at historicization, it was within this evolutionary logic that ACT was incorporated. Thus on the one hand, we are dealing with a convergence of agendas between contemporary art and official cultural politics, and on the other, with a retrospective reading of ACT that subsumes the group within those agendas.

The exhibition *Contemporary Art of Armenia, 1980–1995*, organized in 1995 by the Armenian Ministry of Culture in Moscow, was part of a series of cultural events dedicated to the 1700th anniversary of the adoption of Christianity and was held at the Russian capital's House of Painters.[3] As a survey showcasing approximately forty artists,[4] the exhibition was divided chronologically to represent three generations of alternative art in Armenia, as presented respectively in the practices of the early 1980s group Black Square, the 3rd Floor in the late 1980s–early 1990s, and the mid-1990s conceptual practices of ACT with which the series culminated. What was at stake in this exhibition, as with those that would follow in Venice, Bochum and Yerevan, was to locate the nation in contemporaneity, which is to say as belonging to a world without ideological and communicative barriers, and also to locate contemporaneity in the temporality of national belonging.[5]

In the preface to the catalogue of the Moscow exhibition, then Minister of Culture Hakob Movses maintained that it was in the late 1980s and early 1990s that Armenian art finally synched with contemporaneity, since it chimed with the Euro-American trends of the time.[6] By contrast, the 1960s aesthetic tendencies of National Modernism in Armenia, while ahead of their counterparts in other Soviet republics, were not synched with Western developments. The belated modernism of the 1960s, he argues, did not have the wherewithal to break away from the confines of the Soviet space, and while relevant locally it had no international resonance in terms of originality and contemporaneity. Rather, it was in the 1980s that alternative practices in Armenia broke away from the pre-given spatial and ideological confines of the Soviet state and began to speak to the world in a shared language, but from a position of national uniqueness. This dynamic of national specificity combined with formal innovation, or rather formal innovation expressing national specificity, was not new. As argued in Chapter 2, its historical precedent was the National Modernism of the late 1960s that rearticulated the nation as an ethnically essentialist category in relation to modern form. The modern form and national content dynamic followed the dominant logic of official Soviet cultural representation as well: because Armenia was located on the periphery of the Soviet Union, it was always regarded as a small but culturally 'wealthy' country, expected to make extraordinary contributions to Soviet exhibitions and cultural fairs. Armenian artists, in their turn, conformed to this image imposed on them by the system. Contemporary art in Armenia inherited this exoticizing legacy from the Soviet demand for ethnic representation, which in turn had inherited the orientalist legacy of the Russian Empire.[7]

Hakob Movses's 'Preface' is remarkable in terms of locating contemporary artists institutionally. Coming from the Minister of Culture, it provides compelling evidence for official cultural policy in relation to contemporary art. Movses maintains that while in the past alternative artists were refused

entrance to 'the core text' (i.e. dominant mainstream culture) by the ruling ideology, now they do not enter it since they artistically *choose* not to do so in order to maintain criticality.[8] Remarkably, he stresses that this choice to remain at the margins is an artistic one instead of being a political imposition. This supports the argument I made earlier that the paradigm of the 1990s in Armenia can be formulated as a crisis of negation, where the avant-garde imperative of artistic negation comes into conflict with the structural impossibility of political negation. The minister continues that even if these artists do not represent the 'face of Armenian art', their production is formally more up to date with international developments than a selection of figurative representational art would allow. Here contemporary art's marginal but officially licensed and legitimized status in Armenia participates in the reaffirmation of the 'core text' of the dominant national culture. It should be noted that in the 1990s, official cultural policy, with its programme of reforming public institutions, had a progressive agenda, and relied on the support of alternative artists in various battles with the entrenched conservatism and rampant bureaucracy of public institutions.

The dilemma of representing Armenia as an emerging modern nation with a long history, marked by 1700 years of Christianity, but also one with a distinct and 'up-to-date' contemporary art scene, runs through Grigoryan's entry in the *Contemporary Art of Armenia* catalogue. This dilemma overtly shapes his interpretation of the fifteen years of contemporary art that he subsumes under the conceptual umbrella of 'The New Vision'.[9] Grigoryan locates the New Vision both within the trajectory of national art in Armenia since the 1960s and within the neo-avant-garde engagement with the social world as a resistant alternative to the latter in Europe and the USA around the same time. The 1960s counter-cultural movements that offered an alternative path marked by the 'Great Refusal' were conceived as genealogical sources for alternative art in Armenia since the second half of the 1980s.[10] By 'Great Refusal', a concept borrowed from Herbert Marcuse,[11] Grigoryan meant a resistance to any ideological imperative, be it capitalist or socialist, that makes of art a 'struggle against both capitalism and socialism', destroying barriers and heroically overcoming obstacles. And what characterizes the Great Refusal of the New Vision (for Grigoryan, the latter term is synonymous with contemporary art since the 1980s) is its dream of communication in a big and brave new world without curtains, walls or other physical and mental barriers. And even though each epoch has its own characteristics, for Grigoryan it evolves through the contributions of individual geniuses over the ages.

As mentioned above, Grigoryan's identification with Euro-American contemporary art was symptomatic of the 3rd Floor's role as an aesthetic and ideological 'translator' of 'Western' social, political and cultural values into late Soviet and post-Soviet Armenia, as the Other of everything that denoted

the Soviet. Nevertheless, as noted earlier, this translation was neither direct nor innocent, and the Other was perceived from the point of view of the late Soviet subject who, appearing within a limited information-scape, aggrandized and generalized every bit of information coming from 'outside' as the truthful representation of the outside world. And this quest for communicability was combined with a complex relationship with national tradition. Grigoryan's painting *Armenican Dream* (1999) is an example of this synthesis of signs that 'translates' American Pop Art aesthetics into the Armenian national context (figure 32).

Grigoryan's New Vision encompasses all of Armenian alternative or contemporary art from the 1980s, whose prehistory he locates in the late 1970s' and early 1980s' open-air youth exhibitions organized around the literary magazine *Garun*, and the publication of Arshile Gorky's letters in Armenia at the beginning of the 1980s. His account crystallizes the two central problematics that the alternative art scene was faced with in the context of glasnost: the propagation of a new youth culture and the individual's claim to the universal right to be informed. Two key characteristics distinguish the so-called New Vision from the supposed old vision: aesthetic originality through a paradoxical gesture of cultural quotation, and its mode of ownership of production. The New Vision breaks away from the collectivist production and reception of the artwork and challenges its function as a collective good in communist society. As mentioned in Chapter 2, the collectively produced art in the 3rd Floor's exhibitions and happenings propagated the figure of the artist as a radical individual who challenged social mores and taboos through the right to mix disparate images and styles. In a twisted argument on art and labour in this article, Grigoryan mentions that under the centralized state patronage of the arts wherein the state is both the commissioner and the consumer of the artist's labour, the individual artist is alienated from his labour. Any attempt towards de-alienation needs to start with the return both of the right to (free artistic) labour and of the product of labour (the artwork) to the individual artist.[12] On the one hand, then, the artwork's economy reproduces the capitalist logic of private property, and on the other hand, in a contradictory move, the artwork is a product of a purely individual act of expression that resists exchange value.[13]

Remarkably, in an exhibition that Grigoryan curated two years later called *Civic Values*, and to which I will return at the end of this chapter, he presented an abstract painting with the inscription 'For Sale. $50'. This work encapsulates the contradiction inherent in the artwork's place within the capitalist system of exchange: the individual gesture of the artist as a marker of uniqueness condensed in abstract brushstrokes nevertheless has an identified monetary value. Grigoryan, with a hint of irony, puts on sale both the (priceless) marker of artistic authority and the monetary value through which the unquantifiable gesture of authorship enters into exchange. Grigoryan's

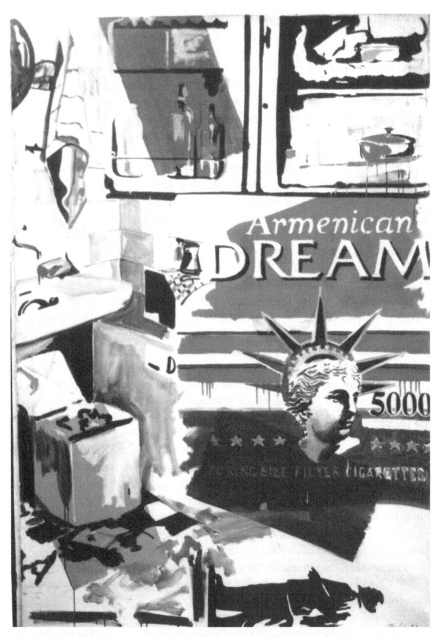

32 Arman Grigoryan, *Armenican Dream*, 1999

gesture can be read in the context of the post-Soviet 'transitional' economy's double operation: on the one hand market relations 'liberate' the artist from the constraints of the centralized state economy, and on the other, they 'liberate' the artist from economy as such. In the context of the newly independent Armenia when the initial attempts at constructing an art market had largely failed, artistic labour was barely subjected to the logic of exchange, and artists simply could not materially survive on their artistic labour. Grigoryan's work stages the 'resale' of art's exchange value under an identified monetary value, and does this in the name of art's authenticity. And it is authenticity that for Grigoryan demarcates the arrival of the New Vision wherein 'free' art functions affirmatively within society and yet 'stays truthful to itself'.[14]

For Grigoryan, art secures its authenticity as a result of its clash with reality, and the disidentification of art and reality is arrived at through intuition. As I argued earlier, the relationship between art and reality became a key problematic in ACT's practice via the paradoxical operation of 'pure creation'. But Grigoryan's conceptualization of the relationship between art and reality is starkly different from that of ACT's affirmative aesthetics: the young artists persistently rely upon the auxiliary verb 'must'. In short, if Grigoryan views art as an empty framework for freedom as opposed to the unfreedom of culture, ACT fills this framework with content. This, for Grigoryan, denotes authoritarian tendencies and a sense of an imperative: something which reminds him of the not-so-bygone past of the communist era. When reaching the chronological culmination of his New Vision in the practices of the artists of the new generation, Grigoryan 'salvages' ACT's practices for the New Vision by attributing to the young artists the ultimate goal of preserving the self above the social, made possible in the tension between art and reality. In a full realization of the paradox embedded in 'pure creation', he states:

> [t]he artists [...] play out the imperative '[You] must' in a self-ironizing way to the point of mental manipulation. In their main exhibitions and actions [...] they stretch not only art but reality to the point of making both grotesque, to make sure that even if they appear at opposing poles, the true artist will not cease to perform an 'act of non-obedience' in order to preserve himself and his world.[15]

Grigoryan locates ACT as the last instance of the New Vision, even though he does so with hesitation and critical irony.[16] With their reliance on rationalism, pseudo-scientism and anti-humanist technocratism, the group mythologizes progress while claiming to get rid of all myths and superstitions. And when Grigoryan quotes one of ACT's slogans which urges the expulsion of 'the information monsters from the sphere of consciousness', he appears to be drawing a distinction between his vision of art as a largely unconscious subjective practice and ACT's desire to overly rationalize art and explain artistic practice from the point of view of a 'pseudoscientific positivism' that aims at

'preserving the borders of the interior of human rationality' and transforms all that is organic and irrational into something mechanical and rational.

Grigoryan's poetic and somewhat verbose outpouring about ACT claims:

> If we do not want to appear in the limited domain of futurism with its joyous infantilism and vivid imagination (and this diapason does not exceed an overly simplistic and recognizable requisite such as a flying saucer, a city in a building, a space journey, adventures with extra-terrestrial beings, especially in order to fulfil popular desires and legitimize the fact of being chosen) ... ; if we have not completely abandoned rationality and have not encountered 'the cybernetic monster' while wandering within our mental abilities, which would drag us to our destruction in the polyvinyl nodes of the biological swamp of materialism; and if we have not abandoned hope in our abilities to plan and to realize what we have already planned while avoiding the pseudo-positivistic 'final' definitions of the demagogic operationalism of 'scientific communism'; then the self-declared movement Actual Art [another name for ACT] ... would give us the hope that art has not yet ceased to be a possibility of knowledge even though currently these artists are more concerned with problems of drawing borders to expel the 'information monsters from the sphere of rationality'...[17]

From the point of view of an artist whose practice was formed in the late Soviet period, art's ultimate goal should be its final emancipation from ideology. Otherwise, before art gets to be autonomous, it is already contaminated by ideological dogmas, falling prey to instrumentalization by political power. What Grigoryan fails to notice is that despite ACT's claimed political participation through calculated rational acts, the group's key notion of 'pure creation' is a more radicalized and sanitized version of his own belief in art's irreconcilability with existing reality. He falls short of seeing ACT's aesthetic defence of art's autonomy behind the façade of the group's pseudo-scientific social claims, formal demonstrations and propagandistic strategies, though he does identify the ultimate goal of the group as the preservation of the self above and despite the social.

Grigoryan's inclusion of ACT in his New Vision typology is both conditional and strategic. On the one hand, he dissociates the group from the New Vision by pointing at differences rather than commonalities as well as adopting a distancing irony in his discussion, while on the other he incorporates ACT into the final stage of evolution of the New Vision. Hence his hope that ACT, at the end of the day, will justify his expectations. Without betraying his earlier belief in the ultimate teleological development of art as the moment of final emancipation of the self, Grigoryan concludes the catalogue entry:

> The exhibition *Contemporary Art in Armenia 80–95* is structured based on the realization that the included creative processes are ongoing and that they

constitute a single whole, which is the New Vision. [The latter] allows us not to complain of everyday discomforts after the unification of the bisected world, and to rise from beneath the ruins and fragments of the collapsed 'Great Dreams' by trusting the ultimate victory of one's own 'Self' and the victory of human solidarity.

Grigoryan, in his attempt to conceptualize the past fifteen years of contemporary art in Armenia, continues the 3rd Floor's strategy of appropriating artistic practices and discourses in a single melting pot – one which the 3rd Floor had put on the fire – and which he identifies as the 'New Vision'. Interestingly, the typologies he constructs and the evolution of the New Vision he suggests bring his philosophy of art history closest to Nazareth Karoyan's Hegelianism, though the teleological element here is not as pronounced as in Karoyan's attempts at historicization. Grigoryan's philosophy is ultimately humanistic, with its reliance on a belief in communication, on conciliation of differences for the sake of one emancipated culture, and on the victory of the self above all.

The national horizons of the Armenian avant-garde reclaimed

Similar attempts at historicization that subsumed diverse practices under a general concept or category had emerged in the months leading up to the Moscow survey exhibition. The exhibition of Armenian art in Bochum's Galerie Bochumer Kulturrat that preceded the Moscow exhibition by several months was structurally similar to the latter. It presented a historical survey that summarized 5,000 years of 'Armenian art' with an 'alternative' exhibition of contemporary tendencies in the alternative location of a former coalmine.[18] Similarly to the Moscow exhibition, practices emergent since the 1980s occupied an officially sanctioned but peripheral location in relation to the properly official cultural representation that relied on past achievements and constituted the 'core text', if we recall Movses's words. The two exhibitions went hand in hand with structural transformations within the Ministry of Culture on the one hand, and the consolidation of its cultural policy in terms of national representation on the other. In 1995 an agency was established within the ministry with the mandate of regulating the temporary export of cultural artefacts from Armenia and serving as 'a real lever for the state to participate in the market-driven circulation of cultural objects'.[19] In the absence of an internal art market, the cultural artefacts produced within the Republic were largely meant for export.

Karoyan, who since the early 1990s had been at the forefront of attempts to develop an art market, saw a danger in the constitution of a state-run agency focused on the export of cultural production whose activities could not be

balanced with an internal art market, which was lacking. The Bochum exhibition was organized according to a new procedure introduced by the ministry in early 1995, one that required the establishment of an organizing committee to oversee the selection of the artworks, their installation and the publication of the catalogue. The Bochum committee included prominent cultural figures from various generations from the medieval art historian Vigen Ghazaryan, to the museologist Lilit Zakaryan, to the painters Vigen Tadevosyan, Ashot Bayandur and Arman Grigoryan, among others.[20]

It is not the exhibition itself that is of primary importance for us here, though it does illustrate the point I made earlier on official cultural policy regarding national representation. What concerns us here is the mode of historicization of contemporary art in Armenia, emerging out of the need to represent its scattered and uneven development in a coherent manner. Further, what is of interest for us is the way in which the show illuminated the larger cultural politics and politics of national representation at play, and involved the main players in the field: the Ministry of Culture, the Painters' Union and Karoyan himself as an independent curator and critic who had ambitions of playing a large role in defining official cultural policy. In a concise text meant for the Bochum catalogue (it remained unpublished due to 'technical reasons') and entitled 'In the labyrinth of the fulfilment of an alternative tradition', Karoyan lays bare his philosophy of history as one that draws from Hegel.[21] In his two-tier discussion of the 'appearances' and 'depths' of the historical evolution of art in Armenia, the appearances (what he calls the 'superficial layer') are perceived as part of a whole, with their interconnected manifestations and stages that 'determine its objective patterns'.[22] At the level of depth, contemporary art in Armenia is considered as an intersection of two axes – synchronic-horizontal (in its relations to global contemporary art) and vertical-diachronic (in its relations to a national alternative tradition). It is to the 'depth' that Karoyan dedicates the rest of the article in order to expose the international reader of the Bochum catalogue to the historically specific development of contemporary art in Armenia according to 'one's [specific] sense of measure'.[23]

Karoyan's conceptual core here is what he calls 'the alternative tradition [of innovation]' that precedes Grigoryan's New Vision by a few months. This tradition is that which culminates with the ultimate reconciliation of form and content and the dissolution of their boundaries. In Karoyan's argument, in contemporary art, form is the carrier of contemporaneity while content refers to the historical past – a conceptualization that is rather similar to National Modernism's dictum 'modernist in form and national in content'. For Karoyan, while 'contemporary' provides an alternative to existing historical art forms, 'the national' roots these forms in tradition. Thus he claims that contemporary art is an alternative tradition.

The two main sections of the text – 'Sacrifice and crucifixion as cultural alternative' and 'The avant-garde in the fold of domestication' – serve as the two thematic and conceptual axes upon which contemporary art as the alternative tradition of innovation realizes itself, in the vein of the Hegelian end of history, albeit with a postmodernist animosity towards historical time. Contemporary art is considered as the ultimate victory of militant modernism over the dogmas of Socialist Realism – a victory which has been arriving gradually, with each generation, since the 1960s, proposing new forms and gestures on the basis of predecessors' failures. At the root of the formation of the alternative tradition, as opposed to the one offered in the dominant historiography and aesthetics of state socialism, was not merely a battle between form and content, but between genres: more intimate genres such as self-portraiture, landscape and still life came to replace the Socialist Realist favourites, historical painting in particular and multi-figure thematically oriented compositions in general. The formation of the alternative tradition in Karoyan's rendering is constituted as an oppositional reaction against the aesthetic principles of Socialist Realism, but one that is historically embedded in the nation and objectively justified.

In Karoyan's archaeology of the alternative tradition, the 1960s accomplished an approximation of national form with national content. And this was the beginning of ridding form of referentiality and discovering the autonomy of brushstrokes, colours, the white surface of the canvas and the painterly construction of the space – though the 1960s generation did not quite succeed in this, since its formal experimentation remained embedded in the referentiality of national content. This content included the themes of the 'patriotic' landscape and its ancient inhabitants, resources drawn from medieval Armenian art, and the works of early twentieth-century modernists such as Martiros Saryan and Georygy Yakulov and later, the work of Arshile Gorky.[24] Another resource that, according to Karoyan, facilitated the emergence of pure form, in the guise of an abstractionism crowning the pillar of tradition, was the 1960s rediscovery of 'national' ornamentation – floral forms derived from medieval ecclesial architecture, which challenged Socialist Realist iconophilia.

Karoyan's philosophy of history maintains that certain pivotal moments of national history, such as the acceptance of Christianity in the fourth century or the adoption of the alphabet and the translation of the Bible in the fifth century, sediment themselves in the collective unconscious as archetypes and become inherited cultural codes. This historiography is ultimately conservative in that it locates the historical evolution of contemporary art within ethnically bound categories, while presenting an essentialist narrative rooted in claims for a national character and psyche combined with a linear understanding of history, where progress in the past culminates in the

present. Although it defends innovation on the grounds that it can be justified by tradition, Karoyan's account does not radically diverge from the myth of the nation embedded in institutionalized historiography since the nineteenth century. This historiography takes up the nation – understood as ethnicity – as a core category upon which narratives of survival, victory and martyrdom revolve.[25]

On the evolutionary spiral of the alternative tradition, the 1960s generation bore the mark of the failure to ultimately reconcile form with content, avant-gardist progressivism with national identification, and paved the way for the 1970s practices that would carry those binaries on towards their reconciliation without yet achieving this task. Bearing the mark of Brezhnev's long epoch of cultural stagnation, the Tbilisi school painters, some of whom physically relocated to Yerevan while the influence of others spread from the neighbouring Soviet Republic of Georgia, borrowed from the colour palette of seventeenth- and eighteenth-century Western European painting as well as early twentieth-century Cubist treatment of form to retreat into an alternative allegorical world of circus acrobats, theatrical performances, actors, clowns and nudes so as to find an alternative to official beautifications of stagnant reality. This escape from the ideologized representation of officially sanctioned reality reached its culmination in the existentially informed artwork of the Black Square movement in the early 1980s, for whom reference to the iconic avant-gardist work of Malevich was perceived not as a futuristic arrival of new form opening up towards the newly constructed social world, but as a negative image of contemporary reality.

The arrival of abstractionism in the early 1980s marked a paradigm that Karoyan here and elsewhere terms the 'national avant-garde', making it a continuation of a hitherto severed tradition beginning with medieval Armenian art. The global arrival of postmodernism – the cultural condition of the post-industrial world, where the end of 'historical consciousness' and the advent of 'mythological consciousness' ushers in an epoch of global communicability without temporal and spatial barriers – was echoed in and fed into the Soviet Union's intensified desire for communication with the outside world triggered by Gorbachev's glasnost. In Armenia the inauguration of *hamasteghtsakan* art reflected the double operation of this term, which was a direct translation of the word 'conceptual': on the one hand, it implied creative conception as a divine act, and on the other, it referred to the artist's privilege to act as a creative subject, as an author. As a postmodernist paradigm of 'local action and global thinking', *hamasteghtsakan* art destroys the hierarchy of representation between high and low art, and presents communication as the core problematic of its programme.[26] Karoyan's historicization deterministically equates each period marked by an artistic formation with a particularity of that period's informational context. He states:

These three facts of artistic presence within a decade and a half – from Black Square's unconfessed power-striving to [Grigoryan's] democratic-anarchistic claim to 'cross the border on a bicycle' to [Kareyan's] parliamentary, if not bureaucratic demand to define borders in *Art Referendum* – clearly correspond to the dynamic changes of the social, political and cultural texture of the information sphere which encompasses the artistic landscape.[27]

It was the problematic of communicating with the larger world, now seemingly one without barriers, using the universal language of avant-garde form (this also includes the neo-avant-gardes), but based upon the specificity of one's national determination, that formed the fabric of the cultural landscape in Armenia, whether state-sanctioned or arising from the scene of alternative art. In Karoyan's linear and deterministic historiography, replete with teleology, *hamasteghtsakan* appears as the locally specific manifestation of global postmodernism.

Consequently, and following from the above discussion, it can be concluded that the state agenda of the representation of the nation as modern and progressive converged and overlapped with the *hamasteghtsakan* philosophy of history and the cultural agenda arising from it. The horizon of culture and politics in the second part of the 1990s was the nation, and even the antagonistic poles formed within the sphere of official cultural politics did not challenge the domination of the nation-form as the political horizon of the state. Rather, within official cultural politics the debate evolved around the *mode* of representing the nation.

It is evident, from the debates in the press preceding and following the Bochum exhibition, that the project, as any project claiming to represent a nation historically would be, was rather controversial. The administration of the Artists' Union sent an open letter to the president of the Republic, the Minister of Culture and other governmental organs, complaining about the organizational procedures of the exhibition and the selection of the artists. The 'alternative tradition' that Karoyan theorized in the Armenian art of the past three and a half decades had excluded the 'mainstream' tradition for which the Artists' Union served as institutional guardian. And it seems to me that this reactivation of select instances of historical memory, as discussed above, was a tool to combat the cultural hegemony of the Artists' Union's historical narrative. In many ways, the paradigm of the late Soviet perestroika antagonism between properly official, closed and bureaucratic cultural institutions and their officially oppositional counterparts represented by the Armenian avant-garde was alive and well, except that the latter now occupied the mainstream of national representation as its agenda for a moment became closely aligned with that of the nation state's.

It is remarkable that in this debate Karoyan appeared in the position of defending the ministry against the attacks launched by the Artists' Union. In his editorial in *Ex Voto* Karoyan focuses on the addressee of the Union's open letter – the president of the Republic – as evidence that the administration of the institution had not abandoned the 'good old past' where the head of state was treated as the 'ultimate authority' and arbiter of all spheres of life from 'military art to the visual arts'.[28] From Karoyan's response to the Union's letter, it becomes clear that the Ministry of Culture did not consult 'outmoded' public institutions like the Union, the National Gallery and the Modern Art Museum in the conceptualization of the exhibition and the selection of the artists. The administration of the Union responded to Karoyan's editorial in *Garun*'s seventh issue of the same year, and blamed him for servicing the Ministry of Culture by defending the exhibition, and particularly for the 'huge oversights' in the conceptualization 'of the past thirty–forty years of Armenian art'.[29] In a cunning move, the authors of this response remind Karoyan that the 3rd Floor had been hosted by the Artists' Union since 1987, and that attacking the institution amounted to being ungrateful.

These debates show the ways in which alternative art's national-progressive agenda coincided with that of the state's, and how these two supported each other at this specific historical juncture of the mid-1990s. In a way the Ministry of Culture at the time was more progressive than many of the official cultural institutions, and often relied on the alternative art scene in its efforts to reform these institutions. But the state ideology regarding national history and representation converged with that of the Armenian avant-garde on yet another level, with profound implications for the historicization of contemporary art in Armenia and the position of avant-garde art in relation to culture.

In a 2006 article entitled 'Memory and/or Forgetting: Historicising Contemporary Art in Armenia', the art historian Vardan Azatyan revealed the ways in which the avant-gardist eradication of history met the dominant cultural mythologization – and thus ahistoricization – of the nation. This problematic of memory and oblivion has defined contemporary practices in Armenia in their identification with dominant cultural discourses, even if this identification has often been fig-leafed in oppositional and resistant rhetoric. It has also been incorporated into institutional modes of remembering and forgetting, as exemplified in the ACCEA's politics of memory. Azatyan argues that in its systematic programme of eradicating traces of the past, political power in Armenia occupies an avant-garde position, and if avant-garde art is to be truly vanguard in relation to power, it needs to occupy the opposite pole, that of historical consciousness. No exhibition better crystallizes the identification of avant-garde art's programmatic oblivion with the mythologized narrative of the nation than the 1996 festival organized at the Armenian

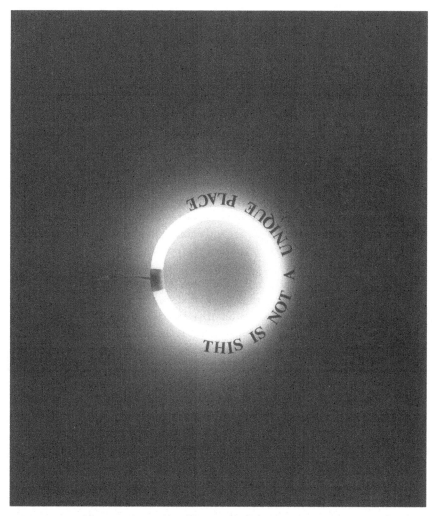

Karen Andreassian, *This Is Not a Unique Place*, 1996. Exhibition dedicated to the fifth **33** anniversary of Armenia's independence

Centre for Contemporary Experimental art. Dedicated to the fifth anniversary of Armenia's independence, and curated by the Centre's founder Sonia Balassanian, this event was a prelude to the structural division of the ACCEA according to disciplines (art, music, film, theatre, and later architecture).[30] Conceived as a festival, the event marked the convergence of the 3rd Floor's theatricality with the ACCEA's institutionalizion of the contemporary art exhibition as spectacle. I argue that this event also marks the beginning of a shift wherein the identification of contemporary art with dominant cultural

narratives arrives at its apogee, followed by their gradual disidentification in the late 1990s and early 2000s.

The paradigmatic transformations of art's relationship to dominant cultural and political discourses can be outlined as follows. The 3rd Floor's understanding of art as a sphere of free creativity structurally echoed the framework of liberalism, since the 3rd Floor's *hamasteghtsakan* art, like the ideology of liberalism, claimed to provide form rather than content for art practices. Unlike the 3rd Floor, in the early to mid-1990s for ACT the autonomy of 'pure creation' was what guaranteed claims to political participation, and the group filled the framework of liberal democracy with content by prescribing ways in which the artist was to participate in the constitution of the new state. Between 1995 and 1998, as the present chapter argues, the official agenda of national representation almost entirely coincided with that of alternative art. And finally, in the art and exhibition practices of the late 1990s we witness a gradual aestheticization of the political that in the early 2000s culminated in a conscious and programmatic disidentification with dominant political discourses, a paradigm that I discuss in the chapter that follows.

To comprehend the contradictions that the fifth anniversary festival embodied, it is enough to mention that the avant-garde artworks – for instance, former 3rd Floor actionist artist Sev's sinister appearance with a torch, welding a metallic pipe sculpture before an audience, Arthur Sargsyan's empty chair precariously sitting on four light bulbs, and Diana Hakobyan's semiotics of prohibition and licensing in the form of public signs strewn across the exhibition space – were received in the midst of religious and folk choir performances. The festival was attended by the Patriarch of the Armenian Church, Catholicos Vazgen I, who blessed the ACCEA;[31] by the head of the constitutional court who legitimized the works by comparing them to what he had witnessed in the Venice Biennale the year before; and the speaker of the Parliament. As a conscious curatorial choice to base innovation upon tradition, the festival claimed to participate in the construction of the state through art. The centre's co-founder Edward Balassanian made this explicit in an interview: 'The same way we need to construct roads, factories and apartments, we need to cultivate souls.'[32] For Grigoryan, who was then trying to reconcile his libertarian anarchist stance with the imperative for national identification,[33] the exhibition marked a convenient marriage of avant-garde negation and national history. If, for Karoyan, the contradiction of national identification and avant-garde progressivism could be resolved in the melting pot of postmodern relativism, for Grigoryan this reconciliation was subjected to a modernist logic.

In an article published in the aftermath of the exhibition and symptomatically entitled 'The Catholicos Blessed the Armenian Avant-garde', Grigoryan conceded that free art is a purely bourgeois notion, and that if it is positioned

against culture it means that culture is not bourgeois. But it is on the side of bourgeois art that Grigoryan stands, and not its repressive 'anti-bourgeois' counterpart. Remarkably, for Grigoryan the etymological root of 'bourgeois' (from the old Frankish word *burgeis*, 'town dweller')[34] is what constitutes the contemporary meaning of the term, denoting one who belongs to the city and is *civil*. And this civility is a value that only art can keep alive in the face of oppressive culture. In this article he defends the figure of the tenth-century Armenian monk and poet Grigor Narekatsi as a spark of enlightenment in the midst of ecclesiastical ignorance and repression. Narekatsi *as an individual* appears as an epitome of national uniqueness. If, for Karoyan, history is constituted by a larger transhistorical zeitgeist that finds its material realization across different times and epochs, for Grigoryan it is unique individuals who ensure progress in history through ground-breaking deeds. And this is how he reconciles national identification with progressive (meaning civic, bourgeois) art, which for him has a civilizing value. For Grigoryan, the presence of the Catholicos and the head of the constitutional court at an event dedicated to Armenia's independence marks a reconciliation between art and culture, one that is a prerequisite for progress and that has finally been achieved in the framework of the nation state's progressivist agenda.

Nowhere but in a 1997 draft for a festival dedicated to the 3rd Floor's tenth anniversary do Karoyan's and Grigoryan's modes of historicizing contemporary art coincide, almost without any frictions and disagreements. These modes, in turn, coincide with official cultural politics on the one hand, and the ACCEA's institutional agenda on the other. Comprising several historical and contemporary survey exhibitions, the festival was to situate the 3rd Floor in relation to National Modernism, or rather the opposite – to retroactively situate National Modernism in relation to the 3rd Floor.[35] The 1997 proposal conceived a series of exhibitions that would bring together Grigoryan's and Karoyan's differing understandings of the 3rd Floor's agenda, materializing the concept of autonomous art as a precondition for the cultural act of communication.

The proposed exhibitions were to situate the movement alongside select instances of what the authors called 'leftist art', which here meant art as a form of resistance to prevailing social conditions and to the reproduction of the official fine arts canon. As mentioned in Chapter 2, this 'leftism' carried perestroika connotations of resistance, for example to outmoded cultural discourses, rather than denoting political leftism in its conventional understanding. The authors justified this attempt at retroactive historicization by putting forth a cultural historicist argument: history could only be realized after the fact, and never during the present moment when the subject is caught up in its making and in the regime of urgency. The festival included a show commemorating the 35th anniversary of *The Exhibition of Five* from 1962 – a

seminal event that inaugurated the emergence of the 1960s–70s modernists[36] – and also proposed a survey show dedicated to the 25th anniversary of the establishment of the Modern Art Museum of Yerevan in 1972. Both were seen as key moments that introduced 'a vital tradition of self-reproduction for the newest art and culture'.[37] An exhibition dedicated to the tenth anniversary of the alternative artists' movement was to form the core of the festival and was to be accompanied by several satellite exhibitions of contemporary art. These parallel exhibitions were to historicize the art practices of the present under the shadow of the 3rd Floor's legacy. The exhibitions would structurally coexist on lateral planes, and aesthetically construct formal and programmatic affinities between various twentieth-century art practices and those of the movement.

The structure of the festival was to support the historical claim, elaborated in the conceptual statement of the proposal, that the 3rd Floor was the legitimate heir of the interrupted tradition of Armenian modernism, while reopening the possibility of the 'self-reproduction' of innovative art beyond the confines of its temporary existence. Given the often contradictory stances, agendas and aesthetic affiliations that various members were exploring in the late 1980s and early 1990s, as discussed at length in Chapter 2, this unified historical claim was a revisionary and retrospective one.[38] This is not to say that this particular mode of self-historicization, which positions the movement as the culmination of a tradition of innovation as it is presented in the 1997 proposal, was *only* retrospective, and that artists did not grapple with the often contradictory and conflicting readings of modernism in the late 1980s. As argued, the 3rd Floor's understanding of its practices as located within the avant-garde tradition of negation, on the one hand, and of providing historical continuity with Armenian modernism's romantic tradition of resistance against ideology and the banality of the everyday through the painterly gesture, on the other, was part and parcel of the movement's self-realization during the years of its existence. Even Grigoryan, who in the late 1980s and early 1990s was a champion of avant-gardist negation, by the mid-1990s had shifted his position towards amalgamating the tradition of National Modernism with contemporary forms.[39]

Avant-gardist negation – seen as having a tradition and a legacy – is exercised in the style that Grigoryan invented called *Armenican* painting, which mixes American Pop Art and national fine arts. It presents an amalgamation of the bright primary colours that characterized National Modernism with the themes, subjects and methods of the organization of the painterly surface borrowed from Pop Art. Armenican painting recycled various local and global signs and symbols on the heterotopic terrain of representation, and yet subjected these to the painterly discourse of National Modernism. This was an avant-garde that marked the amalgamation of 'the modern, the spiritual and the national'[40] through a postmodernist practice of appropriation and

pastiche. If in the late 1980s and early 1990s the movement kept the binary oppositions of innovation and tradition, rupture and continuity, freedom and necessity, official and unofficial, subcultural and mainstream in constant tension, the retrospective historical argument of the 1997 proposal did away with this dialectic by comfortably situating the movement within the trajectory of National Modernism as the last and most evolved instance of that tradition. If in the late 1980s and early 1990s national identification was uneasy and involved conflict, by the late 1990s this identification had secured continuity in relation to tradition.

In the proposal for the festival, the selected historical manifestations of National Modernism were conceptually subjected to the 3rd Floor's ethos of dismantling all hierarchies of value. In this paradoxical reclamation, the institutionalization of the tradition of innovation takes place under the sign of cultural relativism. Faced with the need for self-historicization, the 'national avant-garde' (or for Karoyan, the postmodern avant-garde) saw itself within the historical logic of the interrupted tradition of dissent embodied in the national fine arts. This historical logic was carried forth by painterly discourse, capturing and advancing the spirit of resistance. The writers of the proposal read Armenian modernism as a tradition of resistance against affirmative culture in general and official painting in particular. Even if Socialist Realism with its local variations no longer constituted the official painterly style, its institutions (these included the Artists' Union and the State Academy of Fine Arts) had survived both perestroika and independence-era transformations. It was in relation to these institutions and their constitutive ethoi that the former members of the 3rd Floor were interested in reconceptualizing Karoyan's version of the national avant-garde in order to locate its own history as the last and historically most potent moment of resistance. The fact that Armenian modernism formed a large part of the institutionalized canon of mainstream cultural discourse at the time of the proposal did not impede the latter's rhetoric of resistance.

The festival ultimately did not take place since its ambitious format was beyond the organizers' abilities to execute. But the extensive proposal reveals the complex and often contradictory relationship that the 'national (postmodern) avant-garde' in Armenia maintained with National Modernism. Ironically, by then the latter's institutionalization was not merely confined to the Modern Art Museum, but increasingly came to constitute the cultural politics of the nation state, a process that matured in the early 2000s.

Texts that do not speak

In the second part of the 1990s, it was not merely modes of historicization of contemporary art – in this case, a reliance on an alternative tradition

of national representation and its alignment with official cultural politics – that were at stake. What became obvious as the 1990s rolled towards an end was that the rupture that ACT introduced in the short span of their activities was being undone not only through the subsumption of their aesthetics within the evolutionary historical logic outlined above, but by the very protagonists of the group. David Kareyan's work at the exhibition for the fifth anniversary of Armenia's independence at the ACCEA in 1996 is the best example of this undoing. Gone were his handwritten inscriptions upon various material fixations, the black typewritten letters on white paper applied with linguistic precision and methodical seriousness (though this aesthetics would resurface occasionally up until 1998), and gone were the artistic transformations of the political procedures of democracy. This shift did not entail that Kareyan abandoned text as form, just the opposite: he turned it into pure form and depleted text of all referentiality and of all semiotics. The shift was from the austere black and white letters of constitutional democracy towards a visual language of text as icon. Presented as a vinyl print – *Texty Vorpes Taratsutyan Dzevavorum* [Text as formative of space] – that spans the length of the wall, the work brought Kareyan's earlier interest in text as form to a complete circle, where the text now refused legibility and appeared as image (figure 34). Here the text operates as an intervention in the space of the institution through form. But what kind of form?

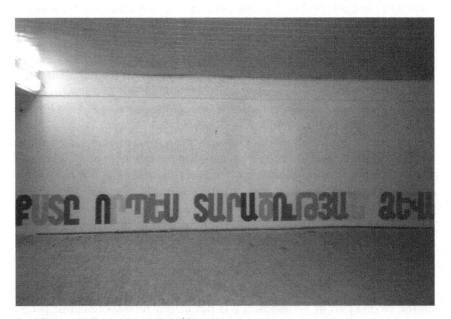

34 David Kareyan, *Text as Formative of Space*, 1996

Kareyan's letters were layered with colour, specifically with primary colours whose juxtaposition in the Armenian context explicitly referred to the National Modernists of the 1960s, and through them to the early twentieth-century modernism of Martiros Saryan, and further, through Saryan, to the colours of medieval manuscripts. Kareyan states this explicitly: 'I am presenting a work where a functional connection with Saryan, [Hambardzum] Kalents and Minas has been established, [one] with their world of colours. I am presenting the coloured layering of Armenian letters.'[41] This was the first manifestation of Kareyan's move away from the chromophobic and counter-visual aesthetics characteristic of ACT in general and of his work of that period in particular. While still producing text-based work and exploring the formal expansion of text into space, the self-referential signs (self-referential in that the sentences would comment on the very conditions of their display, in the same way that in his earlier works, textually inscribed materials were used for these very inscriptions) in Kareyan's text-based works started acquiring mostly primary colours.

Given the insistence on primary colours and their genealogy tracing back to National Modernism (hence his references to Kalents and Minas), was this a revenge of the painterly? Was painting coming back to haunt Kareyan's text-based art after its expulsion from practice as an artist-agitator educated at the Fine Arts Academy with its skill and medium-based pedagogy? If so, what does this 'return of the repressed' entail in terms of 'pure creation's' subsumption within the paradigm of *hamasteghtsakan* art? What were the consequences of this aestheticization of language as image and the depletion of its referentiality? And finally, how does this shift play into the views of history outlined above?

It was in an exhibition that Kareyan curated a year later that this new-found language of text as icon fully manifested itself. In the exhibition *Inscription: Post Factum* (figure 35) curated in 1997 at the ACCEA and involving 19 artists, writers and musicians, the conceptual and formal approaches of Kareyan's work extended to the exhibition as a whole. Compressing the interdisciplinary festival format that the ACCEA had introduced a year earlier into the space of one exhibition, Kareyan proposed collaboration between artists, musicians and poets to work with text as material. Comprising works that ranged from music notes posted on the wall (Mikhail Kokzhaev), to an installation of rubber tyres with colourful textual prints (Diana Hakobyan) and hieroglyphic representations (Ararat Sargsyan), the exhibition confined text to its articulation as writing. Linguistic signs were sieved through an iconographic filter: the indexicality of texts was subjected to iconicity, and inscription was understood as a process of visualization. The works in the exhibition were eclectic, yet they were all complicit in celebrating the domination of text turned into image over the image conceived as text. The poet Armen Davtyan

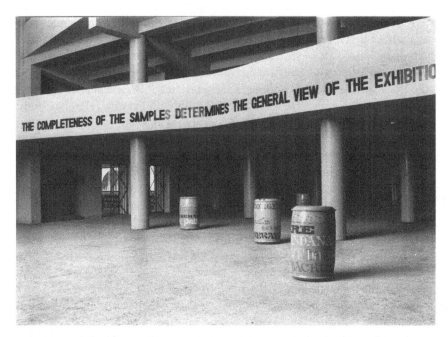

35 David Kareyan, *The General View*, and Diana Hakobyan, *Untitled: Barrels*. Exhibition
Inscription: Post-Factum, 1997

drummed on painted barrels installed by Hakobyan; Karoyan extended his
critical curatorial practice of mapping the landscape of the contemporary art
of the 1990s to an artwork by inscribing the names of artists and exhibitions
that had been part of his attempts to establish commercial art galleries; Grigor
Khachatryan conjugated the verb 'wrap'; while Vahram Aghasyan simply
highlighted columns from newspaper spreads with a black marker in order to
conceal the underlying text.

Grigoryan's work extended his pictorial practice to encompass letters
that were subjected to the regime of painting through accentuated flatness.
Appearing on various geometrically shaped planes, the painted black and
white letters did not perform a readerly but a painterly function. Similarly
to other works in the exhibition, including a condensed and layered version
of Kareyan's spatial text mentioned above and Hakobyan's barrels and tyres
painted and written over with the aesthetics of pop advertising, Grigoryan's
work subjected the textual to the regime of the visual and the painterly. These
were 'visual inscriptions' as Kareyan used to call them, inscriptions 'turned
into feelings'.[42] Combined with Aghasyan's assertion that 'art is spontane-
ous and comes from a deep-seated unknown place',[43] no trace is left of the
former ACT's operationalist and consciously anti-romantic discourses. Now
the *hamasteghtsakan* artist's spontaneous creativity and expressivism is

combined with a growing interest in psychoanalysis, an interest that Kareyan and Aghasyan had started sharing particularly with Grigoryan. Here the cycle of Viennese cultural contradictions came to completion when Wittgenstein, their earlier inspiration, was replaced with Freud. And this shift is one that allows us to draw certain parallels between late 1990s Yerevan and early 1900s Vienna.

Early twentieth-century Vienna in the last days of the Austro-Hungarian Empire gave birth both to the Vienna circle of neo-positivists and to the Freudian discovery of the unconscious. These contradictory ways of relating to the position of the subject within the social encapsulated the dilemmas of a society facing belated capitalist development, with a rising bourgeoisie slowly gaining culturally and economically on the strongly persistent remnants of aristocracy. Out of these class collisions a particularly repressive morality became dominant. If the Vienna circle of positivists articulated the problem of the subject in relation to general morality by applying scientific rules to analyse social phenomena, Freud's answer was another form of scientism grounded in empiricism, but one that situated the ego between the deeply rooted unconscious drives of the id and the moral pressures of the superego.

It can be argued that Armenia shared a peculiar similarity with *fin de siècle* Austria in that class relations were drastically shifting, from the late Soviet 'classless' society to one with a dramatically stratified class composition. This is not to imply that late Soviet society was actually classless. Just the opposite: the elimination of class from Soviet discourse was an ideological operation of constructing a totalizing notion of 'Soviet man' in which officially licensed ethnic and religious identity politics came to replace the Leninist class struggle. However, in the post-Soviet context of original accumulation and the 'shock therapy' doctrine of economic liberalization and implementation of market relations, the Soviet petite-bourgeoisie (the largest and most complex of all classes since it is composed of elements lying between traditional class divisions), composed of teachers, engineers, skilled factory workers, former factory managers, entrepreneurs, cultural workers and so on, appeared in socially and economically precarious conditions, whereas the traditional proletariat was eliminated altogether. The class composition and the social background of the emerging nouveau bourgeoisie – former factory managers, new entrepreneurs and Karabagh war veterans among others, some of whom occupied the highest political and economic echelons in the late 1990s in Armenia – showed that a shift had taken place: from the late Soviet bourgeoisie and petite-bourgeoisie to the post-Soviet new bourgeoisie. In these conditions of transformation, the values of Soviet cultural elites, such as an ostentatiously displayed belief in education and acculturation as class privileges, persisted alongside the newly emerging values of radical individualism, egotism and 'looking out for oneself'.

In the early to mid-1990s the shifts in social relations were seismic, and were combined with the effects of the war, the aftermath of a devastating earthquake in 1988 and the blockade of Armenia's two borders. In this context, the popularity of Wittgenstein and Freud in the contemporary art scene (Freud had been popular among the 3rd Floor members since the late 1980s, and Wittgenstein was read by ACT in the mid-1990s, only to be abandoned for Freud after the latter's collapse) is not accidental. While Wittgenstein helped 'to make sense of the chaotic social world scientifically' by reducing the complexity of everyday life to a measurable order, Freud was instrumental in making sense of what remained beyond measurable order. And it was the latter that dominated the discourse of contemporary art in Armenia in the late 1990s, a discourse that situated creativity in the domain of the unconscious, of the unexplainable and, to an extent, the mythological. The production of myths was to become more tense and radical in the late 1990s and early 2000s in Kareyan's work and in the works of several other artists of his generation.

The exhibition *Yerevan Landscape* curated by Kareyan in a sense encapsulated the contradiction between a desire to objectively map a context through a particular set of text-based practices and a simultaneous retreat to the mythological domain. Hence we have 'inscriptions that have become feelings'. With all its ambitions to bridge the gap between genres and disciplines, the exhibition did not reconcile the dichotomy between text and image. Instead, it subjected texts to a painterly regime of flatness, a return to colour and the expressive gesture of the artist. I hold that the subjection of text to painting had the consequence of playing into the institutionalization of the art-historiographical proposition of the 'alternative tradition' in the format of an exhibition-making practice. Kareyan's own work presented in the show epitomized the irreconcilable opposition between text and image when both were approached as icons (both visual and linguistic). While the basic operation of self-referentiality – text referring to itself – was a conceptual task stemming from Kareyan's earlier practice (in one work, overlapping letters read 'Formation of the text in a space'), its expansion into the field of coloration, and specifically to primary colours, situated the works within the domain of the painterly rather than the conceptual.[44] Inscription here was understood as an inscription of the self within the social through self-expression, rather than the vacation of subjectivity from the procedures of 'pure creation' as explained in the previous chapter. Text was conceived as a painterly gestural act even in cases when paint was not used. In these and subsequent artistic practices in Armenia, it was painting that arguably structured the use of other media, such as video, performance and installation. Throughout the late 1990s and early 2000s, multimedia works emerging from the contemporary art scene acquired a painterly quality. Both videos and theatrical installations and performances, as I will discuss in the next chapter, were conceived as large

gestural acts. This was due to the academic educational training embedded in the fine arts tradition that most of the artists shared, and the subsequent repression of painterly artisanal skills once a conscious and deliberate deskilling took place as a rejection of the authority of tradition.

By the early 2000s contemporaneity had come to be associated with new media and conceptual literacy to the extent that being a contemporary artist meant that the artist had to produce videos, installations and performances. But as with all repressions, painting came back with a vengeance in that even post-medium forms such as video turned into an expression or a gesture, a mark-making practice. In Kareyan's videos and performances of 1999–2007 the painterly comes across as a structural precondition. A closer reading of this shift towards the painterly will follow in the next chapter, but what is important in the context of the current discussion is the re-emergence of the visual and painterly in Kareyan's work in the second part of 1996, and the exhibition *Post-Factum* as a full manifestation of the shift from analytical conceptualism to a version of *hamasteghtsakan* post-conceptualism. This supports the argument made earlier that ACT's analytical conceptualism, combined with the notion of 'pure creation' as that which creates a bridge between autonomous art and the social sphere, was a disruption of the domination of *hamasteghtsakan* art in Armenia. This disruption provided the possibility of reimagining aesthetics and its relation to an evolving social context in ways that could not be accommodated within the aesthetic theories of the late Soviet generation of alternative artists. This opening was short-lived, lasting until the practices of the post-ACT artists were subsumed in *hamasteghtsakan* art. *Post-Factum* was an early but strong example of this tendency.

One of the strongest critiques of the exhibition at the time came from Karoyan, who had vested interests in such critique: text and image as sites of historical inscription were his central concerns at the time. His critical review of Kareyan's exhibition, entitled 'The Waters of a Mythological Birth', is an effort to address the text-based artistic practices 'from within' the deconstructionist Derridean debate over the idea that *il n'y a pas de hors-texte* [there is no outside to the text].[45] Karoyan's review also marks a shift from his earlier Hegelian approach to history to French poststructuralism, a shift that made Karoyan's texts increasingly difficult to read.[46]

In Karoyan's critical commentary on the curatorial strategies of the exhibition, the particular relations that writing/text establishes with context serve as a means for categorizing the works. For him, the relation between text and context revolves around two main axes, the mythological and the historical. The historical axis, constructed upon biblical consciousness and on the anticipation of the Messiah's coming – a thesis he had developed earlier in his 'In the labyrinths of the alternative tradition' – had been the main driving

force behind the historical avant-garde's political platform. According to Karoyan, the avant-garde denied the mythological existence of art outside of either history or historicity. Karoyan holds that it was only in the 1990s, with the defeat of the political wing of the avant-garde and the mediatization of culture, that the discussion about the relations between words and images moved to an extra-political and purely artistic domain. Karoyan conceives of text as the domain of politics and of the state, as a medium of propaganda, agitation and ideology, whereas images are confined to the domain of subjective interiority or what he conceives of as mythological consciousness. The critic categorizes the above-mentioned relation between text and context as follows: there are works that evolve within the axis of history, where 'the text is obedient to its context and develops within it'. The second axis is the mythological axis, where the text rebels against its context and 'tries to overcome the latter's gravitational field'. The mythological takes place within the discourse of the visual, while the historical axis underlies writing. The third relation is developed through the combination of the first two and is referred to as the historical-mythological axis. This is where the text comes forth as the satellite of its context, and revolves around it with a specific radius. It makes possible the objectification of writing through self-referentiality, and for Karoyan marks a certain crisis of the new, the new being a domain where the encounter of text with image would chart a new territory. Instead, the exhibition fails to voice

> [t]he mythological escape of writing to a new territory where it has nothing to do with its historical predecessor, while the image has nothing to do with its archetype. This is a new domain marked by the hegemony of the visual, which asserts the impossibility of iconographic inscription.[47]

Karoyan's criticism of Kareyan's curatorial method focuses on the understanding of text as an icon, and the historicist approach that the curator had adopted to map an entire cultural landscape. The exhibition presents a narrow and limited reading of text and textuality and encompasses only works that use writing. The result is that the curator has separated writing from its mythological, iconic and visual ontology and made it reside only on the historical axis: 'Every historical excursion means also an outlining of a historical course ... If we situate this prepared meaning within the content of the exhibition, it will mean that it fixes a historical meaning ... In that case, what happened to the waters of the mythological birth?' concludes Karoyan.[48]

Karoyan criticizes the exhibition for disregarding the prevailing mediatization that has had a profound impact on the reception of script in the realm of the visual. But I think Armenia was not yet a media society in the mid-1990s, and as I argue in the next chapter, the cultural paradigm shift towards mediatization began in the late 1990s and early 2000s, due to technological

shifts as well as profound shifts in how politics was experienced. In a way, Kareyan's exhibition epitomized the uneven ground of the late 1990s, when visuality was still treated both with awe and suspicion. As opposed to Kareyan who, in the form of an exhibition, provides a reading of text-based art in terms of iconicity, Karoyan refuses to stretch the text so far as to 'fabricate' its iconicity and painterliness. It is precisely the absence of the image proper as text that Karoyan criticizes in the exhibition. By embracing the historical axis, the exhibition refuses to participate in the mythological axis understood as the domain of the postmodernist visual turn. But Kareyan's practice of the time, both as an artist and a curator, I believe, does not quite comfortably sit either in the domain of the textual or of the visual and the painterly.

Kareyan's work of the period immediately following the collapse of ACT never subjected text to pure iconicity and painterliness, even though, as I have shown earlier, with its references to National Modernism it could easily be inserted in the 'alternative tradition' of the painterly. Instead, I hold that his spatialized wall texts suspended the artwork between the flat colour plane and the linguistic domain of conceptual art, between text and image, legibility and painterliness, without reconciling these binaries. His practice of the period was one of paradox, as Azatyan has called it, one that strove to bring together contradictions in a single whole in order to uphold art as an ideal.[49] This classical ideal of combining paradoxes into a single whole had informed Kareyan's work from the inception of 'pure creation' onwards, even though the traumatic clashes of this ideal with reality often yielded different and contradictory manifestations. The binaries that Kareyan had tried to reconcile throughout his various artistic searches over different periods included text and context, text and image, nature and culture, body and mind, the moral and the sexual, subject and society. In the late 1990s Kareyan's work combined ACT's brand of linguistic analytical conceptualism with the 3rd Floor's postconceptualist *hamasteghtsakan* art as a way to return to the painterly. But this return was an impossible one, as painting was already 'tainted' by text.

The 1997 exhibition *Text as Idea* at the Charlie Khachatryan Gallery in Yerevan, presenting the work of three former ACT members – Kareyan, Hakobyan and Aghasyan – carried on Kareyan's concerns with the visualization and spatialization of text as we saw it in *Post-Factum*. If in *Post-Factum* he was interested in the way the spatialized text relates to the architectural context, in *Text as Idea*, the viewer enters into the equation. The emergence of relationality as a problematic of the artwork was made explicit by Kareyan in an interview with the journalist Tsovinar Nazaryan. He says: 'The unknown is located in the intermittent space between two artists' two works',[50] and herein the viewer is someone who converses with this unknown.

The arrangement of the three artists' works in the space of the gallery – works that ranged from two-dimensional texts to three-dimensional

installations, as well as optical play with depth and flatness – used letters, shapes and volumes in order to create empty spaces between the works, gaps that were to be filled by the viewers' bodies. From Kareyan's English inscription 'The Art [sic!] is Behind You' to Aghasyan's 'Text That Allows One to Revolve Around It' (in Armenian), posted on a column and compelling the viewer to perform the prescribed action, and his circularly written 'Text Ends Where It Starts', to Hakobyan's angularly positioned and textually inscribed coloured tubes and her similarly playful tyres with colourful letters painted on them – all were a departure from the austere and methodically executed aesthetic strategies of 'pure creation' towards experientiality. And even if some of the slogans from the 1995 *Art Demonstration* appear on the walls of this exhibition, they neither act as documentation of the action, nor stand for the identification of art and politics, art and fact, art and reality, the way they did during the action. Just the opposite – the slogans, in the context of the exhibition, stand for the ultimate irreconcilability of art with reality, for the insurmountable gap between the two. In an interview Kareyan states, 'there is a space between the word and factual reality', and Aghasyan claims that what interests him is that which lies beyond text.[51] In a way, this exhibition was a true 'post factum' to the three artists' practice in the group ACT. The positivist assumption that reality is nothing but the facts that constitute it, and that thus art is a fact of reality and functions as reality, has given way to the realization that art is what lies beyond facts: it is ungraspable and elusive, and no longer explains the world as we see it. The creative impulse is now located in the unconscious.

As the works of the three artists were suspended between text and image, art and reality, the purity of the former ACT group's conceptual operations and the post-conceptualism of *hamasteghtsakan* art, Grigoryan was quick to subsume the works within the *hamasteghtsakan* trajectory. His interpretation of the artists' works, first published in a 1998 issue of *Garun* and republished in a handmade book-art catalogue of the exhibition two years later (an act that retroactively inscribes his interpretation into the conceptualization of the exhibition), specifies his earlier teleology of the New Vision as a movement towards abstraction. 'Text Art as New Abstractionism' explicitly declares text art as the 'only legitimate offspring of abstractionism'.[52] Resembling the structure of Karoyan's earlier historicization of contemporary art practices in which historically evolving binaries (such as abstraction and figuration, form and content) are ultimately reconciled in the 'alternative tradition', in Grigoryan's view abstractionism marks the primacy of painting as an unmediated mode of communication over literature and narrative. Text-based art's iconoclastic destruction of mimesis is the point of culmination of pure abstraction. With the desire to situate the text-based practices of post-ACT artists within the 'painterly' trajectory of the 3rd Floor (a trajectory pursued

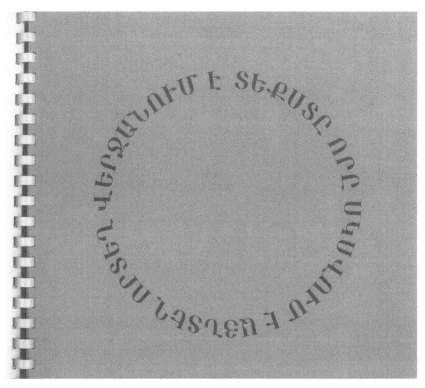

Text Art Book, reproduction of Vahram Aghasyan's work, 1998 **36**

and defended by Grigoryan himself), he states: 'Text art is neither the art of fonts nor of speech. It is a painterly (plastic) art with the same degree of direct impact as music.'[53] Moreover, the artists accomplish the destruction of the boundaries between the material and spiritual as well as 'the fusion of Oriental paradoxical mentality with social-psychological banality, which has been the monopoly of Armenian Pop Art for many years'.[54]

The triumph of abstraction, however, is not an end in itself, an arrival of pure aestheticism, but rather has a cultural and civilizational value. Abstraction, apart from being an aesthetic marker of freedom – a position that Grigoryan had been defending since the late 1980s – stands for culture's location in contemporaneity. As a marker of progressivism, it breaks away from Armenian provincialism. It was the alternative art of the 1980s that saw the values and provincial limitations of 1960s art and liberated some of its formal promise by dissolving the dichotomy between word and image to the extent that 'art critics became unemployed and turned into gallery owners and dealers'. The impulse towards abstraction, the origins of which are located in Armenian medieval arts, is in constant tension with figuration

1 min the flight is normal
2 min the flight is normal
3 min the flight is normal
4 min the flight is normal
5 min the flight is normal
6 min the flight is normal
7 min the flight is normal
8 min the flight is normal
9 min the flight is normal
10 min the flight is normal
11 min the flight is normal
12 min the flight is normal
13 min the flight is normal
14 min the flight is normal

37 *Text Art Book*, reproduction of Diana Hakobyan's work, 1998

which, having stemmed from the Renaissance tradition, has been bastardized in official Socialist Realism.[55] Here we have another example of an attempt to reconcile alternative art's progressivist agenda with the imperative of national identification, a dynamic that was at play in both contemporary art exhibitions at the ACCEA and those facilitated by the Ministry of Culture abroad. It is also noteworthy that from the mid-1990s, abstractionism was being actively promoted and canonized as the 'alternative tradition' of Armenian art. In 1994 the Ministry of Culture issued a decree regarding the organization of a survey exhibition in collaboration with the Artists' Union that would showcase 'one of the most important trends of modernism in the Armenian contemporary art of the last few decades'.[56] Interestingly, as Karoyan states in his critical review of the survey, the exhibition presented abstractionism as a cultural fact rather than a 'creative presence'.[57] This was partially due to the fact that many abstractionists from the former 3rd Floor movement had

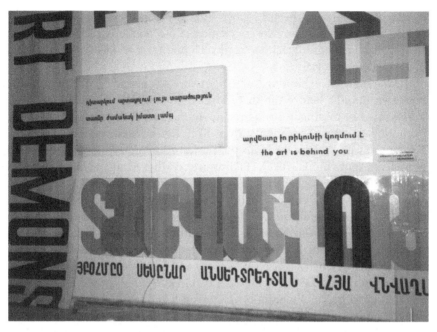

Diana Hakobyan's and David Kareyan's studio, 1997. Photograph: David Kareyan **38**

left the country in the early and mid-1990s, and that the 'new abstractionist movement', as Grigoryan called it, had failed to materialize.[58] And it is in this context of the canonization of the tendencies of abstract art since the 1970s on the one hand, and the fixing of the 3rd Floor movement as a historical and cultural fact with the emigration of most of its active members on the other, that Grigoryan's demand for a new abstraction four years later can be understood. Finally, the younger generation picked up the impulse towards abstraction where the older generation of the 3rd Floor had left it and objectified this impulse in text-based art, as the art of pure abstraction.

Grigoryan's interpretation of text art as new abstraction can be regarded as an attempt to 'salvage' the three artists' work from their own history in the group ACT. If in his 1995 article on the New Vision, Grigoryan had included the group in the latter with hesitation and critical irony towards their 'pseudo-scientific' discourses of 'demagogic operationalism', now the 'painterly' text-based works of Kareyan and Hakobyan and even the more austere linguistic exercises of Aghasyan have purified art from ideology: deprived of their ideological burden of signification, texts become 'pure', and this purity corresponds to the supposedly non-ideological and pure frame of liberal democracy (figures 36, 37 and 38).[59] When turned into a pure painterly fact, text retreats to the zero point of ideology, thus ensuring that we still live

in what Azatyan calls 'the 3rd Floor's waking dream'.[60] In this dreamworld, certain forms structured by the conception of the 'painterly real' imply resistance against ideologically tainted reality. Herein art as an ideal meets the ideal of liberal democracy.

Remarkably, an exhibition that Grigoryan had curated in May of the same year, two months before the three artists' *Text as Idea*, was entitled *Civic Values*, but was originally given the title *Aesthetics*.[61] Bringing together artists from the late 1980s generation such as Kiki, Karine Matsakyan and Varujan Vardanyan with those of the 1990s such as Kareyan, Aghasyan (who presented himself as 'Anonymous artist'), Hakobyan and Mher Azatyan, the exhibition's conceptual framework centred on Grigoryan's enlightenment humanist conception of aesthetics as a civilizational value. Grigoryan's large paintings in the exhibition, truthful to *hamasteghtsakan* art's eclectic aesthetics, brought together citations from the history of painting, such as Velasquez's *Las Meninas*, with grafitti-like images of couples engaged in intercourse, extinct ideological signs (such as the Nazi swastika and the Soviet hammer and sickle) and the inscription *DEM* [Against]. The 'Great Refusal' of the *DEM* movement, as described in a manifesto Grigoryan had published in 1994,[62] is here realized on the surface of the canvas, though it had failed to materialize as an actual movement. The heterogeneous images and inscriptions combined on one large canvas and treated with schematic and scratchy graffiti marks act as realizations of dreams of a civic society on the surface of the canvas.

Kareyan's spatial texts were rearticulated here with hard-edged and geometrically rendered coloured letters reading 'The Letters are Covered by Geometric Figures', and faced another text spatialized in primary colours, 'The Text is Composed of Block Letters', on the opposite wall.[63] Hakobyan's piled-up tyres with colourful texts extended the spatialization of text to sculpture, and unlike Kareyan's, Hakobyan's colours were 'pop' rather than 'national'. Aghasyan's mirrored text promised to 'transfer' the viewer 'through the wall', in an emergent interest in 'the beyond of the text' that was to be rearticulated in the *Exhibition of the Three*. In this latter work he inscribed the English word 'BETWEEN' on a white wall of the Charlie Khachatryan Gallery on a receding perspectival plane, to provide an optical illusion of a mirroring effect by juxtaposing the flatness of the demarcated plane with the illusion of depth. Located between the perspective and the plane, Aghasyan's text-based works of the period explore the notion of art as that which exceeds the facts of empirical vision, with a promise of a 'beyond'. Here text, which had been conceived earlier as a linguistic fact, cancels its own signification and its own factuality to establish art beyond fact, and in the domain of the invisible and the intangible. Here art becomes an alternative reality, but now one that no longer substitutes for actual life conditions. Rather, art exists in parallel to these conditions.

The irreconcilability of language and reality and word and image, where words appear as sedimented images refusing to enter a semiosis, was to reach its critical apogee in Kareyan's practice and that of his peers in the early 2000s. The dialectical clash between art and the everyday and art and politics that characterised ACT's practices in the mid-1990s was to be replaced by a sharp opposition between the two. The conception of art as ideal was to be radicalized and driven to extremes amid increasingly traumatic clashes with the political realities of late 1990s and early 2000s Armenia. I am not claiming here that belief in art's social function was abandoned, but that tensions between art and politics were increasingly being resolved by resituating political questions in the domain of aesthetics, and not the other way around.

I have presented an argument that alternative practices in Armenia since the 1980s, from the 3rd Floor to ACT, largely considered aesthetics as that which provides an alternative to the social world, or reality. One could even suggest that the designation 'alternative', as much as it refers to an art practice outside the mainstream in relation to nationally and officially sanctioned culture, also implies an understanding of art as alternative to reality. What differed from generation to generation, and from practice to practice, was the ways in which art was situated in relation to the actual conditions of everyday life. If for the artists of the early 1980s such as Black Square, art provided a negative mirror of reality – understood as the ideological world of Soviet society – for the 3rd Floor as the cultural avant-garde of the perestroika period, art was the space in which the contradictions of late Soviet culture were resolved; a promise that would be fulfilled with the victory of art as a sphere of individual freedom over the oppressive forces of culture. In the mid-1990s, in ACT's version of autonomous art, the latter was conceived as an ideal that could intervene in and change reality. This chapter has argued that in the post-ACT period, the practices of some of the former members of the group were subsumed in the temporarily extended *hamasteghtsakan* paradigm, now trying to reconcile national representation with a progressivist agenda. Yet even if this agenda of progressive culture and national representation was aligned with official cultural politics, art still remained an ideal that was in constant tension with reality. In both ACT's practice and the *hamsteghtsakan* strategies of the former 3rd Floor members, political participation was conceived as an aesthetic gesture of constituting a new reality through art. Where the two groups differed was not in their version of the structural relationship between the sphere of art and the sphere of the everyday, but in the language and form they used to constitute that relation. If, for the 3rd Floor, art was a sphere purified of ideology that enabled freedom, for ACT that framework was filled with the content and mechanisms of the liberal democratic state. That is why in Grigoryan's perspective, ACT

was too ideological. The aesthetic philosophy of both the 3rd Floor and ACT substituted social and political discourses with aesthetic ones, or rather the former could only enter the discourse of the artistic avant-garde if they had been subjected to an aesthetic regime, and it is this that the exhibition *Civic Values*, originally conceived under the title *Aesthetics*, manifests. In an interview Grigoryan stated:

> Art is that domain from which it is possible to discern whether a given society embraces freedom and rights … since it is the only domain where society cannot penetrate. Even if waking fantasies can be restrained, dream always remains absolutely free. In today's civic society art plays an important role – it is value in itself. By civic value we mean art.[64]

From the late 1990s to the first half of the 2000s, the gap between official culture and contemporary art increased. With official culture propagating an ethno-nationalist ideology and abandoning the progressivist pole, the mid-1990s alignment of official culture and contemporary art was no longer sustainable. It is to these frictions and incommensurability, within a shifting technological landscape, that the next chapter is dedicated.

Notes

1 David Kareyan, exhibition dedicated to the fifth anniversary of Armenia's independence at the ACCEA, 1996, video documentation. Vardan Azatyan's archive.

2 *Texty Vorpes Idea* [Text as idea], book-art catalogue of the exhibition (Charlie Khachatryan Gallery, Yerevan, 2000).

3 National Archive, Ministry of Culture folder, Decree 88 'About the Organization of the Exhibition', 12 June 1995.

4 *Ex Voto 9, Garun* 10 (1995), p. 96.

5 The agenda of national representation had defined official cultural policy since the declaration of independence in 1991. In a 1992 speech at the Council of Ministers of the Republic of Armenia, the Minister of Culture Hakob Movses stressed the need to refine the concept of 'Armenian national culture' and its dissemination abroad. He particularly stressed the need to 'establish an official policy in the spheres of art and culture … to develop and broadly implement economic methods of governance and to strengthen the material base for art'. Council of Ministers of the Republic of Armenia, 28 January 1992. National Archive, Ministry of Culture folder, 1992, subfolder 80-18-23.

6 Hakob Movses, 'Preface', in *Hayastani jamanakakic arvest, 1980–1995* [Contemporary art of Armenia, 1980–1995] (Moscow: Moscow Central House of Artists, 1995), p. 3.

7 Vardan Azatyan discusses the specifically Russian orientalism that functions on an axis between a cold and austere north and a sunny and bright south, in his 'Disintegrating Progress', pp. 62–87.

8 Movses, 'Preface', p. 3.

9 Grigoryan, 'Nor hayatsq: Irakanutyun ev arvest'.

10 Grigoryan, 'Nor hayatsq: Irakanutyun ev arvest'.

11 Herbert Marcuse, *One Dimensional Man* (Boston: Beacon Press, 1964).

12 Historically, this echoes the split of artistic labour in the late Soviet years between official and private spheres. Artists receiving public commissions from the state executed these commissions as social tasks that they termed *khaltura*, which in Russian means a fake. As opposed to this social labour, they produced 'authentic' artworks privately that were meant to satisfy so-called inner spiritual needs.

13 Grigoryan brings in the analogy with collective farming, saying that the question 'are you going to hand your product to the state?' is an absurd one when applied to artists. Grigoryan, 'Nor hayatsq: Irakanutyun ev arvest'.

14 Grigoryan, 'Nor hayatsq: Irakanutyun ev arvest'.

15 Grigoryan, 'Nor hayatsq: Irakanutyun ev arvest'.

16 Grigoryan identifies three intertwined positions in contemporary art in Armenia between 1980 and 1995. The first is 'spontaneous self-reproducibility', where he locates non-figurative, figurative and installation artists. It is a position that most characteristically reconciles binaries such as nature and culture, organic and inorganic, art and life by glossing over differences, a position that does not pose art against culture. The second is 'unique and irreplaceable singularity' and the third is 'serious joy' mixed with 'ironic fear' that is marked by positive certainties about reality.

17 Grigoryan, 'Nor hayatsq: Irakanutyun ev arvest'.

18 Grigoryan, 'Nor hayatsq: Irakanutyun ev arvest'.

19 Nazareth Karoyan, 'Amsva tema' [Theme of the month], *Ex Voto 7, Garun* 8 (1995), p. 88.

20 Karoyan, 'Amsva tema', *Ex Voto 7, Garun* 8 (1995), p. 88.

21 Karoyan, 'Ailyntranqayin avanduyti kayatsman bavighnerum', *Ex Voto 7, Garun* 8 (1995), p. 90.

22 Karoyan, 'Ailyntranqayin avanduyti kayatsman bavighnerum', p. 90.

23 Karoyan, 'Ailyntranqayin avanduyti kayatsman bavighnerum', p. 91.

24 Karoyan, 'Ailyntranqayin avanduyti kayatsman bavighnerum', p. 92.

25 This ethnocentric conception of history in the post-Soviet era is not confined to Armenia. Roger Brubaker discusses the 'actually existing nationalisms' in Europe throughout the 1990s. His central focus is the return of the nation state in the aftermath of the collapse of the nation state in Europe in the 1990s, facilitated by ethnic conflicts in the former Yugoslavia and the rise of nationalism in other parts of Eastern Europe. I thank Nadia Bou Ali for introducing me to Brubaker's work. Roger Brubaker, *Nationalism Reframed: Nationhood and the National Question in the New Europe* (Cambridge: Cambridge University Press, 1996).

26 Karoyan, 'Ailyntranqayin avanduyti kayatsman bavighnerum', p. 95.

27 Karoyan, 'Ailyntranqayin avanduyti kayatsman bavighnerum', p. 95.

28 Karoyan, 'Amsva tema' [Theme of the month], *Ex Voto 2, Garun* 3 (1995), p. 89.

29 Artists Union of Armenia, 'Letter to the Editor', *Garun* 7 (1995), p. 34.

30 Vardan Azatyan, 'Hishoghutyun ev/kam moratsum' [Memory and/or forgetting], *Aktual Arvest* 6 (2008), pp. 50–66.

31 Arman Grigoryan, 'Katoghikosn orhnec hay avangardy' [The Catholicos blessed the Armenian avant-garde], *Garun* 1 (1997), p. 93.

32 Edward Balassanian, TV interview. Vardan Azatyan's archive.

33 Azatyan remarks that Grigoryan changed his pseudonym from the destructive Vandal to the affirmative Feel Good. Azatyan, 'Hishoghutyun ev/kam moratsum'. In addition, the new movement *DEM* (Against) that he had announced in a manifesto two years earlier had failed to materialize. Grigoryan, 'DEM sharjman metsaguyn hrajarumy'.

34 Grigoryan, 'Katoghikosn orhnec hay avangardy', p. 94.

35 Karoyan and Grigoryan, 'Arvestagety ev hasarakutyuny', unpublished proposal, 1997. Nazareth Karoyan's archive.

36 The exhibition of artists known as the Group of Five took place in 1962 and included the emerging young generation of artists – Minas Avetisyan, Lavinia Bajbeuk-Melikyan, Arpenik Ghapantsyan, Henrik Sivasyan and Arman Grigoryan's father, Alexandre Grigoryan.

37 Karoyan and Grigoryan, 'Arvestagety ev hasarakutyuny'.

38 Even with his anarchic ethos in the late 1980s and 1990s, Grigoryan never abandoned his references to National Modernism. It is not unimportant to mention that Grigoryan's father and mother – Alexandre Grigoryan and Arpenik Ghapantsyan – were both protagonists of the *Exhibition of Five* in 1962, an exhibition that marked the entry of modernists into the cultural space of Soviet Armenian art.

39 Azatyan talks about this shift in 'Hishoghutyun ev/kam moratsum'.

40 Arman Grigoryan, 'Hayastany Venetiki 55-rd Bienalein. Miacnel azgayiny, hogevory ev moderny' [Armenia at the 55th Venice Biennale: to unite the modern, the spiritual and the national], published 12 June 2013 in epress.am (last accessed 1 June 2014).

41 TV documentation of the exhibition. Vardan Azatyan's archive.

42 TV documentation of the exhibition. Vardan Azatyan's archive.

43 'Arjevorel nshanakum e arjezrkel', *Chorrord Ishkhanutyun* 41 (1997), p. 8.

44 Arguably, the only experience of such violent reconciliation has been the avant-garde poster production of the 1920s that later turned into official propaganda posters or retreated to such marginal forms as book illustrations.

45 Nazareth Karoyan, 'Araspelakan tsnndi jrery' [The waters of a mythological birth], *In Vitro* 1, (1998), pp. 62–5.

46 Even though Karoyan does not explicitly mention Derrida in his article, his critical practices of the time were highly informed by a poststructuralist reading and more particularly by Derrida's method of deconstruction.

47 Karoyan, 'Araspelakan tsnndi jrery', p. 65.

48 Karoyan, 'Araspelakan tsnndi jrery', p. 65.

49 Vardan Azatyan, 'Hakasutyan chshmartutyuny', unpublished, 2011.

50 'Arjevorel nshanakum e arjezrkel', p. 8.

51 TV interview. Vardan Azatyan's archive.

52 Arman Grigoryan, 'Texti arvestn ibrev nor abstractionism' [Text art as a new abstractionism], *Garun* 6 (June 1998), pp. 95–6.

53 Grigoryan, 'Texti arvestn ibrev nor abstractionism', p. 95.

54 Grigoryan, 'Texti arvestn ibrev nor abstractionism', p. 96.

55 Grigoryan continues to draw upon the perceived opposition between two main tendencies in the Armenian painting of the 1970s: the Tbilisi school of painters who produced figurative small-scale paintings charged with theatricality, and those who continued the modernist tradition of early twentieth-century painter Martiros Saryan. Reviving the colour schemes of medieval Armenian manuscript illumination in landscape and still-life painting, Saryan's tradition enjoyed a renaissance in the 1960s, in parallel to a bigger national revival following Khrushchev's relatively liberal policies. For Grigoryan, the early 1980s abstractionists were still continuing the legacy of Saryan, as a reaction against the Tbilisi school painters. There is also a regionalism (or rather regional nationalism) at play in this rhetoric in that the Tbilisi school painters were considered as alien 'intruders' into a truer Armenian national tradition established by Saryan and carried out by Yerevan-based artists, including Grigoryan's father, Alexandre Grigoryan (Grigoryan explicitly expressed this view in one of our private conversations). This binary view also sustained the fundamental opposition between the figurative tradition stemming from the Renaissance and the non-figurative tradition, the roots of which were attributed to Armenian medieval art.

56 National Archive, Decrees about the Main Activities of 1994, Decree #264, 12.12.94 80-18-9, p. 60.

57 Nazareth Karoyan, 'Abstraktsionismn arants toghadardzi' [Abstractionism without a hyphen], *Ex Voto* 2, *Garun* 3 (1995), p. 90.

58 Grigoryan quoted by Karoyan, 'Abstraktsionismn arants toghadardzi', p. 90.

59 This shift of attitude is not merely a conceptual, theoretical or historical re-evaluation of his own views on ACT on the part of Grigoryan. In the small community of contemporary artists in Armenia, personal relations, 'zones of influences' and intrigues do matter. While in 1995, at the time of the Moscow exhibition, artists Kareyan, Hakobyan and Aghasyan participated in ACT's agenda of creating a local artistic situation that would break away from the 3rd Floor's dominant aesthetics and personality-driven hierarchies, by 1998 the three artists had become very sympathetic to Grigoryan's views and formed a part of his circle. ACT member Narek Avetisyan mentioned in our interview: 'The first ACT collapsed because David, Vahram and Diana brought into our discussions Arman's views on postmodernism and other things that recalled the 3rd Floor's discourse. They fell under Grigoryan's influence and ceased to be faithful to our ideals.' Narek Avetisyan, interview, 9 November 2007.

60 Vardan Azatyan, 'On Video in Armenia: Avant-garde and/in Urban Conditions', http://www.video-as.org/project/video_yerevan.html (last accessed 12 January 2014).

61 Interview with Arman Grigoryan by Satenik Seryanyan (newspaper clipping, source untraced).

62 Grigoryan, 'DEM sharjman metsaguyn hrajarumy'.

63 Video documentation. Vardan Azatyan's archive.

64 Interview with Arman Grigoryan by Satenik Seyranyan.

The reign of the 'painterly real' and the politics of crisis, 1999–2004

This closing chapter offers a reading of the work of two artists of the 1990s and early 2000s – David Kareyan and Narek Avetisyan, both previously members of the group ACT – and discusses their works in the context of social, political, technological as well as cultural shifts in Armenia. The two artists' works, I argue, epitomize the contradictions of turn-of-the-century Armenia. I define this context as a crisis of politics and political subjectivization vis-à-vis the state. This marked a shift from affirmative artistic practices in the conditions of the crisis of negation that characterized the mid-1990s, and gave birth to a politics of resistance. The chapter considers political, economic and art-institutional transformations as interlinked processes that bring about an imperative to rearticulate art's relationship to the social world. It is especially in these conditions of political crisis and political subjectivization that artistic practices crystallize and make visible social contradictions in their sharpest manifestations, and yet maintain the ideal of art's autonomy. When the social world no longer offered a political ideal of emancipation, artists developed aesthetic strategies that they conceived in terms of resisting the social and political worlds. My contention is that social and political structures overdetermine the sphere of art 'in the last instance', in an Althusserian sense,[1] and yet have not subjected the sphere of art to real subsumption. While maintaining art as an ideal, both Kareyan's and Avetisyan's work crystallizes the social contradictions of the turn of the millennium in Armenia, contradictions that arise from local manifestations of global capitalism, from a resurgent nationalism as the political ideology of the state, and from disillusionment with the political promise of democracy. Or rather, their work crystallizes these contradictions in the most acute way precisely because it holds on to art as an ideal.

The discussion in this chapter supports the argument that contemporary art in Armenia has inherited from National Modernism a negative relation to the empirical world, and that this relation not only remains potent but is radicalized in the period under consideration. Even if in the late 1990s and early 2000s we can no longer refer to painting as the dominant medium on the

contemporary art scene, nevertheless the 'painterly real' as a support struc-
ture for art's autonomy persists and is now manifested in video, performance
and installation. The newly configured relationship between art and reality
also manifests a shift from the alignment of nationalism and progressivism
in the earlier period of independence (1991–98) to a schism between these
two ideological poles. Kept in constant tension throughout most of the 1990s,
they had also allowed for a precarious alignment between contemporary art
and official cultural politics. Now, what we witness in the late 1990s and early
2000s is the abandonment of the progressivist pole in the cultural politics of
the nation state and the embrace of ethnocentric nationalism with its regres-
sive emphasis on 'One Nation, One Culture'.[2] A consequent and deepening
misalignment takes place between state cultural politics and the agenda of
contemporary art: while the former unequivocally embraces nationalism,[3]
the latter identifies with progressivist values.[4] In a way, the contemporary art-
ists who actively produced work in the late 1990s and early 2000s saw art as
the only sphere where progressive discourses could flourish and the ideal of
democracy could persist, an ideal that the social world was no longer capable
of accommodating. And it was this ideal that was conceived as a means of
resisting social and political reality in Armenia at the turn of the millennium.
The misalignment between state cultural politics and the agenda of contem-
porary art meant that the latter, which throughout the 1990s had ambitions to
impact and even form official cultural politics, was now finally marginalized
from official discourse. These margins were no longer the margins *of* official
discourse – as they had been in the case of National Modernism in the 1960s
and 1970s, the 3rd Floor in the late 1980s and early 1990s, and ACT in the mid-
1990s. Instead, these margins were now *outside* official discourse.

The real and/as representation: politics of crisis

At the very end of 1991, only a few minutes before the New Year, people in
Armenia – most of whom usually spent New Year's Eve in front of their
television sets watching official greetings and pop star performances – wit-
nessed a highly unusual event on television: a performance that played out
according to the visual codes of a political *coup d'état*. While the well-known
public TV news anchor Varoujan Olqinyan sat tied to his chair, artist Grigor
Khachatryan announced that due to a crisis caused by fuel shortages and
power cuts, it was time to unite around Grigor Khachatryan's tree – an
ironic reference to the New Year tree.[5] This unusual appearance and absurd
announcement was a televised spectacle; moreover it was an artistic perfor-
mance and a joke, conceived by conceptual artist Khachatryan and the head
of the Armenian public TV news section, Alexan Harutyunyan, and executed
by the news section team. It was, in Armenia, a unique instance of an artistic

act with the ambition to instil a belief that it was an actual political act. In the aftermath of the notorious August putsch of 1991 against Gorbachev only a few months earlier, the action artistically played with political codes.[6] The joke was not well received, however. Shortly afterwards, an official announcement followed, assuring the public that there had not been a real coup attempt. The official story was that several opportunists had hoped to create havoc among the population through their provocative television appearance – although no one, in fact, panicked. I would argue that one of the reasons that the televised coup attempt – a political-aesthetic performance by an artist and a journalist – did not succeed in agitating the masses was because Armenia of the early 1990s was not yet a media and consumer society, and for that reason, media representation did not function as a guarantor of truth and authenticity.

On 27 October 1999, eight years after the televised performance of *coup d'état*, and when Armenia was on the path towards the neoliberal transformation of its economy and the commercialization of culture, several gunmen entered the Armenian parliament building and opened fire, killing the prime minister, the speaker of the house and six other high-ranking officials. Remarkably, the violent massacre was seen live on television, since the public station had happened to be broadcasting the parliamentary session before the events started to unfold. Gunshots were heard as the Minister of Finance uttered the word 'transfers' during his speech in the parliament. What followed were hours of live footage showing bloodied politicians left to die on the floor and in their seats, terrorized MPs awaiting their fate, army and security services roaming up and down Baghramyan Avenue where the parliament building was located, and the gunmen voicing their demands to President Robert Kocharyan. Many of those who happened to be on Baghramyan Avenue at the time immediately rushed to their homes to watch the event unfold live on TV. Unlike the televised coup performance of 1991, the 1999 massacre had to be seen on TV to be believed to be true. In addition, since the economy had stabilized and power cuts had dramatically decreased, most households had the means to watch the broadcast.

Taking these two events as starting points, I hold that in the late 1990s a paradigm shift occurred within broader society, from a modernist belief in the truthfulness of reality to a postmodernist trust in media representation. This shift became manifest on the contemporary art scene with the advent of a new visual and media language, as well as in its institutional misalignment with official discourse. This paradigmatic transformation occurred due to deepening social polarization, the reorganization and fragmentation of urban space, the appearance of new lifestyle and consumption practices, and the mediatization of social relations that took place in the latter part of the 1990s and early 2000s. The effect of these transformations in the relationship between art and reality on the scene of contemporary art was formative for

a new aesthetics, though the fundamental distinction between the two was preserved – as argued throughout this book. The 'painterly real' continued to support art as an ideal, and the newly emerging media technologies, especially video, came to contribute to the reconception of the 'painterly real' as fundamentally irreconcilable with the surrounding social world. If both the *hamasteghtsakan* art of the late 1980s and 1990s and the 'pure creation' of the mid-1990s, as I have argued, maintained that the political ideal of emancipation was first encapsulated in the domain of art only to be sublated within the social and spread its effects, in the late 1990s the artwork was seen as the only guarantor of the ideal, and the social world as incapable of accommodating this ideal. Hence a rupture between art and reality intensified without any possibility for reconciliation, and was combined with the identification of reality and representation, or rather representation taken as reality, in the broader culture. This was a shift from the late Soviet years when the media were deeply mistrusted.

While a belief in the possibility of revolutionary transformation through direct action by responsible citizens was nurtured in the late Soviet years as a result of the policies of glasnost, the state-controlled media were regarded as being loaded with ideologically charged misinformation whose function was to protect the status quo, to contribute to social and political stagnation, and to defer the moment of revolutionary victory. This created a sense of rupture between reality conceived as a pure field for revolutionary action on the one hand, and the deceptive representational regime of television associated with the formerly stagnant state apparatus, on the other.[7] In short, in the conflicting world of perestroika reforms, the media represented one of the important bastions of the *ancien régime*, even though since the late 1980s the central television channel had started broadcasting lively political debates, such as the famous debate at the First Congress of People's Deputies in 1989 after much-contested legislative elections.[8]

Because of its conflicting nature, glasnost created a rupture between the meta-politics of the structures of the state and the social base, introducing an element of intrigue between societal and political power. This brought a certain level of drama as the streets became theatrical stages for manifestations of dissent. Whereas the media (and discourse itself) were perceived as a means to freeze and cancel revolutionary action, public spaces such as squares, parks and streets acquired a performative and theatrical dimension in that they accommodated newly emerging forms of subjectivization in the epoch of 'changes'. As opposed to the mass media's inversion of reality, society relied on forms of public manifestation based on the notion of a freely acting revolutionary subject that materialized in mass demonstrations, hunger strikes, sit-ins and round-the-clock pickets. But reality was also often searched for in the romanticized imagery of signs, symbols and values that denoted 'the West'.[9]

By extension, and as I argued in Chapter 2, signs of Western consumerism were perceived by the community of avant-garde artists and intellectuals of perestroika as anti-Soviet. Nevertheless, despite the fascination with consumerism, in the years of late perestroika and early independence, consumer-oriented images had not yet obtained the function of reality, that is, they had not acquired the constitutive power of subjectivization. Reality was still conceived as constituted through the lived experience of direct action.

A comparison between the television coup of 1991 and the parliament massacre of 1999 crystallizes the shift from a shared belief in the authenticity of lived experience to a belief in the truthfulness of media representation in Armenia. In the conditions when the social world was replete with contradiction, media images provided an alternative world devoid of contradictions – a dreamworld. And we should not forget that this dreamworld was a post-Soviet one, where signs of consumerism were romanticized in the absence of consumerism as such. Arguably, it was not the degree of freedom of speech the media represented and enjoyed that made broadcast images more credible than ever before. This shift was instead largely due to the dissemination of global, consumer-oriented media imagery through the increasing number of satellite dishes and through the translated foreign programmes that dominated most local channels through the 1990s and delivered a dreamworld of Western consumer signs and symbols on to the television screen. These programmes – from bodybuilding shows to commercials to Discovery Channel features – were designed to appeal to ever-expanding consumer desires. This dreamworld of consumerism delivered via images, one to which the public had not been exposed before, reconstituted the entirety of social relations. The late 1990s greeted the first translated and re-broadcast reality shows as well as the production of local adaptations.[10] Ironically, the massacre of 27 October 1999, by virtue of its being broadcast live on television, referred to the structure of reality shows that Armenian viewers were becoming accustomed to, and it followed the conventions and visual codes of this form of broadcast in which reality was enacted as fiction and channelled through television.

The late 1990s were yet a prelude to those rapid shifts in economic and technological conditions that took place in the following years and throughout the first decade of the 2000s. The emergence of new oligarchic elites around the president and his cronies, the wide-scale neoliberalization of the economy and active financial investments from the diaspora went hand in hand with the reconstruction of Yerevan.[11] The redistribution of wealth into the hands of a few and the rising polarization between classes found their spatial and visual representation in the structure of the city: the new elites found home in the increasingly gentrified city centre whereas the outskirts were left neglected. The reconstruction of the city centre into clearly demarcated sites of commercial businesses and of equally commercialized leisure brought

about drastic demographic shifts, with older inhabitants being evicted from their homes. The construction of Northern Avenue, completed in 2007, which supposedly finalized a 1920s master plan, resulted in the relocation of the new oligarchic elites and the emerging media stars downtown. The city centre, constructed on the principles of Soviet modernism with its wide avenues and public parks, faced fragmentation of its urban space as public spaces became increasingly occupied by VIP cafés and saturated with billboards and large digital screens. The increasing popularity of mobile and networking devices helped to decentralize television's monopoly over representation.[12]

The spread of capitalist consumer cultural values through the penetration of the images that accompanied them into Armenian society changed the status of media images from being conceived as often deceitful representations of reality to acquiring a function of reality, one which conceals the relations of production and appears more real that those relations from which it evolves. In the face of economic hardship and political and social disillusionment with earlier political aspirations towards the construction of a new society in independent Armenia, and of the economic inability to indulge in consumption, the media promised to deliver a consumer dreamworld. If in the late 1980s and early 1990s it was the 3rd Floor that offered art as a space of dreaming, now the general cultural condition had become one big dreamworld incorporating the former 3rd Floor's repertoire of dreams.

There is a profound connection between attributing credibility to media representation as capable of delivering reality, scepticism regarding revolutionary or at least participatory agency and the unprecedented popularity of video art and video installation in Armenia in the late 1990s. I take, in particular, the televised coup-spectacle and the live massacre on TV as metaphoric for a paradigmatic shift from the modernist split between authentic reality and its perceived deceptive representation on the one hand, to the postmodernist society of simulacra on the other. In the late 1990s, parallel with these events, many prominent contemporary artists started using video to such an extent and with such fascination that one could speak of an attitude of technological fetishism. Here video promised to deliver 'the Real' – reality in its truthful nakedness.

The fetishization of video could be partially linked to its reception as a 'Western' technology, which was often reflected in the choice of the medium as an end in itself. Inaccessible for private use in the Soviet Union and condemned as a reflection of a privatistic bourgeois lifestyle, technologies such as video were romanticized to such a degree that they became another signifier of 'Western' liberalism and consumption. Due to the fact that contemporary art for the Armenian artistic community became largely defined in terms of new media in the late 1990s and 2000s, media technologies for art production were viewed as opening up a bridge of communication with the outside

world. Thus the popularity of video art in Armenia cannot be separated from its artistic community's desire to communicate with the outside world. In addition, as Azatyan convincingly argues, video came to be seen as a source of 'sexually explicit content'.[13] This was due to the fact that erotic films had been disseminated in the youth subculture since the 1980s on VHS tapes, while in the early 1990s both public and commercial film theatres and television channels screened pornographic movies at all times of day.[14] In a way, video became a device where two connotations of fetishism – the commodity fetish and the sexual fetish – intersected.

The trend towards producing video installations in the late 1990s and early 2000s culminated in the participation of 16 Armenian artists in the 49th Venice Biennale in 2001, when the ACCEA selected exclusively video works. The ACCEA's enormous space and, in the Armenian context, relatively advanced technical facilities (they had previously acquired projectors, DVD players and other technologies) made it difficult to display anything other than video installations and highly staged, spectacular multimedia theatrical performances. Video was almost always connected with performances in which the body was rendered as material for art production. Video installation became popular to the extent that being a contemporary artist became synonymous with being a video artist. This was due to a variety of factors, from the mediatization of social relations by manufacturing new consumer desires through new technological means, to the more specific institutional role that the ACCEA played when it made projectors, monitors and VHS players available to artists. And if the 3rd Floor defined its aesthetics in terms of style as a signifier of cultural resistance against Soviet cultural politics and ideology, in the late 1990s artistic practice came to be largely defined through the artistic medium, largely video. Consequently, access to the increasingly globalized art world was at times perceived as granted solely to those artists who produced video art. I hold that the shift in terms of the media as a defining factor for artistic practice cannot be attributed only to the spatial, structural and technological conditions at the ACCEA, but is a product of conditions of political crisis and of a crisis of political subjectivization, that is, of becoming a political subject (a conscious citizen, an active agent for social change) vis-à-vis the available and dominant political agendas and ideologies.

The political crisis of the late 1990s to which many artists so radically reacted was largely triggered by the 1998 resignation of the first president of Armenia after independence, Levon Ter-Petrosyan, who was seen by the community of contemporary artists as an advocate of liberal democracy. Throughout his tenure, Ter-Petrosyan failed to reconcile his conception of politics as a constitutionally sanctioned practice of procedural democracy with the prevalent nationalist sentiments coming from the diaspora repatriates on the one hand, and the growing popularity of the previously banned nationalist

Armenian Revolutionary Federation Party and the former fighters of the Nagorno-Karabagh war on the other. The latter had returned victoriously after the 1994 ceasefire with great political and economic ambitions. The shaky balance between progressivist political rhetoric and nationalism that characterized the mid-1990s could no longer prevail in the cultural politics of the nation state. The honeymoon between the nation state and liberal democracy was over as the state became increasingly repressive and the ruling ideology propagated nationalism via ethnic identification. Ter-Petrosyan's failure to foster economic development, to establish closer ties with the Armenian diaspora (considered as the main importer of nationalism in the 1990s and looked upon with distrust by Ter-Petrosyan and his team) and to reconcile his cosmopolitanism with growing nationalist sentiments, combined with his controversial re-election in the allegedly fraudulent 1996 presidential elections, forced the first president to resign in 1998. The culmination of this crisis came in the aftermath of the 1997 parliamentary and 1998 presidential elections. While the parliamentary elections brought to power a democratically elected coalition of a former late Soviet Armenian statesman and a popular Karabagh war commander, in the aftermath of the presidential elections, the former president of the self-proclaimed Republic of Nagorno-Karabagh came to power. Thus two adversarial political poles – one with a social democratic and nationalist platform and the other with a neoliberal toolbox combined with nationalism – were established. The power struggle between the democratically elected ruling coalition and the new controversially elected president came to an abrupt end in 1999 in the aftermath of the terrorist attack in the parliament, as a result of which the socialist-nationalist pole of power was physically liquidated.

The absurdity of this violent slaughter came to be seen as even more absurd when, after a three-year trial extensively covered by the mass media, the government announced that the assassinations were not politically motivated acts and that there were no hidden hands behind the brutal killings. Instead, they were announced to be the acts of psychically imbalanced and unstable individuals, many of whom were under the influence of narcotics. Broadcast live on TV, the 1999 massacre crystallized a moment at which the seemingly immaterial political body of the state apparatus, functioning through its mostly invisible mechanisms of power and control, was seen as literally composed of human flesh, bones and blood.

Contemporary artists responded to this televised carnage by producing video works replete with brutality and bodily suffering. In a way, video was not only a medium for transmitting sexually explicit content, but also pain and suffering, a medium where death and sensuality met in eroticism.[15] Throughout the late 1990s, the main practitioners of this iconography were Kareyan and Sonia Balassanian, as well as Karine Matsakyan, Harutyun Simonyan, Tigran Khachatryan and Sona Abgaryan among several others. Kareyan's work of

this period in particular is key for showing some of the complex interrelations between the aesthetics of video, the changing social and political conditions and the reconception of art as an ideal in relation to the empirical world of experience. Kareyan's work is especially compelling for such a study given that several chapters of this book have already traced the transformations of his aesthetics from a linguistically inspired conceptualism to a painterly post-conceptualism throughout the 1990s.

Art is behind you: David Kareyan

In the summer of 2002 Kareyan performed a multimedia work entitled *No Return* (subtitled 'Suicide for Eternal Life, Oral Hysteria, Speech Capability Paid [for] by Madness') at the third Biennale of Giumry for the second time after its initial presentation at the ACCEA in the same year (figure 39). Giumry was a town that had suffered dramatic upheavals and losses from a devastating earthquake in 1988. Even fourteen years after the natural disaster that, together with social and economic cataclysms, had left its indelible traces on the town, Giumry was a ghost-like place filled with empty and half-ruined buildings standing in solitude; austere and melancholic people, many of

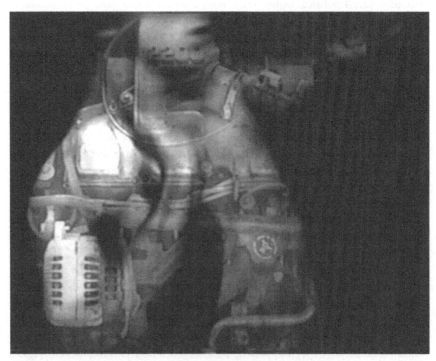

39 David Kareyan, *No Return*, 2003, DVD video, 8 min 23 sec. Still image

whom had lost a family, a relative, a friend or a neighbour in 1988; dogs howling in garbage bins in the streets; sad bazaars; and incongruously new and shiny shops selling imported Turkish and Iranian goods.

Realized in collaboration with curator Eva Khachatryan, Kareyan's work was a three-channel video installation with the two side screens showing a montage of found footage from documentary films and world news reports of various turbulent events of recent years superimposed on politically charged signs and words, and with the central screen showing a Bill Viola-esque video of Kareyan in a white nightdress digitally superimposed on fire (in different versions of the work, the images on the screens vary). An audio piece composed of electronic bits and lyrics by the early twentieth-century Armenian writer Eghishe Charents played in reverse accompanied the videos, as did a live performance involving seven female figures, most of whom were members of the punk band Incest, dressed up in hooded black gowns and drumming on tin plates and logs. When combined, all these elements conveyed a sense of mystical theatricality, enhancing the poignant atmosphere of the ghostly town.

Kareyan's work of 2002 (further developed for the Venice Biennale in 2003) drives to an extreme his earlier concerns with binary oppositions such as nature–culture, nature–technology, mind–body and so on, as manifest in his textual-spatial installations of the post-ACT period – both formally and conceptually. He does this by making use of newly available technological tools and devices such as video camera, digital montage, projector and audio mixer. This work can be regarded as a culmination of a specific iconography of bodily suffering and sacrifice developed since the late 1990s by the artist in an attempt to deal with the alienation induced by the social and political crisis in the country. Gone were the conceptual and minimal aesthetics of black and white letters of the ACT period and his post-painterly spatial installations of the years following ACT's collapse. *No Return* epitomized a paradigmatic shift towards an exploration of the alienated subject whose body functions as a site of violence, evoked with the means and language of theatre. This was a shift that characterized the broader politics of representation in Armenia in the late 1990s and early 2000s, in so far as a certain visual language and choice of medium was favoured and promoted in the institutionalized representations of contemporary art more than others. As mentioned above, this shift is arguably attributable to a variety of social, cultural, aesthetic and art-institutional factors.

Three exhibitions at the Armenian Centre of Contemporary Experimental Art – entitled *Crisis*, *Collapse* and *Civic Commotion*, and curated by Kareyan and the centre's co-founder Sonia Balassanian in 1999, 2000 and 2001, respectively – were reflections of a disillusionment with the promise of the political ideal of democracy and with the state as guarantor of this ideal, an ideal to which perestroika and post-independence generations of artists aspired. The

dominant iconography of the ACCEA's exhibitions of the period was the tormented body shrouded in a ritualistic and mythical atmosphere. It was only during this time of disillusionment with earlier hopes regarding a new society that the body started to be conceived as a site of social constitution through violence: larger social problems were viewed by the contemporary artists gathered around the ACCEA as resulting from not giving a voice to the body and its needs. The ACCEA's space, which became a central place for many of the artists of Kareyan's generation during this period, readily accommodated the emergent and – already in the late 1990s – dominant aesthetics of theatricality. Consisting of a massive concrete building housing two large halls, a film theatre and a smaller modular room, the ACCEA's space demanded a certain scale and monumental aesthetics from the artworks to make them visible within its architectural dimensions. Given that in the early 2000s the institution became structurally divided according to disciplines (fine arts, music, cinema, theatre and later architecture) and that its policies encouraged multimedia collaboration between artists (even today, as some artists attest, Edward Balassanian calls them up with an invitation to produce 'installations'), the late 1990s and early 2000s increasingly saw video works, installations and performances coming to replace the conceptual and neo-Dadaist experiments of the mid- to late 1990s. The shift towards theatrical and performative events was combined with the particular thematic of bodily suffering, sexuality and violence that was to become dominant in contemporary art in Armenia for almost a decade.

The violent killings in the parliament, which brought the mortal body into very close proximity to people's everyday lives through mass media broadcasts, helped to shape this aesthetic of the body in performance as a means to expose the material constitution of the ideology of violence and the violence of ideology. Even if the connection between this political event and this emergent aesthetic is neither straightforward nor causal (for instance, the exhibition *Crisis* was being planned before the parliament shootings), the artists themselves often directly referenced the 1999 massacre in their work. In this context, the exhibitions *Crisis* and later *Civic Commotion*, which Kareyan curated, were extensions of themes such as the crisis of individuality, the search for the lost wholeness of the body and the collapse of democratic ideals, all of which he was developing as an artist.[16] In one statement he makes this quite explicit:

> Our protest was directed at overcoming existential loneliness and the crisis of individuality and prompted us to organize the exhibition *Crisis* in 1999 ... and the exhibition *Civic Commotion*. Then the main aim of [these] exhibitions as well as of my own [work], was to show the conflict between mind and body, and to insist that it is possible to overcome the sufferings caused by this conflict. These sufferings are not ways leading to perfection and holiness but, [on the]

contrary, are an aspiration towards suicide. It is impossible to be in harmony with yourself, with other people, with nature and industry, if one does not take into account the reality, and if one does not refuse the romantic illusions.[17]

Alienation as an objective social condition arising from a material engagement with the world through social labour is most intensely felt and experienced in the moment of a crisis of political subjectivization, that is, subjectivization vis-à-vis political discourses and ideals. And alienation becomes a central theme in Kareyan's video installations of this period. The search for a formal language to convey alienation resulted, as I have said, in an aesthetic of bodily suffering rendered in video and performance, frequently combined with materials and objects such as earth, plants, wooden furniture and tools of labour. Alienation arising from the irreconcilability of man and nature is manifested in the juxtaposition of incommensurable signs, languages, materials and objects in a series of works spanning a little less than a decade (1999–2007). At first sight, these juxtapositions could be seen as repeating a *hamasteghtsakan* gesture of bringing together clashing images, styles, signs and languages. However, upon careful examination, it becomes clear that unlike in *hamasteghtsakan* art, in Kareyan's work of this period art as an ideal is conceived as a sphere where contradictions and incommensurabilities between art and reality become *visible* in their unbearable nakedness, but are never resolved. Art as an ideal in his work does not aim at a synergic cohabitation of opposites, but at the possibility of showing these opposites and of making them visible as such. The ideal in art is not attained via the garden path of harmony and conciliation, but by revealing alienation as it is experienced and lived by the body. The road to the ideal is paved through unmasking the ideal façade of reality and revealing its horrors – a revelation, however, that is only possible in representation, one that I argue Kareyan conceives as more real than reality itself. I interpret Kareyan's work as one that conceives of this revelation, in the very act of making visible 'things impossible to show' (the title of Kareyan's 2003 solo exhibition), as a precondition for the promise of de-alienation, even if this promise is one that is ultimately unfulfillable in reality. The possibility of such a revelation assumes a romantic belief that through the ideal, art has the capacity to overcome the social world of unfreedom and the everyday world of banality, but this is also a belief that stands on the ruins of the political and aesthetic project to sublate art in life.

Kareyan's work counterposes art's real promise of de-alienation to the false promise of the sublation of alienation within the social sphere – where the social technologies of the cultivation of the self in a society of standardized consumerist desires and behaviours promise individual fulfilment but are in reality mere symptoms of alienation. These technologies of false sublation of alienation shape the body as an image of power (as an edified and upright

form) but at the same time subjugate it to control, and thus they do violence to the body and its needs. The result of this seamless marriage of political control and consumerism, the effects of which are directly inscribed on the body, is the naturalization of the patriarchal structures of domination through militarism, patriotism, conservative morality and the perpetual desire to consume and ostentatiously display consumption. The political, technological and consumerist shifts of the late 1990s in Armenia are captured in Kareyan's works in their utmost intensity as internalized political traumas,[18] and expressed through bodily torment. Yet, even within these changed conditions, and given the drastically transformed aesthetic language, Kareyan does not abandon the ideal of democracy: now that the political and cultural spheres have abandoned it (the first by promoting a marriage of nationalism and consumerism and the second by embracing conservative morality), it is only in art that this ideal is preserved.

The exhibition *Crisis* in 1999 inaugurated the artist's newly found aesthetics of brutality exercised upon the body in video installation and performance. The group exhibition, involving a little less than two dozen artists, took place only two weeks after the parliament shootings. The group exhibition diagnosed the contemporary condition as one of disillusionment with the social and political aspirations towards democracy that the Armenian avant-garde art had embraced in the mid-1990s. The self-made publication accompanying the exhibition was a barely legible amalgam of installation shots, newspaper clippings of daily political news, articles on culture and society, and captions of the artists' works following a newspaper layout (figures 40 and 41).

This collaging of images taken from print media and subjected to artistic transformation was to become characteristic of Kareyan's work of the period. Remarkably, the exhibition was conceived before the parliament shootings, as the date of Kareyan's curatorial statement (28 September 1999) testifies, and was carried out two weeks after the massacre.[19] The statement accompanying the exhibition, which reappeared in other works and catalogues in different versions until 2005, crystallizes the way that political crisis was experienced by the community of contemporary artists. A passage from a later and more refined version of this text appeared in Kareyan's 2003 catalogue for the Armenian Pavilion at the Venice Biennale:

> 'No More History'
> You get up in the morning and you don't know what to do. Life has become mechanical and unbearable. You have lost your ideals. To act for satisfaction is as senseless as not to act. Nature does not obey you. You grow old. You strive for illusions, you are forgetting the reality, which is indifferent towards you. You have appeared in the middle of a frantic storm. You do not know how and on whom to take revenge. To become a terrorist or to commit suicide.[20]

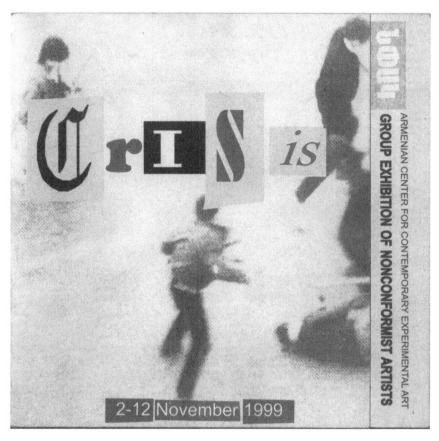

Exhibition *Crisis*, booklet, cover page, 1999 **40**

Kareyan's work *Crisis of Individuality* is a radical departure from the art-ist's conceptual concerns with 'pure creation' of the mid-1990s and the post-conceptual post-painterly spatial texts of 1996–98. The work is an assemblage of discarded furniture, household appliances and other debris of consumerism compiled into an installation from the centre of which a lonely TV monitor displays a cool-coloured and out of focus video (Plate 2 and figure 42). Behind the bluish effects of the cathode ray tube, a close-up of a man's face shot in a home interior setting moves up and down, rhythmically corresponding to an electronic music track that accompanies the video. The man's mouth is sug-gestively open, while his face is strained in an expression of pain and pleasure suggesting orgasm.

Splattered with mostly red, white and black paint and bearing graffiti-like marks and inscriptions, the installation that houses the video functions in a tension between vertical and horizontal axes: while about to collapse into

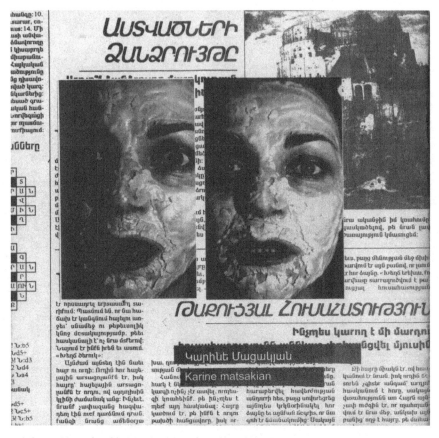

41 Exhibition *Crisis*, booklet, Karine Matsakyan's page, 1999

pure horizontality, the detritus of objects piled on top of each other pulls the overall structure forcefully up towards the ceiling from which this structure appears to be hanging precariously. The convergence of opposing structural axes conceptually enacts another structural polarity – that between high art and abject debris, alienation and the ideal. A *mise-en-scène* of a crime, the work compresses the subject who is the supposed inhabitant of this techno-material dystopia between the material excesses of a society dominated by instrumental reason and the technological screen of the video monitor, in turn 'screened' by a mattress boxspring. If Kareyan's 1994 action *Inspection* – in which the artist meticulously categorized and displayed everyday debris as an act of 'pure creation' – negotiated the precarious boundaries of autono-mous art through the deliberate and intentional act of naming and display, his 1999 work withdraws all intentionality from the sphere of art while revoking agency from the social sphere. By doing this he exposes the radical contin-

David Kareyan, *Uncontrolled Desire to Disappear*, 1999. Exhibition *Crisis*, still image from **42** VHS video

gency of art, where all deliberateness fails, with regard to its social as well as its institutional constitution.

Kareyan's work of the ACT period never referred to the body or to sexuality as sites or materials for art production, and yet this non-reference articulated a subjectivity deliberately and intentionally involved in the empirical world around it. As opposed to this, the works that emerge in the period of the political crisis and the politics of resistance, while bringing the issues of the body and sexuality to the fore, mark the elimination of the subject from the sphere of the social. In *Crisis of Individuality* the subject is buried beneath the debris of material waste from which it desperately tries to salvage its own desire. The precariously held verticality of the work threated by the law of gravity, as well as the graffiti-like inscriptions on the objects, resemble a crime scene from which the culprit has vanished. This is a landscape of material waste, ruins of collective dreams that mark the disappearance of the subject from the Symbolic order – the order in which the subject is socially constituted through the other, through language and history, in a Lacanian sense, while the frequent enactments of and with the body in Kareyan's work become precisely records of the vanquishing of the subject.

The presence of a small video monitor, in this case displaying a body in performance among materials, forms and substances such as earth, fleece, plants and bones that clash with this alien technological insertion, becomes characteristic for many of the performances and installations by Kareyan of the period between 1999 and 2007, before he took another radical turn towards painting that lasted until his tragic death in 2011. In *Dead Democracy*

of 1999 the small display monitor is located in an old and shabby wooden cabinet and is surrounded by fleece on the floor and (mud-made) garments hanging on the walls. In the video the artist rubs blood or a blood-like substance on to his upper body, the psychological effects of which are intensified for the viewer through repetition (figures 43 and 44).

Kareyan's world of the next eight years was replete with allegory, mythology and horror, and populated with ghost-like and priestly characters, earth sculptures, plants, schizoid mixtures of clashing political signs and symbols, trance-inducing electronic sounds, and almost no speech. The video installation *The World Without You* (1999) includes three monitors displaying the same sequence of the artist's body fragmented by camera close-ups, wriggling in the mud and organic matter that surrounds the installation: the monitors are located among tall domestic plants, stressing the artificiality and decadence of the environment (Plate 3). The artist is alone in this constructed environment as if it is a closed world without an other and an addressee. The camera becomes a kind of second skin as it both records and envelops the fragments of the body on to which mud is being rubbed in an attempt to perform a futile ritual of return to pre-subjective existence. The uncomfortable, awkward but at the same time lustful movements of the artist to become one with mud also resembles a vain attempt to simulate sexual pleasure. The loss of the other in *The World Without You*, as implied in the title and as enacted repeatedly in the video, hints at a loss of addressee for the artwork. If the addressee of the mid-1990s artists of the generation of independence was the new subject of the state – the responsible citizen – the late 1990s and early 2000s mark the loss of this addressee in its social and political determinations. Thus Kareyan's works and those of other artists of the same period appear as secluded worlds of their own that require that the audience member re-adapt his or her sensorial apparatus in order to penetrate their close structure. Kareyan's repeated returns to a pre-Symbolic stage, a stage prior to language and history in Lacanian terms, are attempts to construct such closed worlds, separate from and fundamentally irreconcilable with the social world and the empirical experience of reality. It was this separation of art from the empirical world that was conceived as resisting an ideologically stagnant reality replete with national myths.

Kareyan's exclusion of the other in *The World Without You* is a desperate attempt to overcome the alienation caused by history, language and the instrumentalization of labour. This understanding of alienation combines both Hegelian and Marxian conceptions. As I mentioned in Chapter 1, for Hegel, alienation is the Spirit's actualization and its externalization in and as history, whereas for Marx alienation is a historical outcome of man's social productive activity. The alienation from language, history, the body and the self is thus a necessary outcome of both socialization as such and socialization

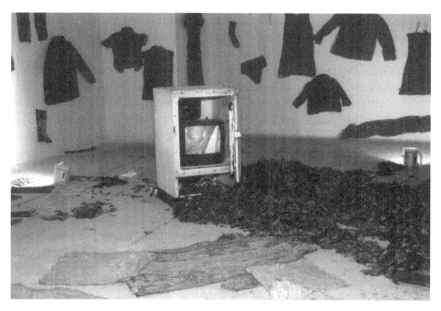

David Kareyan, *Dead Democracy*, video installation, 1999　　**43**

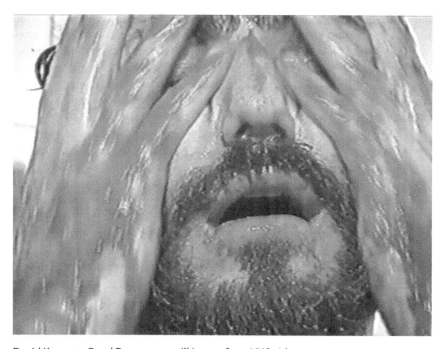

David Kareyan, *Dead Democracy*, still image from VHS video, 1999　　**44**

under capitalism in particular. Kareyan's desperate attempt to overcome alienation through an impossible return to a prehistorical pre-Adamic bliss in order to find harmony with nature and one's own nature, as signified by the subject's material fusion with mud, is paralleled by his desperate attempts to simulate sexual pleasure. But this is a pleasure deprived of desire, an auto-erotic pleasure. In Kareyan's world, organic materials are applied to the naked body in anxious gestures that promise to eject the subject from history. This exit from history is technologically rendered since, as I have argued, technologies, especially video in Armenia around this time, promised to deliver a dreamworld and erase the mediation between the world and experience. In this conception, the technological world of video is an ahistorical realm where death and sensuality meet.

Give Me Back My Innocence of 2000 is another closed world. The installation is structured linearly, starting with one pile of stones and ending with another. In between is a cut tree trunk, a white dress fixed on a mop-like scarecrow, and a video monitor facing a stack of hay that displays the artist's naked upper body cuddling in fleece. A spotlight projector embedded in the soil illuminates the stack while casting ghostly shadows on the wall. The reverberating digitally produced sound animates these objects through its trance-inducing presence. In *Monument of Solidarity* of the same year, presented at the group exhibition *Civic [Petit-Bourgeois] Commotion*[21] which Kareyan curated, the small video monitor appears in a similar techno-industrial-organic environment composed of earth, household debris and spotlights, acting as a *mise-en-scène* for what is to happen. The repetitive sound emanating from the video monitor recalls experiences of intense sexual pleasure and pain. The centre of this *mise-en-scène* is the artist who is dressed in a white women's slip and performs an action barefoot in the foreground of a white painted panel.

After axing a wooden table until it collapses, the artist turns to rub mud upon his white nightdress before turning to the objects that surround him – a broken table, an aluminium bed frame and a video monitor – prior to putting on a fur coat and sitting on a wooden cage. The white painting in the background resembles a negative image in which all traces of representation have been erased and scratched out, leaving only indexes of painterly marks, scribbled ghost-like images and crosses that recall both cave drawings and Hollywood-rendered bogeymen. On the material landscape of civilization represented by these objects, which Marx calls the 'inorganic body of man' and which Evald Ilyenkov refers to as 'thought in its Otherness' ('das Idee in der Form des Anderssein'), the artist triumphs over a temporality where the pre-history and post-history of humankind rejoin in a natural-artificial dystopia.

Sweet Repression of Ideology of 2000, performed during the exhibition *Collapse of Illusions*, extends the theatricality of Kareyan's aesthetic lan-

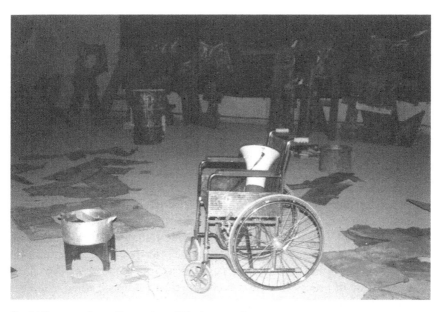

David Kareyan, *Sweet Repression of Ideology*, performance, 2000 **45**

guage of this period to encompass the entire second hall of the ACCEA's large exhibition space (figure 45). If the previous installations remained within the logic of a space formed around and in relation to an object or sculpture (the TV monitor being one such object with its technological-material presence), with added theatricality, *Sweet Repression of Ideology* breaks from any structural concerns with the spatiality of the objects and surrenders to theatre. Throughout the closed performance, viewed by invitation only, Kareyan, in a wheelchair and dressed in a black shirt and trousers, is escorted by a female figure in a long white summer dress. She holds a flashlight behind the artist, affording him light in order to read various passages from books through a loudspeaker. Throughout, he tears the pages from these books and throws them into an aluminium cooking pot on an electric stove while mixing the contents of the pot with a wooden stick. Similarly, *Gastritis* of 2000 – performed at the exhibition *Armenian Artists on Cyber Spatial Relations* curated by Avetisyan – presents a performative environment the theatrical language of which is no longer anchored in a fixed object. Separated from the audience in an enclosed space covered with plastic curtains and litter, the artist is dressed in a white protective suit and mask, and grinds and chops up large animal bones with an electric saw and an axe. Accompanying the disconcerting sounds of the electric saw are timed explosions of plastic bags full of red paint, splattering their content on the plastic walls and the floor.

Similarly to the previous works discussed here, *Sweet Repression of Ideology* and *Gastritis* make visible the material, visceral and bodily grounding of social and political ideals and ideologies, while viewing these latter two as opposites: ideologies are what stand between ideals and their realization. But ideals and ideologies are also inextricably connected: though materially and historically constituted, and while appearing to transcend this constitution, they occupy a third sensuous-supra-sensuous domain. In Kareyan's work it is in the sphere of art conceived as an ideal that foundational social taboos can be undone, and the horror opened up by this undoing made visible. As Mikhail Lifshitz states, 'The ideal in the world exists, but it does not pass through the front gate.'[22]

In a video interview in the aftermath of *Gastritis*, Kareyan sits on a plastic chair amid the debris left behind from the unsettling performance – scattered bones and splattered blood – and explains: 'I attempt to lift the taboo on murder and incest in my art, and perhaps help focus people's attention on what is happening in Chechnya, in Yugoslavia, on October 27, [1999] here, and what kind of processes evolve in each person's stomach when s/he does not come to terms with his/her body.'[23]

Kareyan's battle against social taboos and socially normalized and unquestioned prohibitions was informed by his reading of the psychoanalytic works of Sigmund Freud and Wilhelm Reich during this period, a reading that was instrumental in him countering one of the foundational figures for contemporary art in Armenia – Grigoryan's enlightenment humanism and rationalism. Several of Kareyan's works re-enact the breaking of the fundamental taboo on killing through metaphorical acts of sacrifice. In the video performance *Eucharist-450* (1999), the artist, dressed in a black priestly gown characteristic of Armenian clergymen, repeatedly chops a cow's severed head on a wooden table surrounded by fleece and traditional Armenian bread. In another video of the same year, *Call of Ancestors* (2001), the priest who performed the ritualistic sacrifice in *Eucharist-450* internalizes the death of the sacrificed victim by chewing on its flesh. In this video we see the artist continuously chewing raw flesh – a cow's liver – with his mouth covered with blood. It is an attempt to overcome the painful split between the body and language, the body and culture. The mythical and primordial aura in Kareyan's works as well as the direct references to medieval Armenian ecclesial spiritualism[24] universalize the specific, historically conditioned political crisis in Armenia and its ramifications upon the body, in the aftermath of the collapse of the political ideals of the 1990s. The crisis is marked as one of civilization, or rather it is demonstrated that civilization cannot but be in a constant state of crisis because it is based upon repression. However, Kareyan's emphasis on sacrifice is not merely a reference to Christianity but has its roots in some of the art practices on the late 1970s and 1980s, especially in Vigen Tadevosyan's

work, which combined inner spirituality and abstraction with the notion of the artist as a sacrificial being.

In Kareyan's work, prohibition and liberation from taboo enter into a dialectic of clash and mutual completion. In a Freudian sense, prohibition as directed against the 'liberty of enjoyment and against freedom of movement and communication' ensures the sustainability of a social order after a primeval crime.[25] By acting as a priest who performs a sacrificial rite, the artist enters into the logic of how the taboo functions in relation to the social world – the priest-artist who upholds the prohibition against killing and against art is an alien in relation to the social world, yet has the power to reveal the constitution of this world as based on crime. The one who transgresses the taboo himself acquires the power of taboo. In the words of Freud:

> This power is attached to all *special* individuals, such as kings, priests or newborn babies, to all *exceptional* states, such as the physical states of menstruation, puberty or birth, and to all *uncanny* things, such as sickness and death and what is associated with them through their power of infection or contagion.[26]

The one who is taboo is at the same time the one who has the power to break the taboo. Both sacred and unclean, the artist-priest is in a state of exception, a state that conforms to the social status of artists in Armenia both as visionaries and madmen. The contemporary artist within Armenian society is this alien other whose lifestyle and work are perceived as 'strange' at best and immoral and corrupt at worst in the social imaginary; at the same time, the artist is revered as one who possesses visionary capacities. The artist is seen as an alien body that seemingly has special access to transcendence by virtue of being a 'creator', but at the same time is seen as socially dysfunctional, since his or her labour is not socially productive. Kareyan's project aims at two contradictory ends: to dissociate the artist from the dominant society by rising above it, but also to claim a place for the artist as a socially productive being, and art as the only sphere wherein the ideal of democracy can thrive. It is this slippage between the socially communicative role of the artist and his refusal to participate in the social sphere according to the latter's dictates that gives rise to what might appear as the paradoxical combination of heroic avant-gardism and romantic escapism that characterizes Kareyan's work of this period. And most importantly, this combination marks his art as one of resistance, an interpretation that he himself favoured, rather than one of affirmation, as in the case of his practice within ACT half a decade earlier.

Digestible Reality of 2002 constructs a total environment of technological, natural and bodily symbiosis: trees are planted in soil in the white and clean space of the art institution; white stands hold Mike-Kelly-esque muddy sculptures of animals that seem to be cast from plush toys; female

garments are fixed in mud and attached to a mud-covered panel; abstract concepts (Freedom, Nature, Beauty, Truth, Civilization, Happiness and Eternity) are written in black on white and installed in a house interior where every object is covered with mud – a desk, a table, a cabinet, a pair of scissors, cutlery, books, a lamp and other tools of labour, all made dysfunctional. This is an entire living civilization frozen in a post-historical state, only to be rediscovered by the viewer as an archaeological artefact. Encountering this alien and yet familiar world as an object for contemplation, the viewer discovers her present as a past, one in which time has come to a standstill but one which allows her to see her present in its utmost materiality. The video monitor shows the inhabitants of this non-place – a family (the artist, his wife and his daughter) sitting naked and playing with toys, indifferent to the viewer's presence, and closed within their own world without context and history (figure 46). The incommensurability of the material and the ideal is articulated at the level of the juxtaposition of the nuclear family with the world of objects, though a family devoid of all sociality and surrounded by the world of dead objects turned into art. The

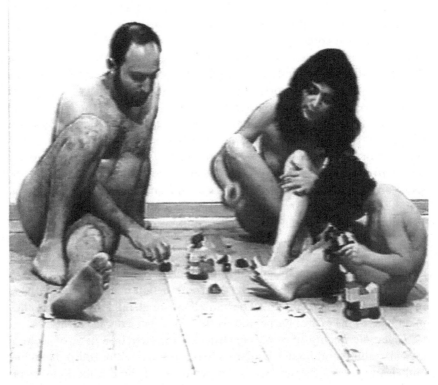

46 David Kareyan, *Digestible Reality*, still image from VHS video, 2002

installation is a total environment where all the binaries are in a state of utmost polarization, bringing Kareyan's aesthetic and political concerns to the fore in the most acute manner.

Culminating in *No Return* of 2002, already mentioned above, this series of video installations and performances can be construed as a *fabula*, one that starts with a profound loss, the object of which cannot be identified (*Dead Democracy, Crisis of Individuality, The World, Without You, Give Me Back My Innocence*); then moves into attempts to overcome this loss through rituals of sacrifice and the internalization of political traumas by the body (*Eucharist- 450, Call for Ancestors, Monument to Solidarity, Gastritis, Sweet Repression of Ideology*); and ultimately culminates in an impossibility of reconciliation that opens up art to a post-historical temporality (*Digestible Reality, No Return*). However, this so-called post-historical temporality simulated by the artworks is in actuality a manifestation of a specific historical condition, one that has arrived on the wings of nationalism and neoliberalism in Armenia. The cultural conditions for this situation of crisis are the marriage of ethnocentric nationalism, patriotic militarism and consumer imagery; its political condition is the consolidation of an autocratic government; while its economic implications are the accumulation of wealth in the hands of an oligarchic elite. In this context Kareyan, along with other artists such as Tigran Khachatryan, Lusine Davidyan and Astghik Melkonyan, developed an iconography of the body as a site of pain and eroticism, an iconography that in the latter part of the 2000s took up problems related to sexuality and sexual identity against the dominant cultural politics that stressed national identity.

In many of the works discussed above, Kareyan appropriates the iconography of Armenian Christianity (the 1700th anniversary of its adoption being marked at the time when these works were produced, 2000–01) in order to overturn its repressive and patriarchal logic of bodily subjugation and erasure of individuality from within, by identifying with its sacral and ritualistic dimensions. Ultimately, the theme and iconography of self-sacrifice is closely related to the sacrifice of the 'ultimate subject' in Christianity – Christ. The narrative of Armenian history, composed mainly in monasteries and other religious institutions throughout the Middle Ages, is told around the event of sacrifice. It was this narrative that yet again returned in official historiography and cultural politics in the early 2000s, as part and parcel of the nationalist and ethnocentric revival. But Kareyan's calls for giving a voice to the body and its needs are not simply subversions of the religious discourses that repress the body. In his works, patriarchy is made visible as a root structure that functions through a multiplicity of interconnected ideologies such as nationalism and patriotic militarism. Remarkably, as with all men in Armenia, at the time Kareyan faced the requirement to complete his two-year military service.

Mandatory recruitment to the army remains a source of immense stress and psychological trauma for many of those who are obliged to comply. For the artist, it triggered both a personal and political crisis. The first was revealed in his attempt to rethink his views, personal affiliations and friendships, and the second in the disenchantment with the failed hopes for democracy. Kareyan's search for the pre-Symbolic and the unconscious was partially a reaction against Grigoryan's enlightenment rationalism mentioned above and elaborated in Chapter 2.

The figure of the suffering artist recurs in Kareyan's work as a way to resist the Enlightenment human as well as the idea of a rational citizen – which in the context of contemporary art in Armenia is also meant to resist the dominance of Grigoryan on the one hand and Kareyan's own beliefs of the mid-1990s, on the other. However, even with his counter-Enlightenment project, Kareyan still upheld the belief that art represents the possibility of preserving that which society cannot accommodate – the ideal. The coexistence of radical anti-bourgeois values and the Enlightenment belief in cultivation through art is part and parcel of Kareyan's ongoing attempts to reconcile irreconcilable contradictions in his work (indeed, most probably the deliberate mistranslation of *Petit-Bourgeois Commotion* as *Civic Commotion* by the ACCEA's Edward Balassanian is an ironic testament to Kareyan's own ambiguities). One can discern this polarization in his video works, always aestheticized and brutal at the same time, operating between the natural and artificial. Video itself was for him an ambiguous and contradictory medium, one that provided an isolated and enclosed space for subjective autonomy where he could be alone and in public at the same time. Another irreconcilable binary that structured Kareyan's work was reality – understood as the empirical world of experience – versus the ideal. In his works of the period, as mentioned, the ideal in art is attainable only via the thorny path of universal primordial horror – incest, murder and sacrifice. By universal horror I mean the pre-Symbolic world that does not succumb to symbolization, to language and history, and where the subject has not been constituted as such. The works discussed above propose an identification of the ideal with this horror while at the same time pulling these apart. And it is this contradiction that is typical of Kareyan's work of the period. What emerges in his works is the notion of art *as the ideal of universal horror*. If horror is triggered from the excessive remainder of the primordial and pre-subjective world of jouissance that threatens to annihilate the subject in the Symbolic order, the ideal is its opposite pole. This ideal is the unattainable harmony between nature and culture made visible through art. Art *as the ideal of universal horror* is the new entity that emerges out of the dialectical movement of the opposing poles without reconciling the contradictions in bringing these poles together. Art thus becomes the only domain where reality can be transgressed, and where

murder, sacrifice, self-mutilation and incest can be made visible as aesthetic acts. The three registers of Kareyan's work, which weave a tripartite *fabula* – one of loss, of an attempt to retrieve the object of loss, and of the synthesis of these two moments within the impossibility of reconciling contradictions – amount to a movement towards making it possible to represent horror as a path to attain the ideal.

The absence of language in all of Kareyan's works of this period links the body to the pre-Symbolic. Here language is considered as necessarily dishonest, while genuine communication can take place only through the body – a stance that is diametrically opposed to Kareyan's earlier aspirations towards linguistic transparency within the group ACT. What Kareyan strives to retrieve is the body conceived as identical with existence, without the forms of appearance. It is the unmediated body that threatens to escape representation, but that is, paradoxically, possible only in art, in the domain of representation of those 'visible things' that are otherwise 'impossible to show'. Kareyan's impossible attempt to retrieve an *a priori* pure existence, from beneath the layers of historical *a fortiori* representation mediated through reason and language, follows a dark path of sacrifice and violence, and yet holds on to the promises of de-alienation.

As mentioned, both in Hegelian and Marxian senses, the constitution of subjectivity takes place through alienation. For Hegel alienation is the externalization of the Spirit in its historical form, and for Marx, it is an outcome of labour as historically defining the human, and the objectification of labour as a value-generating activity. The social world as constituted by the totality of institutional rules, norms, values, symbolic and linguistic systems is itself a product of alienation. It is this externalization of the subject through othering from itself within language and history that Kareyan attempts to overcome in art. Such an overcoming would make it possible to touch upon the ideal while exposing the horror that lies beneath all idealization: it is through this ideal that the horrifying abyss of the pre-Symbolic can be 'represented'. Here the 'painterly real', the conceptual figure of this book that signifies the possibility of attaining the ideal through an aesthetic act, is not abandoned as a structural support for art's autonomy and its ideal of freedom. Instead, it is inverted: once the historical subject is exposed to the ideal, the subject does not discover some harmonious coexistence of free and self-willing individuals (as in Grigoryan's work), but is undone by this encounter. If in *hamasteghtsakan* art, ideal and reality can be reconciled in the dreamworld of the collectively constructed imaginary, for Kareyan this reconciliation is never achievable. In a way, one of Kareyan's earlier works of 1997 is a premonition of his post-1999 video installations. A black text on a white background (a form that brings back his favourite aesthetic of the ACT period) reads 'The art [*sic*] is behind you.' Art as an ideal is always there, at the artist's back, but it is never attainable: if the artist turns

around hoping to glimpse art, it remains behind him – like Orpheus's wife who vanishes as soon as the musician turns around to look at her.

Techno-utopias of the 'painterly real': Narek Avetisyan

In 2000, former ACT member Narek Avetisyan came up with a ten-page document, which he publicized at the discussion of the group exhibition *Armenian Artists on Cyber-Spatial Relations*. This large exhibition involved 40 artists and was curated by Avetisyan himself at the ACCEA. The document, entitled 'V.R. Manifest – A Manifesto of Virtual Art', was rather didactic. It read as an entry in an encyclopaedia aimed at explaining several newly emerging technological concepts to the community of Armenian contemporary artists, writers and critics. These concepts included 'virtual reality', 'information technologies', 'user interface', 'fractal universum' and others. However, instead of supplying any clear informational content, the manifesto read like a piece of obscure academic writing, (mis)translated from a foreign language, with the artist's added mission statement on the impact of virtual reality (VR) technologies on social and cultural life. The ambiguous language of the manifesto aimed at two things at once: to participate in a specifically 'local' discourse, but to do so with a universalist rhetoric of utopian connectivity. Thus in this manifesto the two impulses characterizing not only contemporary art but also national culture in Armenia were visible: to be contemporary, but from the specificity of one's historical/national position. The manifesto is an example of some of the ways in which the new language of information technologies was (mis)translated when imported into the Armenian context: unknown, obscure and fascinating at the same time, but also containing the promise of easy utilization, accessibility and connectivity.

Avetisyan's manifesto of 2000 had the didactic purpose of acquainting the public with the lexicon and discourses of VR-based art, while remaining within the declarative form of the manifesto, spiced up with a millenarian rhetoric about the brave new era of global connectivity. The form and language of the manifesto revealed that, for Avetisyan, new media technologies were primarily aesthetic devices, and that their technological promise of utopian connectivity corresponded to the communicative aspirations of contemporary art in Armenia to be part of the global world. Beneath the seeming rationalism and scientism of Avetisyan's rhetoric was a gestural and painterly impulse. Yet again, the 'painterly real' underlay the reception of new technologies for art production, as also revealed in Avetisyan's work of the late 1990s and early 2000s. With their utopian promise of dematerialization and connectivity, in Avetisyan's work VR technologies as aesthetic devices constructed a structural relationship with everyday life characterized by negation, while they grounded art's ideal in the 'painterly real'. In a way,

these technologies were rendered dysfunctional in the aesthetic sphere, or rather they were transformed from tools of communication into tools of art-making, at times literally replacing paint and brush. Technologies were conceived as means to produce artistic gestures, an aspect of which we also saw in Kareyan's works. And these gestures acquired a sense of urgency since the promise of communication that the technologies brought could be realized in the sphere of art as an ideal. After all, Avetisyan's elaboration of concepts such as 'bio-virtual', 'universal connectivity', 'simulation', 'sensorium', 'user' and so on, and his argument that VR art was the most relevant form of contemporary art production, came at a time when Armenia was geographically isolated from the rest of the world by its two neighbours, Turkey and Azerbaijan. Significantly, this rhetoric came forth when only a handful of people in Armenia could afford to become denizens of the World Wide Web. Virtual reality and the Internet reinforced an illusion of connectivity with the bigger world, beyond Armenia's constrained geopolitical borders. Since this illusion had no grounding in the actual conditions of the everyday, but was part and parcel of the Armenian avant-garde's programme of communication with the outside world, it had to be fanatically reasserted over and over, declared with a futuristic enthusiasm to gain the status of a belief. It was not by chance that Avetisyan earned the title of 'futurist modernist' at this time. Avetisyan's work in the 1999 Venice Biennale is an epitome of the ambiguity between technological fetishism and artistic gesture, science and poetry, as well as between local conditions and universal aspirations.

In 1999, the ACCEA chose Avetisyan's project *Post-Factum* to present at the Pavilion of the Republic of Armenia during the 48th edition of the Venice Biennale. The project, coming from a small country in economic and political turmoil, at least as based on its original idea seemed an ambitious if not an impossible one. Avetisyan intended to create a telecommunicative structure that would connect an estimated 8,000-year-old megalithic observatory in Qarahunj, southern Armenia, to a contemporary astronomical observatory in Byurakan, on Mount Aragats in the northern part of the country (figure 47). The original plan was to establish an audio feed between these two observatories – the prehistoric and the contemporary and the universe – from Dorsoduro in Venice, where the Pavilion was located. The audience would be invited to send audio messages to space, to a distance of 50,000 light years, using projectors, video cameras, satellite dishes and computers. They would then be invited to answer questions, such as 'Do you still believe in the conquest of space and time?' and 'Do you still remember art?'[27]

According to Avetisyan, he wanted to create the largest artistic gesture in human history. The two observatories seemed to provide a frame for exceeding the limits of empirical, spatial and temporal coordinates, while remaining within the framework of national representation. The imperative of national

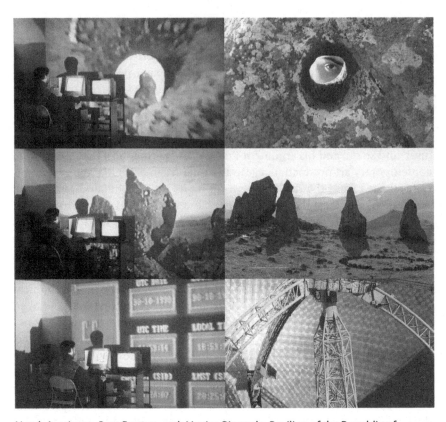

47 Narek Avetisyan, *Post-Factum*, 48th Venice Biennale, Pavilion of the Republic of
Armenia, 1999

representation was embedded in the very structure of the Venice Biennale on
the one hand, and was being advanced by the cultural politics of the Ministry
of Culture of Armenia as well as by the ACCEA, on the other. And given
that both observatories – Qarahunj with its antiquity and Byurakan with its
modern scientific accomplishments – were a source of national pride, the
project had sufficient legitimacy within national cultural politics. According
to Avetisyan, the invocation of national sentiments was meant to make this
project with its universalist aspirations palatable for the ACCEA, the Ministry
of Culture and the diaspora funders.

Avetisyan claims that in the end the ACCEA could not provide the neces-
sary financial means to implement the idea of the project to its full extent.[28]
Rather, Edward Balassanian – the commissioner of the Pavilion – asked the
artist to create an imitation of the original idea without actually sending sig-
nals, while still telling the viewers that their handwritten messages could be
transformed into a sonic equivalent and beamed into outer space. This way

this project, in its ambition to become 'the largest artistic immaterial gesture' as Avetisyan claims, was reduced to a mere simulation of this gesture, thus only gesturing towards a gesture.

If Avetisyan's concerns were poetic and utopian, Balassanian was interested in the project both because of its technological engagement with new media as a 'contemporary' artistic act, and its national content. In a way, the work effectively combined technological claims to contemporaneity with the agenda of national representation. According to the curator, the new generation of artists to which Avetisyan belonged had unburdened itself of Soviet mores and taboos and created a new aesthetic vision:

> Out of this new vision has grown an appreciation of the mysterious, the non-factual and the non-tangible. It is stimulation for their imagination rather than a forbidden boundary, a wellspring from which they create their art – their unconditional projections of what they discover in this zone. Intellectual discourse that is logically derived, deduced, and documented has for the most part been left behind ...[29]

Further on, Balassanian applies a reading replete with romantic nationalism directly to Avetisyan's work in order to reveal its profound connection to the Armenian national landscape:

> Narek Avetisyan's installation is about the earth, space and his dream that 'floats' in between. In a morsel of land called Armenia, he connects an eight millennia-old stone observatory in the south – preceding the English Stonehenge by several millennia – with a state-of-the-art giant radio-observatory in the north, and from there to the unknown depths of the universe 50,000 light years away. And, for the duration of the Forty-eighth Venice Biennale, this network will pulsate from the City of Dreams.[30]

If the founder of the ACCEA situated the artist within both the rhetoric of Armenia's antiquity and the ideology of innovation and national tradition, Avetisyan himself conceived of the project within the universal scientific paradigm of ultimate progress as an extension of his pseudo-scientific utopian ambitions within the group ACT in the mid-1990s: '*Post-Factum* is the present and future development of [the] fact, and its detailed global representation: a powerful information field.'[31]

Whereas in the late 1990s the state abandoned the progressive pole for the sake of ethnic and folkloristic representation, the ACCEA continued to negotiate between the national and the progressive, or rather, used contemporary art to show the world that Armenia was a progressive nation. The obsessive urge, or what cultural critic Hrach Bayadyan called 'a hysterical cry', to be represented to the world, came at a time when Armenia had started to build a nation state while most of the world, and especially Western Europe, was well

beyond the historical epoch of constructing nation states.[32] But Bayadyan also argues that hidden behind this urge for representation was the global imperative to commercialize, package and market diverse identities. Indeed, national representation and the marketing of identities are not oppositional processes, but rather are both part and parcel of the expansive push of global capitalism to reach new geographies and to commodify all differences to an extent that difference itself becomes a product. In short, this is a marriage of identity and commodity resulting in 'ethnic marketing'.[33]

Avetisyan's futuristic modernist agenda and Balassanian's nationalist one have defined the paradox of combining grand modernist gestures with the nationalist ideology on the contemporary art scene in Armenia throughout the 1990s, agendas that were facing a crisis at the time when Avetisyan presented his project in Venice. The work is indeed a reflection of this crisis, since its gestural ambitions are reduced to the level of mimicry and deception: messages supposed to be sent into outer space in reality never left the walls of the Pavilion. The work also reflected the impossibility of enacting modernist utopian gestures from the confines of a nation state. Avetisyan's project itself fed on the ideology of technological progress and on the officially reiterated myth of Armenia's unique potential to become the next Silicon Valley. This rhetoric, especially prominent in the late 1990s and early 2000s, was perceived as a path to economic development despite Armenia's lack of natural resources. IT specialists and cultural critics alike, and most prominently Bayadyan, have argued that this rhetoric was groundless. With the lack of a comprehensive national policy for IT development, as well as the monopolization of Armenia's telecommunication system by a single company which resulted in high prices for domestic use of the Internet, the myth of IT development was an ideological tool in the hands of the government for its market-driven and nationalistic agenda. Bayadyan argues that this myth relied on the Soviet positivist perception of technologies as tools to advance a grand social and/or economic cause. But it was also based upon the dominant urge within mainstream society to preserve the 'purity' of national culture.[34]

It is telling that the first loud advocate of IT development in Armenia was the Ministry of Foreign Affairs. This could lead us to claim that IT was perceived as a gateway to overcoming the geographical isolation in which Armenia had found itself since the early 1990s: it would provide virtual communication with the outside world. This would supposedly help to advance a passive and 'complementary' foreign policy, advocating low-key and cautious engagement with Armenia's geographical neighbours: as long as one could advance technologies of virtual communication, physical communication would not be necessary. Cyberspace offered to replace fragmented communication with the outside world as a result of geographical isolation with the promise of total connectivity. However, in the late 1990s and early 2000s, very

few people could afford to explore this promise of participation and interaction. Another obstacle was the linguistic barrier of the domination of English in cyberspace.

Bayadyan describes how the Internet was infiltrating the everyday, particularly the language of signage: alongside other markers of consumer culture, it was common to see signs such as 'Internet, 600 drams', 'Internet and Hair Salon' or 'Internet and Restaurant' on the streets of Yerevan in the early 2000s. Behind these posters, as the cultural critic writes, there were exits and ways out to the larger world, rather than merely communication systems.

In Avetisyan's work, subjected to an artistic gesture, technologies promised to transcend both the historical conditions in which they were situated and the very instrumentalist logic that motivated technological innovation. They became properly artistic tools to support the ideal of the 'painterly real' embedded in the gestural act. In the VR manifesto Avetisyan declares: 'During the age of "BIOVIRTUAL" transformation and "MULTIDIMENSIONAL LOGIC", political, geographical and all other borders will soon be irrelevant for the essence of creation. The artist's mind is on the other side of reality.'[35]

The series of fractals that Avetisyan produced throughout the early 2000s followed the VR manifesto and testified to the reception of VR and IT technologies as painterly tools. The fractals were two-dimensional prints of mathematical formulae digitally processed, produced and displayed in exhibitions. The colour scheme of many of these digital readymades uncannily repeated the primary colours of the National Modernist painters, the most prominent representative of which was Avetisyan's famous father, Minas. In the fractal prints, which are visualizations of mathematical abstractions, the myth of virtual reality and its utopian promise of connectivity was now suspended, deferred and frozen within the temporality of National Modernism: indeed, these fractal prints were contemporary in technique and 'national' in colour. Arising from the double imperative of global communication and national representation, or in other words, to be contemporary and yet truthful to one's historical roots, the fractals were not conceived merely as outcomes of mathematical formulae, but as mediators between the two imperatives: 'Taking the accurate mathematical formulae as a metaphor, it is possible to understand the division and limitless multiplication and reproduction of the local and the global. Global culture is the alternative project of humanism and universalism, spread everywhere.'[36] Furthermore, as artistic devices, they were endowed with the power to reconcile the rational with the creative, as well as the real with the virtual and to support a conception of art that 'appears in the border between the "courage" of transformation and the syndrome of illusion in which the human being is emancipated from the boundaries that he himself stretched …' (figure 48).[37] Even though the fractals are produced by mathematical calculations according to the principle

48 Narek Avetisyan, *Fractal*, C print, 2006

of approximate self-similarity in which objects are self-similar to parts of themselves, for Avetisyan, as art objects, these are profoundly painterly and gestural: though products of mathematical formulae, it is the artistic gesture that makes them visible as objects with aesthetic properties. In this context, it is important to note that Avetisyan often drew from the artistic legacy of his father, also considering himself an heir to the tradition of the European modernist painters of the first half of the twentieth century. In turn, European modernism, for Avetisyan, was mediated by his artistic icon – the twentieth-century painter Ervand Kotchar. Avetisyan saw VR in particular as the realization of the ideals of *Le Dimensionisme*, a 1936 manifesto that Kotchar signed in Paris along with avant-garde artists such as Hans Arp, Francis Picabia, Wassily Kandinsky, Marcel Duchamp and others, led by Charles Sirato. The Dimensionists declared a break from the two-dimensionality of the canvas for the sake of occupying the third spatial dimension as 'the *kunstwollen* of our age'.[38] Kochar subsequently executed the ideas outlined in the manifesto, and throughout the 1930s produced painted sculptures and sculpted paintings in which painting opened to the third dimension through curves, holes and openings in his tin constructions.

Identifying himself with the legacy of Dimensionism and specifically with Kotchar, Avetisyan saw VR as the ultimate technological space for a true realization of the Dimensionists' ideas of breaking away from the material constraints of painting, while remaining within painting. He was truthful to the promise of the Armenian avant-garde to overcome painting through

painting, a paradigm that had characterized the 3rd Floor more than a decade earlier. While Avetisyan's project in Venice and the fractal prints were part of a consistent trend in his practice throughout the 1990s and early 2000s towards exploring the immaterial artistic gesture through the means provided by new technologies, he did not abandon painting as such. What underlay both aspects of Avetisyan's work – the immaterial gesture and the painterly trace – was the presence of the 'painterly real' as a guarantor of art's ideal and its utopian potentiality.

Vardan Azatyan, who curated Avetisyan's solo exhibition *Spaces of Light and Trace* in 2006 at the ACCEA, thoroughly discusses the Janus face of Avetisyan's work in his curatorial introduction (Plates 4 and 5). According to Azatyan, Avetisyan's works strives towards immateriality while at the same time reinserting the materiality of the body into the artwork: while producing ripped canvases à la Lucio Fontana for the exhibition *Graffiti* in 1992, Avetisyan also performed his action *Fixing of Light* in 1994, thus stressing the privilege of the immaterial gesture over its material and bodily counterpart.[39] The exhibition Azatyan curated presented these two tendencies not so much as extravagant exceptions but rather as patterns that were paradigmatic for post-Soviet artistic practices in Armenia. Azatyan suggests that 'this simultaneous opposition is symptomatic for post-Soviet artists, since the post-Soviet situation is distinguished by an absence of clear paradigms. Here the artist himself turns into a paradigm.'[40]

At the same time as Avetisyan was producing his fractals in the early 2000s, he was also involved in the production of canvases on which he left hand-painted traces of fluorescent paint. The exhibition *Spaces of Light and Trace* juxtaposed hand-painted canvases layered as three-dimensional installations with dark environments flickering with colourful immaterial light. These works – both the canvases and light installations – combine VR aesthetics with painting, and the supposed promise of dematerialization with the material and the bodily introduced into the space of painting. They bring together optic and haptic experience. As Azatyan states, 'the aggressive tactile gesture is turned into an optical aggression'.[41] Rather than seeing the immaterial and the material gestural as oppositions or contradictions within a single practice, my reading suggests that both approaches to art shared the belief in the 'painterly real' as a guarantor of art's ideal and its autonomy.

This reading challenges the prevalent reception of Avetisyan's post-ACT practices of the late 1990s and early 2000s as futuristic and even messianic, with their propagation of an immateriality achievable by utilizing new technologies – although admittedly Avetisyan himself contributed to this reception, with his self-styled posture as a futurist modernist. This posture of the techno-utopian modernist resonated with his self-perception as the 'last Mohican' of 'pure creation'. Avetisyan claimed more than fifteen years after

ACT's disintegration: 'After everyone else left ACT, I was the only one who remained.'[42] He continues:

> After ACT, I developed a belief that the space of intersection of art and science, the space of pure creation, is the digital virtual world. I thought that it is there where we should search for the realization of all these ideals. In cyberspace we have immateriality but also real communication ... the viewer has the sense of being there but s/he is also here ... it is like a waking dream ...[43]

It is in this sense that cyberspace, for Avetisyan, was like art – a reality alternative to empirical reality, like a 'waking dream'. And this conception of art as a waking dream and at times as a real nightmare had characterized the Armenian avant-garde since at least the late 1980s. This dream or nightmare was perceived as attainable through aesthetics, and specifically through a figure that I have established and activated throughout this book, the 'painterly real'.

Despite the socio-political, technological and cultural transformations from the late 1980s to the early 2000s – a decade and a half that comprise the chronological scope of this book – as well as the shifting relationships between the artistic avant-garde and political power in Armenia, the avant-garde artists relied on painting as a structural support for artistic autonomy. The function of this autonomy was to provide a possibility for the ideal of emancipation that the social world either accommodated partially or refused to harbour altogether. Kareyan's and Avetisyan's practices of the late 1990s and early 2000s crystallized the social contradictions in Armenia after the collapse of the initial hopes triggered by the construction of the new state and the belief in art's impact on social and political processes through artistic means. In response to the crisis of political subjectivization, Kareyan explored the body as a site of social and political violence through video and performance as a means to resist the dominant national, cultural and political narratives. Avetisyan, in turn, utilized the language and means of VR technologies as aesthetic devices, and saw in them gateways to the world that supposedly transcended the spatial and temporal givens of Armenia's geographical and political isolation. Thus, Kareyan and Avetisyan responded differently to the complex political, social and technological transformations of the late 1990s and early 2000s in Armenia, yet through a shared belief in art as an ideal. If Kareyan's response to the conditions of crisis was to make visible those things that were 'impossible to show' (thus to show the constitution of the social world by proto-social impulses, drives and instincts) through video installation and performance, Avetisyan sought an answer to the conditions of geographic isolation and the limits of the national discourse in the utopian promise of connectivity brought about by VR technologies as possibilities

for transcending the limitations of the social world. If for Kareyan the retreat from the prevailing political narratives took place through the exposition of the body's extreme materiality and through the exaggeration of the body's 'bodylines', for Avetisyan it was the virtual world of cyber technologies that paradoxically promised to retrieve the body in its materiality.

The reign of the 'painterly real'

In the second half of the first decade of the 2000s, both Kareyan and Avetisyan returned to painting. Both artists grappled with the medium in what could be called a post-medium condition, mediated through digital technologies on the one hand and informed by the postmodern reign of the simulacrum on the other. Kareyan's project 'New Locality', which he started in 2009 and which terminated with the artist's sudden death in 2011, foregrounded the relational triad between nature, technology and the human in a series of large hexagon-shaped canvases (Plates 7 and 8). Comprising mostly bright and colourful images of various industrial products, plants and abstract patterns, they conveyed a childlike naivety that bridged Chinese landscape painting, wallpaper design and pop aesthetics. The fluorescent lighting built into the edges of the canvas and emanating from them, and the text that framed the canvas on diagonal axes, revealed the fact that the artist conceived of the series as an installation. These paintings were based on various found images on the Internet and were the result of various medium transformations – printed out, manipulated, painted and finally re-uploaded to the web as digital repro-ductions. The fact that Kareyan himself conceived of the online documenta-tion of the paintings as part of the project itself is evident in the statement he published on his website documenting 'New Locality':

> In canvases presented in the 'New Locality' project recycling of material has also important significance. Migration of images from the Internet to the per-sonal computer, and from there to the canvases at the studio and back again to the Internet, reiterate [sic] the significance of flexible relocation and wasteless productivity of [sic] contemporary society.[44]

Here, the fluidity of the media transformations and changes of context which these images undergo represents the utopian possibility of a wasteless society in the age of the collapse of political projects of emancipation. And it is paint-ing that has provided a resolution for the tension between nature and culture, human and technology. However, what was gone from these paintings of the second half of the 2000s were the irreconcilable binaries that had informed Kareyan's work of the late 1990s and early 2000s. The several dozen paintings that made up the series, often presented in the form of an installation, with their pleasant decorativeness and deliberate incompleteness, could be taken as

well-designed additions to a bourgeois household, no longer meant to attack and offend but to console and comfort. And it is no coincidence that Kareyan became one of the better selling artists in the still shaky art market in Armenia during this period. Gone were the formal, conceptual and material tensions, and gone were the viscera that had characterized his work of the late 1990s and early 2000s. The painterly surface was now what provided a comfortable semblance of reconciliation and of the synergetic coexistence of binary oppositions. While the belief persisted in art as an ideal, one that provided an alternative to the social world, this ideal was now devoid of its self-negation – the universal horror that lies beneath representation. Here the reign of ideality was devoid of its constitutive other: reality. While Kareyan, in his interviews and verbal statements, continued to explain the paintings of 'New Locality' using the same terms as for his earlier installations, the paintings themselves became too comfortably aligned with new bourgeois values of a post-ideological conciliation between nature and culture – of nature with the material conditions of late capitalist production and the resultant cultural logic. On the ruins of earlier utopian hopes for a confluence of aesthetics and the state, art and ideology, lay an artistically rendered post-utopian landscape of nature and civilization where contradictions were resolved in the painterly act.

Similar to Kareyan's, Narek Avetisyan's work in the latter part of the 2000s moved away from the tension between bodily dematerialization and embodied gesture, virtual technologies and painting that had characterized his Venice Biennale installation of 1999 and the series *Spaces of Light and Trace* in the early 2000s. He continued working with fractals, but this time the digital prints were simply reference points for paintings that reproduced the visual aspect of the fractals through painterly means alone. In these large paintings the gesture of applying the brushstroke is made visible (Plate 6). His 2008–14 series titled *Interfraktals* was presented in the Kunstmuseum Maritzburg, Germany, in 2014, in an exhibition that juxtaposed Avetisyan's work with that of his father, Minas. As mentioned previously, Minas was one of the exemplary figures of what Azatyan termed National Modernism in the late 1960s and 1970s. Here, an unambiguous painterly lineage was drawn between Minas's modernist paintings and Narek's post-medium fractals. These later fractals, in acrylic on canvas, were no longer based on digital prints. While still informed by the structure of computer-generated fractals, in these large paintings the visibly accentuated brushstrokes bring the canvases close to Arshile Gorky's surrealist abstraction, which had inspired Minas in the mid-1960s. What Minas's and Narek's paintings share, separated by approximately half a century, is the use of the predominantly primary colours that had come to stand for an authentic national style. Significantly, the catalogue of the exhibition is titled *Minas und Narek Avetisyan: Moderne und Avant-garde in Armenien* (Plate 9).

Avetisyan's practice in the 2000s is here conceptualized as the avant-garde of modernism. In a post-medium condition where his 'pure', non-digitally-derived *Interfraktals* draw their sources not only from the tradition of (modernist) painting itself, but also from the national artistic tradition, Avetisyan's work of the 2000s fitted the formulation that Karoyan devised in the late 1980s – the national postmodern avant-garde. As discussed in Chapter 2, this meant a *hamasteghtsakan* amalgamation of disparate styles and images that is avant-garde in spirit, national in its historical determination and postmodern in its cultural aspirations. The *Interfraktals* are not the only series that confirm this interpretation. Between 2006 and 2010 Avetisyan worked on a series called *33 Transformations after Vermeer*. He subjects the seventeenth-century Dutch master's painting *Girl with a Pearl Earring* (1665) to 33 transformations in different painterly styles: from Ingres's Neoclassicism, Seurat's pointillist technique, Cezanne's Post-impressionism and Gerhard Richter's blurry 'photo-paintings', to the styles of the Armenian painters Saryan, Kotchar and Minas, among others. In Avetisyan's series, the *hamasteghtsakan* gesture of the 1980s 3rd Floor movement, of compiling incoherent styles, comes full circle, but without the cultural aspirations of the late Soviet artists' movement, or their formally oppositional stance vis-à-vis the official discourses.

With the reign of the 'painterly real' in the second half of the 2000s, as exemplified in Kareyan's and Avetisyan's work after 2005 – that is, with the hegemony of painting (which more often than not can be identified as Armenian painting) in the national cultural discourse and contemporary art alike – the contradiction between art and the social world, ideal and real, politics and aesthetics is reconciled. Here art provides a comfortable semblance of the existing world that fits the ideology of the new bourgeoisie, constituted both on the basis of and in opposition to the late Soviet cultured *nomenklatura* and the bureaucrat-intelligentsia. This newly consolidated class in Armenia in the 2000s – the result of the social shifts introduced at the beginning of this chapter – is not so much defined by acculturation and enlightenment as by a newly found national morality. What we have here is the reactivation of the elements of pre-Revolutionary capitalism and feudalism in the new market conditions. On the debris of the large projects of modernity – both in the East and in the West – and the processes of their disintegration, the world appears to the new bourgeoisie in Armenia as topsy-turvy: it is both a dreamworld and a threat. National morality here functions as a shield from this ambiguously perceived world. While this morality relies on petite-bourgeois values of ostentatious consumption, its self-justification is grounded in ethnic exclusivity, in the perceived privilege of being an Armenian. In this context, the National Modernism of the 1960s and 1970s and its contemporary reverberations or readaptations service that morality. As Azatyan states:

This cultural paradigm of Soviet Armenia [National Modernism] in the 1960s has today become the official ideology of cultural politics in Armenia. If Igityan's museum [the Modern Art Museum] institutionalized national modernism at the level of an art institution, today it is institutionalized at the level of the state [...] Thus, Igityan's museum can be considered as a cultural miniature of today's Armenia, a country that overtly presents itself as an 'open-air museum'. In this regard, one of Marx's formulations is well worth para-phrasing: now we have not only the caricature of the old museum but the old museum itself, caricatured at the state level to suit the twenty-first century.[45]

If throughout the late 1980s and up until the early 2000s, aesthetic concerns – in various articulations – were ways to open up art towards the social world with all the contradictions that this opening entailed, in post-2005 Armenia the aesthetic and the political had become binaries. Those who take up paint-ing leave the social world behind, and those who voice social and political concerns through art-activism abandon aesthetics. In the former case the political and the social are sublated in painting, and in the latter case art dis-solves into other social activities, and is often abandoned altogether.

Post-scriptum

This book has been an attempt to intervene in and challenge the binary established between aesthetics and politics, art and the social sphere, through an account of the historical constitution of contemporary art in Armenia – which turned this binary into an active contradiction. The central argument of this work is that the specific historical situatedness of the Armenian avant-garde in relation to official politics and national culture, for all its claims to resistance and subversion, constructs an often ambiguous, contradictory and almost always uneasy relationship between the margins and the centre, the politics of resistance, of negation and of affirmation. If contemporary art in Armenia is to survive both institutionally and in terms of keeping the above contradiction active in search of new avenues to relate the aesthetic and the social spheres, it needs to revisit its own foundations – both aesthetically and historically – and it specifically needs to revisit its position vis-à-vis the state and its ideology of national culture. As opposed to post-factums and post-scriptums where art appears as commentary in relation to what it once was, contemporary art in Armenia needs to critically re-engage with facts and scripts, within its own aesthetic field as well as the material world that con-stantly reconstitutes this field. A close study of the context of contemporary art in Armenia, this book also challenges the flattening of the world brought about by the global contemporary – understood as a structure, an aesthetics and a discourse at the same time, and which characterizes art today in an

institutional sense. As the constant flow of capital spatializes itself ceaselessly at the expense of historical temporality, it is important to remember that 'contemporary art' and 'contemporaneity' in general – with its technologies, discourses, structures and means – is invested with hopes and aspirations, historically constituted.

Notes

1 Louis Althusser, 'Contradiction and Overdetermination', in *For Marx* (New York: Verso, 2005), pp. 87–128.

2 This was an official slogan that emerged in the early 2000s and encapsulated official politics vis-à-vis the diaspora. Politically, it served the ruling party to rally support from diaspora populations, economically it aimed to attract investment from Armenians living abroad, and culturally it reinforced an ideology of national unity based on ethnic belonging.

3 Azatyan, 'National Modernism'.

4 This is not to say that the ACCEA has abandoned its politics of national representation.

5 Grigor Khachatryan's private correspondence with me.

6 I remember as a child watching TV with my family when this intense and out-of-the-ordinary action took place before our eyes. Years later, I mistakenly remembered seeing the nationalist politician Paruyr Hayrikyan executing the coup; see Angela Harutyunyan, 'The Real and/as Representation: TV, Video and Contemporary Art in Armenia', *ARTMargins* 1.1 (2012), pp. 88–109.

7 Vahram Martirosyan discusses the ambivalent reception of television in Soviet Armenia both as an abstract source of trustworthy information (in the Soviet Union during the 1970s and 1980s, the popular saying 'it was said on TV' served as an unquestionable affirmation of truth) and as an inversion of reality. Vahram Martirosyan, 'Dangers and Delights of Armenian TV Surfing', in A. Harutyunyan, K. Horschelmann and M. Miles (eds), *Public Spheres after Socialism* (Bristol: Intellect Books, 2009), pp. 119–26.

8 Archie Brown, 'Gorbachev, Lenin, and the Break with Leninism', *Demokratizatsiya* 15.2 (2007), pp. 230–44.

9 An anecdote relates that Boris Yeltsin himself, the soon-to-be successor of Gorbachev, was most impressed during his visit to the USA not because of NASA and military technology, but when he saw a US supermarket on a trip to Houston in 1989. Leon Aaron, *Boris Yeltsin: A Revolutionary Life* (New York: St. Martin's Press, 2000). Photographs preserved in Houston archives show a mesmerized Yeltsin walking through the aisles of Clear Lake Grocery. Craig Hlavaty, 'When Boris Yeltsin went Grocery Shopping in Clear Lake', *Chron*, 7 April 2014, http://blog.chron.com/thetexican/2014/04/when-boris-yeltsin-went-grocery-shopping-in-clear-lake/#22200101=0 (last accessed 30 August 2014).

10 Hrach Bayadyan, 'New Social Order and Change in Media Landscape', in Harutyunyan et al. (eds), *Public Spheres after Socialism*, pp. 111–17.

11 Bayadyan, 'New Social Order and Change in Media Landscape'.

12 Cultural and media theorist Hrach Bayadyan locates the emergence of consumer culture in Armenia in the early 2000s, when advertising was no longer a tool to sell products, but turned the consumer into the one being consumed, and thus acquired a power of subjectivization. In this, social communication acquired elements of commercial advertising. Hrach Bayadyan, 'Herustatesutyuny yndardzak hamateqstum' [Television in an expanded context], *Hetq.am* 1–3 (10 May, 17 May, 24 May), https://hetq.am/arm/news/31558/herustatesutyuny-yndardzak-hamate qstum3.html/ (last accessed 18 January 2015).

13 Azatyan, 'On Video in Armenia'.

14 A 1992 decree issued by Minister of Culture Hakob Movses assigned a penalty for showing erotic and pornographic films in cinemas under the ministry's jurisdiction. 80-18-2. 10.09.1992, Decree no. 311. I recall the awkward moments I shared with my grandparents when sex scenes from films aired on television in the middle of the day.

15 With reference to Georges Bataille's 1957 *L'Érotisme* and its English title, *Eroticism: Death and Sensuality*, trans. M. Dalwood (San Francisco: City Lights, 1962).

16 As I argue in 'Theorizing the Politics of Representation in Contemporary Art in Armenia', in his curatorial practice Kareyan never abandoned his artistic ambitions. He conceptualized the exhibition as an occasion to interpret his own work as an artist, and chose other works by other artists to illustrate that the meaning he implied or intended to produce was justified. In this case, the artist-curator's role is diagnostic: the curator diagnoses the syndromes of the diseased society in crisis and attempts to find a solution through his own work and that of others. Sonia Balassanian also shares this mode of curating with Kareyan. In many ways, she arguably brought in this model as early as 1993, when she organized the exhibitions *9* and *Identification*. In both, and in subsequent exhibitions, Balassanian the curator centrally positions the work of Balassanian the artist and structures the exhibition around her own artistic practice.

17 David Kareyan, exhibition booklet, *Are There Visible Things Impossible to Show?* (Yerevan: ACCEA, 2003). The text has been slightly modified to conform to the standards of English grammar and style.

18 Vardan Azatyan, 'Art, Body and Society', in Kareyan, *Are There Visible Things Impossible to Show?*.

19 *Crisis*, exhibition booklet (Yerevan: ACCEA, 1999).

20 David Kareyan, 49th Venice Biennale Catalogue, Armenian Pavilion (Yerevan: ACCEA, 2003).

21 The title is taken from a newspaper article that appeared in 1999 dealing with the issue of prostitution, not from a moral but from a legal perspective. A fragment of the article, 'Petit-Bourgeois Commotion: A Feast of Shame', appeared as a background of the documentation of Sevada Petrosyan's work in the booklet accompanying the exhibition *Crisis* of 1999.

22 Lifshitz, *Iskusstvo i Kommunisticheskiy Ideal*.

23 Video documentation. Diana Hakobyan's archive. *David Kareyan. Exhibitions, Interviews 1994–2009*, http://www.youtube.com/watch?v=_XI_Gjok2f4 (last accessed 18 January 2015).

24 At the ecclesial Council of Chalcedon in AD 451, the Armenian Church officially adapted monophysitism as a doctrine. This doctrine rejected Christ's dual nature as both human and divine in which the first was overcome by the second, as the Roman Catholic Church upheld. The monophysites believed that Christ's human and divine natures were perfect and united.

25 Sigmund Freud, *Totem and Taboo: Some Points of Agreement between Mental Lives of Savages and Neurotics.* (London: Routledge, 1950), p. 21.

26 Freud, *Totem and Taboo*, p. 22.

27 Marcia E. Verdocq, 'The Venice Biennale Reformed, Renewed, Redeemed', *Art in America* 87.9 (September 1999).

28 Narek Avetisyan, interview, 18 October 2007.

29 Edward Balassanian, Commissioner's Statement, *Catalogue of the Armenian Pavilion at the Venice Biennale* (Yerevan: ACCEA, 1999).

30 Balassanian, Commissioner's Statement.

31 Narek Avetisyan, Artist's Statement, *Catalogue of the Armenian Pavilion at the Venice Biennale* (Yerevan: ACCEA, 1999).

32 Hrach Bayadyan, *Mshakuyt ev Texnologia* [Culture and technology] (Yerevan: Yerevan State University Press, 2003), p. 27.

33 Z. Zolghadr, C. Bydler and M. Kehrer (eds), *Ethnic Marketing* (Zurich: Ringier, 2007).

34 Bayadyan, *Mshakuyt ev Texnologia*, p. 111.

35 Narek Avetisyan, 'VR Manifesto', unpublished, 2000 (in Armenian).

36 Avetisyan, 'VR Manifesto'.

37 Avetisyan, 'VR Manifesto'.

38 'The Manifesto of Dimensionists', *In Vitro* 4 (1999), pp. 16–17.

39 Vardan Azatyan, 'Spaces of Light and Trace', exhibition booklet (Yerevan: ACCEA, 2006).

40 Avatyan, 'Spaces of Light and Trace'.

41 Avatyan, 'Spaces of Light and Trace'.

42 Narek Avetisyan, interview, 18 October 2007.

43 Narek Avetisyan, interview, 18 October 2007.

44 http://www.davidkareyan.com/full_statement.html (last accessed 6 July 2015).

45 Azatyan, 'National Modernism', p. 121.

Select bibliography

Aaron, L., *Boris Yeltsin: A Revolutionary Life* (New York: Thomas Dunne Books/St. Martin's Press, 2000).

Adorno, T., *Aesthetic Theory*, trans. and ed. R. Hulot-Kentor (Minneapolis: University of Minnesota Press, 1997).

—— W. Benjamin, E. Bloch, B. Brecht and G. Lukács, *Aesthetics and Politics* (London: Verso, 1977).

Agamben, G., *Homo Sacer: Sovereign Power and Bare Life* (Stanford, CA: Stanford University Press, 1995).

—— *Infancy and History: On the Destruction of Experience* (London: Verso, 1994).

—— *What is an Apparatus?* (Redwood City, CA: Stanford University Press, 2009).

Alberro, A., 'Periodizing Contemporary Art', http://globalartmuseum.de/site/guest_author/306 (last accessed 13 January 2015).

Althusser, L., 'Contradiction and Overdetermination', in *For Marx* (London: Verso, 2005), pp. 87–128.

—— *Essays on Ideology* (London: Verso, 1984).

Andreeva, E., *Sots Art, Soviet Artists of the 1970s and 1980s* (Roseville East, CA: Craftsman House, 1995).

Arevshatyan, R., 'Between Illusions and Reality', in H. Saxenhuber and G. Schöllhammer (eds), *Adieu Parajanov: Contemporary Art from Armenia* (Vienna: Springerin, 2003).

Arthur, C. J., *Lukács, Dialectics of Labour: Marx and his Relation to Hegel* (Oxford: Basil Blackwell, 1986).

Azatyan, V., 'Art, Body and Society', in David Kareyan, *Are There Visible Things Impossible to Show?* (Yerevan: ACCEA, 2003).

—— 'Art Communities, Public Spaces, and Collective Actions in Armenian Contemporary Art', in M. Jordan and M. Miles (eds), *Art and Theory after Socialism* (Bristol: Intellect Books, 2008).

—— 'Disintegrating Progress: Bolshevism, National Modernism and the Emergence of Contemporary Art in Armenia', *ARTMargins* 1.1 (2012), 62–87.

—— 'Hishoghutyun ev/kam moratsum' [Memory and/or forgetting], *Aktual Arvest* 6 (2008), pp. 50–66.

—— 'National Modernism', in R. Arevshatyan and G. Schöllhammer (eds), *Sweet Sixties: Specters and Spirits of a Parallel Avant-Garde* (Berlin: Sternberg Press, 2014), pp. 107–21.

—— 'On Video in Armenia: Avant-garde and/in Urban Conditions', www.video-as. org/project/video_yerevan.html (last accessed 13 October 2016).

—— 'Verbal Stories and History Survey Texts: The Case of Armenian Contemporary Art', paper presented at the conference 'Public Sphere: Between Contestation and Reconciliation', at NAAC, Yerevan, October, 2005.

—— (ed.), *3rd Hark. Yntrani* [3rd Floor. A selection], forthcoming.

Bacon, M., *Richard Rorty: Pragmatism and Political Liberalism* (Lanham, MD: Lexington Books, 2008).

Badiou, A., 'The Communist Hypothesis', *New Left Review* 49 (January–February 2008), newleftreview.org/II/49/alain-badiou-the-communist-hypothesis (last accessed 19 October 2014).

—— *Metapolitics* (London: Verso, 2005).

Bakos, J., 'Strategy of Socialist Realism: A Comment', *Ars* 2.3 (1993), 179–83.

Bal, M., 'Anachronism for the Sake of History: The Performative Look', keynote lecture delivered at the AAH 40th Anniversary Conference, RCA, London, 2014.

Barseghian, A., and S. Christiensen (eds), *Pour une critique de la survie* (Geneva: Metiss Press, 2005).

Bataille, G., *Eroticism: Death and Sensuality*, trans. M. Dalwood (San Francisco: City Lights, 1962).

—— *Visions of Excess, Selected Writings (1927–1939)* (Minneapolis: University of Minnesota Press, 1985).

Bayadyan, H., *Mshakuyt ev Texnologia* [Culture and technology] (Yerevan: Yerevan State University Press, 2003).

—— 'New Social Order and Change in Media Landscape', in A. Harutyunyan, K. Horschelmann and M. Miles (eds), *Public Spheres after Socialism* (Bristol: Intellect, 2009).

Bayer, A., 'Vodka: Part II: Sobering up the USSR', *The Globalist*, 2 August 2014, www.the-globalist.com/vodka-part-ii-sobering-up-the-ussr/ (last accessed 19 January 2015).

Benjamin, W., *Illuminations* (New York: Schocken Books, 1969).

Berlin, I., *Liberty: Incorporating Four Concepts of Liberty* (Oxford: Oxford University Press, 2002).

Bjelic, D., and O. Savic, *Balkan as Metaphor: Between Globalization and Fragmentation* (Cambridge, MA: MIT Press, 2003).

Boyajiev, L., 'Disfunctional'nost', *Khudozhestvennyi Journal* [*Moscow Art Magazine*], 61–62 (May 2006), xz.gif.ru/numbers/61-62/disfunktsionalnost/ (last accessed 15 February 2015).

Boym, S., *The Future of Nostalgia* (New York: Basic Books, 2002).

Brown, A., 'Gorbachev, Lenin, and the Break with Leninism', *Demokratizatsiya* 15.2 (2007), 230–44.

Buck-Morss, S., 'Aesthetics and Anaesthetics: Walter Benjamin's Artwork Essay Reconsidered', *October* 62 (Autumn 1992), 3–41.

—— *Dreamwold and Catastrophe: The Passing of Mass Utopia in East and West* (Cambridge, MA: MIT Press, 2000).

Buden, B., 'The Madman is Sleeping with the Lunatic: The Exhibition »Blut & Honig. Zukunft ist am Balkan« (»Blood & Honey. Futures in the Balkans«) at the Essl Collection in Klosterneuburg', *Springerin* 2.3 (2003).

Budgen, S., S. Kouvelakis and S. Žižek (eds), *Lenin Reloaded: Toward a Politics of Truth* (Durham, NC: Duke University Press, 2007).

Bürger, P., *Theory of the Avant-Garde* (Manchester: Manchester University Press, 1984).

Carneci, M., and C. Vlasie, *Art of the 1980s in Eastern Europe. Texts on Postmodernism* (Romania: Litera, 1999).

Chalikova, I. (ed.), *Utopia i utopicheskoe myshlenie* [Utopia and utopian thought] (Moscow: Progress, 1991).

Chukhrov, C., 'Deideologizatsia Sovetskogo', *Khudozhestvennyi Journal* [*Moscow Art Magazine*] 65–66 (July 2007), special issue 'Progressivnaya Nostalgia', http://xz.gif. ru/numbers/65-66/ (last accessed 13 October 2016).

Clark, K., *The Soviet Novel: History as Ritual* (Bloomington, IN: Indiana University Press, 2000).

Crimp, D., 'Coming Together to Stay Apart: Ronald Tavel's Screenplays for Andy Warhol's Film', lecture at the University of Manchester, 18 April 2007.

Cufer, E., and V. Misiano, *Interpol: The Art Exhibition Which Divided East and West* (Ljubljana: IRWIN; Moscow: Moscow Art Magazine, 2000).

Cvoro, U., 'The Absent Body, the Present Body and the Formless', *Art Journal* 61.4 (2002), 54–63.

Danto, A., *The Body/Body Problem* (Berkeley, CA: University of California Press, 1999).

Dean, C., 'Law and Sacrifice: Bataille, Lacan and the Critique of the Subject', *Representations* 13 (Winter 1986), 42–62.

Degot, E., 'How to Obtain the Right to Post-Colonial Discourse', *Khudozhestvennyi Journal* [*Moscow Art Magazine*], digest (1995–2003), http://xz.gif.ru/numbers/ moscow-art-magazine/.

Desai, P., *Perestroika in Perspective: The Design and Dilemmas of the Soviet Reform* (Princeton, NJ: Princeton University Press, 1989).

Djuric, D., and M. Šuvaković (eds), *Impossible Histories: Historic Avant-gardes, Neo-avant-gardes and Post-avant-gardes in Yugoslavia, 1918–1991* (Cambridge, MA: MIT Press, 2006).

Eagleton, T., *The Ideology of the Aesthetic* (London: Basil Blackwell, 1990).

Erjavec, A. (ed.), *Postmodernism and the Postsocialist Condition: Politicized Art under Late Socialism* (Berkeley, CA: University of California Press, 2003).

Erofeev, A. *Non-Official Art, Soviet Artists of the 1960s* (Roseville East, CA: Craftsman House, 1995).

Esanu, O., *Transition in Post-Soviet Art: Collective Actions before and after 1989* (Budapest: Central European University Press, 2013).

—— 'What Was Contemporary Art?', *ARTMargins* 1.1 (2012), 5–28.

Etlin, R. A. 'Competing Interests: Cautionary Notes on the Notion of Totalitarian Art', *Ars (Bratislava)* 2.3 (1993), 147–54.

Eyers, T., *Lacan and the Concept of the "Real"* (Basingstoke: Palgrave Macmillan, 2012).

Feathersome, M., M. Hepworth and B. Turner, *The Body: Social Processes and Cultural Theory* (Thousand Oaks, CA: SAGE Publications, 1995).

Feher, M., 'Of Bodies and Technologies', in H. Foster (ed.), *Discussions in Contemporary Culture* (Seattle, WA: Bay Press, 1987).

Foster, H., *Compulsive Beauty* (Cambridge, MA: MIT Press, 1993).

—— *The Return of the Real: Art and Theory at the End of the Century* (Cambridge, MA: MIT Press, 1996).

Fowkes, M., and R. Fowkes, 'From Biopolitics to Necropolitics: Marina Gržinić in Conversation with Maja and Reuben Fowkes', *ARTMargins online* (October 2012), http://www.artmargins.com/index.php/5-interviews/692-from-biopolitics-to-necropolitics-marina-grini-in-conversation-with-maja-and-reuben-fowkes (last accessed 31 January 2015).

Freud, S., *Totem and Taboo: Some Points of Agreement between Mental Lives of Savages and Neurotics* (London: Routledge, 1950).

Gaonkar, D. P. (ed.), *Alternative Modernities* (Durham, NC: Duke University Press, 2001).

Golden, T., 'For Collector of Russian Art, the End of a Dream; A Murky Trail behind Rediscovered Works by Malevich', *New York Times*, 31 March 2003, www.nytimes.com/2003/03/31/arts/for-collector-russian-art-end-dream-murky-trail-behind-re discovered-works.html?pagewanted=all&src=pm (last accessed 29 December 2013).

Gray, C., *The Great Experiment: Russian Art 1863–1922* (New York: Abrams, 1962).

Grigoryan, A., '3rd Hark: Irenk irenc masin' [3rd Floor: them about themselves], *Mshakuyt* 2–3 (1989), pp. 54–7.

—— 'DEM sharjman metsaguyn hrajarumy' [The Great Refusal of the movement *DEM*], *Garun* 5 (1994), pp. 90–4.

—— 'Eritasardutyan Anunits' [In the name of youth], excerpt from a speech delivered at the Congress of the Artists' Union in 1987, *Garun* 12 (1988), 23–5.

—— 'Hayastany Venetiki 55-rd Bienalein. Miacnel azgayiny, hogevory ev moderny' [Armenia in the 55th Venice Biennale: to unite the modern, the spiritual and the national], *Epress*, 12 June 2013.

—— 'Inch e hamasteghtsakan arvesty?' [What is *hamasteghtsakan* art?], *Garun* 1 (1994), pp. 63–5.

—— 'Informed but Scared: The "Third Floor" Movement, Parajanov, Beuys and Other Institutions', in H. Saxenhuber and G. Schöllhammer (eds), *Adieu Parajanov: Contemporary Art from Armenia* (Vienna: Springerin, 2003).

—— 'Nor hayatsq: Irakanutyun ev arvest' [New vision: reality and art], in *Hayastani jamanakakic arvest, 1980–1995* [Contemporary art of Armenia, 1980–1995] (Moscow: Moscow Central House of Artists, 1995), pp. 5–12.

—— 'Texti arvestn ibrev nor abstractionism' [Text art as a new abstractionism] *Garun* 6 (June 1998), 95–6.

Groys, B., *Art Power* (Cambridge, MA: MIT Press, 2008).

—— 'Back from the Future', *Third Text* 17.4 (2003), 323–31.

—— 'Capital, Isskustvo, Spravedlivost' [Capital, art and justice], *Khudozhestvennyi Journal* [*Moscow Art Magazine*] 60 (December 2005), http://xz.gif.ru/numbers/60/kapital-iskusstvo-spravedlivost/ (last accessed 10 November 2014).

—— 'Comrades of Time', *e-flux* 11 (December 2009), www.e-flux.com/journal/com rades-of-time/ (last accessed 13 January 2015).

—— 'Globalizatsiya i teologizatsiya politiki' [Globalization and the teleolization of politics], *Khudozhestvennyi Journal* [*Moscow Art Magazine*] 4 (2004), http://xz.gif.ru/.

—— 'Logika ravnopraviya' [The logic of equal rights], *Khudozhestvennyi Journal* [*Moscow Art Magazine*] 58–59 (September 2005), http://xz.gif.ru/numbers/58-59/logika-ravnopraviya/.

—— 'Moscow Romantic Conceptualism', *A-YA* 1 (1979); reprinted in L. Hopman and T. Pospiszil (eds), *Primary Documents: A Sourcebook for Eastern and Central European Art since the 1950s* (New York: Museum of Modern Art; Cambridge, MA: MIT Press, 2002), pp. 162–73.

—— 'O sovremennom polojenii khudojestvennogo kommentatora' [On the contemporary condition of the artistic commentator], *Khudozhestvennyi Journal* [*Moscow Art Magazine*] 41 (2001), http://xz.gif.ru/numbers/41/.

—— 'A Style and a Half', in T. Lahusen and E. A. Dobrenko (eds), *Socialist Realism Without Shores* (Durham, NC: Duke University Press, 1997).

—— *The Total Art of Stalinism: Avant-garde, Aesthetic Dictatorship and Beyond* (Princeton, NJ: Princeton University Press, 1992).

—— *Zeitgenossische Kunst aus Moskau: von der Neo-Avandarge zum Post-Stalinizmus* (Munich: Klinghardt und Bierman, 1991).

Groys, B., and M. Hollein, *Dream Factory Communism* (Frankfurt: Hatje Cantz Publishers, 2003).

Gržinić, M., *Situated Contemporary Art Practices: Art, Theory and Activism from (the East of) Europe* (Frankfurt am Main and Ljubljana: Revolver and ZRC, 2004).

Gržinić, M., and G. Heeg (eds), *Mind the Map! History Is Not Given: A Critical Anthology Based on the Symposium* (New York: Revolver, 2006).

Habermas, J., *The Structural Transformation of the Public Sphere: An Inquiry into a Category of Bourgeois Society* (Cambridge, MA: MIT Press, 1991).

Hansen, M., *New Philosophy for New Media* (Cambridge, MA: MIT Press, 2004).

Harutyunyan, A., '"ACT", Document. Translation and Introduction', *ARTMargins* 2.1 (2013), 120–36.

—— 'Document: Armenakyan, "Post-Art Situation: Logical Syntax"', *ARTMargins* 2.1 (2013), 133.

—— 'Espaces de l'art contemporain arménien et utopies expansionistes', in N. Karoyan and D. Abensour (eds), *D'Arménie* (Quimper: Le Quartier, 2008).

—— 'Maqur estetikayi u maqur qaghakakanutyan areresumy. David Kareyani maqur steghtsagortsutyan gortsoghutyuny' [The encounter of pure aesthetics and pure politics: the operation of 'pure creation' in David Kareyan's work], in Vardan Azatyan (ed.), *Veradarnalov Hanrayin Volort* [*Returning to the public sphere*] (Yerevan: Utopiana, 2014).

—— 'On the Ruins of a Utopia: Armenian Avant-Garde and the Group Act', in M. Jordan and M. Miles (eds), *Art and Theory after Socialism* (Bristol: Intellect Books, 2009).

—— 'The Real and/as Representation: TV, Video and Contemporary Art in Armenia', *ARTMargins* 1.1 (2012), 88–109.

—— 'Redefining the Public Sphere through Artistic Practice in Armenia', in Stefan Rusu (ed.), *Artă, cercetare în sfera publică / Researches in the Public Sphere* (Chisinau: KSAK, 2011), pp. 388–96. [bilingual edition]

——'Rethinking the Public Sphere: The Constitutional State and the ACT Group's Political Aesthetics of Affirmation in Armenia', *Art and the Public Sphere* 1.2 (2013), pp. 159–73.

——'State Icons and Narratives in the Symbolic Cityscape of Yerevan', in A. Harutyunyan, K. Horschelmann and M. Miles (eds), *Public Spheres after Socialism* (Bristol: Intellect Books, 2008).

——'Veramtatselov hanrayin volorty: Sahmanadrakan petutyunn u ACT xmxi qaghaqakan estetikan' [Rethinking the public sphere: the constitutional state and the ACT group's political aesthetics of affirmation in Armenia], in V. Azatyan (ed.), *Public Sphere: Between Contestation and Reconciliation* (Yerevan: Ankyunakar, 2007).

Harutyunyan, A., and E. Goodfield, 'Theorizing the Politics of Representation in Contemporary Art in Armenia', in M. Miles and M. Degen (eds), *Culture & Agency: Contemporary Culture and Urban Change* (Plymouth: University of Plymouth Press, 2010).

Harutyunyan, A., et al., 'Timeline of Socialist and Post-Socialist Body Art: Interstices of History', in A. Jones and A. Heartfield (eds), *Perform, Repeat, Record: A Critical Anthology of Live Art in History* (London: Routledge, 2011), pp. 159–73.

Hegel, G. W. F., *Phenomenology of Spirit*, trans. A. V. Miller (Oxford: Oxford University Press, 1977).

—— *The Philosophy of History* (Amherst, NY: Prometheus Books, 1991).

Heidegger, M., *Being and Time* (Albany, NY: State University of New York Press, 1996).

—— *The Question Concerning Technology and Other Essays* (New York: Harper Row, 1977).

Heiser, J., 'Moscow, Romantic, Conceptualism and After', *e-flux* 29 (November 2011), www.e-flux.com/journal/moscow-romantic-conceptualism-and-after/ (last accessed 3 March 2015).

Henri, A., *Matter and Memory*, trans. N. M. Paul and W. S. Palmer (New York: Zone Books, 1988).

Hlavaty, C., 'When Boris Yeltzin went Grocery Shopping in Clear Lake', *Chron*, 7 April 2014, http://blog.chron.com/thetexican/2014/04/when-boris-yeltsin-went-grocery-shopping-in-clear-lake/#22200101=0, (last accessed 30 August 2014).

Hodges, N., *New Art from Eastern Europe: Identity and Conflict* (London: Academy Editions, 1994).

Hoffman, E., *Exit into History: A Journey through the New Eastern Europe* (London: Heinemann, 1994).

Holly, M. A. 'Past Looking', *Critical Inquiry* 16.2 (1999), 371–96.

Hopman, L., and T. Pospiszil (eds), *Primary Documents: A Sourcebook for Eastern and Central European Art since the 1950s* (New York: Museum of Modern Art; Cambridge, MA: MIT Press, 2002).

Hovalev, A., *Between the Utopias, New Russian Art during and after the Perestroika (1983–1995)* (Roseville East, CA: Craftsman House, 1995).

Huyssen, A., *After the Great Divide: Modernism, Mass Culture, Postmodernism* (Bloomington, IN: Indiana University Press, 1986).

Ilyenkov, E., 'The Concept of the Ideal', *Historical Materialism* 20.2 (2012), pp. 149–93; reprinted in A. Levant and V. Oittnen (eds), *Dialectics of the Ideal: Evald Ilyenkov and Creative Soviet Marxism* (Leiden: Brill, 2014).

IRWIN (ed.), *East Art Map: Contemporary Art and Eastern Europe* (London: Afterall Books, 2006).

Jameson, F., *Marxism and Form* (Princeton, NJ: Princeton University Press, 1971).

—— *Postmodernism, Or The Cultural Logic of Late Capitalism* (Durham, NC: Duke University Press, 1991).

—— *A Singular Modernity: Essay on the Ontology of the Present* (London: Verso, 2013).

Johnston, S., *The Everyday* (*Documents of Contemporary Art*) (Cambridge, MA: MIT Press, 2008).

Jones, A., *Body Art/Performing the Subject* (Minneapolis: University of Minnesota Press, 1998).

—— 'Dis/Playing the Phallus: Male Artists Perform their Masculinities', *Art History* 17.4 (1994), 546–84.

—— '"Presence" in Absentia: Experiencing Performance as Documentation', *Art Journal* 56.4 (1997), 11–18.

—— *Self/Image: Technology, Representation and the Contemporary Subject* (London: Routledge, 2006).

Kalfus, K., *The Commissariat of Enlightenment* (New York: Harper Collins Publishers, 2003).

Kareyan, D., 'Maqur Steghtsagortsutyun' ['Pure creation'], *Garun* 8 (1994), 59.

—— 'Pure Creativity', trans. A. Harutyunyan, *ARTMargins* 2.1 (2013), 127–8.

—— et al., 'Actayin hosanq', *Ex Voto* 13, *Garun* 6 (1996).

Karoyan, N., 'Abstraktsionismn arants toghadardzi' [Abstractionism without a hyphen], *Ex Voto* 2, *Garun* 3 (1995), 90.

—— 'Ailyntranqayin avanduyti kayatsman bavighnerum' [Within the labyrinths of establishing the alternative tradition], *Ex Voto* 1, *Garun* 2 (1995), pp. 94–6; *Ex Voto* 7, *Garun* 8 (1995), pp. 90–4; and *Ex Voto* 8, *Garun* 9 (1995), pp. 90–5.

—— 'Araspelakan tsnndi jrery' [The waters of a mythological birth], *In Vitro* 1 (1998), pp. 62–5.

—— 'Entre politique et esthétique: Discours et figure dans l'art contemporain d'Arménie des années 1960–1990', in N. Karoyan and D. Abensour (eds), *D'Arménie* (Quimper: Le Quartier, 2008).

—— 'Inch e Hamasteghtsakan arvesty?' [What is *hamasteghtsakan* art?], *Ex Voto*, *Garun* 2 (February 1996), 95–6.

—— 'Metaphors of Transition, or: Contemporary Art in Post-Soviet Armenia', in H. Saxenhuber and G. Schöllhammer (eds), *Adieu Parajanov: Contemporary Art from Armenia* (Vienna: Springerin, 2003).

—— 'Public Space as a Place of Gift', in A. Harutyunyan, M. Miles and K. Horschelmann (eds), *Public Spheres after Socialism* (Bristol: Intellect Books, 2008).

—— 'Amsva tema' [Theme of the month], *Ex Voto* 7, *Garun* 8 (1995), 88–9.

Karoyan, N. and D. Abensour (eds), *D'Arménie* (in Armenian and French) (Quimper: Le Quartier, 2008).

Kemp-Welch, K., *Antipolitics in Central European Art: Reticence as Dissidence under Post-Totalitarian Rule 1956–1989* (London: I.B. Tauris, 2015).

Kenez, P., *A History of the Soviet Union from the Beginning to the End* (Cambridge: Cambridge University Press, 2006).

Khachatryan, E., 'The Issues of Alternative Art in Armenia: Video, Media Art and the "Antifreeze"', in H. Saxenhuber and G. Schöllhammer (eds), *Adieu Parajanov: Contemporary Art from Armenia* (Vienna: Springerin, 2003).

Krauss, R., 'Video: The Aesthetics of Narcissism', *October* 1 (1975), 50–64.

——*A Voyage on the North Sea: Art in the Age of the Post-medium Condition* (London: Thames & Hudson, 2000).

Kuspit, D., *The Cult of the Avant-Garde Artist* (Cambridge: Cambridge University Press, 1993).

Lacan, J., *Book VII: The Ethics of Psychoanalysis*, ed. J. Miller (New York: W. W. Norton, 1997).

——*Ecrits: A Selection* (New York: W. W. Norton, 2002).

Lahusen, T., and E. Dobrenko (eds), *Socialist Realism Without Shores* (Durham, NC: Duke University Press, 1997).

Laing, D., *The Marxist Theory of Art* (Brighton: Harvester, 1978).

Lee, P. M., *Forgetting the Artworld* (Cambridge, MA: MIT Press, 2012).

Lengel, L., *Culture and Technology in the New Europe: Civic Discourse in Transformation in Post-Communist Nations* (New York: Ablex Publishing, 2000).

Lenin, V. I., 'Revolution at the Gate: Žižek on Lenin, The 1917 Writings', in S. Žižek (ed.), *The Essential Žižek* (London: Verso, 2002).

——'Conspectus of Hegel's Book The Science of Logic', *Collected Works*, Vol. 38 (Moscow: Progress Publishers, 4th edn, 1976).

Lifshitz, M., *Iskusstvo i Kommunisticheskiy Ideal: Pamyati Eval'da Il'yenkova* [*Art and the communist ideal: in memory of Evald Il'yenkov*] (Moscow: Iskusstvo, 1984).

Lotringer, S., and C. Marazzi, *Autonomia: Post-Political Politics* (Los Angeles: Semiotext(e), 2007).

Lippard, L., *Six Years: The Dematerialization of the Art Object, 1966–1972* (Oakland, CA: University of California Press, 1997).

Manchev, B., *Anti-Modernism – Radical Revisions of Collective Identity, Vol. 4 (Discourses of Collective Identity in Central and Southeast Europe)* (Budapest: Central European University Press, 2007).

Mannheim, K., 'Idealogia i Utopia' [Ideology and Utopia], in I. Chalikova (ed.), *Utopia i utopicheskoe myshlenie* [Utopia and Utopian thought] (Moscow: Progress, 1991).

Manuel, F., and Fr. Manuel, 'Utopicheskoe Myshlenie v Zapadnom Mire' [Utopian thought in the Western world), in I. Chalikova (ed.), *Utopia i utopicheskoe myshlenie* [Utopia and utopian thought] (Moscow: Progress, 1991).

Marcuse, H., *Art and Liberation: Collected Papers vol. 4* (London: Routledge, 2006).

——*Eros and Civilisation: A Philosophical Inquiry into Freud* (New York: Beacon Press, 1956).

——*One Dimensional Man* (Boston: Beacon Press, 1964).

Martirosyan, V., 'Dangers and Delights of Armenian TV Surfing', in A. Harutyunyan, K. Horschelmann and M. Miles (eds), *Public Spheres after Socialism* (Bristol: Intellect, 2009).

Marx, K., *Economic & Philosophical Manuscripts of 1844* (New York: Evergreen Review, 2008).

—— *Eighteenth Brumaire of Louis Napoleon* (Rockville, MD: Serenity Publishers, 2009).

—— 'Preface to *A Contribution to the Critique of Political Economy*', in *Selected Writings*, ed. L. H. Simon (Indianapolis: Hackett Publishing, 1993).

Merleau-Ponty, M., *Humanism and Terror: The Communist Problem* (Oxford: Polity Press 2000).

—— *Phenomenology of Perception* (London: Routledge, 1962).

—— *The Visible and the Invisible* (Evanston, IL: Northwestern University Press, 1969).

Mészöly, S., and B. Bencsik, *Social Commentary in Contemporary Hungarian Art* (Budapest: SCCA – Budapest, 1993).

Meyer, R., *What Was Contemporary Art?* (Cambridge, MA: MIT Press, 2013).

Miles, M., and M. Jordan, *Art, Theory, Post-Socialism* (Bristol: Intellect Press, 2008).

Mirzoeff, N., *BodySpace* (London: Routledge, 1995).

Misiano, V., 'The Cultural Contradictions of the *Tusovka*', *Khudozhestvennyi Journal* [*Moscow Art Magazine*] 25 (1999), 39–43.

—— 'East is Looking at East, East is Looking at West', *Khudozhestvennyi Journal* [*Moscow Art Magazine*] 22 (2000), http://xz.gif.ru/.

—— 'Sredstvo bez tseley ili kak nel'zya voyti dvazhdy v 1990-ye gody' [Means without ends, or how one cannot enter the 1990s twice], *Khudozhestvennyi Journal* [*Moscow Art Magazine*] 58–59 (September 2005), http://xz.gif.ru/numbers/58-59/sredstvo-bez-tselei/ (last accessed 16 October 2016).

Mitchell, W. J. T., *Iconology: Image, Text, Ideology* (Chicago: University of Chicago Press, 1986).

Mouffe, C., and E. Laclau, *Hegemony and Socialist Strategy* (London: Verso, 1985).

Nagel, A., and C. Wood, *Anachronic Renaissance* (Cambridge, MA: MIT Press, 2010).

Oriskova, M., 'New Grand Narratives in East-Central European Art History?', *Ars (Bratislava)* 1.3 (2002), 234–40.

Osborne, P., *Anywhere Or Not At All: Philosophy of Contemporary Art* (London: Verso, 2013).

Pickett, B. L., 'Foucault and the Politics of Resistance', *Polity* 28.2 (1983), 238–56.

Piotrowski, P., *Art and Democracy in Post-Communist Europe* (London: Reaktion Books, 2012).

—— *In the Shadow of Yalta: Art and the Avant-garde in Eastern Europe, 1945–1989* (London: Reaktion Books, 2011).

—— 'Post-modernism and Post-totalitarism: The Poland Case of the 1970s', *Ars (Bratislava)* 2.3 (1993), 231–42.

Poggioli, R., *The Theory of the Avant-Garde*, trans. G. Fitzgerald (Cambridge, MA: Harvard University Press, 1968).

Rancière, J., *On the Shores of Politics* (London: Verso, 1995).

—— *The Politics of Aesthetics* (London: Continuum, 2004).

Raunig, G., *Art and Revolution: Transversal Activism in the Long Twentieth Century* (Los Angeles: Semiotext(e), 2007).

Roberts, J., *Intangibilities of Form: Skill and Deskilling in Art after the Readymade* (London: Verso, 2007).

Rorty, R., 'Postmodernist Bourgeois Liberalism', in *Objectivity, Relativism and Truth* (Cambridge: Cambridge University Press, 1991).

Scarry, E., *The Body in Pain: The Making and Unmaking of the World* (Oxford: Oxford University Press, 1985).

Schilling, C., *The Body and Social Theory* (London: SAGE Publications, 2003).

Schusterman, R., 'Pragmatism and Liberalism between Dewey and Rorty', *Political Theory* 22.3 (1994), 391–413.

Sewell, W., *Logics of History: Social Theory and Social Transformation* (Chicago: University of Chicago Press, 2005).

Seyranyan, S., 'Qaghaqatsiakan arjeky arvestn e' [Art is a civic value], interview with Arman Grigoryan, *Haykakan Jamanak* 9.29 (1997).

Silverman, K., *Threshold of the Visible World* (London: Routledge, 1996).

Smith, G. (ed.), *Thinking through Benjamin* (Chicago: University of Chicago Press, 1989).

Smith, T., 'Contemporary Art and Contemporaneity', *Critical Inquiry* 32.4 (2006), 681–707.

—— *What Is Contemporary Art?* (Chicago: University of Chicago Press, 2009).

Smith, T., O. Enwezor and N. Condee, 'Introduction', in T. Smith, O. Enwezor and N. Condee (eds), *Antinomies of Art and Culture: Modernity, Postmodernity, Contemporaneity* (Durham, NC: Duke University Press, 2009).

Sullivan, M., *The Meeting of Eastern and Western Art* (Oakland, CA: University of California Press, rev. edn, 1989).

Šuvaković, M., 'Impossible Histories', in D. Djuric and M. Šuvaković (eds), *Impossible Histories: Historic Avant-Gardes, Neo-Avant-Gardes, and Post-Avant-Gardes in Yugoslavia, 1918–1991* (Cambridge, MA: MIT Press, 2006).

Tamruchi, N., *Moscow Conceptualism, 1970–1990* (Roseville East, CA: Craftsman House, 1995).

Ter-Petrosyan, L., *Collected Works* (Yerevan: Archive of the First President of Armenia, 2007).

Todorov, V., *Red Square, Black Square: Organon for Revolutionary Imagination* (New York: State University of New York Press, 1994).

Trotsky, L., 'Terrorism and Communism', in S. Žižek, *Slavoj Žižek Presents Trotsky* (London: Verso, 2007).

Verdocq, M. E., 'The Venice Biennale Reformed, Renewed, Redeemed', *Art in America* 87.9 (1999), 82.

Voronkov, V., 'Life & Death of the Public Sphere in the Soviet Union', in T. Goryucheva and E. Kluitenberg (eds), *Debates & Credits: Media, Art, Public Domain* (Amsterdam: De Balie Centre for Culture and Politics, 2002).

Warr, T., and A. Jones, *The Artist's Body* (London: Phaidon, 2000).

White, H., 'Interpretation in History', *New Literary History* 4.2 (1973), 281–314.

Wood, P., 'Modernism and the Ideal of the Avant-Garde', in P. Smith and C. Wilde (eds), *A Companion to Art Theory* (Oxford and Malden, MA: Wiley-Blackwell Publishing, 2007).

Zenian, D., 'Armenia on the Slow Road to Economic Recovery', *AGBU News*, 2 January 1995, http://agbu.org/news-item/armenia-on-the-slow-road-to-economic-recovery-armenia/ (last accessed 20 October 2014).

Zimmerli, J. V., *Beyond Memory: Soviet Nonconformist Photography and Photo-Related Works of Art* (New Brunswick, NJ: Rutgers University Press, 2004).

Žižek, S., *Organs without Bodies* (London: Routledge, 2003).

—— *The Plague of Fantasies* (London: Verso, 1997).

—— *The Sublime Object of Ideology* (London: Verso, 1996).

Zolghadr, Z., C. Bydler and M. Kehrer, *Ethnic Marketing* (Zurich: Ringier, 2007).

Index